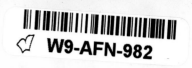

PAINTING

visual and technical
fundamentals

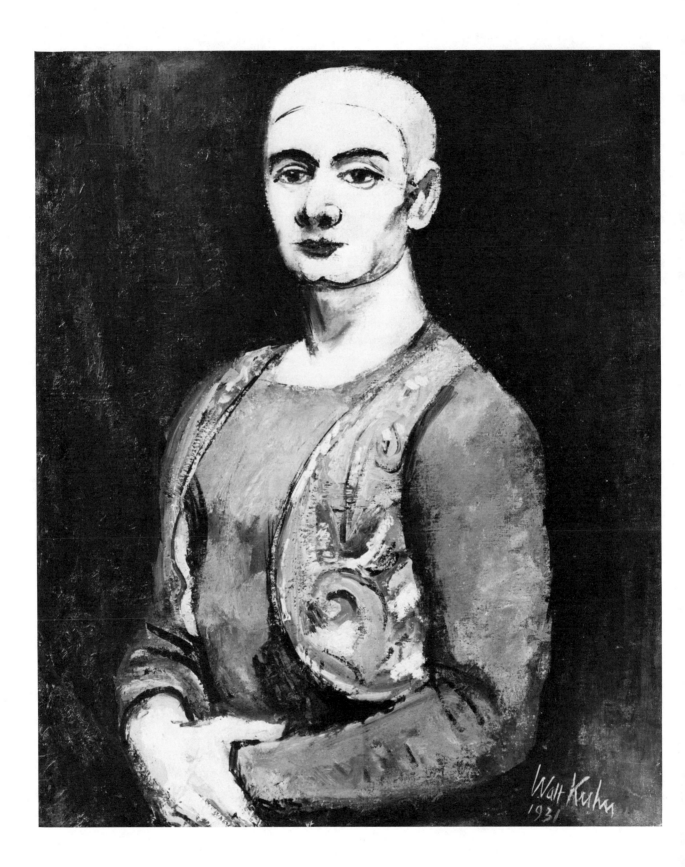

PAINTING
visual and technical fundamentals

NATHAN GOLDSTEIN

PRENTICE-HALL, INC.
Englewood Cliffs
New Jersey
07632

Library of Congress Cataloging in Publication Data

GOLDSTEIN, NATHAN.
 Painting, visual and technical fundamentals.
 Bibliography: p.
 Includes index.
 1. Painting—Technique. 2. Visual perception.
I. Title.
ND1500.G6 751.4 78-15907
ISBN 0-13-647800-X

Printed in the United States of America

10 9 8 7 6 5 4 3

Editorial/production supervision: Hilda Tauber
Cover/interior design: Lorraine Mullaney
Page layout: Martin Behan, Susan Behnke
Manufacturing buyer: Trudy Pisciotti

PRENTICE-HALL INTERNATIONAL, INC., *London*
PRENTICE-HALL OF AUSTRALIA PTY. LIMITED, *Sydney*
PRENTICE-HALL OF CANADA, LTD., *Toronto*
PRENTICE-HALL OF INDIA PRIVATE LIMITED, *New Delhi*
PRENTICE-HALL OF JAPAN, INC., *Tokyo*
PRENTICE-HALL OF SOUTHEAST ASIA PTE. LTD., *Singapore*
WHITEHALL BOOKS LIMITED, *Wellington, New Zealand*

Frontispiece:
WALT KUHN, *The Blue Clown*
Whitney Museum of American Art, New York

In memory of my brother

In the fine arts it is only the convention, the form,
the incidentals that change: the fundamentals of passion,
of intellect and imagination remain unaltered.

<div align="right">ALDOUS HUXLEY</div>

Nothing can permanently please which does not contain
in itself the reason why it is so and not otherwise.

<div align="right">SAMUEL TAYLOR COLERIDGE</div>

In every work of genius we recognize our own
rejected thoughts: they come back to us with
a certain alienated majesty.

<div align="right">RALPH WALDO EMERSON</div>

contents

preface

xi

ONE
from drawing
to painting

1

TWO
pastels and crayons

25

THREE
traditional
water-thinned media
39

FOUR
oils and acrylics
79

FIVE
the dynamics of form
and order
115

SIX
motives and themes
189

bibliography
261

index
263

preface

All mature painters, whatever their creative orientation, know that their skills, materials, and intentions are intimately interrelated, and that insights in any one of these spheres affect the other two. The aim of this book is to provide art students and other interested readers with basic, illustrated information concerning the visual, technical, and conceptual aspects of painting, *integrated* to reflect these interactions.

The questions "What shall I paint?" and "How shall I paint it?" cannot be answered separately. Nor can we separate comprehension from craft. The format I have adopted tries to support the painting teacher's daily attempt to integrate visual and technical information. Thus in the chapters that discuss paints and tools I suggest some of the visual concepts and themes that these materials serve and affect, and in the chapters that discuss visual matters I allude to the differing effects that various media have on the images we make.

The inclusion of a discussion of the bridges between drawing and painting

(Chapter One) is, to my knowledge, unique. That this should be the case is doubly surprising, first, because the need to utilize our drawing skills in painting is obvious, and second, because artist-authors with teaching experience know how frequently students beginning to paint fail to carry over important drawing insights to their visualizations in paint. I hope the examination of these matters will help the readers—as such studio discussions have helped my students—to more fully bring to bear *all* of their visual abilities in their paintings.

Chapters Two, Three, and Four are designed to assist all young painters, especially beginners, in coping with the basic problems of craft. In these sections I present a concise body of practical information and advice focusing on those materials and formulations that pose immediate and daily challenges.

In writing these chapters, I have relied heavily on my experiences as a painting teacher, and have tried to anticipate those technical issues most frequently faced by the beginning student. In these chapters I have

included a variety of exercises suggesting issues to explore, and designed to help the reader to more fully grasp a medium's versatility and character. While few readers are likely to explore every medium discussed, I hope that many will become curious enough to investigate at least some of them, for each offers new responsive possibilities—and new restrictions!

In arranging these media in an order that moves from those more given to linear treatment toward media more often broadly handled, I had in mind an easier transition from drawing to painting. However, because some students will do better to begin with a favored or familiar medium, or with one that invites a more painterly treatment, these media can be approached in any sequence.

Chapters Five and Six explore basic considerations of organization and expression—the dynamics—in painting, and examine the abstract and figurative possibilities of the visual elements—the building blocks of painting. The exercises in Chapter Five represent a variety of approaches to painting that can be adapted to individual interests; they are designed to provide a wide range of visual challenges and experiences. Chapter Six looks into various subject matter categories and tries to help the young painter come to grips with important considerations of theme and purpose that must also be taken into account in finding more fruitful answers to the questions of what and how to paint.

Although the technical passages necessarily concern some exact formulations and processes, and the perceptual ones involve some universal laws, both the format and the philosophy of this book are directed to experiences, and not to rules. Among the most important of these experiences is that of testing our perceptual and technical skills of response to the things, places, and people around us. Great artists always develop original frames of reference for experiencing our world, adding new dimensions of meaning to the things we subsequently see or envision. But such frames of reference do not arrive full-blown; the gifted artist shapes them during his or her formative years out of a sensitive and sustained inquiry about the nature of the things of this world. Similarly, young painters should infer from what their eyes and in-

tuition tell them about the outer, factual state of things, what inner states and meanings these things possess and suggest. In art, as in life, the ability to convey our understanding of what *is* should precede the exploration of what *might* be.

The emphasis in this book on paintings that show our world in more or less recognizable terms does not reflect my own aesthetic bias, but my view of what should constitute an important part of every artist's visual education. Nor, in all cases, do the paintings selected to illustrate points in the text reflect my favorite choices of artists or works. Indeed, some personal favorites such as Velasquez, Goya, and Renoir are missing, as are a number of more contemporary artists. In each instance I have tried to select a work that demonstrated well the point being discussed, and added to the variety of attitudes and techniques for the reader to study and consider. And, while I generally chose examples by acknowledged or highly gifted artists, the occasional inclusion of a less than great work was intentional when it illustrated a particular quality clearly, and because we can learn something useful from the near-miss or the frankly mediocre work, if only what to guard against.

The predominance of oil paintings as visual examples is due mainly to the popularity of this medium from the fourteenth century on. Being the preferred choice of most of the old and recent masters (as it is among contemporary painters), most of the best examples of fine painting were executed in this medium. However, except in the chapters on media, a choice of a particular work usually was based on visual issues that apply to paintings in any medium, and should not detract from the reader's interest in examining it.

In concentrating on the fundamentals of painting I have tried to stay well clear of how-to-do-it solutions and nonvisual considerations. Instead, by discussing basic visual phenomena and themes, and practical technical facts and processes, I have attempted to provide for the serious student a sense of the great realm of painting, a hand-hold on the use of various materials, and an awareness of those tangible factors that seem universally to be present in all paintings of important creative worth.

I wish to express my deep appreciation to the many students, artists, and friends who have helped in various ways to make this book possible. I wish also to thank the many museums, galleries, and individuals for granting permission to reproduce the paintings in their collections.

I wish especially to thank Marc Karlsberg of Studio Eleven, Newton, Massachusetts, who photographed a number of the reproduced works. Special thanks to Walter Welch and Bud Therien of Prentice-Hall, for their initiative, advice, and considerate assistance; to Hilda Tauber, project editor, Lorraine Mullaney, designer, and Marvin Warshaw, art director, for their fine skills and deep involvement in helping to shape this book.

I am particularly grateful to Professor David Ratner of Boston University's School of Visual Arts, a gifted painter, teacher, and highly valued friend. By playing devil's advocate, advisor, and enthusiastic supporter (sometimes all at once), he helped me to clarify my meanings and provided insights and information that have greatly strengthened the text.

My greatest debt of gratitude I owe my wife, for the gracious gift of her time in handling, as she has done in each of my previous books, much of the complex correspondence; for her support and good counsel, and for her strength and understanding in taking on the burdens that issued from my involvement with this demanding project. Finally, a special thanks to my daughter, Sarah, who is herself pretty good in the strength and understanding department, for her patience and uninterrupted flow of affection.

PAINTING

visual and technical
fundamentals

ONE
from drawing to painting

Even the most motivated student approaches the enticing realm of painting with some trepidation. How could it be otherwise? When compared to drawing, painting promises several formidable challenges: the broad, rather than linear means of applying marks, the greater number of technical considerations, the vast options of creative response that color affords, and for some, the perhaps intimidating knowledge that they are using the very painting materials employed by both old and contemporary masters.

There should, then, be some comfort for the beginner in learning that the professional artist also finds painting both exhilarating and hazardous. For, the seasoned painter's concerns, while they converge on highly personal visual and expressive themes, must continue to take into account those facing the beginner. The fundamentals of visuality, response, and procedure can never be disregarded or taken for granted. When they are, the results always show some weaknesses in organization, in execution, or in the use of the materials. Indeed, it is the sense of adventure and opportunity, of

problems and possibilities at every stage in the creation of a painting that is one of the more compelling attractions for the artist. All creativity demands that we live by our conceptual and technical wits.

But if painting is a less calculable art form than, say, weaving or silversmithing, where more predictable results are the rule, there *are* principles and guidelines that can provide beginners with an important measure of control, helping them to more clearly convey their observations or visions. Every visual work of art demonstrates the successful interplay of three factors: *conception, technique,* and *fluency.*

The term *conception* defines both the originating and ordering of our images, the governing of our perceptions, impressions, and visions. It includes what is ordinarily understood as the ability to design or to compose, but it also refers to the character and quality of our visual and expressive imagination. Conception, then, can be understood as our creative resourcefulness and intent.

Technique as used here refers to the science and craft of painting, to a proficiency

1

in the use of our materials. It is the ability to make the mechanics of painting augment our creative instincts and skills.

By *fluency* is meant the general ability to make our conceptions materialize. The term includes what is ordinarily understood as our power to analyze and denote. It is our capacity for judging and the skill to clearly state our responses. Fluency is shaping, giving form to visual experience. Whether we are painting, sculpting, or making pottery, fluency is making our meanings manifest. It is, in the best sense of the term, our skill in drawing.

The reader with a background in drawing already knows the interrelated nature of these three factors. Their interdependence in painting is of course greater to the degree that more ambitious imagery, an expanded technical range, and the element of color are utilized. In the following chapters we will explore the book's main themes: the visual and procedural fundamentals of painting. But first we must examine those drawing skills and insights we already possess, to see how they may serve both as a bridge to painting and as a fund of knowledge crucial to fluency in painting.

LINE IN PAINTING

The well-known British art critic Herbert Read has observed that "Art began with the desire to delineate."* Small wonder, for line is the element instinctively and universally relied upon to form any visual plan or statement, be it a map, chart, blueprint, or any other graphic communication. And, while we can cite paintings in which line plays a decidedly minor role, its functions in painting are generally of great importance, although its presence is more often sensed than seen. In this brief examination of the components that lead to fluency in painting, the best place to begin is with a discussion of this powerful element.

In drawing, where lines are usually the dominant visual element, they serve various shape-making, form-building, and calligraphic functions. Used in thin or dense ranks they produce light or dark tonalities. A single line can convey a surprising amount of information about a form's structure as well as contour.

*Herbert Read, *The Meaning of Art* (Harmondsworth, Middlesex, England: Penguin Books Ltd., 1967), p. 38.

Lines can measure, search, touch, direct, and define, and can do so in a variety of expressive modes.

Nor is the drawn line the only manifestation of this potent element. We sense lines moving within and among forms. A line of trees or dancers refers to their collective horizontal direction, the result of the *alignment* of their individual vertical direction. Such lines, often acting as the long axis of one or more forms, can be straight or convoluted. Like drawn lines, they can be keenly mechanical or sensual. They inherently suggest movement.

Line also exists in shape. When we speak of the flowing lines of a drawing or a vase, or the majestic lines of a sculpture or a building, we are responding to the rhythms and energies of their edges as well as to their inner, directed movements.

In painting, line may appear directly, as in Matisse's *Large Interior in Red* (Figure 1.1), where lines enclose forms or define forms, as in drawing. Line may also be used in fluid media in the hatched manner often used in charcoal and pastel works, as in Toulouse-Lautrec's *The Sofa* (Figure 1.2). But more often in painting, line is expressed more by its presence as edge and inner movement, or as directed action between parts of a work than by lines drawn for calligraphic, diagrammatic, or structural purposes, although in many paintings the visual effect of the brushstrokes, especially when they are unblended, long, or heavily built up is of a linear nature. This can be seen in Marin's watercolor, *Movement, Fifth Avenue* (Figure 1.3), where the strokes *and* their interspaces create an energetic linear pattern. Yet line as *outline* scarcely exists. When we realize just how futile it would be to try to make a copy of this painting in pen and ink, we begin to see some of the ways in which painters use line. Again, in Sloan's oil, *The Cot* (Figure 1.4), the thickly painted strokes depicting folds and pleats simultaneously enact abstract linear actions that enliven the image. Note how the upper edge of the bedding's shape restates horizontally the vertical curved line of the figure's draped back and leg. By such discreet relationships painters can employ the implied lines of edges to help organize their pictures.

As these examples demonstrate, lines in painting, whether they exist as the edges of parts, as inner movements like those which

Oil on cardboard, 24¾ x 31⅞ in.
The Metropolitan Museum of Art. Purchase, Rogers Fund, 1951.

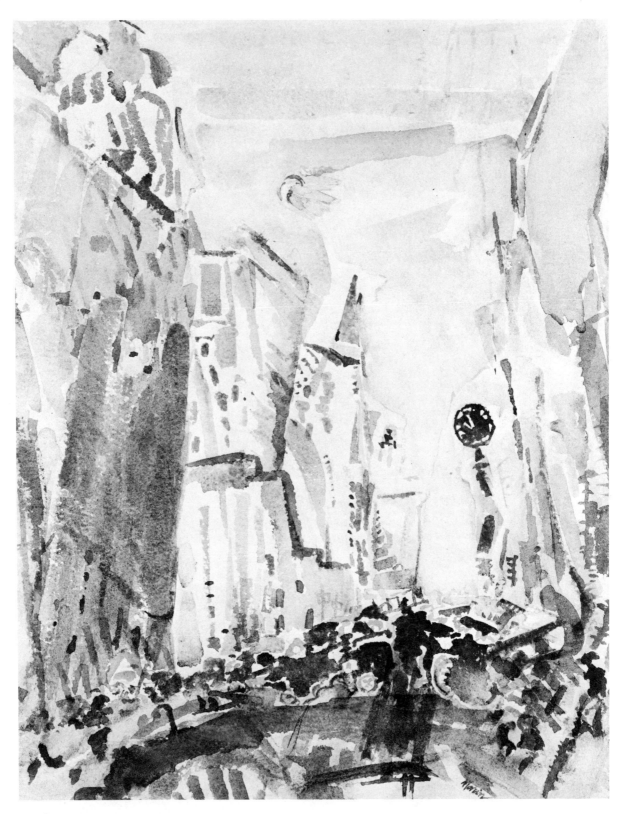

Figure 1.3
John Marin, *Movement, Fifth Avenue*
Watercolor, 16⅝ x 13½ in.
The Art Institute of Chicago, Alfred Stieglitz Collection.

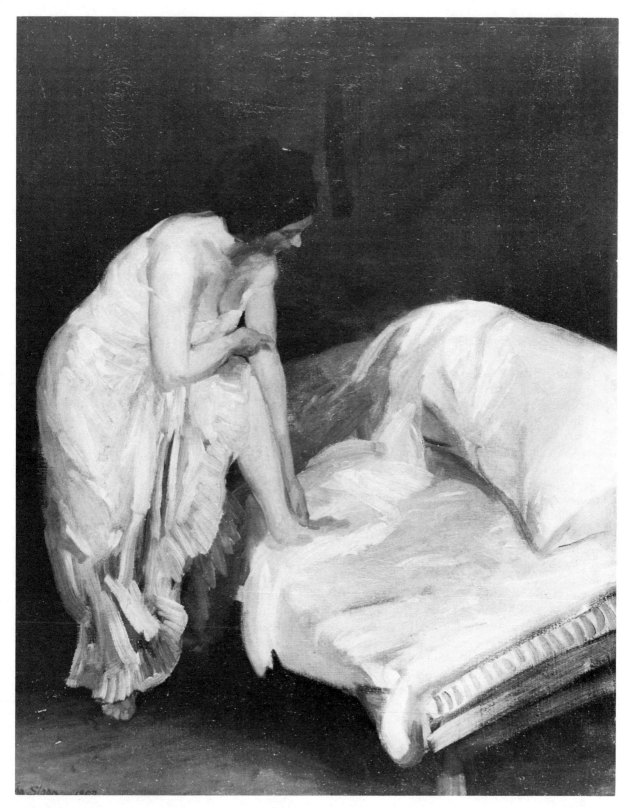

Figure 1.4
John Sloan, *The Cot* (1907)
Oil on canvas, 36¼ x 30 in.
Bowdoin College Museum of Art, Brunswick, Maine.

animate the buildings in Figure 1.3, or the woman's gown in Figure 1.4, or function in more calligraphically motivated brushstrokes as in Figures 1.1 and 1.2, can be broad or indefinite—unfocused—in ways that are less natural to the pointed instruments associated with drawing. This difference in how line may function in painting is a common source of difficulty for the beginner trying to confront nature objectively. He sorely misses the precision so easily achieved with the pen or pencil; he is distressed to find that a concentration on contours doesn't begin to meet the problems of form-building or designing in painting. Then, too, he finds the broad, pliant brushes and the various fluid or viscous painting materials hard to manage. In fact, great precision with any of the painting media is possible, as we shall see. But first it is important that the beginner experience what different types of stiff and soft-haired brushes, used with oils, gouache, watercolor, or other painting media can do—what the range and *feel* of such materials is like. For this reason we should, at first, avoid merely carrying over into painting the kinds of lines and line uses familiar to us in drawing, but be sensitive to how these new tools and materials may be utilized. This attitude should extend to our work in pastel. Although pastel is an abrasive material often applied as hatched lines, it is, by virtue of its extensive chromatic and textural range, a rich painting medium, as Redon's painting *Roger and Angelica* demonstrates (see Plate 5).

The spirited drawing in Figures 1.2, 1.3, and 1.4 tells us that despite the virtual absence of contours, of delineation, these artists enjoy *drawing with paint*. Instead of restricting brushes and paint to the marks that pointed tools produce, they utilize the versatility of their flexible and fluid materials. In doing so, brushstrokes sometimes broaden into shapes and planes, and fuse or emphasize forms. Here and there a brushstroke begins as a powerful eruption of pigment or tone only to subside into obscurity among other strokes. Even in Matisse's painting (Figure 1.1), which relies heavily on drawn lines, the brushwork of the floor, table, wall, and flowers expresses a more painterly use of line.

In the following chapters we will discuss many of the structural and design possibilities of actual and implied line in painting. For now

we should note that line, although usually less central to painting than color, exerts a principal force, even in its implicit state, as rhythms and directed actions within and between segments of a painting. No matter what kind of image we choose to make, line can never be wholly absent.

SHAPE IN PAINTING

The beginner in drawing soon learns to see the two-dimensional boundaries of three-dimensional mass and space. He knows that a form's silhouette—its shape—and the shape or shapes it creates by displacing a background or by overlapping other forms gives him information necessary to his objective understanding of the form. In drawing, the shape actualities of form and space can be shown by line, or tone, or both. The shapes created indirectly by the spaces left between drawn areas, as for example, the wedge-shape of space, the *negative* shape, that results from drawing the separated legs of a standing, front view of a figure is often left as the white of the paper, as is the enveloping, outer part of the page if the configuration is more or less centrally located on it.

In painting, however, these shapes are seldom left as unpainted areas. The painter, unlike the draughtsman, cannot so easily concentrate on the configuration alone. He must consider the color and value of such areas. And these considerations influence the kinds of shape judgments that the painter makes. The shapes in a painting of the same subject as a drawing will need to change in response to the effects of color, and as additional shapes and values provide new visual conditions.

This can be seen when we compare Degas' preparatory sketch with his painting of *Diego Martelli* (Figures 1.5 and 1.6). In the drawing, the sitter's dark vest consists of three shapes, the two larger ones being obliquely aligned to counteract the opposing diagonal thrust of the figure's legs and the table top (here represented only by a line or two for each). This arrangement permits the light shape of the folded arms to touch the light shape of the trousers, thus avoiding the isolation of either area and creating a major organizational idea in the sketch: a radiating pattern of lines and edges. This pattern, in af-

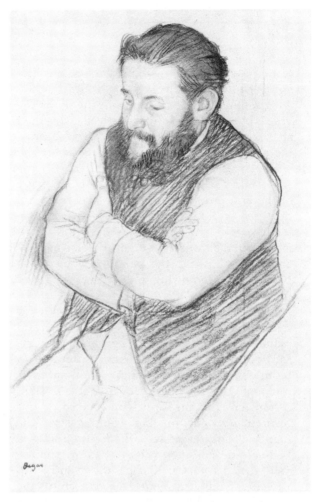

Figure 1.5
EDGAR DEGAS, *Study for Portrait of Diego Martelli*
Charcoal, 17¾ x 11¼ in.
Fogg Art Museum, Harvard University.
Bequest, Meta and Paul J. Sachs.

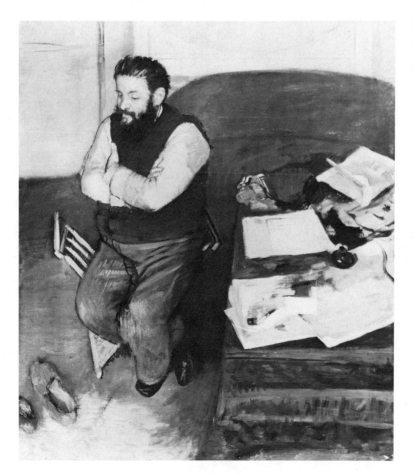

Figure 1.6
EDGAR DEGAS
Portrait of Diego Martelli
Oil, 43½ x 39¾ in.
The National Gallery of Scotland.

fecting every part of the figure shown, acts as a strong unifying agent.

All this changes in the painting. Now the vest is reduced to two vertically oriented shapes, and the resulting large, upward-turning arc of the vest's lower margin answers the even larger, downward-turning arc of the sofa's upper edge. Now, too, the angular shape of the arms *are* isolated, but because they are they act as a light-toned reply to the light-toned books and papers on the table. Had Degas left the trousers as light in value as they are in the drawing, the painting would have been imbalanced owing to the visual weight of the dark tones on the right side.

For Degas, the shape solutions necessary in the drawing, where their scale, value, and pattern form a balanced design among themselves and on the page, no longer appeared to be the best solution for the figure in an environment. The drawing's self-contained design, if transferred to the canvas unchanged, might form an isolated unit that would destroy the painting's greater design. The figure *needed* to be made dependent on the rest of the shapes, values, and colors in the painting, and vice-versa. Note how, in Figure 1.6, the arc of the sofa also runs through the figure, turns at the right knee, and seems to jump to the table, where it follows the curve of the books and papers to return to its starting point. Note, too, that the vertically oriented shapes of the sitter now associate strongly with the similarly directed shapes of the table, door, and wall. The figure has become an integrated member of a system of vertically and horizontally oriented shapes.

By color, shapes relate in bonds and contrasts of hue, value, direction, and scale. In color we would see that although the value of the green-gray trousers is similar to the values of the warm tones of the rug, their hue links up with the cool colors throughout the painting. Just the opposite occurs with the sitter's dark vest, which joins the great shape formed by the dark tones of the blue table and sofa, but, by its warm color, relates with the several warm-colored shapes in the painting.

These two works point to other differences between drawing and painting shapes. In Figure 1.5, Degas leaves the shape of the folded arms empty of any detail, and in the context of the drawing's simple shapes and

tones, this is a useful tactic. But in Figure 1.6, where smaller shapes and tones representing the planes of the slipper and those of the books and papers are required to make these objects read as masses in space, Degas apparently felt he had to break up the large, flat area of the shirt sleeves. In the context of the painting's structural and spatial clarity this shape would appear to rise to the surface, too simple and harsh. But notice that in defining the planes that give the crossed arms weighty volume, Degas maintains their original strong shape.

In painting, then, shapes, like lines, will undergo changes determined by color, value, and organizational needs. As with line, many shapes in painting will not be sharply focused, but will emerge as the results of mass, tone, brushwork, and color relationships. Some painters, however much their figurative orientations may differ, emphasize strong shape-clarity, as Hals and Cremonini do (Figures 1.7 and 1.8).

Finally, it is harder to keep painted shapes as fresh and strong as they may seem to be in our drawings. This is to some degree a technical matter having to do with the manipulation of paint, but it also has to do with the fact that in painting we generally approach an edge from either side. We not only define, say, an edge of a cloud, but must paint the sky around it. In doing this we may weaken a shape's clarity, character, and original function in the design. The ability to insist on the shapes we intend and need as color meets color is as much a matter of visual discipline and theme as of technique.

VALUE IN PAINTING

Although when drawing we may have little difficulty in extracting and ordering the various light and dark tones in a subject, the fact that our subject is made up of one or more colored forms can blind us to its value *actualities* when painting. Values in drawing are directly stated: the sail is light, the sea is dark; in painting they are properties of the colors used: yellow is naturally light in value, violet is dark. Seeing the relative lightness and darkness of a subject's often subtle colors, and judging the tones as well as the colors we use in interpreting it, is one of the most important per-

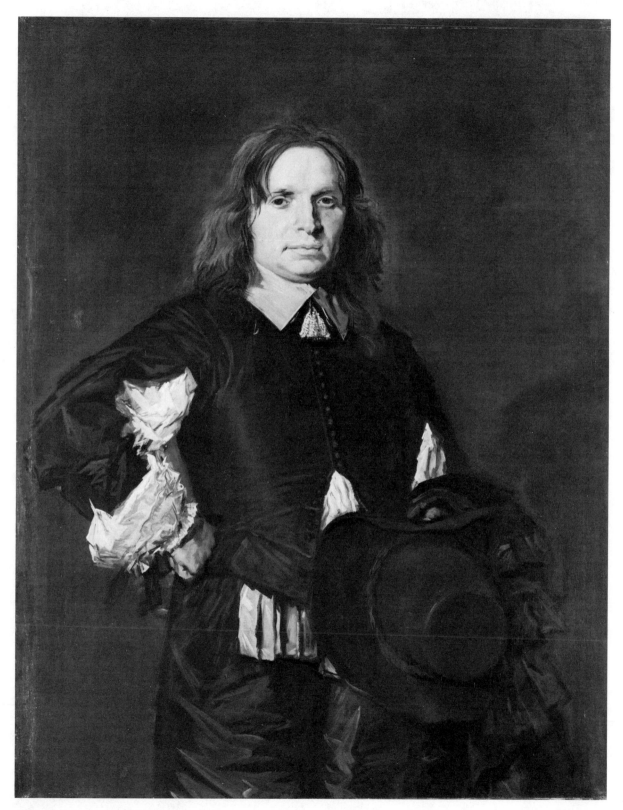

Figure 1.7

FRANS HALS, *Portrait of a Man*

Oil on canvas, 43½ × 34 in.

The Metropolitan Museum of Art, Gift of Henry G. Marquand.

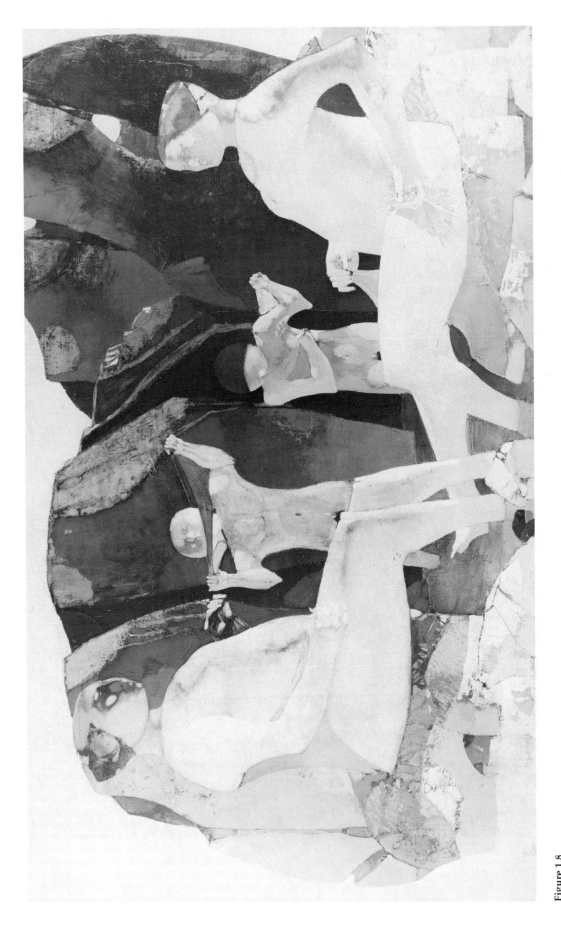

Figure 1.8
Leonardo Cremonini, *Bathers amongst Rocks* (1955–56)
Oil, 35 x 57½ in.
Hirshhorn Museum and Sculpture Garden, Smithsonian Institution.

ceptual skills the beginner must acquire. He must be able to see just how light the particular yellow of a certain lemon is when compared to the darker value of a certain apple's particular red, and be able to hold these value judgments in mind when mixing his colors.

These perceptions are as necessary for the student who intends a highly subjective interpretation of a subject as they are for one who means to represent the subject more objectively. In painting, as in drawing, understanding the nature of what *is* precedes and profoundly affects the quality of what *might* be. The better we understand our subject's *measurable* and *dynamic* actualities, the more vitally original will be our responses, no matter what our stylistic and expressive intent may be.

By *measurable* actualities we mean the objective, provable, physical qualities of a subject: the dimensions, location, shape, color, and value of its parts. The term *dynamic* refers to the visual expression generated by the relational behavior of the subject's parts: the moving energies, the tensions, the rhythms, and the bonds and oppositions inherent in the arrangement and surface character of these parts. (These factors are more fully examined in Chapters Five and Six.)

Even in paintings that rely more on color than on value, the abrupt or gradual gradations of tone, whether they extend from white to black, or only show a small range of tonal change, are, as in drawing, part of the painter's design. So much is value an intrinsic condition of color that the only way to exclude it from consideration as part of a work's total order is to make every color in the painting the same in value. A black and white photograph of such a work would then appear as a more or less flat field of gray tone. Except when this is the case, value is a given condition of painting, presenting options and challenges for the artist, no matter how intense or varied the color may be, or how provocative or intricate its interworkings.

Examining the tonal organization of this book's black and white reproductions reveals that value is a substantial factor in the design of paintings, uniting differing forms, contrasting similar ones, and forming its own patterns and movements. Nowhere does a design fail in balance or unity because values are randomly placed. Tonal considerations may vary in importance according to an artist's point of view, but no point of view can permit this major visual element to go unregarded.

In painting, as in drawing, clear-edged and vaporous tones are not only powerful agents of representation and illumination but also of directed movement, balance, and mood. Figures 1.9, 1.10, and 1.11 show how three artists, separated more by intent than by time, utilize value to order and to express. In Rubens' *Battle of the Amazons,* the action of the figures and animals is matched by the action of the values. Rubens knows that a gradually changing tone suggests movement, and uses this device to amplify the action of the scene. On the far left, the light tone of the curved line of warriors and horses on the bridge grows darker as it moves toward the right. Here, the dark tone of the rearing horses leads us back to the left side along the route of the dark tone beneath the bridge, which becomes lighter in value on its upward swing. A second circular movement, of light values, begins in the falling figures and horses in the foreground, swings upward alongside the aforementioned curving dark tones, and enlists light values in the sky to complete its rotation. In the sky, which grows lighter toward the right side, values act to set off the values (and action) on the bridge. Other, smaller tonal changes further animate the activity of the battle. By purposely squinting at the reproduction we can more easily see some of these abstract actions working, as, for example, the burst of light tone among several groupings of figures and horses. Note how Rubens, through extremes of value, contrasts the similarly posed horses on either end of the bridge. Likewise, in keeping with the Baroque idea of dramatic action at both the representational and abstract levels, Rubens adds energy to the painting's turbulence by causing forms as different as clouds and horses to unite in fast-moving value changes.

But value can do more than add fuel to the fire. In an early Picasso still life (Figure 1.10), gently changing tones express the painting's air of hushed delicacy. In the foreground, dark tones subtly grow darker still as they approach the teapot—the darkest tone in the painting. Picasso locates a dark-toned cup near to the teapot to make the graduation

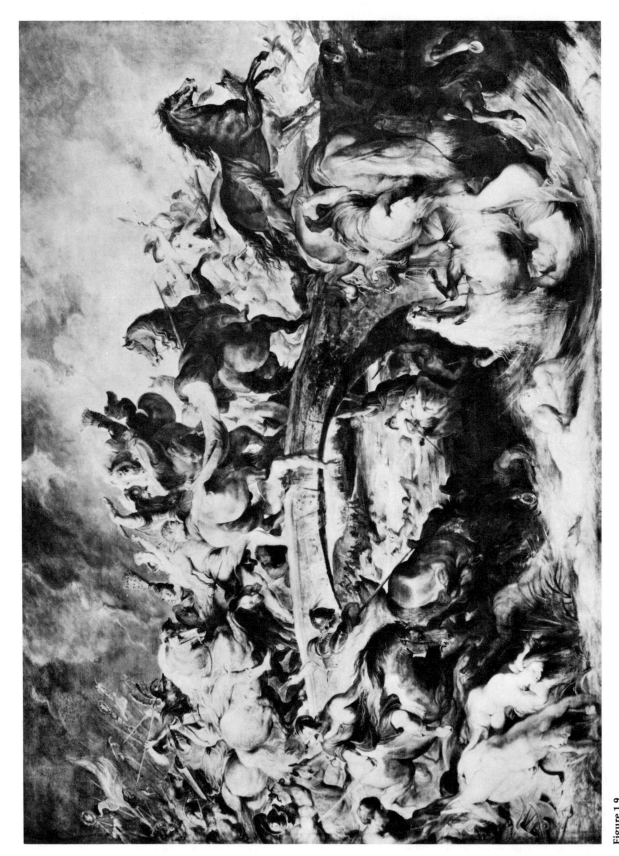

Figure 1.9
PETER PAUL RUBENS, *Battle of the Amazons* (ca. 1618)
Oil on wood, 47¾ × 65¼ in.
Alte Pinakothek, Munich.

12

Figure 1.10
PABLO PICASSO, *Still Life with Portrait* (1905)
Oil on canvas, 32¼ x 39½ in.
Collection of Mrs. Duncan Phillips, Washington, D. C.

Figure 1.11
NICOLAS DE STAËL, *Musicians* (1952)
Oil on canvas, 63⅞ x 45 in.
The Phillips Collection, Washington, D.C.

from light to dark even less sudden. Surrounding the light-toned teapot on the right side are values that, while darker than the teapot, do not force a strong contrast. Each teapot carries its opposite number's value within itself in small highlights and shadows, and each has an adjacent form to one side that comes near to the opposite teapot's value. Throughout the rest of the painting, values stay away from the quiet encounter of the two teapots, their various colors holding to a common, narrow range of values that fall between those of the two main protagonists. Note how soft edges, affinities and oppositions of line, and especially of shape help to unite the design and enhance the mood of the painting.

In de Staël's *Musicians* (Figure 1.11), large "pillars" of a middle-gray tone frame the lively tonal action of the musicians. The musicians' light-toned forms are held by an encircling band of small, dark tones whose directions and shapes suggest a sprightly arrangement of musical notes on a page. On the right side, a thin band of dark value runs the length of the painting, answering the horizontal shape of the light value encircled by the small, dark shapes. Note that the large, vertical, light-toned shape in the center of the upper half of the painting acts as a rest area, as a foil for the thickly pigmented shapes throughout the painting, and as a suggestion of deep space. Although the rich color here, as in Rubens' and Picasso's paintings is vital to the total meaning of the imagery, its chromatic functions never conflict with its tonal ones.

Once we learn to see the values of colors, adapting our knowledge of value in drawing to painting comes easily. In drawing, even the manner of applying tones is usually similar to the broad application of paint. We often use the side of the chalk, charcoal, or graphite to more quickly and easily lay down a tone in a sketch.

In painting, as in drawing, value can identify an object's tone: the light gown, the dark cup, etc.; it can bathe forms in a unifying light, or cause forms to stand apart; and it can, as we have seen, create atmosphere and mood, and help organize and animate the image.

COLOR IN PAINTING

Up to now we have examined those visual elements common to both drawing and painting. With color we enter upon an area of perceptual and expressive phenomena incidental to drawing, but at the very heart of painting. Although we cannot establish a precise boundary line between drawing and painting, we can pinpoint their "capitals"; for drawing it is *line,* and for painting, *color.*

Color is capable of three main functions in painting. First, color can describe a subject's various hues, its particular reds, blues, etc., and the tints and shades of hues, the lighter and darker states of colors resulting from light rays playing upon the subject's forms. This descriptive function is color's most simple and straightforward role: the chair is light green, the blouse is dark blue, etc. When color is limited to descriptive duties, forms, when modeled, are generally treated *monochromatically,* that is, by the adding of only black or brown, and white to the color of the object, to give it solidity. An apple might then be painted with say, cadmium red deep, black, perhaps some burnt umber, and white.

But such a narrative use of color does not always mean naturalistic color. Descriptive color has often served symbolic rather than observational motives. In oriental, medieval, and early Renaissance painting, in children's art, and in the works of those untrained adults called *primitives,* color usually describes preconceived notions: tree trunks are invariably brown, grass is a vivid green, cheeks are always rosy, and water is unfailingly blue. Only among objectively-oriented artists with acute analytical skills does the descriptive use of color more nearly approach the colors and values of a subject observed in a particular light.

A second important function of color is in the building of form and space. Because in certain ordered arrangements various colors will appear to advance while others will seem to recede, color can play an active and even dominant role in forming a volume's structure and its spatial "container."

Used in this way, color is not necessarily less involved with describing a form's perceived or assumed colors, but does so in a

more interpretive way. Such a use of color does establish a form's particular color *and* those warm and cool variants of that color essential to giving the form substance. Sometimes, of course, the colors needed to model the form can take over its local color, leaving the form a well explained solid but of no particular hue. Cézanne, who led the way in showing the mass-making properties of color, is known to have warned young painters to "maintain the local color."

Paintings in which color evokes form and space often show less dependence on tonal modeling. Instead of descriptively modeling, say, an apple with red, white, and black, color-oriented painters are more likely to use a variety of red hues ranging from a light orange-red to maroon, and even several blue and green colors, although white and perhaps black may be used as well. For, despite a concentration on color as the means of expressing form and space, value, in being inherent to color and light, is always part of the process. But to the extent that color relationships define form, there is less need for value relationships to do so, as Plates 1A and 4 demonstrate.

The artist who regards color as a primary means of realizing form and space rather than as only an adjunct to it is usually less concerned with a subject's surface character—its tactile or textural nature—but seeks instead to comprehend its underlying structural and dynamic nature. For him, the color requirements and sensations that stimulate and sustain his creative efforts are derived from an empathic analysis of his subject, and not merely from retinal impressions.

A third role of color, in addition to its descriptive and form-building functions, is to provide patterns of hue and intensity resulting from various kinds of color similarities and contrasts—what we might call *color confrontations.* Such color patterns move or pulsate upon the picture-plane in ways quite independent of the descriptive or structural roles of color. One such basis for abstract color-play is the relational play of hues. If, for example, a still life arrangement contains an orange and a plum, the orange will relate strongly with other orange-colored forms, even across the canvas, or with the sun seen through a window behind these objects, as well as with any

other orange or reddish spots and tones in the arrangement. Likewise, the plum will become a member of other bluish or violet-toned forms or areas in the scene. While the orange and the plum may relate by shape, size, and proximity (not to mention their edible classification), they will, nevertheless, confront each other as opposing hues. Such strong color contrasts trigger vibrations and tensions as each color intensifies the other, as we shall see. Less obvious color harmonies and dissonances set off subtler kinds of visual activity, producing all sorts of "quieter" energies and tensions among the colors in a work. Such actions may have little to do with a work's representational content, although in the best figurative paintings the autonomous, abstract life of the colors reinforces the character and mood of the depiction, as in Klimpt's painting of flowers in a garden (see Plate 3).

By intermingling various blue, violet, and red hues Klimpt sets the stage for the explosions of yellow and white flowers. The almost impressionist character of so many differing color spots reinforces the idea of crowded, luxuriant growth. Note that here too it is color rather than value changes that explains form and space.

Again, in Cézanne's *The Basket of Apples* (see Plate 4), color confrontations help organize and animate the painting. The various fruits group themselves into several patterns according to hue, value, and relative warm and cold tones. Note, for example, how green is used to weave parts of the design together. The largest eruption of green is in the three apples on our left. Green continues to snake across to the painting's far right, insinuating itself into many of the apples, where it serves to model those forms, and into the table at the far right, finally returning to the left side again by its periodic, subtle appearance in the cool colors of the wall. Similarly, red can be seen to be a strong color note on the right side and to grow more subtle as it moves to the left side, appearing finally as a single spot of red on the basket's handle.

Such color activities result from several kinds of color phenomena that we will now examine. And, while the following five categories do not directly explain the emotional, psychological effects of color (such effects are bound to be too personal and varied to yield to

any attempt at analysis), they do account for color's main repertoire of visual effects.*

1. Hue Contrasts

The most obvious way to associate and contrast colors is by their specific chromatic quality, that is, by hue. The more nearly alike any strokes, areas, or forms are in hue, whether near or far apart in the painting, the more strongly they will relate and, in doing so, tend to unite differing, opposing hues. Such color unions and contrasts depend firstly on hue and secondarily on the relative warm and cool characteristics of surrounding hues. For example, green and blue shapes will seem related if encircled by orange and red areas. Adding a red apple to our orange and plum would have it relate with the orange if the apple were painted in the warm cadmium reds, and with the plum if painted in the cooler, alizarin tones. If the color of the apple maintained an equal hue (and warm-cool) distance from both the orange and the plum, it could, depending on the nature of the other colors in the painting, oppose both the orange and violet colors or serve as a color bridge between them. The former would occur if other

*For a further explanation of color effects, see Johannes Itten, *The Elements of Color* (New York: Van Nostrand Reinhold Co., 1970).

segments of the painting contained reddish colors; the latter, if it showed various muted, grayed colors.

2. Value Contrasts

Some colors are inherently dark in value, others, light. As we said about hue contrasts, the more nearly alike any strokes, areas, or forms are in value, whether near or far apart in the painting, the more strongly they will relate, and thereby tend to unite all other colors that contrast with them in value.

Seen this way, if the apple were painted in light red tones, it would be associated with the orange, and if painted in dark red tones, with the plum. As with hue contrasts, the apple's value can contrast with those of the orange and plum or can act as a tonal bridge between them. This depends in part on the tones in the rest of the painting. The former would occur if the rest of the colors were near in value to the tone of the apple; the latter, if the rest of the colors in the painting were very much lighter or darker in value than any of the three fruits.

3. Complementary Contrasts

Complementary colors are those located directly opposite on the color wheel (Figure 1.12). Hence, they are arranged in a way that

Figure 1.12
The *primary* hues are red, yellow, and blue. Mixing any two primary colors produces a *secondary* hue. The secondaries are green, orange, and violet. Mixing any primary with either of its adjacent secondaries produces a *tertiary* hue. For example, a mixture of red and orange produces red-orange, a tertiary hue that only subtly suggests yellow, which is still present in the mixture.

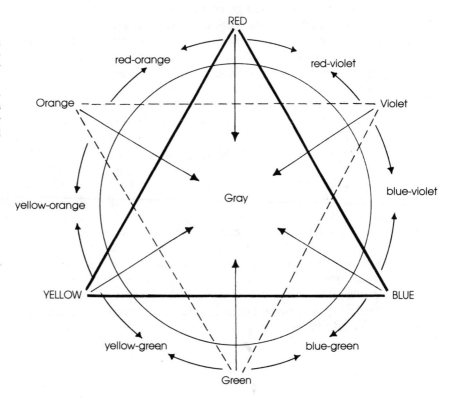

parallels the tendency of our eyes to produce the illusion of a color opposite to the one we fixate upon. If, for example, we stare at a blue shape for a minute or so and then turn to look at a white surface, the shape will seem to reappear in orange. In the same way, a strong color such as a primary or secondary one will seem to show a faint aura of its complementary.

In painting, any color can be made to seem more brilliant by surrounding it with colors that suggest its complementary. If yellow is encircled by violet tones, even grayed ones, both color areas will appear more intense. The opposite occurs if any color underlies its complementary. An intense green will appear duller if it covers a red in such a way as to permit some of the red to show through or between strokes. Mixing equal amounts of any two complementary colors, in theory at least, produces a gray tone. The more nearly any colors complement each other, the more they will oppose and intensify each other, thus tending to unite all other colors not engaged in the confrontation. However, for this to occur, color shapes must maintain a fairly large scale in the painting. Small shapes of color, no matter how varied or brilliant, will, if crowded together, cancel out their complementary action. Our eyes then see a field of small spots of pure colors as a muted, somewhat grayed color area, as in the impressionist-like segments on either side of the sunflowers in Klimpt's painting (Plate 3). Now our orange and plum, in being only somewhat complementary, can intensify each other's hue more if their surrounding colors are muted, or can both be reduced in brilliance if encircled by colors engaged in stronger complementary actions.

Related to this phenomenon is the tendency of any strong color to make neighboring weaker or more neutral colors take on the hue of the strong color's complementary. A red shape painted on a neutral gray field will give the light tone a light greenish cast, while a strong yellow shape on the same gray field will impart to it a violet overtone. In this way painters sometimes suggest rather than actually use colors to create ineffable and mysterious effects. Rembrandt seldom used blue, but many of his paintings suggest passages of subtle blue and violet nuances, the effect of finely tuned surrounding warm colors on various cool grays.

4. Intensity Contrasts

Every color has its inherent brilliance, sometimes called its *saturation power*. Orange is brilliant, pink and brown are not. A pure color, such as those shown on the color wheel, can be lessened in intensity by mixing it with a neutral gray *of the pure color's value*. This can be seen by painting a square of say, yellow, next to a square in which you have painted a mixture of 90 percent yellow and 10 percent of a gray that matches the value of the yellow. They will appear to be the same color, but the pure yellow will be more brilliant, more advancing than the mixture. The more gray added to a color, the weaker its hue identity and impact. Of course, when the added grays are lighter or darker than the pure color or have a pronounced warm or cool color-character of their own, the nature of that pure color is altered more. If in our still life example the three fruits possessed the purest colors in the painting, they would, despite their other points of contrast, relate as a triad of intense color-notes in a duller setting, no matter how fresh the tints or resonant the shades of the surrounding colors. The ability to adjust the intensity of colors is a powerful compositional, form-building, and expressive tactic.

5. Quantity Contrasts

Yellow and yellow-orange were not casual selections for the colors of life-jackets and emergency dinghies. These hues have the strongest visual impact, especially when seen against the cool colors of the sea. And while it would surely be necessary, if oceans were orange, to make life-jackets blue, there *is* among colors a hierarchy of intensities. At the top is yellow, followed by orange, then red and green, next is blue, and lastly, violet. Thus, the lessening of intensity among pure colors roughly parallels the lowering of their value. But this correlation does not hold true for grayed colors or mixtures made of exact or near complementaries. A pale pink or a tan color may be light in value but cannot generate the brilliance of an orange or a green hue. Nor can the intensity of yellow ochre or Naples yellow compete with the chromatic punch of darker colors such as cobalt blue or cadmium red. The visual implications of the differing intensities

of colors are important considerations in how we use them.

In a composition where yellows and oranges occupy a major portion of the format, other colors can only support or set off these potent colors. They can act as visual foils or rest areas, but cannot take on the yellows and oranges in any way that would reduce the domination of those warm colors. Under these circumstances no combination of violets, red, blues, or greens can do more than serve as friendly or antagonistic satellites of these large "suns." However, if the situation is reversed and various blues, greens, violets, or reds (or any two or three of these colors) occupy large segments of the pictorial area, a few patches of yellow, orange, or orange-red can engage those large areas in a serious battle for chromatic dominance—and often win (see Plate 7). Because, in our still life, the orange would, by its hue intensity, dominate the similar sized plum and apple, it would need to be slightly dulled if it were to equal the others in brilliance.

The beginner should be aware of these relative differences in the visual impact of his colors, and should examine their compositional and form-building potential. A common error is to confuse a color's brilliance with its value. But, as observed above, bright and light are not always the same thing, and graying the color of every form near its edges to suggest a lessening of the light falling upon it usually results in chalky or muddy color. As Cézanne's painting shows (Plate 4), some of the richest colors are found in half-tone areas and not in those parts of a form most highly illuminated.

Cézanne's painting also shows that such a use of color need not lead to strident results. Indeed, stridency—raw, screaming color—is avoidable even when powerful colors dominate, as long as those colors succeed in performing visually logical functions. Derain's *Portrait of Matisse* (Plate 6), a fine example of the strong color-modeling of the Fauve painters, demonstrates this. Additionally, these colors succeed in creating their own abstract patterns and energies, and in establishing a vibrant psychological mood. Yet note that local color—the colors of the things depicted—comes through.

But subtle colors, gentle tints and shades, as well as interesting, nameless mixtures can also avoid chalky or muddy results. In Turner's watercolor sketch, *Lyons* (Plate 2), the quiet yellows and blues in the sky carry as much of the responsibility for suggesting the brilliance of the setting sun as do the value changes.

As those readers who have already begun to paint will have recognized, these five categories of color activity can interact and overlap in ways that make it impossible to track. Moreover, other considerations modify these color effects. Direction, shape, scale, and location in the design are some of the visual phenomena that influence the way we see the color functioning. Besides, the very way the paints or chalks are applied affects our reaction to the colors. An opaque patch of color is less lively and light-filled than the same color is when applied transparently. But opaque color, especially when laid on in a heavy impasto (a thick layer of paint), seems more substantial and rugged than transparent color does, as is evident by comparing the Turner and Derain paintings (Plates 2 and 6).

In a similar way, an urgent or aggressive handling of paint seems to enhance the strength of color interactions, while a deliberate and precise paint application seems to lessen their force. Even two paint strokes of the same color can be made to contrast subtly when one is opaque and the other transparent, or when the manner of their application differs.

Much of color's expressive powers, although greatly affected by how we use the five foregoing phenomena, do not yield to analysis. The influences of shape, location, handling, and even the medium used are too pervasive and intangible to permit this. When discussing the symbolic uses of color, it is often observed that certain colors trigger certain associations. Yet the usual color associations cannot always be relied on to communicate the desired meaning. Pink may suggest blossoms, parties, candy, or innocence to many of us, but not to the person who was punished or confined in a room painted pink. In some cultures, black is associated with death and evil; in other cultures, with beauty and good luck. To a farmer, yellow-green suggests one thing; to a doctor, something else. Clearly, relying on color's symbolic functions for expressive purposes is risky, for, whatever universal agreement there may be about various colors, the differences

among individuals and cultures make mis-readings of our intent a certainty for many.

A far wiser plan for arriving at an expressive use of color is to uncover our own unique feelings about it. This can be accomplished in several ways: (1) by noting what kinds of colors and color activities attract us in the works of old and contemporary masters; (2) by examining those color functions and choices in our own paintings that seem to satisfy our feelings about color and noting those which recur; (3) by the conscious, controlled use of color for both abstract and form-building reasons as outlined in the foregoing categories; and (4) by making charts of colors on a free association basis (see Chapter Five, exercise 1).

Many painters, consciously or not, gravitate to certain kinds and uses of color. This becomes apparent when we compare the color differences of Rembrandt and Vermeer, Cézanne and Gauguin, or Braque and Picasso. In each of these pairs although the two artists were roughly contemporary and shared many similar influences, aspirations, and processes, they differed sharply in their use of color. Each of these six artists, because they enjoyed and required their unique color choices and issues, and were sensitive to their interplay, found inventive and expressive color phenomena. The sensitive viewer responds psychologically to these artists as though their engrossed excitement were infectious. One reason we enjoy the color in their paintings so much is because obviously *they* did.

All of these color considerations, and the influences upon them of direction, location, shape, etc., will be discussed further in later chapters. But we cannot begin too early to search for these phenomena as we examine masterworks and re-examine our own efforts.

In discussing these differing functions of color we have not drifted from our examination of the components of drawing in painting. For, as we have seen, color relationships can augment or to a considerable degree even replace value as a form-building and compositional agent. Cézanne put it this way: "Drawing and color are not separate at all; in so far as you paint, you draw. The more the color harmonizes, the more exact the drawing becomes. When the color achieves richness, the form attains its plenitude. The contrasts

and connections of tones—there you have the secret of drawing and modeling."* Although Cézanne is referring here to color's form-making role, we should recognize that whatever else our colors are engaged in, they are always engaged in drawing.

PAINTING MEDIA

In this survey of the bridges from drawing to painting we come finally to materials. Although the differences between the abrasive materials of drawing and the fluid ones of painting are pronounced, there remain useful similarities which can help ease the beginner's introduction to painting. Obviously, paintings done with pastels and oil crayons will more directly benefit from our experiences in drawing with the various abrasive media, just as our earlier drawing experiences with fluid media will be useful in painting with the various wet media.

Many paintings are actually begun as drawings on the canvas or paper supports. Sometimes such preliminary drawings are carefully executed and highly detailed, but far more often they are schematic in nature, intended as no more than general statements about the subject's arrangement and character. The drawing medium used for such sketches will vary according to an artist's preference and intent, but it is sometimes indicated by the painting medium he will use to complete the work. Pen and ink would be generally regarded as a poor choice to underlie pastels, and few artists are likely to begin an egg tempera painting with a chalk or crayon drawing.

Generally, the preliminary drawing is completely hidden by subsequent layers of paint, but some artists permit passages of the preliminary drawing to be visible in the painting's final state, as Pascin does in *Back View of Venus* (Figure 1.13). When this is the case, the lines of the drawing do not appear in one or two isolated places in the design, but create a linear pattern integrated with the design of the painting. Pascin uses the lines produced by charcoal (the most frequently preferred drawing medium to underlie an oil or acrylic paint-

*Emile Bernard, "Paul Cézanne," L'Occident, July, 1904; quoted in Judith Wechsler, ed., Cézanne in Perspective (Englewood Cliffs, N.J.: Prentice-Hall, Inc., 1975), p. 42.

Figure 1.13
Jules Pascin, *Back View of Venus* (1924)
Oil on canvas.
Musée d'Art Moderne, Paris.

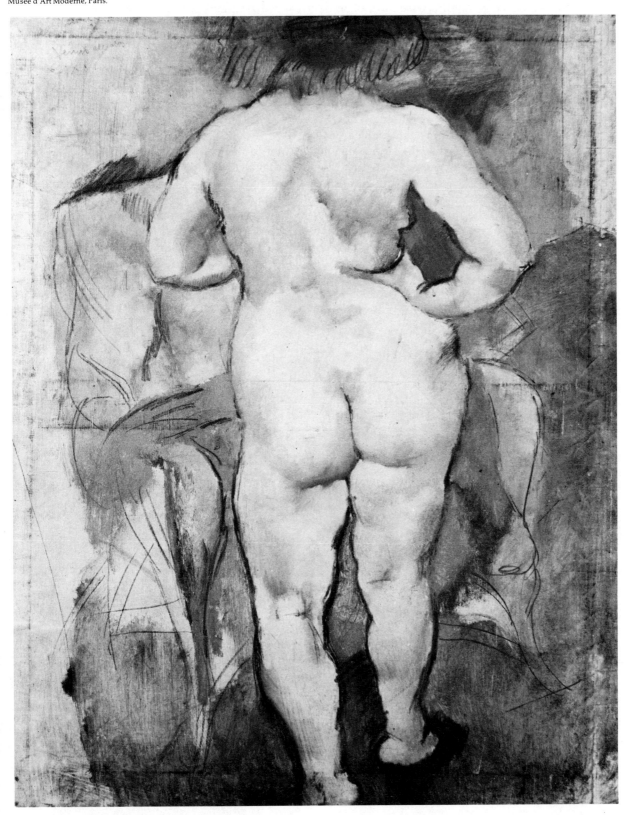

ing) in a volume-informing way, especially in the figure. This permits him to concentrate on large shapes of color, now free of the tonal modeling that would otherwise have been necessary to explain the form and space of his subject. Extensive tonal modeling tends to lessen the force of color confrontations. Instead, the figure is subtly modeled by warm and cool tones that do not vary much in value. In the background, too, cool browns and blues are seen first as color shapes. A single fiery red drape alongside the figure's left thigh serves as a counterpoint of intensity to the painting's otherwise muted colors. Some of the lines, such as those which delineate the figure, are reinforced with thin paint, while those in the background are the lines of the original charcoal drawing. Much of the left side of the canvas is left almost bare, touched only here and there with thin oil washes. The paint is applied in a more opaque manner in the middle and right side of the canvas, and there are even small passages of palette knife painting.

In allowing both the original surface and drawn lines to be part of the completed painting, Pascin shows us a work in transit between drawing and painting.

A common error in pastel and crayon painting is to begin by drawing in black and adding color later. But because these materials cannot as easily cover underlayers, and because they are so well suited to the linear modes of drawing, most artists make the underdrawing in some light color.

In the fluid media, too, some artists prefer to begin by drawing in color, or by brushing in broad, transparent washes or more opaque patches of color, bypassing the preliminary drawing. This is more easily managed in media capable of opaque paint layers such as casein, oil, or acrylic where extensive overpainting is possible and early trial and error efforts can be hidden or modified. Actually such a direct approach is possible with any painting medium. Picasso's watercolor, *Brooding Woman* (Figure 1.14), is begun by washes of

Figure 1.14
Pablo Picasso, *Brooding Woman* (1904)
Watercolor, 10⅝ x 14½ in.
The Museum of Modern Art, New York.
Gift of G. David Thompson in honor of Alfred H. Barr, Jr.

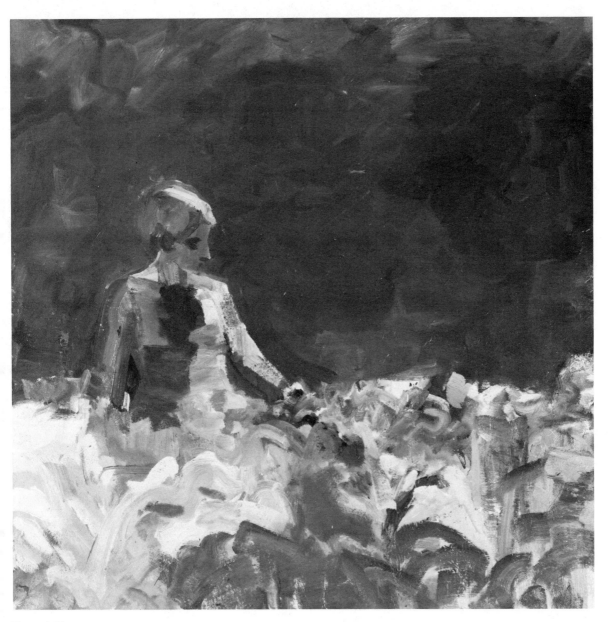

Figure 1.15
Elmer Bischoff, *Woman with Dark Blue Sky* (1959)
Oil, 68 x 68 in.
Hirshhorn Museum and Sculpture Garden, Smithsonian Institution.

color overlaid by additional colors, sometimes applied upon the still wet first layers. Nowhere in the figure on the left do we find those drawing guidelines so frequently used by watercolorists. Here the edges and small forms are drawn with the brush. For some artists, drawing with the brush and with color is so central to their theme, that even when the paint is applied heavily and could be hiding a preliminary drawing, we sense, partly through the painting's spontaneity, that the work was begun without such a drawing, and that its final state was arrived at by manipulating shapes of

color into place. Bischoff's *Woman with Dark Blue Sky* (Figure 1.15) is such a painting. Note how economically the artist establishes the form of the figure, and how convincingly the powerful brushwork of the foliage evokes the feel and form of plants and leaves. We even sense the vast space of the field in which we find the woman.

As these two paintings suggest, the medium used exerts a considerable influence on the kinds of perceptions we make and on the goals we set for a particular painting. Picasso, because he is using a transparent medium,

takes advantage of the light of the white paper, which imparts a vibrancy to even the dullest colors. This enables him to establish a network of dark, cool colors that convey his expressive interests without appearing muddy. And Bischoff, using oils, is aided by the powerful brushwork it can produce, in creating a monumentality and force not as easily achieved with watercolor.

Some media are technically complex but rather easy to use; others though basically simple may be hard to manage when painting. Oil paint, for example (although it can be applied straight from the tube), can be modified in various ways with drying oils, varnishes, waxes, balsams, and inert additives and requires special solvents and specially prepared surfaces. Yet in practice oil paint is one of the most versatile and accommodating of painting materials, permitting a great range of uses. By contrast, transparent watercolor, which is simple in formulation and requires only water for thinning and a good quality of paper, is one of the most challenging of media, permitting few changes, demanding a resolute attitude, and a keen sensitivity to its subtle characteristics.

Every painting medium in popular use permits a fairly wide latitude in the resulting imagery. Even transparent watercolors, generally understood as given to direct and often splashy effects, can be used in a less than transparent manner and are capable of great precision. In fact watercolor is still much preferred in medical illustration. Of course each medium has its unique characteristics, technical limits, and unexplored possibilities. The next chapters will examine the basic materials and tools of painting and discuss their use.

TWO

pastels
and crayons

Leonardo da Vinci once observed that the greatest tragedy for the artist is when "theory outstrips performance." To avoid that fate we must acquire right at the start a good practical grounding in the craft of painting. When we have at our command a knowledge of the materials, tools, and procedures, we can more nearly produce the images we intend.

The various painting media discussed in this text are generally arranged in a sequence that moves from the more linear to the more painterly uses. Of course, each of these materials can be used in either way, but because the basic characteristics of some media suggest a handling somewhat nearer to drawing than do others, the order adopted may permit the beginner to more comfortably move from the familiar concepts of drawing to the challenging ones of painting. We begin in this chapter with pastels and crayons.

The beginning painter usually starts with one of the fluid media, and finds himself fighting on two fronts. The complexities of controlling both color and an unfamiliar medium create understandable frustrations for many. Often the preoccupation with these two demanding considerations takes its toll on the quality of the drawing aspects of his painting, further complicating matters. When this is the case, pastels and crayons can be a useful media with which to begin. Because their linear and abrasive characteristics are the familiar ones of drawing (Figures 2.1, 2.5, and 2.6), they permit a greater concentration on color considerations. Equally important, they promote deliberate color analysis and judgment. For, unlike the fluid media, pastel and crayon mixtures cannot be pre-mixed on the palette, but must be made on the painting surface by actual mixtures (blending) or by optical ones (hatching and overpainting), from a fixed number of color sticks. These restrictions actually assist the beginner's efforts in learning to see and mix colors. Painting with fewer colors in any medium, by forcing us to get the most out of them, teaches us much about their versatility and range. Likewise, mixing colors on the painting, where among the colors al-

25

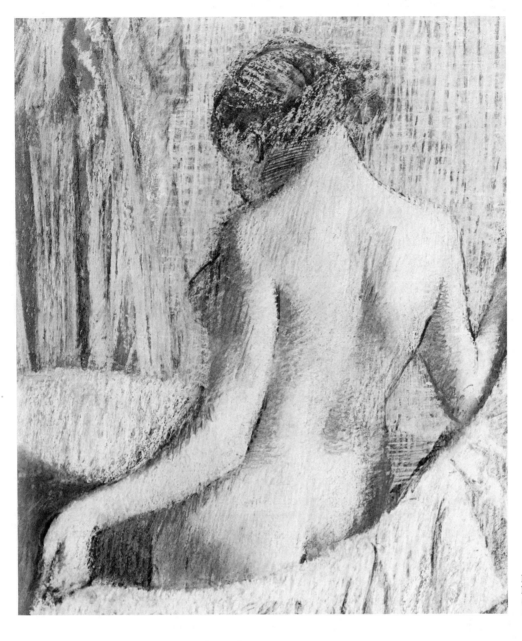

Figure 2.1
EDGAR DEGAS, *After the Bath*
(detail)
Fogg Art Museum, Harvard University

ready painted we can better judge the right-
ness of a particular color note, helps to develop
our color sense.

PASTELS AND CRAYON COMPARED

Pastels are colored chalks consisting of dry
pigment and a binder such as gum tragacanth,
starch, or methyl cellulose solutions. Addition-
ally, whiting, kaolin, or bentonite powders are
added to some colors to impart better texture
or to produce the various tints of pure hues.
Because of these additives and the absence of a

fluid binder, pastel colors lack the tonal and
intensity range of the fluid media, or even of
crayon.

Pastel is the purest of painting media,
consisting of not much more than dry pig-
ment. So much is this the case that pulverized
pastel can be made into a fairly serviceable
paint by adding water and some compatible
binder, or by mixing with a drying oil such as
linseed oil. Unlike many fluid media, pastel
does not undergo changes of value, hue, or in-
tensity after it is applied. If pastel paintings
are well protected they can remain unchanged
for centuries.

By contrast, oil and wax-based crayons are often made of dye pigments of questionable permanence, with paraffin, soap, and other waxy or oily materials added as binders. Unlike pastel, wax crayon cannot be blended, and oil crayon is fused with some difficulty. Neither oil nor wax crayon is erasable. Some artists are attracted to crayon's paint-like texture and color vibrancy, and to the effects achieved by scraping away upper layers of color to reveal the colors below; or to the results of partially dissolving crayon by brushing on a diluent such as turpentine. The best brands of oil crayons allow for some degree of overpainting before the crayon turns smeary, making additional applications of color difficult. When employed by a gifted artist sensitive to crayon's character, its unique properties can lead to impressive results (Figure 2.2).

The disadvantage of pastel and to a lesser extent crayon is their susceptibility to smudging and damage. This stems from the absence of a strong liquid binder to hold the color particles in suspension. Pastel and crayon deposits are held in place mainly by the pressure used to file off the material and drive it into the "hills and valleys"—the tooth or grain of the surface.

Although crayon paintings are less prone to smudging than are pastels, a light coating of damar varnish will make their storage less of a problem and provide some degree of protection. Applying to pastels a light coating of *fixative,* a weak solution of resin and some quick-drying solvent, provides some protection against the powdering off of pastel particles and even imparts a slight lowering and enrichment of the color. But even a heavy application of fixative will not prevent some smudging and will seriously darken the colors, destroying pastel's delicate nuances and velvety character.

To apply a fixative, the painting should be placed on a flat, horizontal surface and the spray directed so that the mist *settles* on the work rather than being driven into it. Do not hold the spraying device closer than two feet from the work. Spraying from a closer distance may blow the pigment particles from their places, causing unwanted changes in color. For large-scale works an air brush or spray gun can be used. Smaller works are usually sprayed by mouth atomizers or prepared spray can dispensers. All such spraying should be done in well-ventilated spaces.

Because neither pastel nor crayon paintings can be cleaned, they are best protected by proper framing under glass. The painting should be placed in a thick mat to prevent the color particles from coming into contact with the glass, and the back of the frame should be carefully sealed with paper or cardboard and gummed brown-paper tape.

Works in wax and oil-based crayons are a relatively recent development and their longevity is yet to be tested, although their ingredients do not suggest permanence. Pastels, however, are impressively durable. Well-framed works of the sixteenth and seventeenth centuries are as fresh and unchanged as the day they were painted (Figure 2.3).

Unframed and lightly fixed pastel paintings on paper can be safely stored for long periods by placing glossy-surfaced papers between them and sandwiching the stack with stiff plywood or particle boards. The stack should then be wrapped and tied to prevent any movement. Although the vertical pressure of such an arrangement will have virtually no effect on the chalk deposits, be careful to avoid any sideways movement; even the smallest lateral motions can smear the surface of the works. The tacky surface of crayon paintings, even when coated with damar varnish, doesn't permit such a storage arrangement. Crayon paintings are better stored in low, loose stacks, the works also separated by glossy sheets, and stored in a cool, dry place.

Both pastel and crayon are made in sticks of soft and semi-hard consistency. These differences in formulation permit a greater range of handling, and artists will frequently combine soft and hard pastel or soft and hard crayons in a given work. (It should be noted that pastel and crayon cannot be mixed.) Additionally, both media are available in pencil form, enabling artists to work in quite a precise manner.

Pastel and crayon take well to paper with some degree of tooth. Special pastel papers in various colors are available in two forms. One, an all rag paper, possesses a tooth designed to facilitate the filing off of the chalk particles. The other is a paper coated with some inert material such as pumice or silica, or a powdered cloth called flock. The first type of paper,

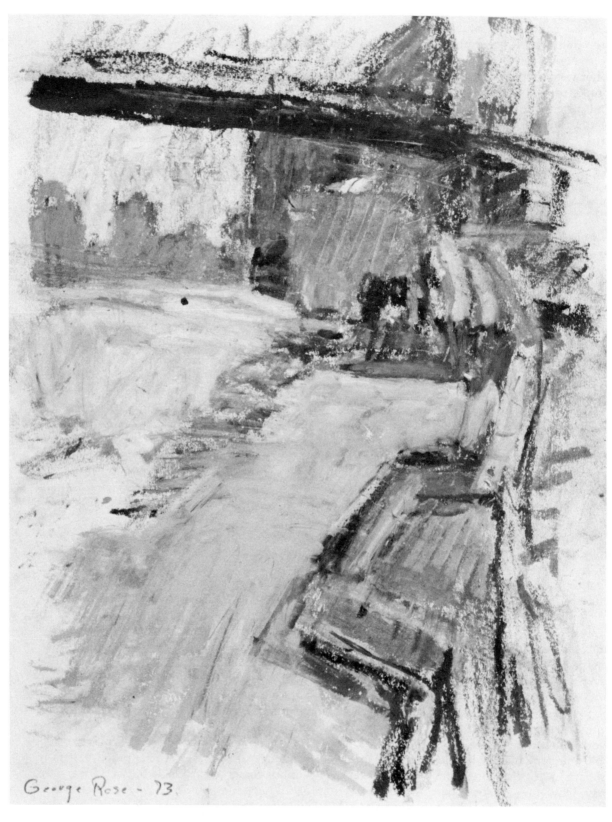

Figure 2.2
George Rose, *East River Series #6* (1973)
Oil crayon, 10½ x 13½ in.
Courtesy of the artist.

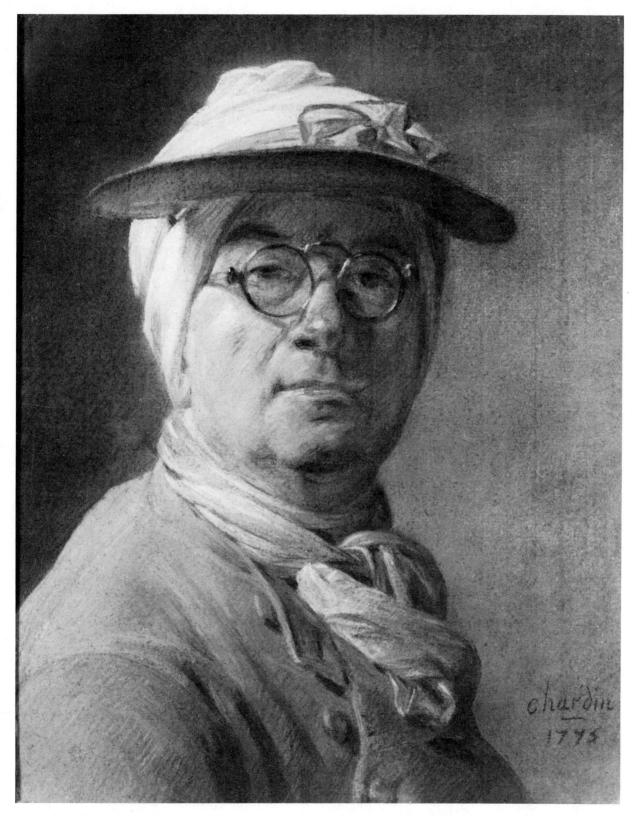

Figure 2.3
JEAN-BAPTISTE CHARDIN, *Self Portrait* (1775)
Pastel, 18 x 15 in.
Musées Nationaux, Paris.

in imposing its character less than the various abrasive or velvety surfaced papers, permits a broader range of handling and is universally preferred for serious creative efforts. The latter type, by its pronounced texture, promotes the softer blending of colors, a tactic too often indulged in to excess by the beginner. Because one of the common misuses of pastel is just this tendency to emphasize the slick graduations and blendings of colors and values, forsaking structural and pictorial strength for theatrical polish, it is better to avoid these coated papers. Most of the finest pastel paintings are on paper supports of the first type, or on various good quality watercolor or drawing papers.

Less frequently, prepared canvas, thin muslin, natural linen, or silk fabrics are used as supports for pastel paintings. Sometimes these fabrics are mounted on wooden frames, or *stretchers;* more often they are mounted on stiff boards to provide a solid surface. Each method has its advocates, but pastel's fragility is only increased when applied to stretched fabrics where vibrations as well as movements due to changes in temperature and humidity may cause some dusting off of the colors.

The common practice of working on toned surfaces such as colored pastel papers (or papers tinted by the artist, usually with watercolor) enables a more open, linear or patchy handling of pastels, the color of the sheet often functioning as an active participant in the painting's overall tonal and color system. However, many artists prefer a white surface, favoring the sparkle of the white field as a base. (Figure 2.4)

Figure 2.4
Hobson Pittman, *Flowers in Three Vases*
Pastel, 20 x 25 in.
North Carolina Museum of Art, Anonymous Gift.

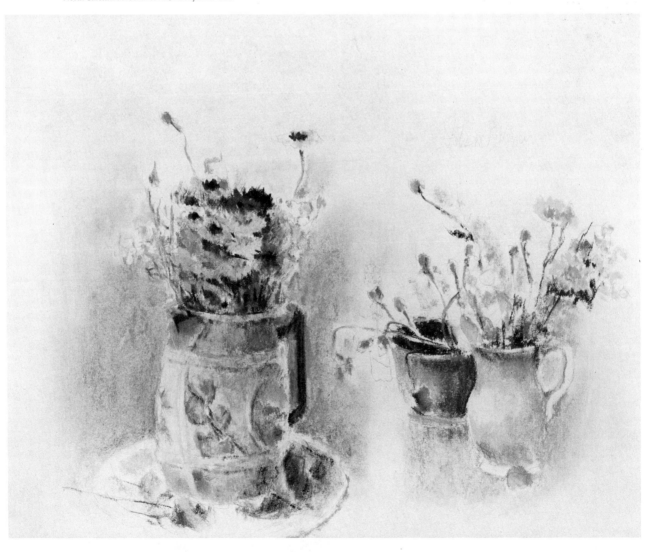

PASTEL IN USE

As noted in Chapter One, pastel paintings are not usually developed over a drawing in black chalk or pencil, but are begun directly in color. Some artists do establish a preliminary, schematic drawing, but in a light color such as yellow ochre or some blue tint, or any other color that may assist the form-building and color-character of the subsequent image. Thus, a portrait may be started with one or more colors of a warm fleshy nature if the artist intends a rather descriptive use of color, or by one or more cool grayed blues, violets, or greens if the color is to more actively participate in establishing form and space. In the latter case, the cool-colored lines, often defining edges, are optically or literally blended with the warmer strokes of the overpainting which develop the forms, imparting a more convincing turning of the volume at the edges and a more engaging play of color.

Pastel paintings may show a dense network of hatched lines, as in Degas' paintings of ballet dancers (Figures 2.1, 2.5, and Plate 8), or the broad strokes and fields of color we associate with oil or water-based paints, as in Manet's portrait of his wife (Figure 2.6), or in Redon's and Klee's paintings (Plates 5 and 7). Often both techniques are used together, as in Morisot's *Marthe Givaudan* (Figure 2.7), where the canvas support gives the broad areas of pastel an especially painterly character. And just as paintings executed in fluid media may emphasize or camouflage the brushwork, pastels handled in broad patches of color, sometimes applied by turning the stick on its side to produce wide swatches of color, may show a bold, spontaneous handling, as in the Redon (Plate 5), or an extensive blending of strokes, as in the Manet (Figure 2.6), or as in Chardin's *Self Portrait* (Figure 2.3). Note especially in the Chardin how the blendings are mainly in the service of form clarity and tonal pattern, and not for slick imitation of surface effects.

Slick blendings are easy in pastel, but are generally made at the cost of softening and obscuring structural and spatial clarity, and invariably produce weak and tawdry results. The freshness and spirit of pastel is a fragile quality easily lost by such slick rubbings, which should be avoided.

Another difficulty for the beginner in pastel is the establishment of a full range of rich color and value. Pastel's relative lightness of tone when compared to fluid media makes it necessary to rely more on hatchings and mixtures of the more intense light and dark colors than is the case when using any of the fluid media. This is not to say that white tints and black shades of pastel are to be avoided, but that the fuller range of brilliant and subtle colors which come from color modeling better suits this medium than do the often pale and sooty results of tonal modeling in pastel. For this reason many artists model forms by relying more on impressionist-like spots, patches, and lines made of various warm and cool pastel tones than on a monochromatic treatment of such forms. This can be seen in Degas' *The Morning Bath* (Plate 8), where the intermixing of warm and cool colors overcomes the painting's overall high value-key. Even the relatively low tone of the blue curtain is more intense than dark.

In working with pastel, care must be given to the choice of surface. A smoother support will not allow for much overpainting but permits smaller-scaled works and a highly maneuverable handling. A more pronounced grain permits many layers of richly textured color. Once the chalks have filled up the "valleys" of the support's terrain, no further applications of color will adhere well. If additional painting is to be done over heavy layers of pastel, the surface can be prepared by scrubbing those areas with a clean, dry bristle brush, such as those used for oil painting. Sometimes a light application of fixative serves to improve the tooth of such areas.

Because of pastel's dry nature, working with this medium is certain to create a considerable amount of dust. Tilting the easel slightly forward prevents the dust from settling on the lower portion of the work. Although no poisonous pigments go into their manufacture, pastels should be used in a well-ventilated room, because the inhaling of any finely powdered substances may be harmful.

Pastels are often combined with other media. Casein, watercolor, gouache, and oil paints are all compatible and such mixed-media combinations have a long tradition. But such combinations work best when pastel is

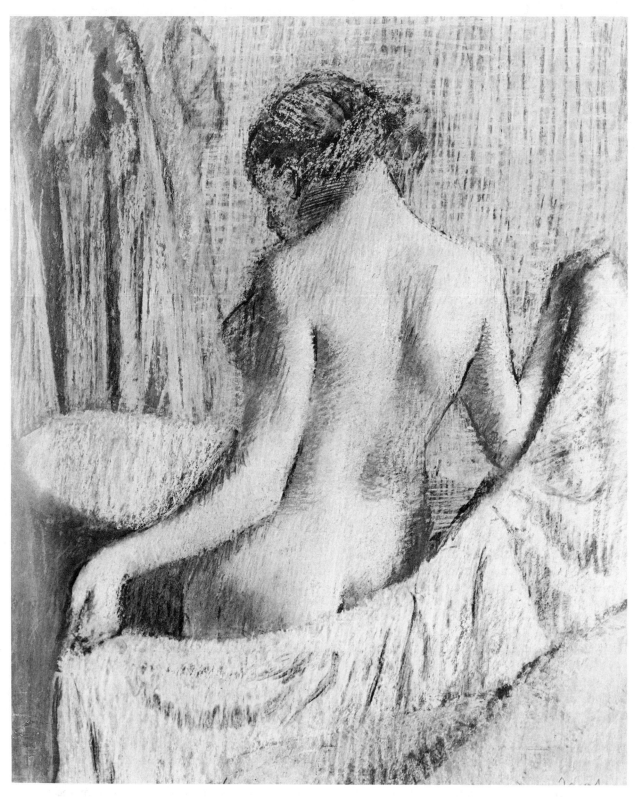

Figure 2.5
Edgar Degas, *After the Bath*
Pastel, 28 x 22⅝ in.
Fogg Art Museum, Harvard University. Gift of Mrs. J. Montgomery Sears.

Figure 2.6
EDOUARD MANET, *Madame Manet Reclining on a Blue Couch*
Pastel, 19¼ x 23½ in.
Musées Nationaux, Paris.

permitted to play the dominant role. Tiny touches of pastel in works otherwise done in some fluid medium usually seem isolated and arbitrary. But occasional washes of any fluid paint in a pastel painting act as pleasant counterpoints and transitions among the dry chalk strokes. A common practice in such mixed-media works is to begin the painting with fluid paints and carry it to completion with pastels.

As the pastel paintings in this chapter show, pastel is highly compatible with the direct and linear handling we associate with drawing. But if the beginner keeps mainly to contours and calligraphic devices, he will find it difficult to give the element of color any serious employment. Therefore, no matter how nearly such a linear use of pastel may approach drawing modes, some large, strong, or pictorially significant areas of color—some kind of color confrontations—must occur.

There is the frequent temptation in using pastels, to build a painting's color system from the colors in the pastel box instead of mixing the exact colors required. The beginner may settle for, say, the nearest blue to the one he de-

33

Figure 2.7
BERTHE MORISOT, *Marthe Givaudan* (1886)
Pastel, 25 x 20⅞ in.
La Jolla Museum of Contemporary Art. Gift of Mr. and Mrs. Gerald Parker.

sires, instead of producing it by hatchings, blendings, or overlaying of various blues, greens, and purples he possesses, thus bypassing important experiences in color mixing.

The relatively greater effort required in mixing a desired color in pastel, and the impossibility of pre-mixing colors on the palette, as is the case with all other painting media, have prompted manufacturers to offer literally hundreds of pastel colors. But such unwieldy numbers and the frequency with which we find, no matter how lavish our pastel set is, that we are missing a certain necessary color, makes it more practical and economical, as well as beneficial to developing a sense of color, to work with fewer sticks and plan more on color mixing to produce those nuances we need. Logically enough, we may wish to have more cool colors if we are painting landscapes and more warm ones if we are painting figures, but some sixty to seventy colors is a serviceable number for most purposes. Additional colors can always be purchased or made,* but one should try to keep the total colors in use well below one hundred.

CRAYON IN USE

The term *crayon* encompasses any of the wax or oil-based color sticks, from the familiar wax crayons used by children to the richer-hued oil crayons of growing interest to artists. However, the handling characteristics of these types vary greatly. Oil crayons, being softer and more brilliant in color, require less pressure to apply, and being generally more versatile than wax crayons, allow the traditional advantage of a limited degree of blending, thereby making possible various smeared and glazed effects.

All crayons can be thinned out after they are applied by scrubbing with a bristle brush dipped in turpentine or mineral spirits, and can be painted into areas wetted by such solvents for softer effects. All crayons can be scraped with a sharp tool such as a penknife or a nail to reveal lower layers of color or the tone of the support itself. Both media can be interworked in the same painting and can overlay

*See Reed Kay, *The Painter's Guide to Studio Methods and Materials* (Garden City, N.Y.: Doubleday & Company, Inc., 1972), pp. 228–38.

thin layers of water or oil-based paints, and both handle best when applied to a surface with only a moderate grain.

Like pastel, crayon can be applied in a linear or broad manner on white or toned surfaces. Except for the restrictions in blending, crayon can be used in much the same way as pastel.

SUGGESTED EXERCISES

All of the following exercises can be done with either pastel or oil crayon. You should try them with each of these media to note the differences in handling. Additionally, exercises 1A, 2A, 2B, and 4 can be done with wax crayons.

Before doing these exercises, experiment with these materials. Simply make marks, tones, and mixtures of various kinds to get the feel of these materials and to note their different color qualities. Try them on smooth and rough surfaces, scrape into them, wet them, and erase them.

1A. On any suitable white support, subdivide a horizontal rectangle measuring 4 by 12 inches into twelve 2-inch squares, as in Figure 2.8. Select any six pastel or crayon colors that show a variety of light and dark, and warm and cool colors. Using dense hatchings in several directions, paint each of the six squares of the top row with a different color, in any order that pleases you, using all six colors. Next, break down the boundaries between these six colors, *not by blending* but by hatched overpainting with any square's color, a short segment of its neighboring square's color. For example, if the first square is a light yellow, the second a brownish orange, and the third a

Figure 2.8

deep violet, the orange color strokes should invade both the yellow and violet areas for say, one-half inch, and these two colors should in turn be painted into the orange square for some small distance.

When the top row is completed, each color should seem to grow out of the preceding one and subside into the next color, so that the entire row appears to be a gradually changing series of colors. Don't permit any color to be overwhelmed and lost by the hatchings of its neighbors.

This exercise will introduce you to some of the possibilities of color mixing with pastel or crayon (see Plate 8). Where chance provides a compatible color mixture, beautiful color effects will occur; where complementary colors are mixed, quite subtle colors are more likely to result than the "mud" that such colors produce when mixed with any of the fluid media. Still, muddy mixtures are all too possible in pastel and crayon and some trial and error study is advised.

1B. In the second row, place the six colors in the same sequence as in the top row, but this time lay in thinner layers of color and blend them into each other either with your fingers, a small cloth, a bristle brush, or with a *tortillon* (a rolled up strip of some soft-textured paper). Note that in this row of squares some of the mixtures will seem duller and that the overall look of the lower row will lack the liveliness of the upper row.

2A. On a cool-toned support such as a light blue or green pastel paper, draw a horizontal rectangle 2 by 12 inches. Select six colors differing in hue and value and, using hatched lines, make each color appear to well up from the tone of the paper, attain a dense and rich character, and then subside again into the cool tone of the support. Because the paper's tone will separate each of the six colors, none will touch. The completed exercise should show the gradual rise and fall of each color into the cool tone of the support. Use no blending. Instead vary the density of the hatching and the thickness of the strokes. Pastel and crayon can produce ultra-fine lines that will appear to fuse with the tone of the paper.

2B. Repeat exercise 2A using the same col-

ors in the same sequence, but on a warm-toned support.

2C. Repeat exercise 2A, using any blending method. Maintain the cool tone of the paper between each color.

2D. Repeat exercise 2B, using any blending method. Maintain the warm tone of the paper between each color.

3. Working on either a white or toned surface about 16 by 20 inches, paint a two-dimensional design that contains both hard and soft-edged shapes. Begin by working directly in color, using hatchings and blendings in various combinations. Allow the paper's tone to be visible in some areas. Plan on having one area of the design extremely brilliant, and building up to this color crescendo by placing more muted colors around it. Here you should utilize your experiences of the earlier exercises and experiment freely. The shapes may fill the format and be as formally arranged as in Plate 7, or may appear to float or interpenetrate and form a more turbulent image. Try scraping or brushing away some color. When using crayons, experiment with color thinned by turpentine. When using pastels, spread some of the color around with a bristle brush dipped in water. Don't settle for your first efforts, but plan to rework any areas that seem capable of producing a better integration of shapes, colors, values, and directional movements.

4. Arrange a simple still life containing some four or five objects and several small sheets of differently colored construction papers. Avoid intricate forms and highly reflective ones. Place the objects on the construction papers in ways that create interesting shapes and colors. Begin by laying in, on a white support, flat washes of watercolor or gouache color that establish the *general* color and value of each part. Here you are trying only to state the general *color shapes,* in their relative scale, direction, and proximity. Keep this stage of the painting quite loose and simple, even vague. Avoid very weak tints of the colors you see; here you want to establish the essential brilliance and delicacy of the still life's differing colors. Upon this base of flat, colored shapes begin to model the forms with as little use of blending as pos-

sible. Avoid using the black, gray, and white colors whenever you can. In any case, use them sparingly. The goal here is to produce a sense of simple masses, simply conceived. Therefore, resist being sidetracked by details and surface textures. Because the earlier washes of color went some distance in establishing the colors of the still life, you may find it possible to pinpoint each color by modeling with open hatchings or thin overpaintings that utilize the colors below. In modeling the forms, note how strong the colors are in both light and dark areas, and do not merely add white to light areas and brown or gray to dark ones, unless the color of an object or area demands it.

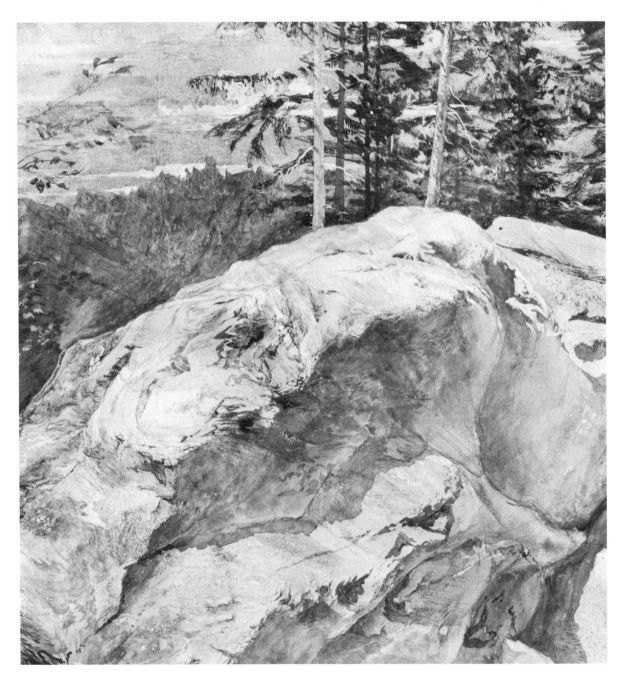

Figure 3.1
JOHN RUSKIN, *Fragment of the Alps* (detail)
Fogg Art Museum, Harvard University. Gift of Samuel Sachs.

THREE

traditional
water-thinned media

With few exceptions, the greatest pictorial techniques have universally employed some process of suspending dry pigments in one of a number of binders and thinning the resulting paint with a suitable solvent. Until the fifteenth century, the solvent was always water. The history of water-soluble colors goes back to the dawn of human civilization. Very early painting processes, whether in the murals of the Assyrians or the tomb paintings of the Egyptians, employed water as the vehicle for applying paints. Likewise, in the Orient, in ancient Greece and Rome, and in medieval Europe, paints using binders made of various animal glues, vegetable gums, gelatins, and milk by-products were all thinned by water.

The water-based paints in popular use today, some of them not much altered from their earlier formulations, fall into two categories: those which after application can be dissolved again, and those which dry to a more or less insoluble paint film. Transparent watercolor, gouache, size or distemper paints, and the contemporary group called poster paints are all resoluble; the several formulations of tempera paint, casein, and the contemporary acrylic paints (discussed in Chapter Four) are not.

In keeping with our format of discussing those media that tend to more directly utilize drawing devices before turning to those regarded as more purely painterly, we begin with gouache, a member of a group of opaque or semi-transparent paints which, for all the painterly possibilities they offer, tend to yield to linear handling more than do oils, acrylics, and watercolors.

GOUACHE

While the physical properties of gouache and transparent watercolor paints are nearly alike, their handling characteristics and surface textures are very different. The opaque nature of gouache, its easy application in hatched strokes that produce optical impressions of color blendings, its restrictions on actual, physical color blendings and fusions of strokes, and its overall surface appearance in a completed painting place it far closer to tem-

pera and casein paints than to transparent watercolor, where splashes and fusions of color washes and the absence of white paint as a means of adjusting color and value set it apart from all other media.

The chief difference between the materials used in the manufacture of gouache and watercolor paints is in the ratio of vehicle to pigment. Gouache is simply watercolor made opaque by increasing the percentage of the gum arabic binder to pigment, and by adding a small amount of some inert pigment such as chalk to enhance the color quality and the paint texture. These differences give gouache its solidity as well as its hiding power. Unlike transparent watercolor, which tends to enter the paper in a staining manner, gouache's denser texture—its body—lies upon the paper in layers that show rugged striations and ridges

even in thin paint layers. Something of this can be seen in a detail from Ruskin's *Fragment of the Alps* (Figure 3.1). The gouache brushwork of the rock lies upon the surface, the watercolor painting of the background lies within it. This is both an attractive and advantageous characteristic, for gouache, as in the case of all traditional water-based paints, will crack and flake off the surface if applied in a heavy *impasto,* that is, a thick layer of paint. Gouache colors, while showing a certain chalkiness when compared to most other paints, have a light-reflecting energy that gives even thin paint layers a distinctive freshness and force.

These characteristics make gouache an ideal medium for spontaneous and vigorously stated works such as Toulouse-Lautrec's *Alfred la Guigne* (Figure 3.2), where the bold calligraphy of the brushwork benefits from the easy

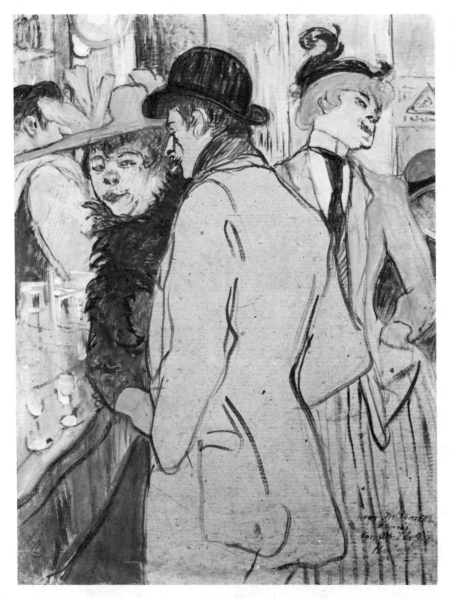

Figure 3.2
HENRI DE TOULOUSE-LAUTREC
Alfred la Guigne
Gouache on cardboard, 25¾ x 19¾ in.
National Gallery of Art, Washington, D. C.
Chester Dale Collection.

flow and opacity of this medium. So much has gouache been identified with direct and spirited handling that the term has come to define not only a particular medium, but any kind of sketchy handling of opaque, water-based paints which may or may not include gouache itself.

However, gouache is capable of producing very detailed imagery, in either its opaque state or when thinned with water, and is a popular medium for artists and illustrators intending realistic works of a precise nature. The best gouache colors contain finely ground pigments and can be thinned enough to function as watercolors.

Gouache is frequently used in combination with watercolor, pastel, casein, inks, and various drawing media. Except with pastel, where gouache seems most compatible when it underlies or connects areas of chalk, such combinations usually show gouache in the dominant role. This is especially common when it is used with inks or watercolors, where small islands of gouache usually appear isolated and out of keeping with the quality of light these transparent media possess.

Gouache can be used on any moderately heavy paper such as the heavier watercolor papers (see, Transparent Watercolors, page 58), on gessoed panels, cardboards, and any other stiff paper supports of a high rag content. Usually gouache works better on only moderately grained surfaces. In contrast to watercolor painting, which demands a white surface, gouache is often used on a toned surface where, as in Figure 3.2, the toned surface becomes part of the painting's color and design. The tone, visible through the linear brushwork or showing through translucent layers of paint, serves much the same role as the toned surface in pastel painting.

GOUACHE IN USE

Gouache paintings are frequently begun with thin washes and brushstrokes, often light in value; or, if a toned ground is used, in colors and tones near to that of the support. Because the paint dries within a few minutes, additional painting can proceed without delay. Some artists thin the first layers of paint to the consistency of watercolor, reserving the opaque layers until later. Colors can be removed by re-wetting or worked into while wet; both procedures make possible a degree of blending.

Gouache permits a wide range of uses. It is suited to such gentle and enigmatic imagery as Graves' *Owl of the Inner Eye* (Figure 3.3) or to such animated and forceful works as

Figure 3.3
MORRIS GRAVES, *Owl of the Inner Eye* (1941)
Gouache, 20¾ x 36⅝ in.
The Museum of Modern Art, New York. Purchase.

Figure 3.4
GEORGES ROUAULT, *Nude Torso*
Gouache, 15⅜ x 12¾ in.
The Art Institute of Chicago.

Rouault's *Nude Torso* (Figure 3.4). Note the variety of edges, fine lines, and broad, chalky strokes in Graves' painting and the more transparent, looser handling of the Rouault, where some rubbing of the color along the figure's right side, perhaps with a dry bristle brush or cloth, gives the paint a softer, pastellike quality. Such contrasts of wet and dry paint handling are especially effective in gouache.

Because gouache, like egg tempera and casein, cannot be blended in the manner of oils or acrylics, a mainstay of these water-thinned media is the technique of modeling form and effecting color or tonal graduations by hatched strokes similar to those of pastel and crayon painting. This process is well demonstrated in another Toulouse-Lautrec painting, *Maxime Dethomas at the Opera Ball* (Figure 3.5). The man's coat is modeled as much by the changing directions of the hatched strokes as by changes in the coat's tone or color. Underlying the coat's hatchings are light washes of green, red, and ochre tones which relate to similar colors in the painting and prevent the dark coat from becoming isolated. In the pillar and in the two light-toned figures, a linear use of the paint expresses the form and optically blends subtle pinks and tans together.

Both soft and stiff-hair brushes are used in gouache painting. The best soft-hair brush is the *red sable,* available in both round and flat

Figure 3.5
Henri de Toulouse-Lautrec
Maxime Dethomas at the Opera Ball
Gouache on cardboard,
26½ x 20¾ in.
National Gallery of Art, Washington, D. C.
Chester Dale Collection.

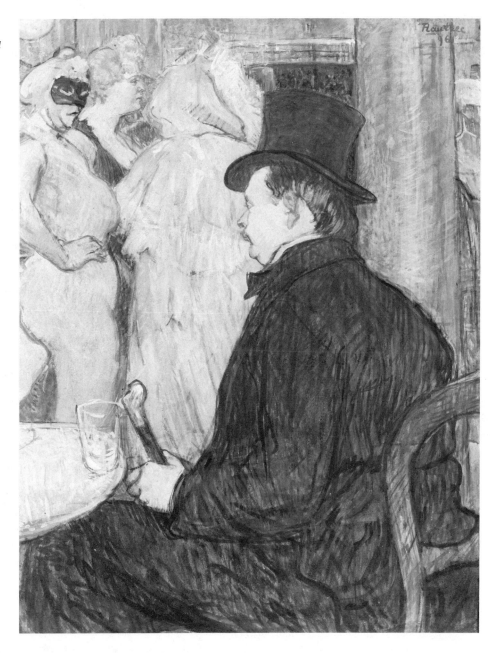

shapes. Unfortunately, genuine red sable brushes are expensive, but their resiliency and general versatility in handling and the round sable's capacity to hold a point cannot be duplicated by any other type of brush. Another favorable feature is their durability. If well cared for by washing with a mild soap and warm water immediately after use, and if they are not stood on their ends when not in use, sable brushes will last for many years. This may prove more economical in the long run than frequently replacing less expensive, but less durable brushes.

A basic set of round sable brushes, for paintings up to 14 by 18 inches, might include numbers 0, 2, 3, 4 or 5, 7, and 9 or 10. Additionally, a flat, square-ended sable brush,

Figure 3.6
Drybrushing in gouache.

about one-half inch wide is useful for *drybrushing* larger areas. The drybrush process, another technique for optically blending any of the traditional water-thinned paints, can best be thought of as a cross between hatching and *glazing*, the brushing on of transparent color over lighter toned, dried colors.

Drybrushing consists of loading the brush with color thinned almost to a transparent state, squeezing the excess color from the brush with the thumb and forefinger or by brushing back and forth on a more or less nonabsorbent scrap of paper until the brush slips across the surface leaving many fine lines of color (Figure 3.6). Drybrush painting is done with the paint remaining in the brush. In this "dried" condition even the round sable will flatten out, producing not a solid stroke of color but a stroke made up of scores of fine lines through which lower layers of color will be visible. Optically, the effect appears somewhat glaze-like. For example, an area of yellow, when blue is drybrushed over it, will appear green, as in Plate 1B, where the drybrushing varies from barely visible strokes to bolder and more open ones, similar to hatched strokes. Indeed, hatching differs from drybrushing only in being made by the point of a more fully loaded brush, giving larger and longer paint strokes and a more rugged effect. This range of drybrush handling can be seen in the large boulders of Ruskin's *Fragment of the Alps* (Figures 3.1 and 3.7). By varying the direction and density of the drybrushing, the artist suggests the changing directions and textures of the stone surfaces.

Other soft-hair brushes of squirrel or ox hair, or of mixtures of sable and either of these softer hairs can be used for laying in washes, for glazing, and for various textural effects where their softer and less springy character may serve as well as sable. In fact, some of the better grades of mixed-hair brushes give almost as good service as sable and cost considerably less. At least one housepainter's brush of good quality, either of bristle or nylon hairs, and about one inch wide, is most helpful for brushing on large washes, for scrubbing paint on or off, for stippling and spattering color on, and for other textural effects.

Gouache handles well with bristle brushes, (see Brushes, Chapter Four), but care must be taken not to apply thick impastos, or subse-

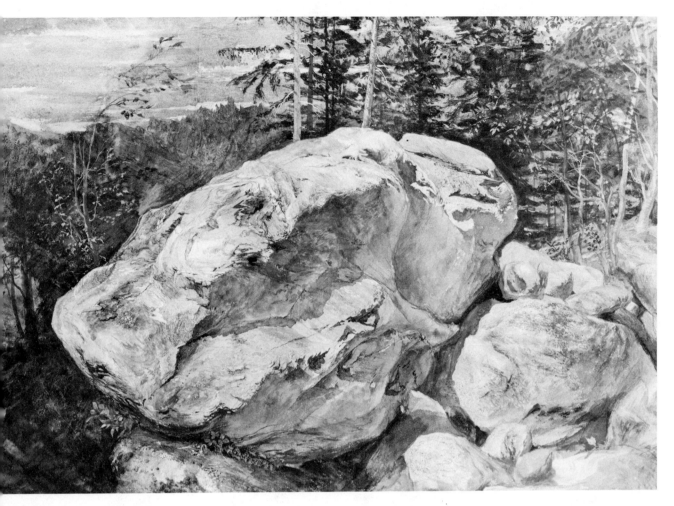

Figure 3.7
JOHN RUSKIN, *Fragment of the Alps*
Watercolor and gouache, 13¼ x 19½ in.
Fogg Art Museum, Harvard University. Gift of Samuel Sachs.

quent cracking of the paint is likely. A basic set of bristle brushes for small-sized gouache paintings might include: round bristles— numbers 2 and 5; flats (a square-ended brush)— numbers 3, 5, 7, and 9 or 10.

Sponges, which are used for developing soft-edged forms such as clouds or foliage, have earned a justifiable role in gouache and tempera painting, as has cloth rags and cheese-cloth for various broad effects, and painting knives to lay on thin layers of paint or to scrape paint off while still wet.

A few drops of glycerin added to the wa-ter used for thinning the paint will keep the painting wet a little longer, permitting more leisurely changes and additions to be made. Additionally, this imparts an even smoother, more flowing quality to the paint that im-proves its blending ability somewhat.

An alternate method for increasing gouache's flowing properties is to use as a thinner a mixture made of equal parts of acrylic medium and water. Such a thinner makes the paint more or less insoluble, per-mitting repeated overpainting without picking up the paint beneath.

While such technical innovations are valid and useful, most artists prefer to work with the qualities and limitations of the tradi-tional gouache paint and tools. Ratner's *Blue Steel Interior* (Figure 3.8), a handsome abstrac-tion that fuses a strong formal design with a delicate play of light, benefits from the crisp yet painterly character of gouache. Inter-estingly, Ratner used only sable brushes for this work. Note the texture of the paint in the large shape at the bottom of the painting, achieved by patting on thin layers of paint—

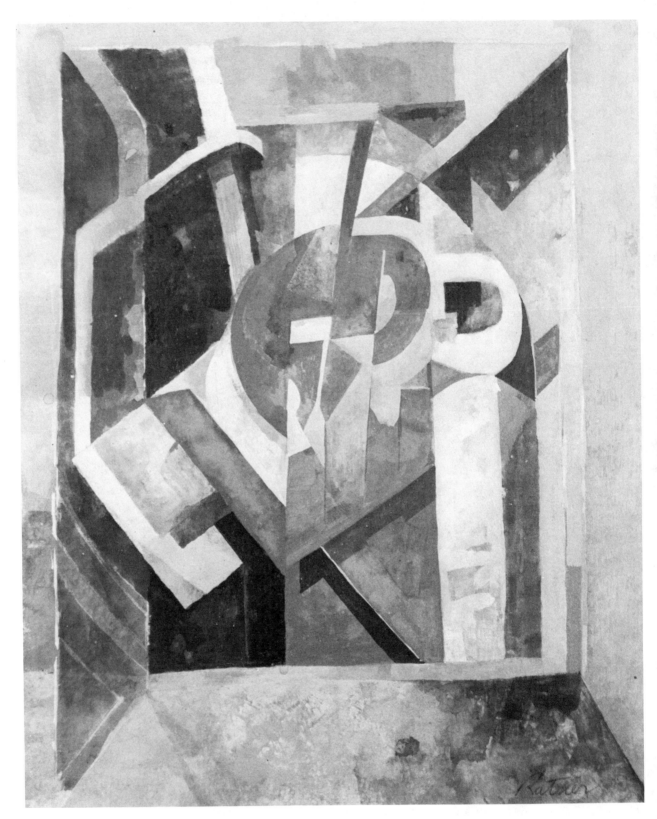

Figure 3.8
DAVID RATNER, *Blue Steel Interior*
Gouache, 7¾ x 9¼.
Collection of the author.

lightly pressing the brush to the surface, instead of pulling it in some direction.

Although gouache can produce a great range of striking color effects, it tends to be especially effective when kept to a higher tonal range and when cool colors predominate. Picasso's *Two Acrobats with a Dog* (Plate 9) shows something of the airy freshness that cool, light colors achieve in this medium. Notice how the sparkling blue of the sky acts as a visual foil for the grayed nature of the ochres, pinks, and blues throughout the painting, and that the painterly strokes are quite thinly applied, revealing other colors below. Here, Picasso makes good use of the airy crispness of gouache color to amplify the painting's pensive and somber mood.

Gouache is a versatile and too often overlooked medium. The ease with which overpaintings and changes can be achieved makes gouache a far more manageable medium for the beginner than transparent watercolor, and, as we have seen, is suited to a wide range of visual and expressive themes. After all, a medium that can serve points of view as different as those of Ruskin, Rouault, and Ratner is one to consider.

DISTEMPER AND CASEIN PAINTS

In use as early as the ancient art of the Tigris Euphrates, distemper (or size paint) is made by grinding dry pigments in glue. The contemporary poster and show-card colors are forms of distemper paint. They are opaque paints which, upon drying, are matte and tend to turn somewhat lighter and less intense—characteristics regarded as drawbacks by some artists. Distemper paints can be thinned to transparent washes and, like gouache, give a sense of juicy paint handling even in rather thin layers. Like gouache, distemper will crack if applied in heavy impastos. It dries almost immediately to a tough but resoluble film, but can be kept moist for a short while by the addition of a few drops of glycerin to the water used for thinning. Some artists mix dry pigments with the glue medium as they paint, which requires some arrangement for keeping the medium warm as it will gel upon cooling.

Distemper is often used in flat, decorative modes and has long been employed for the painting of theatrical scenery. The fact that this medium can be put to more intricate representational uses is evident in Vuillard's *Portrait of Comtesse Marie-Blanche de Polignac* (Figure 3.9). Distemper paint films are normally too brittle for use on canvas and should be applied to boards and panels, as the cracking in Vuillard's painting suggests. In use, distemper handles much like gouache.

Like gouache and distemper, casein paint is a quick and matte-drying material. Unlike these paints, it dries in minutes to an insoluble film. Casein is a skim milk by-product with strong binding power, and casein colors are noted for their durability. It is too brittle for use on any but rigid supports. Several good quality brands are available today, especially the Shiva brand of casein paints, which are outstanding in their overall textural, handling, and color qualities.

In use, casein paints have an attractive painterly character and are capable of great precision, or can be used in somewhat heavier impastos than is advisable with either gouache or distemper. When equal amounts of casein and acrylic paints are mixed for use, the resulting paint maintains much of casein's character, but gains in color intensity, flowing properties, and in the quality of transparent washes. Used alone, casein washes tend to be cloudy and mottled. Casein is handled in the manner of gouache or distemper, but its density in heavier layers is better controlled by bristle brushes. When mixed with acrylics it can be used in somewhat thicker impastos, and can be manipulated more nearly like oils or acrylics. With age, casein paints, like gouache and distemper paints, tend to undergo less darkening and color change than do oil paints.

EGG TEMPERA

Despite its decline in popularity with the advent of oil paint, egg tempera, either alone or in conjunction with oils, resins, and waxes, continues to find favor among some artists of every school of painting, and is presently enjoying a renewed interest among artists of differing points of view.

Egg tempera has unique color and handling properties. It has a translucent intensity in its bright colors, a luminous opalescence in

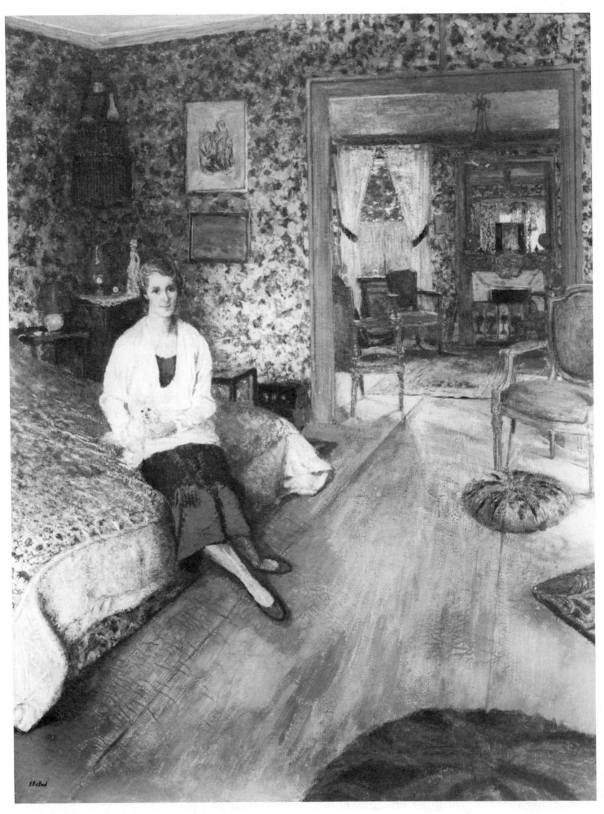

Figure 3.9
Edouard Vuillard, *Portrait of Countess Marie-Blanche de Polignac* (1929)
Distemper, 115 x 88 cm.

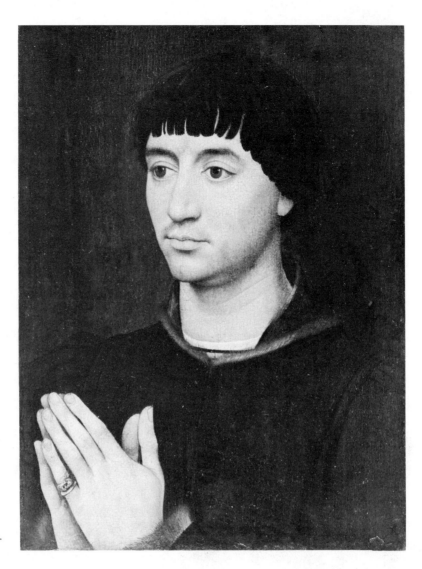

Figure 3.10
ROGIER VAN DER WEYDEN
Jan de Gros (ca. 1450–60)
Oil and tempera, 15³/₁₆ x 11¼ in.
The Art Institute of Chicago.

its dark and grayed ones, and a fluidity that results from the nature of its binder. The binder in egg tempera is an emulsion, that is, a mixture of oily and aqueous droplets held in suspension by an emulsifying agent. Nature has provided just such an emulsion in the egg yolk. When egg yolk is mixed with dry pigments and water it imparts to the paint some of the visual and handling characteristics of both oil and water-based paints. This emulsion formula makes it possible for egg tempera paint to be applied with more precision and delicacy than gouache, distemper, or casein paints, as well as in slightly heavier layers than is recommended for gouache or distemper. However, egg tempera cannot be brushed on in the thick impastos that are possible with oils and acrylics, without cracking or flaking from the support.

The traditional and simplest recipe for egg tempera consists of dry pigments held in suspension in a mixture of equal parts of egg yolk and water. Its distinctive characteristics can be significantly varied by mixing both the white and yolk of the egg with drying oils such as linseed or stand oil, and a resin such as damar varnish. Even wax and gums have been added to the whole-egg mixture. Although such egg–oil mixtures, behaving more nearly like oil paint, have a long and distinguished usage, they are more prone to eventual discoloration than egg tempera, and their various emulsion mixtures may separate in use, causing serious problems in drying. But when the ingredients are carefully balanced, such variants are capable of striking and enduring results (Figure 3.10).

Most practitioners in tempera regard the traditional egg yolk and water binder as the best of the various tempera emulsions. In addition to its unique visual and handling qualities and its freedom from the later color

49

changes associated with oils and some egg–oil mixtures, it is sufficiently insoluble to be overpainted with either oil paint or additional layers of tempera. Egg tempera colors tend to be slightly deeper and richer than is the case with other water-thinned paints (except acrylics), and paint strokes, whether opaque or transparent, dry within minutes. The quick drying property of tempera paints permits various stages of a work to proceed without the considerable delays necessary when using the slow-drying oils, and makes it easier to produce various textural effects, details, and sharply-focused images (Figure 3.11). Completed paintings dry to a less matte finish than other water-based paints and can be given even more luster by buffing with a soft cloth.

But egg tempera has some drawbacks too. Its brittle paint film restricts its use to rigid supports such as wood, particle board, or untempered wood-pulp panels. (Masonite, a brand of wood-pulp panel, is a currently popular support.) Furthermore, because layers of paint must not be applied too thickly, egg tempera discourages those aggressive techniques in which the texture of the paint itself plays a strong expressive role—a role the other water-based paints achieve in even the thinnest applications. Egg tempera is not easily suited to large-scale works or to dark, brooding tonalities. Like gouache, its natural tonal range is in a rather high key, just as its finest color qualities seem to be among the cooler hues, where the delicate harmonies and pearly

Figure 3.11
ROBERT VICKREY, *Wooden Horses* (1965)
Egg tempera, 31 x 41½ in.
Canajoharie Library and Art Gallery, Canajoharie, New York.

freshness of egg tempera color come through best. And despite its oily ingredients, it does not permit the easy fusing and flow of colors so natural to oils and acrylics, or the range of paint application that is possible in these media. The tempera technique, being a deliberate and exacting one, is poorly suited to quick painting sketches or to works that evolve through many changes. It is an excellent medium for the methodical artist and for the student wishing to explore the challenges of sharply-focused imagery, and is capable of subtleties not possible in any other medium. But the restrictions imposed by egg tempera are rather fixed and narrower than those of the other water-based paints, or of oils and acrylics. Nevertheless, for the developing painter the traditional and technically prescribed manner of applying egg tempera, in thin and somewhat linear strokes, is a useful exercise in bridging the way from drawing to painting.

The fourteenth century Italian painter and chronicler Cennino Cennini, in his treatise on painting, *Il Libro dell' Arte,* described in detail the basic egg tempera process as it was then practiced.* The process of preparing the medium, the color paste, and the panels has not changed much in the five hundred years since Cennini outlined the procedure.

Preparing the Yolk Medium

Crack the egg and carefully separate the yolk from the white by passing it back and forth between the two shell halves, pouring off the white. When the unbroken yolk is more or less free of the white, take it in your hand and continue to pass it back and forth between your hands, drying your palms continually on a towel. When the egg yolk sac is reasonably dry and free of the white, pierce it with the point of a knife and gently squeeze the contents into a small jar. Discard the yolk sac.

Add cold water to the jar in very small amounts until, when stirred, the medium is no thinner than light cream. Some yolks are denser than others and require more water to reach this consistency. Often equal parts of yolk and water will suffice, but sometimes as much as two parts water to one part yolk may be

needed. Since these proportions will vary with the thickness of the yolk, it is best to be guided by the cream-like consistency of the medium.

To avoid quick spoilage the medium must be refrigerated when not in use. Even so, the mixture will begin to break down and smell after some three or four days. A few drops of oil of cloves, sodium benzoate, or camphor will preserve the mixture a few days longer. Because it takes only a few moments to prepare this medium, many artists prefer to mix it in small batches, as required. The fresher the medium, the greater its binding properties.

Preparing the Color Pastes

The pigment-water pastes which, when tempered with the yolk medium become the paints, can be made in two ways. Some artists grind each pigment with water, using a palette knife or muller and slab, until the mixtures take on a paste-like consistency, and then store them in small glass jars (2 or 2½ ounce jars are adequate). Others prefer to half-fill each jar with its appropriate dry pigment, add a small amount of water, and stir with a bristle brush. Because the various dry pigments differ in absorbency and texture, some will need more water, some less. Adding small amounts of water to each jar helps to control the consistency of the color pastes, which should be stiff, not runny.

It is technically sound to grind or stir the dry pigments directly into the prepared yolk-water medium if you intend to use the paints up in a few days. But because of the medium's quick spoilage, most artists mix the pigment-water and medium at the outset of each painting session. Other artists do not temper their color pastes prior to painting, but add a little medium to each daub of color paste they use in the course of a painting, as discussed later.

Preparing the Panel

Before the wood or wood-pulp panel can be painted upon it must first receive a coating of *size*—a thin solution of glue or gelatin—to reduce the absorbency of the panel and to prevent the oily substances in the medium from

*A useful translation by Daniel V. Thompson, Jr. is given in *The Practice of Tempera Painting* (New York: Dover Publications, Inc.), 1962.

penetrating the panel itself, causing its eventual deterioration. This is followed by several coats of *gesso priming*—a paint-like material made of powdered whiting and a dry white pigment—to provide the necessary smoothness and moderate absorbency for tempera painting.

To Make the Size

Materials:

- Double-boiler
- Measuring cup
- Rabbit-skin glue powder
- Fine-tooth sandpaper
- 2- or 3-inch housepainter's brush

1. Place 1 pint of water in the top of a household double-boiler and add 1 level cup of rabbit-skin glue powder. Allow the ingredients to stand for three or four hours (or longer) to permit the glue particles to soften and swell.

2. Warm the mixture almost to the boiling point, stirring occasionally, but do not permit the solution to boil. Remove from the stove and allow the glue to melt, again stirring occasionally. It is best to err on the side of less rather than more heat, as heat reduces the adhesive strength of the size.

3. Leave the thoroughly dissolved solution upon the lower pot to keep it warm, and apply to the panels immediately. Cold glue-size is difficult to brush on. This solution may be kept for ten days to two weeks before it will lose its adhesive properties and begin to spoil. Upon cooling, the mixture will become a thick gel; to reuse, merely reheat over a moderate flame until the solution thins.

4. Using a moderately fine sandpaper, roughen the surface of the panel to improve the bonding of the size with the panel. To apply the size, use a large housepainter's brush and cover the panel by scrubbing the size into the sanded surface, working in several directions. Avoid applying a thick layer of size that appears as a shiny film upon the surface. Correctly applied, the thin coating of size will seem to be *in*, rather than *on* the panel. Sizing the back of the panel prevents the board from warping.

Leaf gelatin or casein powder may be substituted for rabbit-skin glue in the recipe, using the same proportions. These sizing agents have a long history of usage in gesso preparations and are preferred by some artists for their slightly different surface character.

To Make the Gesso

Commercial gesso preparations are available in both a liquid form ready for use and as a dry powder requiring only the addition of water. Products from reputable manufacturers are well formulated and give good results. None, however, are able to use rabbit-skin glue as a binder because of its quick spoilage. All ready-made gesso mixtures employ casein or various nonspoiling binders, and, except for slight differences in absorbency and "feel," perform very well.

However, do not make the common error of confusing the popular acrylic "gesso" products with the real thing. This material is a primer intended as a ground for rigid or stretched supports and does not possess the absorbency requirements for tempera painting.

Preparing your own gesso panels permits you to produce them in the desired shapes, sizes, textures, and quantities, and is a most economical practice. The use of these ready-made gesso mixtures is a technically sound shortcut that does not add much to the cost of working in tempera, and should be considered. For those who wish to prepare their own gesso, the following formula is suggested.*

Materials:

- Double-boiler
- Dry titanium or zinc white
- Powdered whiting
- Measuring cup
- 2- or 3-inch housepainter's brush
- Fine-tooth sandpaper

1. Be sure the size is dry on the panel before applying the gesso. This may be a matter of a

*For useful elaborations on the making of gesso, see Reed Kay, *The Painter's Guide to Studio Methods and Materials* (Garden City, N.Y.: Doubleday & Company, Inc., 1972), pp. 139–45. Another source is Ralph Mayer, *The Artist's Handbook of Materials and Techniques,* 3rd. ed. (New York: The Viking Press, 1970), pp. 268–83.

few hours, but to be safe, allow the sized panels to dry overnight.

2. Prepare a mixture of 9 parts of powdered whiting, which is simply finely powdered chalk (Paris White or Gilder's grade are often recommended) and 1 part of dry titanium or zinc white pigment. Mix 1 pint of water and 1 cup of rabbit-skin glue powder, as described above, and, as soon as the warm solution is ready, gradually add 1½ ounces of the whiting-pigment mixture for every liquid ounce of size solution. This mixing of roughly 1½ times the amount of whiting-pigment filler to glue size must be done by slowly stirring the ingredients to avoid air bubbles, which will later appear as tiny pin holes on the gessoed surface of the panel.

3. Should small lumps of unmixed material appear, strain the contents of the pot into another pot covered with two thicknesses of cheesecloth held down around the rim by masking tape. If the mixture has cooled and begun to solidify, rewarm by pouring it back into the upper part of the double-boiler, place it over a low flame, and stir briefly. The gesso mixture should have the consistency of light cream; a fact to bear in mind, for this consistency is more important than a strict adherence to the given proportions.

4. Using a 2- or 3-inch housepainter's brush, apply a thin first layer of gesso by scrubbing the mixture about in several directions, working it into the surface vigorously. This will produce enough tooth to insure a good bonding with the subsequent layers.

5. When the first layer appears dull and dry to the touch (usually less than ten minutes) apply a second coat in strokes that run from the top to the bottom of the panel. As soon as the second coat has dried, apply a third coat at a right angle to the second one. Normally, two or three more layers should be applied, each at a right angle to the direction of the previous strokes.

6. Apply two coats of gesso to the back of the panel. If the panel is larger than 16 by 20 inches, apply three coats. Like the sizing on the back of the panel, these gesso layers will help keep the panel from warping.

7. Using a fine garnet sandpaper, smooth the face of the panel. The more fine the sandpaper and the longer you sand down the surface, the smoother it becomes. Some artists prefer to retain a slight tooth, others enjoy painting on an extremely smooth surface.

8. The finished panel should be set aside for several days to insure its being thoroughly dry before use.

Ready-made gesso panels can be purchased but their cost and the uncertainty of their physical composition are points to be considered. Most prepared panels are extremely absorbent when compared with handmade ones, a feature that many artists find troublesome.

EGG TEMPERA IN USE

Most beginners in this medium use the paint too thickly. It handles best when considerably thinned with water. As with most other painting media, egg tempera painting can be started by laying in large washes of thinned color. Because it is neither technically nor visually suited to heavy layers of paint, it should not often be used without some thinning.

Both bristle and sable brushes or the nylon "hair" brushes can be used, as can all the tools and materials used for applying paint discussed in the section on gouache painting. Because the bristle brush is not normally suited to the more traditional egg tempera technique of applying thin layers of various kinds of hatched or drybrushed strokes, it is usually employed only in the early stages of a work or for various textural effects. However, if thick impastos are avoided when using bristle brushes, they can add to the range of effects possible. In general, the sable and other soft-hair brushes are mainly relied on.

There are two methods of tempering the color pastes for painting. The traditional procedure when preparing to paint is to set out on the palette a small mound of each color paste and mix into each one a small amount of yolk medium. Painting begins once all the colors have been tempered. In the second method, you do not pre-mix the laid out color pastes

with the medium but, dipping a clean brush into the medium, take it to a mound of the required color and remove some of it with the brush, mixing the medium into the paste on the palette. In this method each color (or color mixture) is tempered as you use it.*

There is no set rule for determining the proportion of medium to paste, as each color may need a slightly different mixture. The best guide in deciding when a color is well-tempered is to note the condition of the dried strokes. A technically good layer of paint will show a subtle gloss when seen at a pronounced angle. If the paint dries slowly and looks shiny when seen straight on, reduce the amount of medium; if the paint seems matte and chalky, add a little more medium to the mixture.

In the traditional egg tempera technique according to Cennini, the painting is begun over a drawing, usually in pen and ink, by painting on pre-mixed tones for each part, often in opposing colors. For example, a blue drape might first receive its modeling in various shades and tints of venetian red or burnt sienna prepared on the palette prior to the painting of the drape. Over this underpainting the blue tones, also pre-mixed, are applied, utilizing the colors and modeling of the underpainting by keeping the overpainting semi-transparent in the half-tone and dark areas. Thus, the blue drape is modeled in two ways: by optical mixtures of tone and color which occur by seeing the lower paint layer *through* the upper one; and by the several blue values of the overpainting, which would be used in a more opaque manner in the lighter areas of the drape.

Traditionally, there are four basic methods of applying egg tempera paint: (1) by transparent layers of color overlaying other, lighter colors (*glazing*), (2) by color laid on in thin lines with the point of a brush (*hatching*), (3) by the flattened brush leaving a trail of many fine lines of paint (*drybrushing*), and (4) by *scumbling*.

In contrast to a glaze, which is both transparent and darker than the color it overlays, a *scumble* is at least semi-opaque and is usually

lighter than the color it overlays. Essentially, a scumble modifies the surface below it by being scrubbed to a thinness that permits the color below to be seen through the covering layer. While egg tempera does not as easily adapt to scumbling as oils or acrylics, it can, if scrubbed with a worn brush or some cheesecloth, produce the smoky or pearly qualities of scumbling. Something of this effect can be seen in Shahn's *Liberation* (Plate 10), where the scrubbed light tones in the sky, on the childrens' dark clothing, and along the right side of the bombed-out building are of a diaphonous nature, permitting the darker tones to assert themselves, as through a veil.

By contrast, contemporary methods are far less rigid and, as noted earlier, utilize tools as different as the sponge and the painting knife. These expanded means permit contemporary users to create images as different as Figure 3.11 and Plate 10. The best earlier masters created quite a range of effects by integrating all four basic ways of handling egg tempera (Figure 3.12). Even today, these methods form the mainstay of egg tempera painting.

In Wyeth's *Northern Point* (Figure 3.13), the mist that obscures the horizon is scumbled in, there are glazes on the brass sphere and on parts of the roof, and both the grass and shingles are mixtures of hatching and drybrushing. Additionally, there is some opaque and rather "juicier" painting in the waves. Underpainting colors are visible both through and between the strokes of the overpainting in the rocks, roof, and grasses. In general, these differing paint applications are not isolated to a particular area in the painting. For example, there is some scumbling in the brass sphere and in the roof, and there is some drybrushing in the painting of the waves.

In egg tempera painting it is important that one layer be dry before another is added. Depending on the humidity and the thickness of the paint layer, this may take from two or three minutes to one-half hour. Painting over an undried layer or painting in heavy impastos destroys tempera's special crispness and translucence.

You will no doubt need to experiment with the colors and materials, becoming familiar with egg tempera's range and character,

*See Robert Vickrey, *New Techniques in Egg Tempera* (New York: Watson-Guptill, Inc., 1973).

Figure 3.12
BRAMANTINO, *Madonna and Child in Landscape*
Egg tempera, 18 x 14 in.
Museum of Fine Arts, Boston. Purchased from the Picture Fund.

Figure 3.13
ANDREW WYETH, *Northern Point*
Egg tempera, 36 x 18³/₁₆ in.
Wadsworth Atheneum, Hartford. Ella Gallup Sumner
and Mary Catlin Sumner Collection.

slightly adjusting medium to color paste proportions to suit your needs and the varying nature of the pigments, and getting the feel of hatching and drybrushing with a medium especially suited to these techniques.

If you would like to try egg tempera painting but do not want to go to the trouble of mixing color pastes, preparing panels, and so on, you can produce a paint that strongly resembles egg tempera's look and feel by mixing the yolk-water medium with transparent watercolors. Simply lay out daubs of watercolor and, using a palette knife, mix with the medium. This preparation can be used on gesso panels or on any good grade of watercolor paper.

Egg tempera is not an easy medium to work with if ambitious projects, changeable tactics, and an impulsive approach to painting is your style. But if you plan quite simple themes and stay within the technical boundaries of the medium, tempera's fresh clarity, the quality of its color effects, and the speed with which it can be executed (when compared to oil painting) are most instructive, no matter what kind of imagery and media subsequently attract your interest.

EGG-OIL EMULSIONS

Some mention has already been made of emulsions consisting of egg to which various drying oils, resins, and waxes are added. Little has been recorded of earlier formulations, and chemical analysis of existing works is seldom conclusive.

In such emulsions the egg acts as the emulsifying agent, holding the oily and watery ingredients in suspension. The addition of one or a combination of these more viscous materials to egg gives the tempera paint some of the characteristics of oil paint. The greater the proportion of these materials in the emulsion, the more nearly the character of the paint will approach that of oils. Such paints can be more easily blended and built up in thick impastos than egg tempera, and they have a richer range of color intensities. Often such emulsion paints serve as underpaintings for oil paintings done on rigid supports. The following simple formula produces a paint that be-

haves somewhat like oils, but retains egg tempera's crisp translucency.*

Materials:
- 1 egg
- Stand Oil
- Damar varnish
- 4- or 5-ounce bottle

1. Chip a dime-sized opening at one end of the egg and empty the entire contents into a 4- or 5-ounce bottle. Cap the bottle and shake vigorously to beat up the egg.

2. Using the empty eggshell as a measuring cup, fill with a mixture of equal amounts of stand oil and damar varnish, pour into the jar and again shake the mixture vigorously.

3. Add two eggshells of water to the bottle. Shake well to combine the oily and aqueous materials.

This medium is mixed with color pastes made as for egg tempera just prior to painting. The tempered paint will thin in water or in the egg emulsion.

If refrigerated, the medium will keep for many weeks. Always shake the bottle well before tempering the color pastes to be sure all the ingredients are in suspension. Although more flexible than egg tempera, this paint should be used only on rigid supports.

In use, the bristle brush may handle the heavier, more viscous paint better than sables when the paint is not diluted. Unlike egg tempera, the egg-oil paint will stand up in ridges as oil paint does. But sable brushes work well when the color is thinned, and blendings, hatchings, and drybrushing can achieve softer fusions of tones than egg tempera or gouache.

OTHER TEMPERA PAINTS

Tempera paints can also be made using rabbit-skin glue or gum arabic to replace egg as the emulsifier. As with egg tempera, such paints must be used on rigid supports. Both produce handsome paint textures somewhat more

*For those interested in experimenting with other emulsion formulations, several excellent sources are listed in the bibliography.

painterly and rugged than egg tempera, but just as capable of its fine definition, and both, especially glue tempera which produces easier fusions of tones, offer color nuances subtly different from egg tempera. Both can be applied with bristle as well as sable brushes, or with a painting knife.

To make glue tempera, the color pastes are tempered with two parts of rabbit-skin glue (prepared to the same strength as for gesso size) and one part of either stand oil or sun-thickened linseed oil, and thinned with water or the emulsion.

To make gum tempera, dissolve one part of gum arabic in two parts of near-boiling water and add either stand oil or damar varnish (or a mixture of the two materials) up to one-half of the volume of the gum–water solution. Because gum tempera is especially brittle, many users recommend the addition of glycerin, not to exceed 5 per cent of the total mixture.

Additional variants on tempera paints include casein and wax as emulsifiers, and all emulsion paints can have their proportions altered to bring them close to true oil painting. Some formulas omit the use of water altogether and are thinned with turpentine or mineral spirits.*

TRANSPARENT WATERCOLORS

Watercolor paint is made by finely grinding pigments in gum arabic together with glycerin to keep the colors moist and easy to dissolve, and a wetting agent to improve the paint's staining and brushing properties. Commercially prepared watercolor paints of excellent quality are available in pans and tubes, and should be selected over less expensive brands for several reasons. So-called student brands of watercolors sometimes contain fugitive colors, that is, colors that will fade or change upon sustained exposure to daylight. They do not offer the brilliancy or value range of the better paints, and do not handle as well, being either too gummy and stringy or too hard to dissolve easily. And because so little paint is used up in the course of a single paint-

*For additional information on other tempera materials see the sources listed in the bibliography.

ing, the benefits to be gained from the best colors, despite the initially greater cost, will be enjoyed for quite a long while and are well worth the moderate difference in price.

In watercolor painting, the thin paint films are held to the surface as much by the pigment particles being enmeshed among the paper's coarse fibers as by the gum binder's adhesive properties. Being dilute washes of color, these paint layers are not prone to the cracking and flaking associated with the thicker paint layers of the other water-thinned paints or of oils. But such fragile paint films are not as much protected from atmospheric conditions as are these more dense paint layers. For watercolor paint loses much of its bulk when its vehicle—water—evaporates, leaving the dried paint partially exposed to dirt, fumes, and chemicals in the atmosphere. But a transparent watercolor painting, or *aquarelle*— a French term that specifically denotes work executed with these paints in a transparent manner—when painted with permanent colors on an all-rag paper, and if protected by being framed under glass or stored in an acid-free portfolio or in an all-rag matboard called *museum board,* will be as permanent as works done in other painting media.

Transparent watercolors as we know them first appeared in the fifteenth century in a series of works done by the German artist Albrecht Dürer, whose brief excursion into the technique seems to have been an isolated effort (Figure 3.14). Not until the sixteenth century did transparent watercolor painting begin to attract some artists, mainly in Holland, as a medium for serious creative enterprise. By the late eighteenth century many European and American artists were at least occasional users, and some, particularly in England, frequently turned to watercolor for both preliminary studies, a role to which it is uniquely suited (Plate 2), and for final creative statements (Figure 3.15).

Unlike all other painting techniques, which mix white paint with the other colors to achieve pale tints and where white areas are represented by white paint, in watercolor painting all tints are made by diluting the colors with water, and white is represented by the white tone of the paper. Perhaps the problems and novelty of a technique restricted to washes and glazes of color accounts for its

Figure 3.14
ALBRECHT DÜRER, *Steinbruch*
Watercolor, 21.4 x 16.8 cm.
Staatliche Museen Preussischer Kulturbesitz, Berlin.

slow acceptance at first. For the watercolor technique, when used in a purely transparent manner, does not permit overpaintings that obscure lower layers of color, and painting over darker tones with lighter washes has only limited uses. Colors are not easily removed and only moderate changes can be made in a work's forms or colors, requiring the artist to have a more or less fixed visual idea in mind. For example, all white areas in a work, even quite small ones, must, in theory at least, be anticipated at the outset. In practice, though, small flecks and lines of white are often painted in with some opaque white paint, or scratched in with a razor or nail.

Thus, transparent watercolor painting requires an ability to plan ahead, to envision tonal and color patterns, and to use the white of the paper in establishing these patterns. Although a favorite choice of the amateur, water-

color is a demanding medium that requires a sophisticated grasp of form and color, and the ability to work in a rather direct and resolute manner.

SUPPORTS AND TOOLS FOR WATERCOLOR

Watercolor paint can be used on any white, heavyweight paper of moderate absorbency and possessing either a fine or pronounced grain. Even slick-surfaced and somewhat nonabsorbent papers take watercolor rather well, permitting the brush to glide upon the surface in a way not possible on the more absorbent papers.

Most artists, however, prefer to use the various types of papers made primarily for watercolor painting. The best of these papers are

Figure 3.15
THOMAS SANDBY
St. Paul's Covent Garden
Watercolor, 19¾ x 15⅞ in.
Yale Center for British Art,
Paul Mellon Collection.

made entirely of linen rag, but papers of linen and cotton mixtures are often of equally fine quality. Such papers are available in three surface textures: *hot-pressed* papers, which have a quite smooth surface and are best suited to small or precise works; *cold-pressed* papers, which have a moderate tooth that imparts a lively character to the brushwork and color (and are perhaps the most popular papers for watercolor painting); and *rough* or *not pressed* papers, which have a very pronounced grain that causes the brush, in scraping along the paper's "hilltops," to leave many tiny unpainted "valleys" within and among the strokes, creating various rugged and sparkling effects.

These papers receive a sizing during their manufacture, usually a weak solution of gelatin or glue, that provides just the right degree of absorbency. Papers with too much sizing for watercolor will resist the paint, causing it to form beads of color on the surface; if undersized, they make the colors appear dull and blotted.

Artist's papers are available in many differing thicknesses. Those suitable for watercolor painting should be heavy enough to keep from wrinkling badly, as thin sheets will when water is unevenly applied in the coarse of painting. Paper weight is determined by the weight of a *ream,* usually 500 sheets. For example, 500 sheets of pastel paper weigh about

60 to 70 pounds, but 500 sheets of newsprint paper weigh about 35 pounds. The lightest paper used for watercolor painting is rarely less than 70 pounds per ream. The most frequently used papers are about 140 to 150 pounds and are of a rather substantial thickness, suitable for most painting purposes. The heaviest sheets, more nearly like cardboard than paper, and capable of withstanding the most rugged handling operations, range from 250 to as much as 400 pounds. Such heavy sheets do not require *stretching*, a procedure that prevents thinner sheets from wrinkling and buckling during the painting process.

All papers less than 200 pounds should be stretched. To do so, first soak the paper in a tub filled with cold water for several minutes. If several sheets are soaking together, separate and turn them once or twice, to prevent uneven soaking. Next, tape the sheet to a rigid board such as a drawing board or heavy particle board, by applying gummed brown-paper tape to the outer one-half inch of all four edges of the sheet. The paper, stretched by wetting, will shrink to a drum-like tautness and will remain flat during the execution of the painting. Any slight unevenness in the paper that occurs during the painting process will flatten out again when the paint dries. If a second sheet is stretched to the back of the board, the chance of the board's warping is avoided and a second sheet is ready for use.

Blocks of watercolor paper, in the three surface finishes described earlier, and in weights of 70, 90, and 140 pounds are useful for outdoor painting sketches or for techniques that do not employ large amounts of water, for example when sheets are soaked with clear or colored washes at the outset of a painting to produce various fused and feathered effects among the subsequent brushwork. These watercolor blocks, usually of 25 sheets taped on all four sides, do not reduce buckling much during the painting process, but upon drying, the painting will flatten out and is then removed by slipping a knife blade into a small, untaped segment of the block and cutting the painting away from it.

Because watercolor painting is primarily a staining and glazing process, soft-hair brushes are used almost exclusively. However, some artists do occasionally employ bristle brushes for rugged drybrushing and various textural effects. Again, sable brushes are far superior to other soft-hair brushes in overall handling properties and are generally preferred for watercolor painting. The same number and types of sable and other soft-hair brushes as used for egg tempera painting will suffice. For large-scale works, the addition of a round Number 10 sable, a 1-inch wide flat sable, and a quite large, round camel or ox-hair brush, known as a *mop*, may be added for laying in large washes and for broader painting purposes. A small sponge is also useful for large, sweeping strokes, for moistening the surface, and for removing excess color. Scraps of cloth can be used for similar purposes and for wiping excess color from the brush. Both of these materials are also useful to create various textural effects.

The dilute nature of watercolor paint requires a metal, plastic, or china palette designed with numerous small depressions to hold the colors, and several larger ones for mixing colors. Except when working outdoors, where it is difficult to manage large pieces of equipment, the palette should be a big one. If large-sized watercolor palettes are unavailable, an extra mixing surface of glass, metal, or plastic will provide the additional room needed for color mixing. A cookie sheet or large plate will do.

Watercolor's usually dilute nature also requires a working arrangement that permits the support to lie flat, or nearly so. Easels designed for this purpose, a table top, or a drawing board that can be held flat are necessary. Watercolor paint applied to more vertically held supports will run uncontrollably.

A large quantity of water is used for cleaning brushes, and as a vehicle. The water used for thinning and mixing the colors should be changed frequently because discolored water will seriously affect the colors used. Many artists use two large containers of water: one for cleaning brushes, and one for use with the paints. Some add 1 part acrylic medium to 9 parts of the water used for thinning and mixing colors, a step that renders the dried paint films insoluble.

WATERCOLOR IN USE

The sparkling vitality of watercolor paint results from the brilliant white light of the paper passing through the thin color films, much as

daylight activates the colors of a stained-glass window. And while most other kinds of paint, when used transparently, produce roughly similar results, none have watercolor's unique luminosity, its sparkling floods and inflections of light-filled colors, or the spontaneity of its calligraphic brushwork when used in a direct and economical manner (see Plate 11). But watercolor, because its paint films are nearer to stains than to the more buttery consistency of most other paints, is also highly suited to imagery of a very precise and intricate nature. For this reason it is the preferred medium of many medical illustrators.

Although some early watercolorists began their works in a manner nearer to most contemporary modes of approach, that is, by beginning with light-toned washes of the desired colors and continuing to paint in increasingly richer and darker colors until they achieved their intended results, a more common practice was to work *indirectly,* that is, in separate stages. They began with an underpainting in light-toned washes of gray or gray-green to establish the composition and major masses, and completed the painting by colored glazes brushed over the gray tones. In doing this, artists were adapting the then current techniques of oil painting to watercolor. Watercolor, however, lacking the opacity of oil paint, is not easily adapted to such techniques. The grayed underpainting, remaining visible through the topmost layers of color, tends to dull them. Although some interesting color effects are possible this way and dull colors might well serve as underlayers for some segments of a work, their unselective use seems to have an unpleasant restraining effect upon both the color and handling.

Later artists, responding to the speed and economy with which watercolor can be handled, and recognizing its expressive strengths when handled with a resolute directness, developed a number of methods for using watercolor in more spontaneous ways. But all methods accommodate themselves to the need, in this transparent medium, of working from pale tints toward more intense and darker-valued colors. For any stroke, though overlaid by several other colors, in remaining visible remains part of the completed painting's color, value, texture, and design. It cannot be made lighter easily or be hidden by overpainting.

Some artists begin with more or less clearly defined strokes that purposely do not touch. This method leaves white lines and shapes between the mosaic-like strokes that increase the variety of the color nuances which occur when these strokes and interspaces are overpainted. For example, if a yellow and blue stroke are separated by say, a half-inch of white paper, and overpainted by a large red wash, the three overpainted areas will become orange, red, and violet. Should a part of *this* large area be overpainted by one or more colors the color variations will multiply greatly. Some of these additive color effects can be seen in Plate 11, where Cezanne evokes the scene's essential color and form character by utilizing the medium's transparent nature. He creates numerous color subtleties by strokes which, like many colored glass steps hovering in space, allow us to descend into the painting's depths.

There are many variants of painting transparently from light to dark on a dry surface, each stroke sharply defined. Often this method is used when quite small units are to be painted, such as the figures and foliage in Eakins' *Drawing the Seine* (Figure 3.16). This general mode is sometimes called the *dry* method, in contrast to the *wet* method, where paintings are begun by first moistening most or all of the paper's surface, causing the colors to spread into soft-edged stains which meet and fuse to varying degrees, depending on the amount of water in the paper and in the brushstroke, or by painting into still-wet strokes.

The gentle, foggy atmosphere of Whistler's, *The London Bridge* (Figure 3.17), is due in large part to just such fluid blendings. Effects such as the soft, dark mass of the barges and boats, almost dissolved into the scene, are not possible in the crisper, dry method. The wet method requires a knowledgeable control, gained only through trial and error, of surface moisture. Too much water will cause the colors to form unwanted fusions and rivers of color; too little will keep the desired soft-edged unions from occurring.

The seemingly simple *Scheldemusch,* by Parker (Figure 3.18), demonstrates the artist's sensitivity to this technical matter. The lines and washes are softened just enough to suggest air and space, and were executed on the

Figure 3.16
THOMAS EAKINS, *Drawing the Seine*
Watercolor, 8 x 11 in.
The John G. Johnson Collection, Philadelphia.

moist paper at the exact moment when the damp surface was judged right; the artist knew how the paper would receive the paint.

Many artists combine the wet and dry methods. When this is the case, the early, light-toned washes are likely to be those painted into a moistened surface, the later strokes being painted on the dried sheet. For, just as the paler tints permit a greater range of tonal and color freedom in the painting's later stages, so do strokes which are not harsh and definitive allow for more changes in shape and mass in the later stages.

In Hassam's *In the Rain* (Figure 3.19), washes of pale color floated onto a wet surface can be seen to underlie the later painting on the dried surface. This is especially evident in the painting of the pavement and the building.

Often, as here, a light drawing in pencil or chalk, done before the sheet is moistened, helps to guide the artist. Avoiding the placement of paint in areas intended to be white, as in the coachman's hat, is very difficult without a preliminary sketch. But such underdrawings serve best when they are extremely schematic, generalized, and sparsely stated. Note the several loose lines in the area of the horse; they do not attempt to outline the form, but merely locate it—establish its *general* scale, direction, and position.

Again, in Sargent's *Crashed Aeroplane* (Figure 3.20), it is evident that the far hillside and near field were washed into the wet paper before he painted the stumps and plane on the hill or the figures and husks in the foreground. Note how Sargent, in the painting of the base

Figure 3.17
James Abbott McNeill Whistler, *The London Bridge*
Watercolor, 6⅞ x 10¹⁵/₁₆ in.
Smithsonian Institution, Freer Gallery of Art, Washington, D. C.

Figure 3.18
ROBERT PARKER, *Scheldemusch* (1854)
Watercolor, 8½ x 13 in.
Albright-Knox Art Gallery, Buffalo, N. Y. The Martha Jackson Collection.

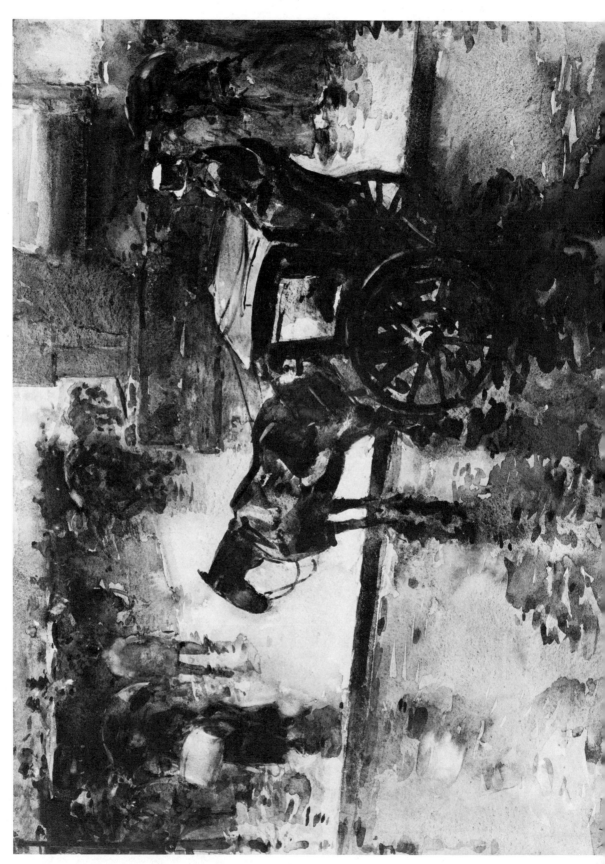

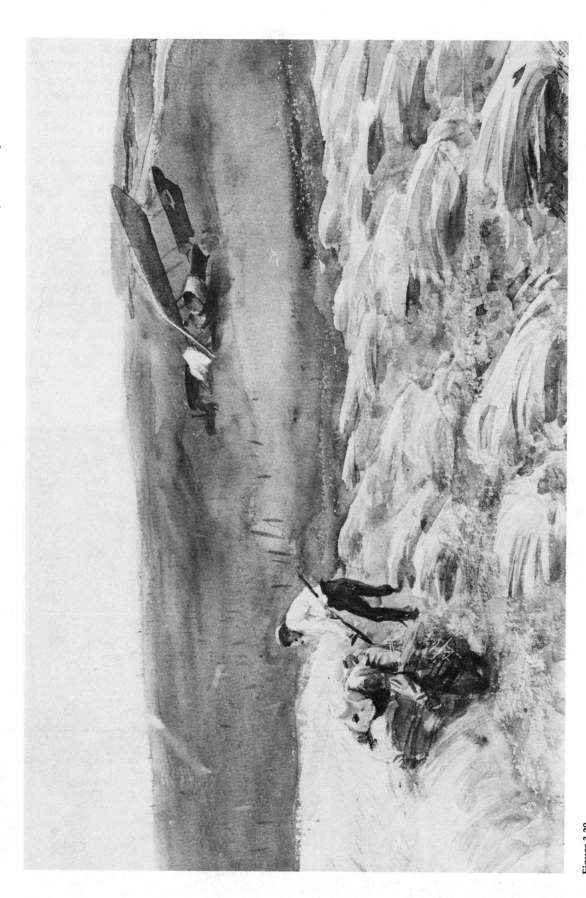

Figure 3.20
JOHN SINGER SARGENT, *Crashed Aeroplane* (1918)
Watercolor, 13½ x 21 in.

of the hill and the foreground, uses the paper's grain to suggest the texture of the ground and grasses.

Because of the several sharply defined passages, the extensive wet painting in Wyeth's *Waiting for McGinley* (Figure 3.21) is not immediately apparent. Yet it underlies all but some parts of the face and the snow. This work is a useful example of many watercolor painting maneuvers: note the dry, scraped brushwork on the window sill; the spattered painting above it, suggesting the texture of dried leaves and pods; the scratching in of light lines in the grasses, hat, beard, and coat; the aggressive sweeps and smears of the wall and coat, perhaps with a sponge or fingertip; and the precise touches around the eyes, cheek, and nose, deftly stated with the point of a sable brush. As this work shows, watercolor need not be restricted to a light value-key, as is often done, but is fully able to express sonorous, brooding dark tones and colors.

As the foregoing examples demonstrate, most watercolorists, responding to the medium's unique and appealing strengths when handled directly and economically, avoid an approach that relies on extensive reworking, a method well suited to oils and acrylics, but which invariably stifles watercolor's lively spirit. For the same reason they avoid a technique that builds slowly and methodically toward completion, as is often the case in egg tempera, a medium given more to caressing forms into being than to seizing them by bold strategies.

As Picasso stated, "One must act in painting as in life, directly."* This advice applies to work in any media, and a penetrating

*Quoted in the New York Post, September 8, 1953.

Figure 3.21
ANDREW WYETH, *Waiting for McGinley* (1962)
Watercolor, 14¾ x 21¾ in.
Hirshhorn Museum and Sculpture Garden, Smithsonian Institution.

Figure 3.22
EMIL NOLDE, *Still Life, Tulips*
Watercolor, 18½ x 13½ in.
North Carolina Museum of Art,
Bequest of W. R. Valentiner.

economy of means is a universal aesthetic principle. Watercolor painting, like drawing, is particularly valued for its power to say much in a few strokes. And while its capacity for suggestion is corrupted by some into a mannered facility of a breezy sort, most artists of quality do approach watercolor with the intent of economically stating a subject's visual and expressive essentials.

Such an attitude is clearly at work in Nolde's *Still Life* (Figure 3.22). In contrast to the familiar versions of pretty floral arrangements daintily painted, Nolde's furious interpretation, in perhaps a hundred brush strokes, is one of wild force. Likewise, the grandeur and great space of Turner's *Lyons* (Plate 2) is conveyed with impressive brevity. Note that both these works show dry and wet handling.

Hopper's *Methodist Church, Provincetown* (Figure 3.23) is another useful example of economy in watercolor. Using the dry process al-most exclusively, Hopper reduces a complex architectural network of forms to simply-stated shapes. There is almost no retouching of a segment; each stroke is the result of a visual and technical judgment. As in drawing, especially with nonerasable materials such as ink or crayon, any faltering in visual or technical involvement in watercolor painting can be costly to the worth of the work. As Hopper's painting suggests, if watercolor requires a knack for anticipation and fast action, it also demands patience and precision.

Watercolor is compatible with all water-thinned paints and most drawing media and is often used in combination with gouache, pastel, crayon, charcoal, or ink. It is, as we have seen, an efficient material for quick painting sketches and for fully realized creative statements. And while the traditional use of watercolor has tended to favor pastoral and otherwise gentle imagery, perhaps because of its

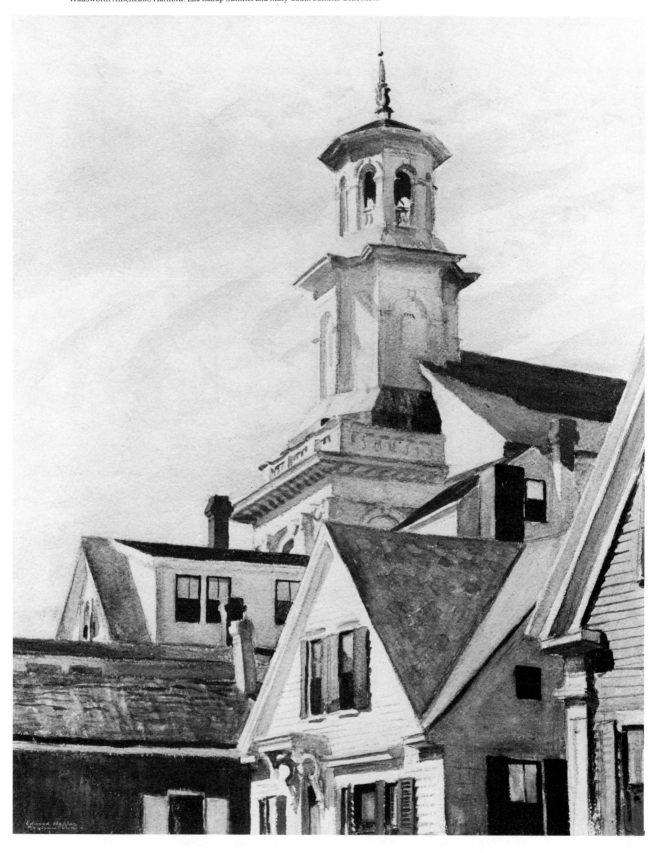

thin paint films and delicate feel, it is a medium capable of tumultuous expressive power, as Figures 3.21 and 3.22 suggest, and as is evident in Grosz's *Punishment* (Figure 3.24).

SUGGESTED EXERCISES

As in the previous chapter, a period of exploration with those paints you will use in these exercises should precede their use in this section. Again, mere manipulation of these paints, noting how they differ from one another, and how the various brushes and tools respond to your demands is a vital prelude to their use here. In doing so, do not overlook experimentation with different supports.

The following exercises are designed for use with gouache, egg tempera, and transparent watercolor. Those wishing to experiment with distemper, casein, egg-oil emulsions, or paints tempered with rabbit-skin glue or gum arabic may substitute any of these in the exercises designed for gouache or egg tempera. The exercises designed for watercolor are less easily adapted to any other medium, but gouache, egg tempera, egg-oil emulsions, and the other tempera emulsion paints make more tractable substitutes than distemper or casein. Still, with the frequent exception of watercolor paint, whose formulation does not allow for broadly applied, opaque brushwork, each of the above media can be interchanged

Figure 3.24
Georg Grosz, *Punishment* (1934)
Watercolor, 27½ x 20½ in.
The Museum of Modern Art, New York.
Gift of Mr. and Mrs. Erich Cohn.

for any other in these exercises, with rewarding results. For when, say, gouache can be made to function well in a wholly transparent manner, or watercolor is used with the hatchings and drybrushing associated with egg tempera, important discoveries are made in controling these materials, and in understanding their range *and* limitations.

1. Use either gouache or egg tempera. On a small, suitable support, perhaps a 10-inch square, draw a design, in pencil, of some fifteen to twenty simple geometric and organic shapes, some of which may touch or seem to overlap, as in Figure 3.25. Using only black and white paint of an opaque or barely translucent consistency, paint this two-dimensional shape and value design. Do not settle for some four or five values, but try to establish some nine, ten, or more. Paint each shape in a manner that results *in a very even tone.* Avoid splotchy, uneven levels and values of paint applied within a shape. Always mix up a little more paint than you estimate you will need.

More often than not, it will be used. Paint the shape or shapes of the background, as well as those you have drawn. The purpose here is to develop control in laying down an even paint layer of a single, unchanging tone, and to explore subtleties of tone with these paints, as you establish a design that is balanced and interesting in its shape and tone relationships.

2. Use either gouache or egg tempera. Again, using only black and white paints on a small-sized support, draw another arrangement of simple shapes, this time no more than seven to ten in number, as in Figure 3.26. Begin by painting the background, using paint of semi-transparent consistency. This time, *gradually* change the value of the background. For example, it may be quite light in tone on the left side of the panel and subtly grow to a dark gray as it approaches the right side. Likewise, paint each shape to show a transition in value.

Because gouache and egg tempera points do not blend as oils or acrylics do, you will have to resort to hatchings and drybrush

Figure 3.25

Figure 3.26

painting. In doing so, remember to keep the paint thin. Do not attempt an absolutely even graduation of tone if such an effect seems to elude your best efforts; most artists avoid such a "seamless" smooth effect, preferring the texture of these fine strokes to show their weaving, interacting behavior, as in Figure 3.13. But do avoid harsh divisions between value changes that make them appear to be bands of abutting tone. Some shapes may be lighter than others in their overall value, some may undergo great value graduations, and others, only minor ones. You may wish to first paint a shape an even value, as in exercise 1, and, when it has dried, paint in its value variations. A shape may grow from light-to-dark-to-light again, and do so in rather sudden (but not abrupt) changes, or it may change its tone only slightly, and in a very gradual way, as in Figure 3.26. The skills you are developing in this exercise are vital to the more exacting kinds of form modeling in any medium.

3. Use gouache or egg tempera. Using black, white, and an earth red such as Venetian, English, or Indian red, and again working on a small-sized surface, perhaps 12 by 15 inches or so, first draw some seven to ten invented forms that seem to float in space, as in Figure 3.27, and then paint them in a three-dimensional manner. Here, you will be applying the skills acquired in the previous exercises, to create a sense of convincing masses in convincing space.

Begin by painting the background in rather thin washes of tone. Don't hesitate to paint over your line drawing of the various forms; the thin washes will allow the drawing to show through, and later painting of these forms will hide such early washes. Now you can gradually change both the value *and* the color of the background and forms as you build a cavity of space and carve the forms within it. For example, you may begin to paint the background (or a form) by laying in a thin wash of say, a light-toned reddish gray, and, when it has dried, hatch or drybrush a darker, pure gray tone into a part of this first wash, causing it to gradually turn from a light, warm tone to a darker, cold one.

Here it will be helpful to assume a light-source to help you decide when a flat or curved plane should change in value. Flat planes generally do not change value much, but appear to grow slightly lighter along their abutment to a darker tone, and vice-versa, as

Figure 3.27

change it to a blue color *of the same value,* so that one part of the shape is red, another blue, and between them an area showing their gradually changing mixture. Or, try a transition from a light, cold color such as blue-green to a dark, warm one, such as yellow ochre. Now you are changing both the color and the value. In the background, too, several colors may subtly insinuate themselves in various places. Although the analogy is rather clumsy, think of such mixtures as similar to speed and direction. Just as you may choose to walk swiftly to the right and slowly to the left, your colors may change swiftly—with only a brief transitional mixture—from say, warm to cold; or they may change gradually—in an extended band of mixture—from cold to warm. Additionally, just as you can walk fast or slow, to the left or right, and *up or down* a hillside, so can your colors change swiftly or slowly toward warm and cool nuances *that are lighter or darker in value.* Understanding the expanded options that the element of color introduces, and developing the control to produce them, is of course as basic to painting as an understanding of value is to drawing.

in Figure 3.27. Do not model these forms in heavy impastos or by large strokes. Instead, rely on hatchings and drybrushing of thin paint. Much of this kind of painting is really tonal drawing with a brush, and you should call on your prior drawing experience to help you establish these forms.

The use of red here enables you to see how intimately color and value are related. For, in addition to giving a warm hue to some forms, the red color will help model through its color intensity as well as by its value. If the background is kept somewhat thinner and more loosely painted than the forms, there is an additional gain in the sense of masses in space, as in Figure 3.7, where the background is painted in watercolor washes, and the rocks in more or less opaque applications of gouache.

4. Use gouache or egg tempera. This exercise is essentially the same as exercise 2, but here use all of your colors to practice fusions and transitions of colors as well as values, as in Plate 1C. You may, for example, begin to paint a shape with a cadmium red and gradually

5A. Use gouache. Arrange a still life containing some five or six simple forms. Avoid highly reflective, textured, or patterned objects. Using a full range of color, but restricting your tools to your largest (flat or round) sable and bristle brushes, paint the still life on any suitable support no smaller than 12 by 16 inches, or larger than 16 by 20 inches. Your goal here is to suggest the basic structural nature of the forms and the space enveloping them in the simplest, most economical terms possible.

If there is any rule governing how to proceed here, it is to begin by trying to match the value and color of the many color shapes that constitute the observed objects' surfaces. Bypassing all but the briefest and most schematic of preliminary drawings, begin to paint the major planes and major color notes of your subject as accurately as you can. For example, a red apple in the still life may show every kind of subtle color and value nuance, and do so by very gradual changes. But you are to set down only the more obvious differences in color and value, disregarding the smaller or subtler transitional passages. If you see two reds side by

side that appear nearly alike, paint them as one red. Similarly, if two values are barely different, paint them both as being one or the other. Here it helps you to squint at the subject. Like shutting down the aperture of a camera, squinting pulls together similar values, and more clearly separates differing ones.

This broader handling helps to simplify color and value, and to establish major planes and masses in color. The forms will take on a somewhat blocky nature, as in Plates 4 and 9, works that may be referred to as rough guides in grouping color and value. The restriction to larger brushes also encourages a more direct and broader approach to the subject.

Use paint of an opaque density, but avoid very thick layers. To adjust shapes or tones, paint into the still wet paint, or, when an area has dried, paint the desired color over it by as few strokes as possible, to avoid unwanted blendings with lower paint layers. To isolate the underlayer, lightly brush a weak solution of acrylic medium and water over it. This prevents such mixtures between paint layers.

The goal here is to experience modeling in color in a medium suited to such a broad handling. In painting such color and value summaries, notice how often the shapes of color and value conform to the subject's planar condition. That is, the color and value tend to change as the surface terrain changes.

Remember that gouache dries a little lighter than it appears when wet. Therefore, mix your colors a little on the dark and intense side of what you see, rather than the opposite. Be mindful of *color expectations,* of "seeing" a color you expect to be there in place of the color actually before you. Such expectations can fool us. For example, if shown a disk that is colored a cadmium yellow and told it symbolizes a lemon, we are likely to see it as slightly greener than it is. If told the same yellow disk symbolizes an orange, we will tend to see it as a warmer, more orange-tinted yellow.

In the end, color accuracy is of less importance here than the emergence of a sense of form construction through shapes of color—as though variously shaped and colored facets are made to fall into place in a manner that explains each form's surface in planar terms. Such an approach is not unlike making a mosaic, where small colored tiles convey mass

and space by their differing values, hues, intensities, directions and shapes. This kind of painting, which is not restricted to gouache (see Figures 5.13, 5.16, 5.17, 6.15, 6.21, and 6.43), in forcing us to simplify, causes us to perceive our subject in a more analytical way; we must see in order to choose.

5B. Use gouache. Begin a second painting in the manner described in 5A, but once the general masses and spaces are established, however broadly, use your smaller soft-hair brushes to carry the forms further, using Figures 3.2 and 3.5 as rough guides. In this more linear mode, use the paint in thinner mixtures.

5C. Use gouache. Add 1 part acrylic medium to 8 or 9 parts water to make a vehicle for thinning and mixing paints that will render the paint films insoluble. Using a full range of colors, and working on any small-sized panel (preferably not to exceed 15 by 20 inches), paint a landscape, preferably from the site, but if necessary, from a photograph. Use any of your painting tools. Here, lay in large, simple color shapes that will serve to underlie an entire form, or even a large segment of the observed scene. These underpainting washes should to some degree contrast with the colors you see. For example, you might wash in a large wash of an earth red to underlie a green tree, or, as in Plate 9, a grayed blue tone as an underlayer for a tan house.

When you have established an underpainting of more or less contrasting colors, overpaint with barely opaque paint, scraped on to reveal and optically mix with the colors below, as in Plate 9. Note that Picasso uses the same light tint of raw umber to overpaint the building, the hill behind the figures, and much of the ground. It even appears in the small figure's head. Yet, because of the different underlayers in these areas, the tan color takes on nuances of difference. Utilize your experiences with the previous exercises, but don't restrict your instincts for exploration here. Allow the overall color character of the emerging image to suggest other colors that you feel would enhance the color quality and mood further.

6A. Use egg tempera. Arrange a simple still life as in 5A, and, on a gesso panel about 10 by 14 inches, paint the arrangement using a full range of colors, and using Figure 3.11 as a

rough guide in handling. Begin by establishing a line drawing on the panel using either pencil or ink. Do not establish values in this drawing, although you may want to analyze the forms for their major planes, thus carrying the drawing beyond only an outline of the forms.

Next, lay in transparent washes everywhere to establish the general, basic colors and values of the objects. For example, if you are painting a blue mug in a gentle light that does not produce strong value changes on the mug, lay in over its entire shape the color of the mug itself, not of its lighter or darker segments. However, if the mug is strongly lit, show the overall color and value of its light side and of its dark side. When every part of the subject has been reduced to these generalized color shapes, begin to model the forms by hatchings and drybrushing, using sable brushes. Some forms may require an underpainting that is different from the color of the object's surface color. For example, a green pear that suggests a golden cast might best be underpainted in yellow ochre. Your modeling of the pear's form would result in the yellow ochre being seen through the greens of the overpainting, imparting the golden cast.

As in exercise 3, much of the modeling here is in a linear mode. However, the addition of full color provides you with intensities of hue, as well as warm and cool, or light and dark tones with which to model forms. This being the case, take advantage of the brilliance or dullness of a color to help you model masses and clarify space.

6B. Use egg tempera. Using a full range of colors and working on a small panel (approximately 12 by 16 inches), paint a cityscape detail, that is, no more than a building or two, or even part of such a structure, such as a door front and stairs, or part of a courtway or other close-up views. Avoid a panoramic scene. Do not paint from the site, but from tonal drawings made on location. In developing the drawing on the panel make any changes and simplifications you wish. Select a site that triggers your interest in its forms and movements, as well as color, and that holds potential for some psychological or social expression. Perhaps you will want to rework the

original drawing to suggest some remembered place that holds meaning for you.

Plan to use the sponge, bristle brushes, and other tools, as well as the sable brushes. The goal here is to use the subject as a point of departure, making it your own by responding as much to the nature of the paint and to the unique qualities of egg tempera color as to your observations and form inventions. Again, utilize your experiences in the earlier exercises, but explore with the various tools and colors to see what formal, textural, and expressive qualities a more free-wheeling treatment of egg tempera may be capable of. Refer to Plate 10 as a rough guide in possible surface effects.

7A. Use watercolor. On a suitable support draw a horizontal row of some eight or nine 2-inch squares. Using only black paint and a large round or flat sable brush, start with the square at the far left to lay in *even,* transparent washes that grow progressively darker from square to square as you work to the right side of the row. These squares should not touch. The completed row should show few, if any, undulations of tone within a square, and the squares should maintain a more or less even tonal "pace" as the row grows darker toward the right side. Avoid letting the paint dry in one part of a square before you have completely filled it in. Such dried areas will show dark edges where they are overlapped by other brush strokes. Slanting the board helps to keep a "puddle" going, thus aiding you to fill a square before drying occurs. Larger brushes will lay in a wash more quickly, reducing the chance of the paint drying before you want it to. Always mix a bit more of the tone than you think you will need. Running out of the desired color in the middle of a wash is a serious problem in watercolor painting.

7B. Draw another row below the first, of four shapes, 2 inches high and 4 inches long. Again using only black paint, show the following value transitions: in the first box on the left, show the white tone of the paper growing gradually darker as it moves toward the right side of the box, reaching a light-gray tone at its far right border; in the second box begin again with the white of the paper, but this time the tone should grow to a dark gray at the right

side of the box; in the third box begin with the white of the paper, have the tone grow to black, and then lighten again to white; in the fourth box begin with black, gradually reaching white around the middle of the box, and then growing darker again, to a middle gray at the right side.

To do this you will first need to moisten each box prior to painting it. The water should not be visible on the surface of the paper. That would cause the paint to run in an unmanageable way. To paint a gradual transition of tone the paper should be only faintly damp. In this state the strokes stay where you put them, but, softening and spreading at their edges, adjacent tones will smoothly blend. As in 7A, don't let part of the paint dry before you have completed its fusion with other tones. As this exercise will show, such graduations of tone in watercolor require some speed and will no doubt take much practice. Once you have mastered the damp state of the paper and have developed a feel for the way the wet colors fuse, you will have conquered one of the more demanding skills in watercolor painting.

8. Use watercolor. Using black and any earth red color, and working on a cold-pressed paper about 12 by 15 inches, first draw some six or seven invented forms, as in exercise 3, and then paint them in a three-dimensional manner. Do not paint any background. Begin with very light tones to paint in the various flat and curved planes. Although many fusions of tone will be necessary here, be careful not to permit wet tones to touch where you mean to show a clear abutment or sharp change in color. Now you may sometimes require a stroke to dry in order to bring another color up to it. If you mean a form to be dark, build up to it by adding fresh color over dried areas. Remember that you can always paint a part darker, but not lighter. One of the advantages of this dry method is the more leisurely, additive process of color and value development. As in exercise 3, utilize the red color for its intensity as well as for its value.

9. Use watercolor. Arrange a simple still life of some four or five objects, and, using a full range of colors on any suitable surface about 10 by 14 inches, paint it with a view to establishing its structural essentials, in the general mode discussed in exercise 5A. In doing so, rely on the experiences of the previous watercolor exercises, working from light to dark, moistening the paper for gradual color changes and in the dry method elsewhere. Begin with large washes that define the background and work forward, painting objects further back in space before those located in the foreground. Again, the translucent surface of some forms, suggesting one or more colors seen through the surface color, may better be painted (as in gouache) by underpainting in the color or colors hinted at in the object, and overpainting with its surface color. But here the color and value of such primary washes must be rather pale or the later washes will be too much altered by the underpainting. Note the building up of color and value in Plate 11 as a further guide in developing this painting.

10. Use watercolor. Working from the site or from a photograph, using full color and a small-sized rough watercolor sheet of about 10 by 14 inches, paint a wet-in-wet landscape. This painting should tend to reflect your interpretation of the scene—its mood and character—by more intuitive and perhaps bolder color choices, and by a simplification of the subject, as in Plate 2. Begin by moistening the entire sheet thoroughly, but wait until it has attained a damp state before starting to paint. Now the brushstrokes will spread and blend into each other, growing somewhat lighter as they do. For this reason plan on mixing somewhat stronger, darker tones. Unlike the dry method, where numerous transparent strokes may overlay each other, in wet-in-wet painting too much overpainting or fussing with the washes tends toward muddy and mottled results. Note the fresh simplicity of the washes in Whistler's wet method painting (Figure 3.17). Note too that other, crisper strokes are added after the large washes have dried.

11. Use watercolor. Working on any small-scale cold-pressed paper, about 14 by 17 inches, and using full color, arrange a still life possessing many strong, dark colors. Combine both dry and wet modes. Here, you should assume the light falling on the forms is less bright than it is. You are to paint the arrangement as it might look in a dim light. Do not hesitate to lose edges in shadow, and to

darken the tones of the colors you see. Do not, however, darken them merely by adding black. Mix colors that are darker, cooler, or warmer versions of those before you. You may wish to begin with a somewhat bolder preliminary drawing, perhaps with a soft pencil or even a crayon, which, in resisting the paint, often creates useful effects. Too often watercolors are assumed to be limited to the upper register of values and to something less than pure, powerful color intensities. But watercolor is capable of the sonorous tones associated with oils and should be explored for these qualities (Figure 3.21).

12. Use gouache and watercolor. Working on any rigid support of any desired scale, combine these materials in any way you wish in a painting of anything observed or invented. Be-cause you are now to combine (to the extent your theme allows) glazing, drybrushing, hatching, scumbling, wet and dry handling, and, when using gouache, even some low impastos, give some thought to selecting a subject and conception that will enable you to test these materials and techniques together.

You may wish to begin in watercolor and overpaint in gouache, or do just the opposite. Adding some acrylic medium to the water used for thinning will keep layers of color separate, and may be a necessary aid in works that will include so many differing paint applications. That combining these materials and modes need not result in tortured paint surfaces or bizarre visual themes is demonstrated by Figure 3.7, a work that includes each of the abovementioned techniques.

FOUR

oils
and acrylics

References to the use, in the decorative arts, of several kinds of drying oils and of oil varnishes date from the Middle Ages. By the fourteenth century oil-based paint was increasingly employed as an adjunct to tempera painting, either as glaze coats in the final stages of tempera paintings or in various egg-oil emulsion formulations (Figures 3.10 and 4.2). At the same time some artists had begun to experiment with oil paint in ways more or less independent of tempera-based works. Despite the technical complexities in the use of oils as compared to tempera painting, and despite such drawbacks as their slow drying and tendency to eventual cracking and darkening of the paint film, early users were strongly attracted to oil paints because of their considerable advantages. They welcomed a medium that permitted painting in both glazes and impastos in various combinations, that allowed a work to develop from darker to lighter tones, that made for easy fusions and blendings of colors, that did not alter in color or value upon drying, that provided them with a more resonant and expanded color range, and that enabled them to produce visual effects of any kind.

Developments in the science and techniques of oil painting in the fifteenth century speeded the pace of the medium's growing popularity and, by the sixteenth century, oil paint had become the principal medium for painting throughout Europe. It is still regarded by many painters as the standard medium for major pictorial endeavors, and by many painting teachers as the ideal medium for studio classwork. For oils, despite their several disadvantages (which sound technical practices can largely overcome), remain the most adaptable and easily managed of paints. The heavy impastos of vibrant color (Plate 6) and the clarity of even thin applications of paint (Figure 4.1) are especially attractive features for many painters. Even acrylic paint, a relatively new and highly versatile material, falls just short of matching oil paint's tractability in handling and subtlety of color-nuance. For these reasons and because the technical aspects of oil painting are more complex, our study of this medium will go into greater detail.

79

Figure 4.1
PAUL CÉZANNE, *Village of Gardanne* (detail)
The Brooklyn Museum, Ella C. Woodward and A. T. White Memorial Funds.

Oil colors consist of finely ground pigment mixed with a drying oil such as linseed or poppy seed oil, and an inert stabilizing material such as aluminum stearate, aluminum hydrate, or one of several waxes used to keep the oil evenly dispersed in the paint, to reduce color intensity, or, in the case of dye-based colors, to add body to the paint. These materials are mixed in proportions that vary with each color in order to produce paints of a uniform, buttery consistency. In inexpensive brands of paint such stabilizers, costing less than pigments, are used in greater amounts to extend the paint, a practice that reduces tinting strengths and sometimes, intensity.

Additionally, drying agents are added to slow-drying paints and slower-drying oils are added to fast-drying paints to reduce somewhat the differing drying rates between oil colors. Even so, drying rates vary considerably and the beginner in oils should, as he experiments with this medium, take note of these differences, as they can help or hinder a painting's development.

When oil paint dries, the oil, through a process of oxidation, becomes flexible and tough, imparting a slight degree of elasticity to the paint film and a good deal of protection against moisture and damage. One of oil paint's more important advantages over the traditional water-thinned media is its durable and slightly pliant paint film, which enables artists to undertake large-scale works on stretched canvas rather than on the much heavier and more cumbersome rigid panels. The stretched canvas, which provides the artist with a kind of give and take as the flexible surface reacts to the pressure of the brush or painting knife, is the most popular of oil painting surfaces. Although stretched and prepared

Figure 4.2
QUENTIN MASSYS, *Portrait of a Lady*
Oil and tempera, 19 × 17 in.
The Metropolitan Museum of Art. Bequest of Michael Friedsam.

(*primed*) canvases may be purchased, both their cost and the questionable quality of the materials used make it important for the beginner to know how to stretch and prime a canvas.

STRETCHING A CANVAS

1. Select the four *stretchers,* that is, the slot-ended wooden bars, in the desired size. Be sure none are warped or twisted, or the resulting work will present vexing problems in framing and hanging. Next, assemble them by fitting the mitred, tongue-and-groove ends together. Usually, stretcher bars can be worked into place by hand; if a hammer is required to fit the corners together, use a rubber or leather mallet, or place a small block of wood over the corner to be hammered. Never hammer directly on the fragile slotted ends. Use a carpenter's square or a dependably true door-

frame to determine that all four corners of the stretcher frame are square, that is, at 90 degree angles.

2. Cut the desired canvas shape from the roll, allowing about one and one-half inches on each of the four sides, to enable you to grip the canvas during the stretching procedure. Thus, if your canvas is to be, say, 20 by 24 inches, the cut fabric should measure no less than 23 by 27 inches. If you are mounting commercially primed canvas, place the canvas piece face down on a table top and position the stretcher frame so that there is an equal amount of extra canvas on each side, as in Figure 4.3A. Because either side of *unprimed* canvas may be used, it doesn't matter which side is placed down on the flat surface.

3. Using either a tack hammer and no. 6 carpet tacks or a staple gun capable of using staples with a $5/16$ inch leg, begin to attach the canvas to the frame by hammering or stapling it to the

Figure 4.3

center of one of the short bars, as in Figure 4.3B. Note that it is driven into the outer, thin edge of the stretcher.

4. Move frame to standing position. Using an artist's canvas pliers to pull the material taut, repeat step 3 on the opposite short bar. If correctly taut, there will be a long fold running between the two points of attachment, as in Figure 4.3C. If you are mounting unprimed canvas do not pull nearly as tight. Let the barest slack remain in the overall stretching of the canvas. Sizing unprimed canvas shrinks it, and overstretching it here can cause the frame to warp badly.

5. Check to see that the fabric's weave runs horizontal and vertical to the lines of the frame and not at an angle. Turning to either long bar, pull the canvas taut with canvas pliers and again tack or staple to the outer, thin edge of the bar. Now, two more folds should appear, as in Figure 4.3D.

6. Repeat step 5 on the opposite long bar. This should show four diagonal folds, as in Figure 4.3E.

7. Continue to place tacks or staples along each bar edge at two- or three-inch intervals, pulling the canvas back and slightly outward toward the corner each time. Rotate the frame frequently, attaching the canvas to all four bars at about the same rate, that is, avoid completing the securing of one side with only single points of attachment on the other three sides. Should unwanted folds and wrinkles develop, do not assume that increased stretching force will solve the problem. Instead, remove the tacks or staples to the left and right of a wrinkle and slightly relocate the canvas by stretching. This may only move the wrinkles further along the edge, but continued adjustment of the canvas in this way should remove them.

8. At the corners, fold one part under the other and use two or three tacks or staples to secure the several layers of canvas, as in Figure 4.3F.

9. Either fold back and attach the surplus canvas to the back of each bar, or trim away with a scissors or razor blade. Note that cutting the excess canvas away gives a neater result but does not allow for future restretching.

10. Should the canvas fail to have a drum-like tautness, place stretcher pegs (eight of these should be supplied free with the purchase of the stretchers) in the inner of the two small slots that will remain on the inside corners of the frame, and hammer in lightly. Do not rely on these pegs to correct a warped canvas, or to greatly tighten a slack one. They should be used now (if necessary) only to increase slightly the tautness of the stretched canvas. Their more important function is to tighten up a canvas that has lost its "bounce" as a result of vigorous painting actions and heavy impastos. The canvas, if primed, is now ready for use. Before an unprimed canvas (or panel) can receive oil paint, it must first be prepared to accept the paint.

PRIMING CANVAS AND PANELS

Although commercially prepared cotton or linen canvas of excellent quality can be purchased by the roll or by the yard, it is expensive and warrants, at least occasionally, the preparing of one's own canvases. Prepared wood-pulp panels are rarely marketed.

Canvas or panel supports, being vegetable materials, will in time deteriorate if permeated with oil, and when untreated by any primary coating are too absorbent to receive oil paint well. The purpose of priming is to isolate the surface from direct contact with the paint and make it less absorbent. In the case of stretched canvas, flexible materials must be used that will follow the expanding and contracting movements of the cotton or linen textiles. Rigid supports such as untempered, pressed wood-fiber panels (Masonite is a brand name of one such material), plywood, or particle-board may be prepared with the gesso formula given in Chapter Three, or with an oil-emulsion ground (described later on), or in either of the two following methods in popular use today for priming both canvas and panel supports.

Oil Ground

The term *ground* refers to the primary *paint* layer that makes the surface ready for use by providing a white or lightly toned reflective

surface, giving a fresh brilliance to the colors that overlay it. An oil ground is simply a layer of white oil paint, usually lead white, also called flake white. Before applying the oil ground, a thin sizing of rabbit-skin glue or gelatin is first brushed on, using a 2- or 3-inch housepainter's bristle brush. The sizing prevents the oil from reaching the fibers themselves.

The size solution (see To Make the Size, Chapter Three) must not be applied in a thick, shiny layer. This coating would be too nonabsorbent and brittle, providing a poor tooth for the oil ground, and would probably lead to early cracking. Instead, a thin size solution is scrubbed firmly into the horizontally placed canvas or panel surface, working in several directions until the surface is saturated. Coat the outer, thin edges of the canvas as well. When dry, the surface will feel rather rough and can be *lightly* sanded. Too much sanding will expose the fibers, just as a too weak or thinly applied sizing will fail to protect the surface adequately or reduce its absorbency.

Normally, the commercially prepared lead white priming mixtures (available again in art supply stores, after the recent ban on lead-based paints had removed all such paints from general use)* are the right consistency for priming, being a paste somewhat thicker than housepaint but thinner than tubed white oil paint. If the primer is too thick, it may be thinned with turpentine or mineral spirits, which should be added in small amounts until the desired consistency is obtained.

To apply the lead white oil primer to a canvas, place the sized and sanded canvas on a flat surface and, using either a 2- or 3-inch bristle brush or a palette knife, work the paint into the weave vigorously, coating small sections of the surface at a time. When the entire surface has been coated, use the bristle brush to even out the surface by long, light strokes that cross the entire surface in one direction. Then brush the oil ground onto the size-covered outer sides of the canvas. To avoid a line or ridge of paint appearing where the brush or palette knife moves over the canvas-covered stretcher bar, lift the canvas a bit and, pressing

with your fingers, push the canvas away from the bar as you paint over the area.

The primed canvas should be allowed to dry for four or five days (at least a week during humid weather) before use. Some artists prefer to apply two coats, believing that the thicker priming permits the oil in the first layers of the painting to have a deeper base with which to bond. If a second priming is desired, it must be applied after the first coat has thoroughly dried. The second coat will require a two-week drying period. Allow to dry in a light storage area; drying in the dark will cause the priming to yellow somewhat. Should this occur, storing in the light for a few days will lighten the canvas again.

The same procedure should be followed in applying an oil ground to a panel. However, allow a few days more of drying time after each coating of the primer before use.

If the canvas or panel is lightly sanded after each of the two ground-coats are dried, absorbency will be slightly reduced. For those who desire a still less absorbent ground, the addition of a small amount of damar varnish to the ground, perhaps a teaspoonful to the amount of primer needed to prepare a 24 by 30 inch canvas, will reduce absorbency further, as will a more extensive sanding of the surface.

Although titanium or zinc white oil paint are occasionally used as oil grounds, neither has the lean and elastic properties of lead white, or dries as quickly, but both produce more intensely white grounds. These whites are frequently used in commercially prepared canvas, often in combination with lead white paint. The term *lean,* for painters, describes paints containing a small amount of oil; the term *fat* applies to paints containing a large amount. White lead pigment requires very little oil in the grinding process; a color such as raw sienna requires a great deal of oil.

In general, it is best for a painting's durability and freedom from excessive darkening and yellowing when fatty layers overlay lean ones. There are several reasons for this. First, the more oil in a paint film, the longer time required for drying. If a faster-drying lean paint film hardens atop a layer that is still drying, the expansion and contraction that a drying oil paint undergoes will cause the lean layer to crack. Second, as each increasingly oily layer bonds with the leaner layer below it, the oil drawn downward by the more absorbent un-

*Lead white paint, unlike lead white powder, is quite safe for adult use, provided the normal precautions are observed against ingesting the material or letting it enter open cuts. All oil paints should of course be kept out of the reach of children.

derlayer produces a strong bonding between the layers, and this greatly reduces the likelihood of later cracking and flaking of the paint surface. Also, because the amount of oil in the upper layers has a strong bearing on the amount of later discoloration the painting will undergo, in causing the oil to move downward the original color of a work can more nearly be maintained. But when the process is reversed and oil from lower layers moves upward toward the surface, the adhesion of upper paint films is weakened. A third reason for painting fat layers over lean ones is that the artist enjoys a far superior paint surface upon which to continue working. Lean upper layers often result in dulled colors.

Acrylic Polymer Grounds

Like oil grounds, acrylic polymer grounds (also called synthetic resin grounds) can be applied to both canvas and panel supports. Their increased use in recent years is due in part to the fact that they are applied directly to untreated canvas or panel supports, no size being necessary. Acrylic polymer grounds are quite flexible and produce an intense, cold white tone that will not yellow. Manufacturers refer to these primers as "gesso" but, as observed in Chapter Three, they are not true gesso, but a mixture of an acrylic emulsion binder and white pigment. White lead is not used in these formulations. Among the popular trade names are Liquitex Gesso, Hyplar Gesso, and New Temp Gesso. These materials can be used as they are, or can be slightly thinned with water. Apply them in the same manner as described for oil ground, and sand lightly when dry. Acrylic grounds dry in about one to five hours, depending on their thickness and the humidity. Panels should be allowed to dry overnight before use. Because of the absence of a sizing layer, a second coat of the primer is recommended. Again, sanding after each coat has dried decreases absorbency somewhat, as will the addition to the ground of a small amount of acrylic painting medium.

Oil-Emulsion Ground

The oil-emulsion ground, recommended for rigid supports only, attempts to combine the best features of the oil ground and the gesso ground, which is used mainly for tempera painting. The flexibility of the former, the brilliant whiteness of the latter, and the superior lean character of the oil-emulsion ground make this an appealing and technically fine priming.

To make the ground, prepare the gesso as described in Chapter Three, but using 5 parts zinc white pigment and 5 parts whiting, instead of the 9-to-1 ratio. To this mixture add boiled linseed oil (available at hardware as well as art supply stores), up to 20 or 25 percent of the total of the gesso solution. If more of the gesso's character is desired, reduce the amount of the boiled linseed to as little as 10 percent; if more of an oil ground character is desired, the amount can be increased to 30 percent. Apply as you would the other grounds, but allow at least two weeks between coats, and before use.

Casein-Oil Ground

A fast and excellent priming for use on a sized panel is a mixture, in equal parts, of casein white paint (preferably Shiva brand) and either lead white (flake white) or titanium white oil paint. Use a palette knife to thoroughly stir the two paints together and to apply. To reduce absorbency, add a teaspoon of damar varnish to an amount of priming needed to cover a 20 by 24 inch panel. As with any other ground, do not apply thickly. Allow three or four days to dry, a week in humid weather. This ground has a decidedly different feel than the others, makes an opaque and bright white surface, and provides a quite lean base.

OTHER SUPPORTS FOR OIL PAINTING

In addition to cotton and linen canvas and the various panels mentioned earlier, canvas boards, paper, and paper "canvas" are sometimes used. Canvas boards are simply canvas-covered cardboards. These are available in a primed state only and are usually made of an inexpensive grade of cotton canvas. They should not be regarded as a permanent support. Their cardboard backing has a high acid content which will in time affect both the fabric and the colors on it. They also have a tendency to warp.

Canvas boards of high quality and permanence can easily be constructed in the studio. Using ⅜-inch untempered pressed wood-

fiber panels cut to the desired sizes, simply mount good-quality canvas to them, using rabbit-skin glue as the adhesive. Cut the canvas with a 1½-inch surplus on each side, taking care to bevel the corners so that they exactly match the shape of the panel, as in Figure 4.4. When mounting unsized canvas, wet the back of the panel with a water-filled sponge, to prevent warping. Any glue soaking through the unsized canvas and showing on the face side (a common occurrence with loosely-woven fabrics) will not affect the quality of the size or ground placed over it. When the unprimed canvas board has dried, lay it face down on a flat surface, rewet the back, and place weights on top. A larger board with several books or other heavy objects placed upon it will serve. Keep under weights for at least two days. Prepare the unsized mounted fabric in one of the priming methods already discussed. To mount primed canvas, again moisten the back of the panel with water, but, after gluing, place face down under weights immediately. Primed canvas boards should be kept under weights for at least three days. Wood-fiber panels of ⅜-inch thickness will not warp (especially when the precautions given above are taken) when mounting canvases up to 24 by 30 inches. For quite small canvas boards up to 12 by 15 inches, ¼-inch wood-fiber will suffice. For canvas boards larger than 24 by 30 inches, use ½-inch boards or, using thinner boards, attach a wooden "cradle" or supporting brace, as shown in Figure 4.5. A word of caution: larger rigid supports are heavy and difficult to manage in or out of the studio. Unless some

Figure 4.5

compelling artistic or practical reason warrants using large boards as painting surfaces, it is best to use stretched canvas for oil paintings larger than 30 by 40 inches.

Paper is occasionally used for making quick oil painting notations and is a practical, if fragile, support for some student painting projects. In terms of permanence, paper is not a very practical choice. Yet there are examples of oil sketches on paper by Toulouse-Lautrec and even earlier works by John Constable, both of whom showed an apparent indifference to considerations of permanence (Toulouse-Lautrec even painted on corrugated cardboards used for packing). If care is taken in their preparation, 100 percent rag papers of 140 to 200 or more pounds may be about as permanent as any other support.

To prepare a good-quality paper for oils, attach the sheet to any rigid board, using gummed brown-paper tape, as you would prepare a paper for watercolor painting (see Watercolor, Chapter Three). Using a 2- or 3-inch bristle brush, coat lightly with pure white shellac or with acrylic medium which has been thinned with water to a 50–50 mixture. In either case, allow two or three hours for drying. The sheet may, of course, be removed from the board before or after painting. Museum board, an all-rag mat board of a semi-rigid weight, is a good candidate for works in oil on paper. Prime it as you would paper.

Some manufacturers market a primed paper that is embossed with a canvas-like tex-

Figure 4.4

ture. The mechanical look of the "weave" and the absence of any mention of the paper's rag content (if any) are points to consider. But they too have a useful role in student painting exercises, where permanency is not an issue. A recently developed paper by M. Grumbacher, called Hypro, is made of "pure pH controlled alpha cellulose fibers in a sophisticated acrylic resin binding system which gives it exceptional tensile strength" (quoted from Grumbacher literature). Hypro paper, embossed with a canvas-like weave on one side and smooth on the other, is available in sizes up to 24 by 36 inches and in larger rolls. It can be stretched in the manner used for mounting canvas, but requires further preparation. Instructions on its preparation are included with the paper.

In general, stretched canvas remains the most popular support, and in selecting cotton or linen fabrics several considerations should be noted. Linen canvas, made of flax fibers, is the more durable and has the greater strength and elasticity when stretched. This responsive give to the pressure of the brush or painting knife is widely regarded as a desirable factor, enhancing the flow and energy of the strokes made upon canvas. While the best cotton canvas, of a close and even weave of heavy strands, is excellent for painting, and may surpass lower grades of linen in most respects, all cotton canvases tend to sag more under the weight of paint and the pressures of painting tools than all but the poorest quality of linen fabrics. Cotton canvas is somewhat less durable, growing more brittle with age than linen. However, this less expensive fabric has a long history of usage, is preferred by some artists using acrylic paint, and is a highly suitable support for most student painting projects.

Canvas materials may be obtained in a wide variety of weaves and weights. Normally, a light-weight and close-weaved fabric is used for small-scale works, the heavier and coarser fabrics for large-scale works. In choosing canvas, be sure that the strands of the warp and weft are of the same weight and weave, otherwise the stretched canvas will expand and contract erratically.

When selecting commercially primed canvas either of cotton or linen, test to see that the priming possesses a degree of flexibility when an edge of the canvas is sharply bent. The priming should not crumble or show long cracks when bent, but should, with just a few small cracks at most, bend with the fabric.

OIL PAINTS

We have already discussed the general physical properties of oil paint. Here it will be useful to add some observations about what features to consider when selecting colors and grades. In general, the beginner in oils, like most seasoned painters (and especially many of the finest colorists), requires few colors. What is important is that the paints selected be versatile and permanent.

Most manufacturers offer two grades of oil paint: a moderately priced "student grade" and an "artist's" or "professional grade." The less expensive student grade paints are sometimes less exactingly produced. A particular color may vary slightly in value or hue from one batch to another; pigments and binding oils may be less purified and their ratios less carefully balanced in the mixing operation; less expensive pigments, having most of the characteristics of more costly ones, may be substituted or mixed with costlier pigments; and, as noted earlier, stabilizers may be used to considerably extend colors. However, the high federal standards governing the manufacture of paints have resulted in a most serviceable and stable quality of student grade paints of American manufacture.

Two quite evident differences in the character of the more expensive artist's grade oil paints are their stronger tinting strengths, that is, their ability to better withstand turning quickly pale upon the admixture of white oil paint, and their stiffer consistency. Both the tinting power and denser body of these first-quality paints are due to the higher ratio of pigment to oil used in their manufacture and the minimum use of stablizing agents. These colors are produced by more exacting standards, and only the best grade of pigments and binders are used. The less liberal use of oil and other additives, and the greater percentage of pigment make these paints less prone to yellowing and darkening.

But student grade colors easily meet the requirements of the painting student. And more than a few professional painters find that these colors meet the requirements of good oil paint, and steadily employ them, though often in combination with artist's grade colors. The major requirements of good oil paint are: *permanence*—the ability of a color to retain its value and hue under normal light conditions for several hundred years; *durability*—the paint film's flexibility and resistance to deterioration; *handling range*—the paint's ability to be smoothly or ruggedly brushed, and having the body to hold the striations characteristic of oil paint; and the aforementioned *tinting strength*—the power to retain its hue and value longer when intermixed with white (or other colors).

Some oil paint colors, roughly similar in hue and tone, differ in their surface character by being either opaque or transparent. For example, cerulean blue is an opaque color, but manganese blue, a similar bluish-green color, is semi-transparent. Similar differences exist between cadmium yellow and hansa yellow, between cobalt green and viridian green, and among the red and earth colors. There are differences even among the white paints, titanium white being highly opaque, and zinc white, semi-transparent. In selecting colors, some consideration should also be given to *covering power*, in order to obtain a range of both opaque and transparent colors. Such a selection expands the color and handling possibilities of oil painting.

Although each artist soon settles on a particular group of oil colors, or *palette*, that seems to meet his or her color needs, the beginner, faced with the forty or more tubed colors on display in the art supply stores may well wonder how many of them are necessary.* The following suggested basic palette of permanent colors, conceived with the foregoing considerations in mind, can serve as a guide. Where several choices of a color are given, they are listed in the order of preference; you need only one of each group for a basic palette.

*For additional technical information on oil colors and on other aspects of oil painting, a concise and useful work is Clifford T. Chieffo, *The Contemporary Oil Painter's Handbook* (Englewood Cliffs, N.J.: Prentice-Hall, Inc., 1976).

A Basic Palette

1. WHITE
 a. *Titanium/zinc mixture* (a white that combines the best features of both paints; opaque
 b. *Flake white* (sometimes called *Cremnitz* or *lead white*); moderately opaque
 c. *Titanium white*; opaque
 d. *Zinc white*; semi-transparent
2. *Cadmium yellow light* (or *pale*); opaque
3. *Cadmium orange*; opaque
4. *Cadmium red light* (or *pale*); opaque
5. *Alizarin crimson*; transparent
6. *Ultramarine blue* (either *light* or *deep*); transparent
7. *Cerulean blue*; opaque
8. *Viridian green* (or *Guignet green*); transparent
9. *Chromium oxide green*; opaque
10. *Quinacridone violet* (or *magenta*); transparent
11. BLACK
 a. *Ivory black* (a cool, bluish-black); transparent
 b. *Mars black* (a warm, brownish-black); opaque

Some artists (and art teachers) limit a basic palette to the colors listed above, or to some variant of this selection. They rightly observe that all other color mixtures can be made from such a palette. Some would exclude black and chromium oxide green, and perhaps cadmium orange and quinacridone violet as well. True, these colors (and we might add cerulean blue) can be at least roughly approximated by the remaining colors, but these approximations always lack the intensity and clarity of the excluded colors, not to mention their various opaque and transparent functions. The case against black is a strong one. Too many beginners overuse it, adding it to any color they wish to darken. Then too, both ivory and mars black, having powerful tinting strength, are difficult to manage in mixtures. However, when black is used sparingly and is treated as a color with its own unique character, it can greatly expand the range of a small number of colors.

Because a well-balanced basic set of colors can also closely duplicate all the *earth colors*, those muted or grayed yellow, red, and brown tones, some painters and teachers advise against their inclusion in a basic palette.

But again, their particular nuances of color and behavior are lost, and some, at least, of these colors should be considered as part of a basic selection. The following earth colors make useful additions to a basic palette (again, you need only one out of each group).

12. LIGHT EARTH YELLOWS
 a. *Yellow ochre;* opaque
 b. *Mars yellow;* opaque
13. DARK EARTH YELLOWS
 a. *Transparent gold ochre;* transparent
 b. *Raw sienna;* transparent
14. EARTH REDS
 a. *Indian red;* opaque
 b. *Venetian red;* opaque
 c. *English red;* opaque
 d. *Light red;* opaque
15. *Burnt sienna;* transparent
16. BROWNS
 a. *Burnt umber* (a warm-toned brown); semi-transparent
 b. *Raw umber* (a cool-toned brown); semi-transparent

Optional Colors

In addition to the colors suggested above, the following optional ones are useful and convenient.

1. *Underpainting white.* A fast-drying white that speeds up the drying-time of any colors it is mixed with, it can also be intermixed with slower-drying whites to adjust their drying time. Its extreme opacity and stiff body are imparted to those colors it is mixed with.

2. *Hansa yellow.* A less expensive yellow than the cadmiums, it is sometimes substituted for them. The only purpose for including it is to have available a strong, transparent yellow that yields more transparent orange and green tones than occur in mixtures using cadmium yellow.

3. *Naples yellow.* Now usually a mixture of zinc white, cadmium yellow, and yellow ochre, it is a pale, sunny, earth yellow that can subtly warm other colors. Genuine naples yellow is a lead-based color with a faster drying time than the tubed mixture.

4. *Phthalocyanine blue.* Usually marketed under the manufacturer's name, as, for example, Winsor blue, Rembrandt blue, Bocour blue, etc. It has extremely powerful tinting strength, is transparent, and can obviate the need of all other blues, with the possible exception of the reddish-tinged ultramarine blue. Indeed, its overwhelming strength in mixtures, and its tendency toward harshness when used in a near-pure state make it a difficult color for the beginner to control.

5. *Phthalocyanine green.* Also sold under the manufacturer's name, it is a dark and cold transparent green of extremely powerful tinting strength that yields strong yellow-greens in mixtures with any yellow color. Its bluish undertone makes it possible to produce purple tones when mixed with alizarin crimson. When used sparingly in mixtures, it can replace all other green hues, but its powerful tinting strength makes it a difficult color to control.

Some colors, such as the cadmiums, differ in composition in the two grades of colors. Artist's grade colors normally use the earlier formulated, "pure" cadmium sulfides, whereas student grade colors are likely to be made of cadmium-barium. Except for the somewhat stronger tinting strength of the former, both are permanent colors, difficult to distinguish between in use. Several manufacturers now list the chemical ingredients of each color on the tube. This is, of course, a great convenience to the user concerned with the permanence and safety of his colors, and is a practice that all manufacturers should adhere to, as suggested by the U.S. Department of Commerce in 1938.*

DRYING OILS

Perhaps the single most intimidating and even confusing aspect of oil painting, for the beginner, is the purpose and usage of the various binding agents—the drying oils, varnishes, waxes, and prepared mediums to be seen in the art supply stores. Before we examine some of these materials and how they are used, a

*An excellent source of information on the origin, chemical composition, and characteristics of oil paints is Reed Kay, *The Painter's Guide to Studio Methods and Materials* (Garden City, N.Y.: Doubleday & Co., 1972), pp. 17–53.

word of advice. Because virtually any additive to oil colors has a tendency to darken and discolor them, the fewer materials added, and the smaller their amounts, the better.

In oil painting the drying oil acts as the binder. Upon drying, the oily fluid solidifies into a tough, hard film that holds the pigment to the support. In painting, colors can be thinned by oil alone, although usually paints are thinned by various formulations of oil, varnish, turpentine, and sometimes, wax (see below, Oil Paint in Use). The following list of drying oils contains only those which most nearly satisfy the necessary requirements of an oil paint binder. A satisfactory binder should: (a) undergo little or no yellowing over an extended period of time; (b) maintain its binding function indefinitely; (c) dry into a flexible, tough film within a reasonable length of time; and (d) upon drying, should resist solubility by turpentine and other mild solvents.

The following oils are commonly available at art supply stores in 2½ ounce, 4 ounce, and larger quantities.

1. *Cold-pressed linseed oil:* a pale yellow oil, extracted from the pressed seed of the flax plant. Once extensively used in the manufacture of oil paints, its infrequent industrial use has all but ended the production of this oil in the United States. Regarded as the best drying oil for the grinding of oil colors, it is most often replaced by refined linseed oil (see below). Occasionally it is available at art supply stores and is much prized by some artists for its behavior in various medium formulations. It has, however, a tendency to yellow considerably with age.

2. *Refined (hot-pressed) linseed oil:* a pale yellow oil, extracted from flax seed which is steam-heated prior to pressing, then refined, bleached, and chemically treated to simulate many of the properties of cold-pressed linseed oil. Used in the manufacture of oil paint and as an ingredient in the formulation of various painting mediums, it is perhaps the most commonly used drying oil in oil painting.

3. *Sun-thickened linseed oil:* a golden-toned, viscous oil, made by exposing cold-pressed or refined linseed to the sun and air for about a month. The action of the sun and air partly oxidizes and bleaches the oil, making it faster drying than cold-pressed or refined linseed oil. Its thick, honeylike consistency tends to make brush strokes hold their shapes and striations.

4. *Stand oil:* a golden-toned, very viscous oil, made by heating cold-pressed or refined linseed oil to approximately 550°F. in the absence of oxygen. The resulting oil is polymerized, that is, it undergoes a molecular change that has the effect of slowing its drying time and making it the least yellowing of the drying oils. Stand oil also has pronounced leveling qualities, giving the paint an enamel-like glossy surface.

5. *Poppyseed oil:* a pale, straw-colored oil, made from the seed of the opium poppy, it yellows less than cold-pressed or refined linseed oils, but is a very slow dryer. It is used in the manufacture of paints, especially of white and light-toned colors. Although its films are not as durable as those formed by linseed oil, it is favored by some artists, especially for works that must remain wet until completed.

Other drying oils, such as boiled, or blown oil, hot-pressed raw linseed oil, and walnut oil are either inferior to those listed above or altogether unusable for artist's oil paint. Still other oils, such as safflower oil (which at least two firms use in the preparation of white oil paints) and sunflower seed oil, both reputed to have many desirable properties, are not normally available for individual studio use.

VARNISHES

Varnishes of several kinds are used by the oil painter to: (a) isolate one layer of paint from another; (b) to enliven dulled, "sunk in" areas of color; (c) as an ingredient in painting mediums, where it serves to enhance the flow of the brushwork and imparts a lasting gloss to the paint; and (d) as a final protective coating on completed paintings. Varnish can be defined as a resinous substance dissolved either in an evaporating liquid such as alcohol or turpentine (spirit varnish) or in a drying oil (oil varnish).

A spirit varnish for the oil painter is simply a mixture of damar or mastic resin and tur-

pentine, and can easily be made in the studio.*
Oil varnishes, which usually use the harder
resins such as copal, can be made only under
controlled industrial conditions. Here, it is as-
sumed that the painting student, as do the
overwhelming majority of professional paint-
ers, will purchase the prepared spirit or oil
varnish materials, briefly described below.

The following varnishes are commonly
available at art supply stores and are sold in
2½ ounce, 4 ounce, and larger quantities.

1. *Damar (dammar) varnish* is made of resin ob-
tained by tapping the dammar fir tree, *Agathis
Dammara,* found throughout southern Asia. Of
a light yellow color and somewhat aromatic,
damar varnish is used in the formulation of
certain painting mediums, as a final picture
varnish (for which purpose it is further diluted
in turpentine), and (in an even more diluted
state) as a *retouch varnish,* to "re-awaken" dull,
matte paint films to their original hue, value,
and gloss. Retouch varnish, in spray or liquid
forms, is also available at art supply stores.
Damar varnish, like all spirit varnishes, hard-
ens just as soon as the turpentine is evapo-
rated. When dried, it can be re-dissolved in
turpentine. As with all varnishes made with a
natural resin, damar films become yellow and
brittle with age. However, this varnish yellows
less than other natural resin varnishes. Used
sparingly, its disadvantages are within accept-
able limits.

2. *Mastic varnish* is made of resin obtained
from the Mediterranean pistachio tree. Even
glossier than damar varnish, it is said to have a
tendency to "bloom," that is, to produce a
bluish, cloudy effect upon dark-toned colors.
Its greater darkening and yellowing tendencies
make it a poor choice as a final picture varnish,
and, unlike damar, which can be mixed with
linseed oil in the formulation of permanent
painting mediums, mastic varnish reacts with
oil and cannot be used in this way. Further, its
film structure is somewhat softer than that of
damar. Its single advantage over damar is its
inability to be dissolved in mineral spirits.
This makes it possible to overpaint lower paint
layers containing mastic varnish, with paints

thinned by mineral spirits, without redissolv-
ing the paint below. There is some advantage
in this, as changes can be made without fear of
losing the underpainted areas; unwanted
strokes, or even large segments of the over-
painting can simply be wiped off the support,
leaving the underpainting unchanged.

3. *Copal varnish* is made from the fossilized
resins of dead trees, as well as from resins ob-
tained by tapping a variety of live trees. Copal
varnish cannot be made in the studio. A
honey-colored, heavier-bodied varnish than
damar or mastic, it is used in some oil painting
mediums and, despite the known difficulty in
dissolving copal varnish, as a final picture var-
nish (much to the distress of restorers). Its film
is harder and glossier than those of damar and
mastic, and when dried cannot be redissolved
by turpentine or other ordinary solvents. For
this reason it may serve to isolate under-
painted areas, but its reputation for darkening
and cracking should be considered. In the
opinion of one outstanding authority on the
technical aspects of oil painting, copal varnish
should not be used by anyone concerned with
the permanence of his work.* On the other
hand, another authority has strongly defended
copal-based products of his own formulation.†
While the predominant view among experts is
against the use of copal, the many varieties
and grades of this material make it difficult to
evaluate its long-term effects.

WAXES

Less familiar than oils and varnishes as a bind-
ing agent in oil painting mediums, several
kinds of wax are used in the manufacture of oil
paints as a stabilizer for certain pigments, in
the studio manufacture of oil paints, and as a
final protective coating for finished works. The
following two waxes of interest to the painter
are occasionally available at art supply stores,
sometimes in commercially prepared oil paint-
ing mediums.

*For information on making your own resin solutions, see
the technical books listed in the bibliography.

*Ralph Mayer, *The Artist's Handbook of Materials and Tech-
niques,* 3rd ed. (New York: The Viking Press, 1970), pp.
195–96.
† Frederic Taubes, *Painting Materials and Techniques* (New
York: Watson-Guptill Publications, 1964), pp. 48–49.

1. *Beeswax:* obtained from beehives. In its natural yellow state or when refined to a bleached white, small lumps of melted beeswax (it melts at about 145°F.) can be dissolved in turpentine, mineral spirits, or oil. Unlike oils and varnishes, this wax does not change color or darken. However, it does not form the protective, hard film of these materials. But when a moderate amount is used as an ingredient in an oil painting medium, it imparts a handsome luster to the colors and is an aid in holding the shapes and striations of the brushwork.

2. *Ozokerite:* a yellow-white earth wax from Boryslav, Galicia. This has a higher melting point than beeswax, and because of its overall superiority as a painting medium additive, is sometimes substituted for beeswax. One product that handles especially well and is highly regarded by users is Dorland's Wax Medium, made by Siphon Art Company, Ignacio, California. This is described by the manufacturer as a prepared mixture of "Ozokerite wax, reinforced with additive waxes, oils, and resins." Oil paint can be thinned with this medium either in its prepared state or after diluting it with turpentine, oil, or varnish.

Several other waxes, such as paraffin or carnauba wax, are either less efficient or less commonly available. However, paraffin wax finds occasional use in painting medium formulations. The role of wax in oil painting dates from the earliest efforts in this medium. Its non-yellowing feature and the engaging textural properties and luster it imparts to oil paint make this a binding agent worthy of serious attention.

DRIERS

Commercially prepared driers (siccatives) are sometimes used to speed the drying and hardening of the paint film. They are metallic salts combined with oils or resins and diluted with solvents for use. Because driers tend to cause darkening and cracking of the paint except when used very sparingly, and are said to weaken the quality of the paint film, their use should be restricted to glazing mediums and to thin layers of slow-drying colors. Driers seem to have little effect on thick paint layers and should not be added to such impastos. To do so will cause the surface of the paint layer to dry at a much faster rate than the paint beneath, a certain cause of cracking. But, sparingly used, they serve a useful role, drying a thin paint film in some seven to ten hours. A more prudent course is to rely on those colors that are natural driers, as are all paints containing lead, cobalt, and manganese. All earth colors are also fast-drying. When such fast-drying colors can be utilized without compromising a painting's color character, the risky use of driers is avoided.

Of the several driers available, cobalt linoleate is said to perform well and to pose fewer risks.

BALSAMS

Balsams are viscous, sticky liquids obtained by the tapping of certain coniferous trees such as the larch and silver fir. They are used as ingredients in painting mediums, often in the later stages of paintings, where they impart a high gloss and smoothness to the paint film. The two balsams currently in use are very similar in character and function. They are Venice turpentine, extruded from the Austrian larch, and Strasbourg turpentine, extruded from the silver fir of the Tyrol. Both are extremely thick and resinous, virtually non-yellowing and permanent, and, in combination with drying oils, both impart a desirable elasticity and durability to the paint film.

Balsams have been in use since the sixteenth century and were highly regarded, but are not much used today. However, their desirable characteristics, when used in stand oil or sun-thickened linseed oil mixtures, make them better choices than cooked oil varnishes. Both of the above-mentioned balsams must be used sparingly. Their function is not increased by adding large amounts to a painting medium, and to do so will prolong the drying time and give the paint an unpleasant greasiness. Venice turpentine is the more readily available and less expensive of the two balsams.

SOLVENTS

In oil painting, solvents are used to dissolve solid resins, to thin oil colors, to clean brushes and tools, and as ingredients in mediums and varnishes. All solvents used in oil painting are volatile, that is, they change rapidly to vapors, and therefore all present, to some degree, a fire hazard. Appropriate precautions should be taken when using them. The two most frequently used solvents are turpentine and the family of solvents called mineral spirits.

1. *Turpentine* is obtained from the sap of live pine trees by separating the volatile "spirit" from the solid material in the sap. Good spirits of turpentine should be clear and free of water. While it is not normally necessary for artists to use *rectified* turpentine—turpentine that has been distilled twice—its milder aromatic odor and superiority in varnish and medium mixtures are advantages that make it popular with painters. Turpentine is an excellent paint thinner (diluent) and an effective solvent. It is the most popular solvent in use among oil painters.

Some users find turpentine a skin irritant that causes blistering and inflammation, and they must turn to other solvents. Prolonged usage on a daily basis will tend to dry the skin of any user. Thorough washing with soaps designed to remove oily and greasy materials is important, as is the occasional use of hand creams. Turpentine should be used in well-ventilated rooms; its vapors and odor can reach unpleasant and even unhealthful levels.

2. *Mineral spirits* is a term for a group of petroleum by-products whose mild solvent actions and slight fire risk make them useful solvents in oil painting. Many of these products are manufactured by large petroleum refiners who market them under trade names such as Sunoco Spirits, Varnolene, Varsol, Amsco, and others. All are clear and odorless liquids, well suited to cleaning brushes and tools, and as a diluent of oil paint. As noted earlier, mineral spirits do not dilute mastic varnish (or damar and mastic resin lumps). Their drying time is a little longer than that of turpentine.

There are other types of usable solvents for oil painting, but their greater fire risk (some, like gasoline, have dangerously low flash points and should never be used) and their usually stronger solvent action make them far less desirable than turpentine or mineral spirits.

BRUSHES FOR OIL PAINTING

For most oil painting techniques bristle brushes are the preferred tool. The best bristle brushes are made of white hog's bristles, naturally curved and showing their natural tips, a tiny, branched end, or *flag*—a sign of quality, for cheap brushes are merely cut to uniform lengths. While the beginner might do well to buy student grade oil paints, it would be false economy to buy inexpensive brushes. They neither last nor serve as well.

Bristle brushes are made in four shapes:

1. *Flats:* a square-ended, flat shape, such brushes are available in sizes 1 to 18. The smaller the number, the smaller the brush. A good all-purpose brush, their long hairs promote a more flowing brush stroke.

2. *Brights:* a square-ended brush that differs from a flat only in the shorter length of the bristles. They are available in sizes 1 to 24. These shorter-haired brushes are well suited to scrubbing operations and the application of heavy impastos. They promote a more blocky, "plain spoken" type of brushwork.

3. *Filberts:* rounded at the ends and somewhat fuller in body than flats and brights, they are available in a length comparable to that of the flats, in sizes 1 to 12, or in an extra long length, in sizes 1 to 8. These versatile brushes can hold large amounts of paint and are suited to both the calligraphic and scrubbed brushwork of the flats and brights.

4. *Rounds:* somewhat long-haired, tubular-shaped brushes that come to a point, are available in sizes 1 to 12. These versatile but somewhat overlooked brushes were the type used by the old masters almost to the exclusion of all other shapes. Their rounded bodies and pointed tip give them an exceptional agility, making them adaptable to almost any painting technique.

Sable brushes (see Gouache, Chapter Three) are also used in oil painting, especially in glazing operations, but far less than bristles. For, while it is possible to apply glazes with a bristle brush, it is virtually impossible for sable brushes to carry and manipulate large amounts of heavy-bodied paint or to move through thick and viscous paint layers as bristles can. Still, they have their functions, and for painters who work thinly, the sable is a useful tool. Oil painting sable brushes should be long-handled, as are the bristles. Sables are available in shapes and sizes similar to the bristles, but the sizes range from 00 (small) to 20 (large).

Although individual interests must determine the types of brushes used, a suggested supply for the student painter might include the following: *flats* numbers 3, 5, 7, and 10; *brights* numbers 4, 6, 8, and 12; *filberts* (shorter length) numbers 5 and 7; *rounds* numbers 2, 6, and 10. Additionally, two *sable flats* (sometimes called *longs* in sable designations) numbers 10 and 16, and one *round sable* number 10. The flat sables are excellent for laying in large glazes and for softening harsher brushstrokes; the round sable allows for quite fine operations and for a flowing, more linear kind of brushstroke.

A more restricted but quite serviceable selection of brushes might be: *flats* numbers 3, 5, and 8; *brights* numbers 4, 6, and 12; *filberts* (shorter length) numbers 7 and 10; *rounds* number 7; a single *flat sable* number 14; and a *round sable* number 10.

Care of Brushes

The correct care of brushes is important to their function and longevity. To clean a brush when painting, use mineral spirits or turpentine. If the container holding the brush cleaner has a screened "false bottom" that permits the paint residue to settle at the bottom, the solvent will not need to be replaced nearly as often. Such containers are available at most art supply stores. You can also make one cheaply by placing at the bottom of a jar a common dishwashing device made of plastic thread in the shape of a ball. If the ball and jar have the same circumference, the ball will hold securely to the bottom of the jar as you rub the brush against it to remove excess paint. The dislodged paint will settle among the curled threads of the plastic ball at the bottom of the jar, leaving the topmost level of solvent quite clean. When the inexpensive plastic device is filled with paint residue it can be discarded and a new one installed.

Brushes must be thoroughly washed after each painting session. First, the brush should be cleaned in the mineral spirit or turpentine solvent and wiped clean with a rag or paper towel (three-ply, large facial tissues also work well). Next, the brush must be washed in warm water, using a soap designed to remove oily or greasy substances. Fels Naptha or Lava soap are good for this purpose. The brush hairs should be soaped and rotated in the palm of your hand, using enough pressure to cause the hairs to splay out somewhat. Rinse the brush in warm water to remove the suds and repeat the washing process until the suds show no trace of color. Be especially careful to remove any color showing at the base of the hairs, where they emerge from the metal ferrule.

Finally, rinse and reshape the brush to prevent stray hairs from drying out of place. In case the brush hairs have dried askew or have been bent at an angle to the brush handle (this happens easily with the fragile sable brushes, which should never be stood on their tips), work some library paste into the hairs, reshape them, and set the brush aside for a day or two.

OTHER OIL PAINTING IMPLEMENTS

1. **Palette knives.** These are used for removing excess paint from the palette and for mixing color pastes or for grinding paints. They are of two types: trowel-like (having a bent shank) or spatula-like (having a flat shape). The trowel type is somewhat more convenient for color mixing because its shape prevents the knuckles from touching the palette. The spatula type, usually made of a stiffer grade of steel, is best for scraping dried paint from the palette.

2. **Painting knives.** These are used for applying paint to or removing paint from the support. They can also be used to mix the colors on the palette. Painting knives always have a bent shank whose extremity is flattened into the blade's shape. Many shapes are available.

Most painting knives are trowel-ended, but there are fan-shaped, oval-shaped, and tooth-edged varieties as well. The steel used in painting knives is thinner and more flexible than that of palette knives.

In selecting palette and painting knives, you should look for a good grade of steel firmly seated in a wooden handle. If you can choose only one type of palette knife, the bent-shank type is preferable. Most painters use two or three painting knives, others never employ them, and still others use them almost to the exclusion of brushes. The beginner might find a small and a middle-sized trowel-ended knife convenient for flattening, simplifying, or blending confused or overworked areas, for removing small daubs of paint (or debris), and for scraping through to reveal lower paint layers.

3. **Palettes.** You can choose from among various materials, but avoid small palettes, even for small works, except when working away from the studio where the transport of large items is impractical. Even then, the palette should be no smaller than those designed to fit into the lid of the standard wooden or metal paint-boxes that measure about 12 by 16 inches.

Romantic movie versions of the artist often show him in his garret, holding an oval palette, his thumb stuck through the hole. As often as not, he smokes a pipe. Aside from the fire hazard this presents, such a palette, even the largest of them, would leave the artist with little room for color mixing and, at the end of a day's painting, a sore thumb. Although such wooden palettes, balanced to ease the chore of holding them, are still available and find strong favor among some artists, especially for working outdoors, their brown tone can confuse the artist's color mixings, which are best seen against a white or gray background. Then, too, the restrictions and physical effort of holding such a palette are obvious disadvantages. No doubt these palettes suited earlier, more meticulous techniques and more somber color keys, where the brown tone of the palette was in accord with the brown tone of the painting. But the greater chromatic range available today and the more aggressive handling of many contemporary artists are not well served by this device.

Perhaps the best type of palette for studio painting (or for studio classrooms where storage space is provided) is one made of thick glass, such as tempered or plate glass. This type of palette is not held, but placed upon a small table or stool. To prepare it, merely cover the sharp edges with masking or surgical tape, or file them to a dull edge and tape a sheet of white or light gray paper or board, face up, to its underside. This also acts as a protective shock absorber. Such a palette is easy to maintain, as dried paint can be easily removed with a single-edge razor blade.

Palettes of aluminum, porcelain, formica, and other hard-surfaced materials are not uncommon and can be adapted from various household or hardware items. Wooden palettes, either of plywood or pressed wood, and even palettes of thick cardboard can be made by sizing them with shellac and painting them with two or three coats of a glossy, white enamel housepaint. If a final coat of shellac is applied, such palettes are quite resistant to the usual oil painting solvents. Although less than a permanent solution, such palettes will last for a year or two before a new coating of white enamel paint is required.

Coated paper palettes, sold in pads bound on all four sides, offer some advantage, especially to the landscape painter. Their white tone, lightness, and traditional thumbhole, and the ease with which the used sheets can be disposed of are useful features in landscape painting. Their small size and tendency to wrinkle make them only fair choices for studio painting.

A suggested size-range for palettes made of glass of any other material is between 16 by 24 inches and 20 by 30 inches. The advantages of placing a palette on a table with casters, and having drawers or shelves for the storage of paints and other materials are obvious.

4. **Containers.** Normally, the painter needs three containers: one for the mineral spirits or turpentine used for washing the brushes, another for the diluent used for thinning the paint (or the painting medium), and a third for the painting medium (see below, Oil Paint in Use).

Containers used to hold the various fluids employed in oil painting should be of metal or glass. Test containers made of other

materials to see whether they are affected by the solvents being used. For example, styrofoam drinking cups will quickly deteriorate.

Containers should not be too small. Baby-food jars may serve to hold the medium, but containers that will hold at least 5 or 6 fluid ounces are required for the solvents. The clip-on metal paint-cups available at the art store are quite serviceable for palettes that permit such a clip-on arrangement. However, select the larger sizes.

5. **Easels.** The easel for oil painting should be a stable one of at least moderate weight. Lightweight outdoor easels are unsatisfactory in the studio for any but the smallest-sized works. Several types of easels are available, and the choice should be determined in part by the quality of the construction, the size-range of the supports it can accommodate, and the range and ease of maneuverability in tilting it at various angles and in raising and lowering a work in progress.*

OIL PAINT IN USE

The colors to be used should be set out in some orderly sequence around one or two edges of the palette. Otherwise, time is lost trying to find the colors *and* the space for mixing them. Some painters prefer to arrange the colors in a row across the top of the palette that begins with white in the upper left-hand corner, and the rest of the colors arranged according to value. Thus, yellow precedes orange, red follows, and so on to the greens and blues (or black) on the far right. Other painters restrict this row to those colors found on the color wheel. A second row, running vertically down the left or right side edge of the palette, contains all the earth colors, the grayed yellows, reds, and greens, browns, and black. In this row too, the colors are arranged from lighter ones at the top to darker ones below (Figure 4.6).

Other painters place white in the center of the row across the top, with earth colors arranged to the left of it and the pure colors to the right. Still others use two mounds of white, one for each row of colors. And some artists

pre-mix warm and cool states of each color to be used, to reduce the time spent mixing various tones while painting.

The amount of paint set out is, of course, determined by the size and intended treatment of the work. But it is always better to set out generous amounts than little daubs of color; in painting, more faults can be traced to a frugal attitude towards paint than to an extravagant one.

Oil paint may be applied to a primed support directly, using no medium. But the buttery consistency of tube oil paint is not always suitable, and most painters dilute the paint for various purposes. This is done by dipping the brush into the medium and mixing it on the palette with the desired color. Colors can be thinned by any one of the fluid materials earlier discussed, but, because each, used alone, poses certain dangers to the paint film or color quality, they are generally used in various combinations that neutralize or diminish their individual faults. Turpentine or mineral spirits are frequently used to thin the colors used in a painting's early stages, and this is a technically acceptable procedure (especially when using student grade colors, high in oil content) provided the paint is not applied in thin, watercolor-like washes. Such diluted stains do not allow for a continuous film of oil to bind the pigments to the support, and early deterioration of the paint film is likely. Even here, a better practice is to add a very small amount of oil and varnish to the solvent; 1 part oil and 1 part varnish to 8 parts of solvent will work well. The resulting paint film will hold together and not show the excessive dullness of paints diluted by solvents alone.

But no such tentative exception can be made for using any of the binding agents alone. Varnish dries to a very brittle, yellowed film; the drying oils, to differing degrees, all yellow and darken; balsams are too viscous and slow-drying; and waxes are too soft and fragile. But, when combined in various proportions, such painting mediums, *sparingly used*, give oil paint increased versatility at the cost of insignificant changes in the painting's condition in the years to come.

There are numerous possible combinations of these fluid materials, some of which are commercially prepared, and each painter sooner or later settles upon the several formulations that serve him or her best. The follow-

* An excellent practical discussion of easels can be found in Clifford T. Chieffo, *The Contemporary Oil Painter's Handbook* (see bibliography), pp. 72–76.

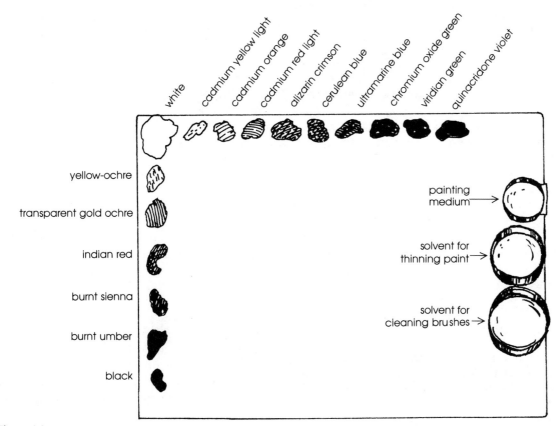

Figure 4.6

ing suggested mediums, like the commercially prepared ones, can be moderately modified and, of course, further diluted with a solvent. All references to damar varnish are to its "five-pound cut," which is made of 1 part by weight of resin to 1½ parts by weight of turpentine—the formula used in commercially prepared damar varnish.

Painting Mediums

The following six formulas are for all-purpose painting mediums with various drying times.

1. *All purpose, fast drying time:*
 2 parts damar varnish
 6 parts turpentine
 1 part sun-thickened linseed oil

2. *All purpose, fast drying time:*
 1 part damar varnish
 5 parts turpentine
 1 part linseed oil (for still faster drying, substitute stand oil)
 1 drop of (cobalt) drier to each fluid ounce

3. *All purpose, moderate drying time:*
 3 parts damar varnish
 6 parts turpentine
 1 part Venice turpentine
 2 parts sun-thickened linseed oil

4. *All purpose, moderate drying time:*
 1 part damar varnish
 2 parts turpentine
 2 parts stand oil

5. *All purpose, moderate drying time:*
 4 parts ozokerite wax or beeswax
 4 parts turpentine
 1 part damar varnish
 3 parts stand oil

6. *All purpose, slow drying time:*
 5 parts damar varnish
 8 parts turpentine
 1 part Venice turpentine
 4 parts poppyseed oil

In addition to their differing drying rates, these six suggested formulas possess discernibly different handling characteristics, and each has its subtle effect on the paint texture itself. Some artists will use a lean medium such as formula 1 for the early stages of a painting, and a fat medium such as 3 or 6 for the later stages, thus gaining the benefits of

the earlier noted fat-over-lean system. But many artists, having found a formulation they like, simply dilute it more with turpentine for the lower paint layers, and increase the percentage of binders to solvent for the upper layers.

These mediums will serve to thin the paint at every stage of a painting's progress, except for final glazes, when a medium richer in varnish is usually employed. But again, each must be used sparingly. To thin the colors in a rich "sauce" of any medium is to invite early disaster to the work. However, if our aim at every stage of a work's progress is to see not how much but how little medium need be used to manipulate the paint in various ways, the medium's positive benefits will far outweigh its possible future faults.

Glazing Mediums

When glazes are employed to darken, enrich, or alter the color of dried segments of a painting, the medium, now carrying less pigment within it, needs to be richer in binding strength. This is usually supplied by increasing the amount of varnish, which imparts a harder, more protective surface. But because varnish alone is too brittle (it should never exceed one-third the volume of any medium), other ingredients must be added. The following formulas for glazing mediums are suggested:

1. 1 part damar varnish
 1 part turpentine
 1 part stand oil

2. 4 parts damar varnish
 5 parts turpentine
 1 part Venice turpentine
 3 parts sun-thickened linseed oil

Direct and Indirect Painting

All painting techniques may be categorized either as basically *direct* or *indirect* in method. Direct painting, sometimes called *alla prima*, is intended as a one-layer process. In this method, the painter's judgments are set down in strokes meant to be final. Something of this attitude is evident in an unfinished work by Cézanne, *Village of Gardanne* (Figure 4.7). Such single layer works, often stated in opaque brushstrokes have a freshness and

spontaneity sometimes lacking in paintings done in the indirect manner, where several layers of paint work together to produce the intended results. But indirect painting offers color effects not possible in direct painting. Many painters—whichever of the two methods may dominate their approach—realizing the benefits to be gained through both, combine them in oil painting. The following chapters will discuss more fully these methods and variants (already alluded to in earlier chapters). But here, some technical observations are in order.

The lasting popularity of oil paint is due largely to the great range of handling and effects made possible by the nature of its binding materials, which make oils ideal for either the single layer "assaults" of direct painting, or the multi-layer "campaigns" of indirect painting. In either approach, the artist may begin on a white or a toned surface. In the direct method, whether or not the paint is used transparently, the luminosity of the white surface contributes its energizing light to the colors, as in Plates 4, 6, 16, and 18. To maintain some of the benefits of this white light, painters desiring to work from dark-to-light, will coat the white priming with a *transparent* layer of color, often called the *imprimatura*.

This thin veil of color is usually an earth red, gray, or other muted tone (bright colors are usually slower-drying and too intrusive to the colors of the final stage). The imprimatura is made by slightly thinning the paint with a lean medium and scrubbing the mixture into the priming, permitting the white of the priming to enliven the color of any transparent or semi-opaque layers placed over it, while preserving the desired dark base. In this way, dark colors, when thinly applied, maintain an inner light and freshness missing in thick layers of dark tones.

But to maintain such an inner light in areas of thick impasto, it is necessary to underpaint in thick layers of near white values, and overpaint such passages with thin layers of the desired colors. This indirect process can be seen in Tintoretto's unfinished painting, *An Allegory of Fidelity* (Figure 4.8), where the artist prepares the knee, right hand, and dress of the figure as well as passages of the dog's fur with thick light-toned paint, to be later brought to the desired color and value by half-covering

Figure 4.7
Paul Cézanne, *Village of Gardanne*
Oil on canvas, 36½ × 29⅜ in.
The Brooklyn Museum, Ella C. Woodward and A. T. White Memorial Funds.

Figure 4.8
DOMENICO TINTORETTO, *An Allegory of Fidelity*
Oil, 43¼ × 41 in.
Fogg Art Museum, Harvard University. Gift of Mrs. Samuel Sachs in memory of Mr. Samuel Sachs.

colors and glazes. This has been done in the upper part of the figure, largely hiding the broader underpainting still visible in the painting's lower part. Note that the imprimatura throughout most of the work's lower half is allowed to show through *and* between the brushstrokes in the sky, the hills, and the dark side of the figure's head and neck.

The imprimatura, because it influences the color and value of the final results and acts as a unifying agent throughout a work, is often permitted to show through in this way. In Rembrandt's *Lady with a Pink* (Plate 12), the original brown tone of the imprimatura is much in evidence, if sometimes glazed over in violet-grays and earth reds. In the background area near the hands, the dark tone is scumbled over by thin golden tones, and in the hands and hair it is the tone of the imprimatura that cools and darkens the colors. But in the head and in the red dress, thick layers of light-toned grays and tans underlie the colors we see.

Although we generally associate such indirect methods with the styles of the old masters, and direct painting with the more recent modes of expression, both methods have served old and contemporary masters alike. Bloom's *Apparition of Danger* (Figure 4.9), painted in 1951, is a primarily indirect work. Although some segments are directly stated, especially in the painting's upper half, the dominant means is one of repeated overpainting, glazing, and scumbling. But Hals' *Portrait of a Man* (Figure 4.10), painted in the seventeenth century, is primarily handled in the direct manner. Hals does utilize some techniques of the indirect painter: there is in fact an imprimatura and even some passages that are loosely underpainted, but upon these few indirect underpinnings there is an almost purely direct painting.

Oil paint can be placed over egg tempera or any of the water-thinned media. Earlier indirect techniques were usually begun by underpainting on a rigid support with tempera, the final effects achieved by overpainting with oils. There are two advantages to this. Much time is saved by underpainting in a fast-drying medium, and, as no oily binders are used in the lower paint layers, less yellowing is likely to occur.

Painting in either method can be *wet-in-wet*, that is brushing paint into still wet areas.

One of the distressing restrictions of oil paint is that each layer must be allowed to dry thoroughly before another can be painted over it. The expanding and contracting nature of oil paint as it dries acts as "shifting ground" which, as noted earlier, will soon crack dried layers placed upon it. This problem exists for direct painters as well, if, as is often the case, they return to a painting to make final changes and adjustments before the paint has thoroughly dried. But if diluting materials are used sparingly and kept lean in the lower layers, and the artist resists painting upon still-tacky or freshly dried paint, many later problems are avoided. Although the longer the time between layers the better, waiting at least three or four days for thin layers to dry and perhaps two weeks or more for very thick ones is a wise practice. Again, the use of the faster-drying colors and the prudent use of driers can help reduce drying time considerably.

But because the drying process for oils is a slow one, no final picture varnish should be applied to completed works for at least three months. A protective coating of varnish imparts a uniform gloss to the completed work, keeps dirt and chemical fumes from attacking the paint surface itself, and permits cleaning with mild picture cleaning preparations. A final picture varnish should be one that can be easily removed, it should dry quickly, and should yellow little, if at all. Recent developments in synthetic varnishes have made available such final varnishes for the painter. They remain flexible, clear, and non-yellowing. Univar (Weber Co.), and Krylon's Crystal Clear are two brand names of such products.

ACRYLICS

The recent advent of paints using synthetic resins as binders has strongly attracted the attention of painters, teachers, and students alike, and for a number of good reasons. The acrylic polymer emulsion paints are fast-drying and permanently flexible; they are claimed to be unchanging in color or value; they can be used in thick and thin sequences without the restrictions and precautions necessary in using oil paints (or other paints); and they can be used on a wide range of less expensive supports that require no elaborate priming prepa-

Figure 4.9
HYMAN BLOOM, *Apparition of Danger* (1951)
Oil, 54¼ × 43¼ in.
Hirshhorn Museum and Sculpture Garden, Smithsonian Institution.

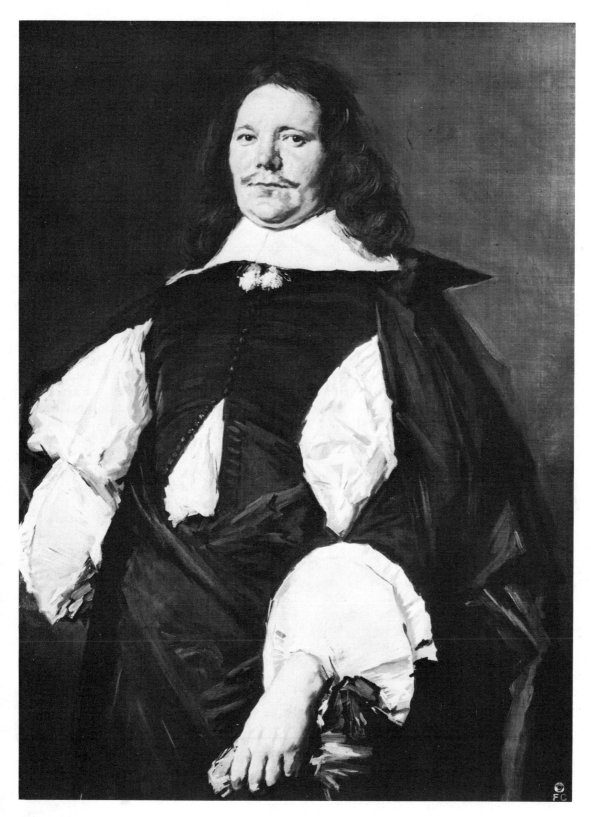

Figure 4.10
FRANS HALS, *Portrait of a Man*
Oil on canvas, 44½ × 32¼ in.
Copyright The Frick Collection, New York.

rations. Additionally, acrylics are somewhat cheaper to use than oils, and require no toxic or flammable materials. Moreover the relative ease of working with and cleaning up paints thinned by acrylic medium and water make this a practical as well as a creatively exciting product.

The polymer emulsion binder consists of an acrylic plastic resin suspended in water. When the water evaporates, the binder becomes insoluble, forming a permanent protective encasement for the pigments. The same binding medium used in manufacturing the paint is used by the artist to dilute colors further, for glazing, and as a final picture varnish. This medium, a milky-white liquid that dries to a glossy, transparent film, can be used as it comes from the container or, as is more frequently done, it can be diluted with water to any degree. In fact, there is no need for diluting acrylic paint with anything more than water unless very thin washes of color are applied. In that case, as with oil paint, the addition of medium is advisable to insure that the dispersed pigments are adequately bound.

The medium is also sold in a matte form, thus enabling the artist to control the degree of gloss a painting will show. The matte medium cannot be used as a final picture varnish because it causes dark colors to appear clouded. However, a matte varnish is available, and can be used alone or in combination with the glossy medium to control a completed painting's surface reflectivity.

The colors themselves are sold in both jars and tubes. Tubed colors are denser, the paints having more of the body of oils, which they closely resemble in texture and appearance. Some acrylic paint brand names are Hyplar, Signa-Tex, Liquitex, and Aquatec. All give good service and are available in a range of colors similar to those of oil paint. But because the binding medium, when wet, is actively alkaline and reacts with some of the traditional pigments, several substitutions have been made. In place of viridian, phthalocyanine green (among others) is used, yellow oxide replaces yellow ochre, and alizarin crimson is replaced by napthol ITR crimson.

That acrylic paint is fast-drying is often an advantage; but for artists who wish to work in a wet-in-wet manner the drying speed can be a serious restriction. Tube paint stays wet a little longer than does jar paint, and if *gel medium*—a viscous and glossy medium used for making transparent impastos—is added to it, the drying time of tube colors is extended further. Even so, thin paint layers are likely to dry in 15 minutes and thicker layers in less than an hour. Acrylic paints level out to a surface devoid of brushmarks more easily than do oils. This even and more impersonal surface character makes acrylics especially suited to hard-edged and other flat, sharply focused modes of painting.

Modeling paste, a thick, white "putty" made of marble dust and acrylic resin may be added to the paint for building up very thick impastos, but will crack unless mixed with gel medium. It can also be applied as it comes from the container and then glazed or painted over. When this is the case, the amount of gel medium should be about one-third the total volume of the mixture.

Acrylic paints can be used on canvas or other fabrics, on wood or paper supports of any kind, and even on plaster or acetate surfaces. Supports such as canvas or wood can be prepared with a more receptive surface by applying several coats of the acrylic polymer primer, marketed as a gesso (and discussed earlier as a primer for oil paintings on canvas or rigid supports). The use of this primer on artist's paper or boards is optional.

Acrylic products do not adhere well to non-porous or oil-based surfaces. Therefore, the use of acrylics over oils is not recommended unless the dry oil paint is first roughened by sanding to increase its tooth (oil paint, however, is able to hold to an acrylic paint layer, but the long-range permanence of such a procedure is doubtful).

When greatly diluted, acrylics take on much of the character of watercolor paints. Of course, such "watercolor" painting will not pick up the color of lower layers, nor can colors be lightened by re-wetting them. This may be an advantage for some painters. For others, who count on the ability to remove or lighten colors when using transparent watercolors, thinned acrylic washes may be used in the final layers, providing a more protective final paint layer.

Something of egg tempera's luminosity can be approximated by adding egg yolk to acrylic colors. Such paintings can then be

done on flexible supports. Acrylic medium can be mixed with casein paints, or casein and acrylic paints may be mixed in equal amounts. In either case, the result produces a paint that is less brittle and chalky than casein paint, but retains much of its attractive handling properties and opacity. The addition of acrylic medium to gouache paint has already been mentioned.

Acrylic products cannot be mixed with oil paint or its solvents, nor with vinyl or copolymer paints. Some colored inks mix with acrylic materials, others do not; some testing should be made before use, to see which combinations are possible.

BRUSHES AND OTHER ACRYLIC PAINTING MATERIALS

Although both bristle and sable brushes may be used with these paints, great care must be taken to keep the paint from drying in the brush. When painting, brushes with acrylic paint on them should be kept wet by placing them in a container of water until needed again. A paint-hardened brush can be cleaned with an acrylic paint remover, but such brushes lose some of their spring and shape. Sable brushes handle all but the thick acrylic impastos quite well, but bristle brushes, although they are serviceable, tend to become rather limp in water, losing their resilience and shape. A better tool is the nylon "hair" brush, designed for use with these materials. These are available in the same range of sizes as bristles, but not in all shapes.

The difficulty of removing dried acrylic paint, and the speed with which it hardens, makes the use of wooden palettes impractical. Glass, Formica, or porcelain surfaces work best as palettes for acrylics. Dry paint can be easily scraped off by first soaking the palette in or applying warm water. Disposable paper palettes are often used with acrylics because the unused paints dry so quickly and starting a painting session with a new palette is preferable to the chore of cleaning a permanent one.

Palette and painting knives are used in the same manner as for oil paint, but care should be taken to avoid rusting these tools (and metal paint cups) by keeping them too long in contact with water. Plastic picnic knives and other plastic household utensils that can serve as tools for cleaning and painting are sometimes employed with acrylic materials. Plastic materials are easily cleaned by placing them in water. Plastic ice cube trays covered with plastic wrap will keep acrylic paints moist for a time.

One of the main purposes for the development of artist's acrylic colors was to make available a paint that functioned and looked like oils (or any other paint), but would be free of their various drawbacks. Acrylic paint succeeds largely in doing this. But a problem arises exactly because of its trouble-free and versatile nature. In trying to be all paints to all artists, acrylic paint falls short of fully being any one of them, and seems to lack a strongly attractive character of its own. And, as in other spheres, character is shaped as much by idiosyncracies and limitations as by strengths. Egg-tempered colors' inability to be blended gave rise to the art of precisely crafted nuances of color and form; watercolors' inability to be laid on in thick impastos gave rise to the art of marvelous delicacies of transparent color; and oil colors' slow-drying nature gave rise to the art of color fusions and to the wet-in-wet styles, actually less leisurely achieved with the fast-drying acrylics.

But acrylics, lacking such restrictions, pose a greater danger of a fascination with technical novelty as an end in itself than do less accommodating media. Then too, the plastic base that gives acrylic paint its great range of effects also gives it a rubbery, and even slightly tacky consistency that some artists object to. As one painter observed recently, "I don't like a paint that bounces." Indeed, the tackiness of acrylic paint films can be a problem when works are stored face-to-face. Small parts of the paint film of one work may adhere to another when they are pulled apart, and such tight or horizontal storing of acrylic paintings is to be avoided.

But the technical advantages of acrylic paint, its impressive range of handling, and its compatibility with many other media make it the most important addition to the arsenal of visual resources in recent times. In the hands of gifted artists sensitive to their materials, acrylics can help manifest images as different as Close's *Phil* (Figure 4.11) and Golub's *Assassins II* (Figure 4.12).

Figure 4.11
CHUCK CLOSE, *Phil* (1969)
Acrylic, 108 × 84 in.
Whitney Museum of American Art. Gift of Mrs. Robert M. Benjamin.

Figure 4.12
Leon Golub, *Assassins II;* detail (1966)
Acrylic, 120 × 288 in.
Collection of the artist.

SUGGESTED EXERCISES

Again, a period of independent, free-wheeling exploration of your materials and tools should precede these exercises. Plan on repeating various textures or sequences of paint application on differing supports, to experience the differences in absorbency and touch. Clearly, you would not want to invest in a stretched canvas for such purposes alone, but if these explorations are scrubbed from the canvas before the paint has dried (this is possible only with oil paint), the canvas is again readied for use. To remove the (oil) paint, scrape as much paint as possible from the canvas, using the palette knife, and complete the cleaning with a solvent-soaked rag. The remaining light stains on the canvas will in no way affect its subsequent use. Indeed, as noted earlier, some artists purposely tone a white priming, preferring to see colors against an imprimatura and not a harsh white base.

These exercises touch only upon some of the basic challenges of oils and acrylics. Other

uses and issues occur in the exercises of the following chapter.

1. Use oils or acrylics. Paste up on any muted or grayed, warm or cool-toned board measuring about 16 by 20 inches, a design made of various colored shapes, cut or torn from construction, or other types of colored papers. This two-dimensional design, which should extend over the entire surface of the toned board, will be your model in this exercise. Avoid a complex design of many shapes, especially intricate and small ones, in complex overlappings. Some ten to fifteen simple shapes, several of them overlapping, are adequate (see Figure 4.13).

Next, on any suitable support of the same size as the model, use either vine or compressed charcoal to make an accurate line drawing of every shape. Note the location, scale, and shape-actualities of each one, and of the background shapes created by the arrangement of the pasted shapes. Do not rush this state of the exercise. One of your goals is to duplicate the model as closely as possible, and your line drawing should match the model's shapes exactly.

Figure 4.13

When the drawing is completed, use a fixative to isolate it, and, beginning with the background tone, proceed to match each color in the design as accurately as you can. Starting with the background shapes is useful here because, in touching all the other colored shapes, they quickly re-create a large part of the observed design's tone and color base, and help you to make better judgments about the exact hue and value of the other shapes. It is very important that this background color be true to the original. Otherwise, all your subsequent color judgments, in being keyed to the first, false one, will be too light or dark, or too warm or cool.

Paint each shape in an opaque manner. While there is no need to trowel on the paint, avoid mottled, partly transparent layers of paint because it is almost impossible to "read" the color or value of such an application, for the purpose of matching it with the original. To judge a tone, you may even apply a test color to a scrap of paper or the palette knife and go up to the design to compare your mixture with the color of the shape in question. Doing this with the first three or four colors will help you to better judge the remaining ones without such close-up matchings, and makes it easier to see when you have struck a wrong color-note.

When you start painting any color, look around for other colors in the design that are roughly similar—*and compare them.* Ask yourself which of these similar colors is lightest? Which is darkest? Which is more intense, cooler, or warmer? To what degree is your judgment influenced by surrounding colors? Decide which shape or shapes in the design are more intense than the rest and which are the dullest. After having painted, say, the lightest shape in the design, check subsequent light tones against it, to be sure the tonal relationships are being maintained. Similarly, be sure the most intense and the most dulled colors in the model are also the most intense and dulled colors in your painting.

Continue until you cannot see (or mix) closer matches than those you have painted. The completed painting should appear to be a "forgery" of the original design.

2. Use oils or acrylics. On a 16 by 20-inch canvas or other suitable support, make a charcoal

line drawing of some seven to ten invented masses that seem to float in space, as in Figure 3.27. After fixing the drawing, wash an imprimatura of Venetian or Indian red over the entire surface of the support. This tone should be thin enough to permit the drawing to show through.

Next, using black and white in addition to the earth red, in thin applications begin with the background, which can be thought of as a vast expanse of a dark to middle-toned sky, swept by gusting winds and changing light. Allow yourself a certain freedom in painting the sky. Or, the background can be treated as a field of gradually changing tone and color that suggests a great spatial cavity. Large brushes will help you to pull together the tones of the background. If you avoid using opaque paint layers here it won't matter that you may overpaint the drawing of the invented forms; they will remain visible. Do not begin to paint the forms until the background is thoroughly dried.

Using only black and white, paint the forms in a three-dimensional manner, applying the colors thinly when you wish to utilize the tone of the imprimatura for color and modeling purposes. Such half-covering tones of black and/or white, optically mixing with the red tone below, will create subtle color nuances in both the background and the forms.

Paint the forms by working from dark to light wherever possible, painting those areas receiving the least light before turning to lighter planes and tonal transitions. Keep the darker passages of each form somewhat thinner than the lighter parts, which can be handled in a quite opaque manner. The lightest tones can be made by raking white paint on in various densities. The heavier the raking, the more nearly the tone will approach pure white. Some painters, working in an indirect manner, are able to produce a great range of tonalities using only white upon a dark-toned support.

When dry, the painting can be further adjusted by glazing with black over areas that are too light, and scumbling light tones into areas that are too dark. A scumble, you will recall, was defined in Chapter Three as an application of paint that modifies the surface below it by being scrubbed to a thinness that permits the color below to be seen through the covering layer. The raking strokes described above are related to scumbling, but the latter is produced by repeated scrubbing over an area.

Because you are modeling forms you do not actually see before you, it is important to select a light-source and establish the values of the planes according to their position relative to the light's direction. The ability of oils and acrylics to be blended makes the gradual changing of tones an easier process than the hatchings necessary with most water-thinned paints. But this ease of modeling can cause beginners to indulge in an unnecessary "polishing" of forms. Avoid such slick and fussy effects. Let the sense of mass come through by the rightness of the tones, the planar structure, and, however limited, by the function of the warm and cool colors. Our purpose in this painting, which may extend over several sessions, is to create a sense of masses floating in space at various levels and distances. A broader, more rugged handling that suggests solid masses in convincing space is preferable to a precise handling that fails to do this.

3. An informing variant of exercise 2 is to use white and Venetian red (or burnt sienna) over a thin black imprimatura, varied in tone to suggest a deep spatial field. Dark passages on forms are achieved by painting thinly over the imprimatura, light ones, by increasingly opaque painting. The value and warm color of the Venetian red, in various mixtures with white, helps to model the forms, especially through the middle tones.

4. Use oils or acrylics. Working in the manner described in exercise 2 or 3, paint a white drape that has been tacked to a wall, and which is illuminated by a single light-source. Daylight, especially north or east light, is best because such sources change least over the course of the day and reveal more of the surface character of the subject than does the harsher light of the sun or of an artificial source. If an artificial light is used, place it where it will explain the surface form best and create the fewest cast shadows. Usually, less intense light is preferable. Here, you should work on a larger support: any size between 18 by 22 inches and 24 by 30 inches will do.

5. Use oils or acrylics. Arrange a simple still life consisting of no more than four or five ob-

jects such as shoes, books, simple pottery shapes, fruit, or other forms uncomplicated in structure and surface detail, and muted in color. Even an arrangement of various dull-colored blocks and cylinders, or bottles or cigar boxes painted in solid colors will do. A solid-colored drape of a gray or tan hue, simply arranged, may be placed under or behind the objects.

Tone a small-sized canvas or panel (between 14 by 18 inches and 16 by 20 inches) with a light imprimatura of any muted color. A thin veil of raw umber or raw sienna will work well. Using a round sable or bristle brush, make a line drawing over the dry imprimatura in some thinned, dark color such as ultramarine blue or burnt sienna. To make changes in the drawing, merely wipe the paint off with the appropriate solvent. Again, our goal is to paint the forms in a three-dimensional manner, but this time color will play a somewhat more active role, and the color of the brush drawing can play a part as it mixes with other colors.

This is to be a one-session painting of three to four hours, using only four colors: white, black, yellow ochre, and a red made by pre-mixing equal parts of alizarin crimson (or napthol ITR crimson, if you are using acrylics) and any earth red such as Venetian or Indian red. Although the possible color variations of their intermixtures, and the additional colors made by painting thinly over the toned support are greater than one might expect with such a restricted palette, it is unlikely that you will be able to do more than approximate the color of some of the objects in the still life. But such color matching is a secondary part of the challenge here. The color should be used mainly to model the form. When painting planes that are turned away from the light, try to mix tones that are not only darker, but cooler as well. And use warmer tones to paint those planes turned toward the light. If it will help you to better locate a form in space by showing its overall color as being warmer or cooler than it is, paint it that way.

But, when you have not purposely changed an object's color, do try to get as near to its observed colors as your restricted palette will permit. Such an effort teaches us a great deal about color mixing in general, and about the way oils and acrylics behave in particular.

Moreover, in attempting to force your few colors to reach out for those you see, you will mix many nameless tints and shades of subtle colors that can expand your understanding of color's grayed, quieter qualities.

Because this is primarily a painting sketch, use larger brushes and work in a forthright manner. Although thinly applied paint can utilize the tone of the support in establishing the darker colors, let the lighter values be stated in more rugged impastos. Wrong color or value "notes" can be quickly removed with the palette knife and restated with fresh paint. Or, if you wish to adjust some part of a freshly painted area, try painting into it with the desired color. Such wet-in-wet operations work well in oils and acrylics when the added color is at least remotely related to the color of the area being adjusted, and when the strokes are full-bodied and resolutely applied. Timid pattings of near-complementary colors in such areas can produce muddy and muddled effects. The completed painting should show the *general* nature of the still life's forms conveyed by color as well as value, and in broad strokes that feel their way around the forms. That such simple arrangements, economically stated, can have enormous creative importance, is demonstrated by Morandi's *Still Life* (Figure 4.14), a strangely expressive work.

6. Use oils or acrylics. This exercise requires two three-hour sessions. Arrange another still life, similar to that used in exercise 5, but this time select simple objects that are strong in color. Fruits, children's blocks, or dolls will do, or you can simply cover or paint various geometric forms with bright colors. Again, use no more than five objects. These objects can be placed on a tabletop covered with four or five sheets of construction paper, arranged in some pleasing order and selected with a view to providing other more or less rich colors. However, to avoid a gaudy effect, include some muted colors in the arrangement. Keep the background empty of additional forms and colors. A light-toned wall or board of any muted color is all you need here.

In the first session draw the still life in either paint or charcoal upon a primed, white support, about 16 by 20 inches or 18 by 22 inches. Keep the drawing schematic, its purpose being to establish the direction, general

Figure 4.14
GIORGIO MORANDI, *Still Life* (1953)
Oil on canvas, 8 × 15⅝ in.
The Phillips Collection, Washington, D.C.

shape-character, and scale of the component parts. Restrict the drawing time to no more than an hour.

Using only the larger bristle brushes, but all of your colors, begin painting by establishing the subject's *major* planes, matching as closely as you can the particular color and value of each. As in exercise 5A of Chapter Three (which it will be helpful to re-read), bypass small or subtle color changes in a plane or an area, in order to state the major color and value of such segments. Again, squinting at the subject will help you to see these essential facts more easily. Use the paint in an opaque and generous manner, and wherever possible, try to state a shape or plane with as few strokes as possible. For example, the side of a small box might be established with a single, thick stroke made with a large brush. Painting in this direct mode, plan to make each brush stroke count, as in Figure 4.14. Of course, you will need to make changes and additional notations upon these first strokes, and painting into the wet paint is both necessary and desirable here. But *intending* each stroke as final will help you analyze the color and value of each plane more, and will encourage you to give some thought to the shape, size, and location of each brush stroke.

Do not settle into developing one part of the painting, but force yourself to move about the canvas, advancing it all together on a broad front, as Cézanne does in his view of a village (Figure 4.7). As the painting progresses, do not feel bound by the earlier drawing. It represents a first attempt to understand the fundamental arrangement of shapes; but as you develop the basic color and value of the subject's forms, you will come to recognize that some of these earlier estimates are faulty. You may then either disregard the drawing in such passages, painting over it, or correct the drawing in paint, to clarify the direction, shape, and scale of the parts in such areas.

At the end of the first session, you should have established the *dominant* colors and values of each form, of the construction papers, of the background, and of any other components of the still life. But these observations will have been broadly noted in opaque paint strokes that stress the *basic shape-state* of the subject's flat and curved planes.

Your goal in the first session is to strongly suggest the subject's planar nature—to show the still life's forms as the "products" of a particular arrangement of colored planes in space. This mode of direct painting, a recurring theme in Western art, was summed up in a statement made in Paris in 1900 by the French painter Maurice Denis, who observed that "a picture—before being a war horse, a nude woman, or an anecdote—is essentially a flat surface covered with colors assembled in a certain order." Such an attitude to painting encourages a bolder use of oils or acrylics, a use that tests their (and your) ability to produce exact nuances of hue and tone, in bold strokes that collectively form a rich pattern of color shapes as well as forms in space.

Many beginners find it difficult to use these media in generous impastos of wide-ranging color and tone. They settle instead for cautiously small, thin strokes which are too often concerned with surface details. The seasoned painter knows how greedily details devour essentials, and how important it is to guard against this. In painting in a manner that demands judgment and forthright response to a subject's fundamental conditions, we learn to direct our interests away from its surface niceties and toward its unique visual qualities.

Begin the second session by glazing and scumbling upon the *dry* painting. Neither of these techniques is possible on a wet or tacky surface. Look for ways to pull planes and parts together by these means. Now tones can be quickly adjusted, harsh passages softened, and color nuances achieved that are not possible in single-layer painting. Continue to glaze and scumble until you cannot further advance the painting by these means. At that point you should continue the painting using half-covering, opaque, and even thickly applied strokes until you have established at least some further, secondary facts about the subject's colors, values, and forms.

7. Use oils or acrylics. Collect some three or four photographs of landscapes or cityscapes that offer opportunities for being combined in some way. For example, from among three landscape photos, you may select a tree from the first, the entire ground-plane view from the second, and a turning road and fence from the third. Make several drawings based

on these extractions, combining them in various ways until you find an arrangement you like. The drawing will be your model in this exercise.

Working in any size and on any suitable support, make a preliminary drawing on the support that boldly simplifies the more representational drawing that is your model. The subject can be reduced to a geometric severity as in Plate 7, or may be only moderately simplified, as in Plate 10.

This painting should be handled in any way that combines some or all of the indirect and direct features of the previous exercises. Color can be used in an independent rather than descriptive way, to call forward a particular mood, to create an overall color pattern, or simply to experiment with different mixtures and overpaintings of colors. Here, it would be useful to experiment with the painting knives, applying thick impastos or scraping into wet paint to reveal colors below. Your goal now is to arrive at a balanced and unified image that relies mainly on color and shape, and is evolved in part through the use of glazes, scumbles, and half-covering strokes, as well as direct painting with the brush and knife.

Such a work can be a fascinating visual treat of painterly devices or quite a confused jumble. Therefore, do not attempt to use every color and every device in one painting, and use none merely as ends in themselves, but only when you feel they may advance your theme. It is, of course, important to select a subject that you think is likely to provide opportunities for using a number of colors and kinds of paint application.

8. Use oils or acrylics. Collect a number of textured objects and materials such as wood, stone, marble, cement, silk, leather, etc., but do not exceed some six or seven items. On any suitable support, rule off six or seven 3-inch squares. Using any direct or indirect devices, or any combination of techniques, paint each of these textures as objectively and precisely as you can. Your purpose here is to deceive the viewer into believing the painted surface is the real thing, as in Plate 14. Thus, in viewing the square containing your illusionistic treatment of, say, wood, we will accept it as real veneer.

This time drawing, in the usual sense, is absent. Now your concern is wholly on the values, colors, and surface-character of each texture. In trying to reproduce these textures in a manner that will "fool-the-eye" (*trompe-l'oeil,* as this French style of painting is called), you will probably call upon almost your full complement of painting tools, from small sables and large bristles to painting knives, and you may even hit upon unorthodox tools such as combs and cloths. No doubt some of you will discover the versatility of the oldest of all painting instruments, the fingers. The "fine tuning" necessary to create these textures will teach you much about your tools.

Likewise, the need for a delicacy of value and color judgments, and of touch, will heighten your sensitivity to the nature of the paint. In concentrating on visual challenges rather than technical tricks, we are more likely to develop an intimate knowledge of a medium's strengths, limitations, and special characteristics.

9. Use only acrylics. Earlier, it was observed that acrylics can be used to approximate several other media. In this exercise you are to make four paintings from the same subject, using different materials for each painting, and making acrylics "imitate" other paints.

Each of the paintings will measure about 8 by 10 inches. If you wish, they can all be done on a 16 by 20-inch panel that is ruled into four parts. For the model, arrange some two or three simple objects in a simple setting. All four paintings should be the same view of the still life. Each painting should be developed in the technical manner best suited to the combination of materials or the style being used. And, not only may the processes change, but even the visual themes may be adjusted to suit your responses to the paint's changing character. Thus, the first painting may be quite objective, the second one may be less so and chiefly concerned with color, the third may be two-dimensional and highly tonal, and so on. Your goal here is to experience the differences in handling, in color, and in method that each paint formulation or use offers, and to allow the paint to influence (but not dominate) the painting's expressive theme.

a. Mix 1 part acrylic paint to 2 parts casein or gouache paint. In this formulation the

paint may be safely used on stretched canvas. To dilute the paint use 2 parts acrylic medium to 5 parts water.

b. Mix egg yolk with acrylic paints and handle as you would egg tempera. Such a mixture does not require a gesso priming. This paint may be thinned with water.

c. Using acrylic paints alone, handle as you would watercolor paints, restricting your use of the paint to transparent washes. Dilute with equal amounts of medium and water.

d. Prior to painting, add 3 parts modeling paste and 1 part gel medium to 6 parts acrylic paint, preparing all your colors in this way. For thinning, use equal parts of medium and water.

FIVE
the dynamics
of form and order

We turn now to an exploration of the basic visual processes and forces that shape our perceptions, and to an examination of their effects in works of differing aesthetic aims. In doing so we will review the visual elements discussed in Chapter One, to consider how they interwork, relate, and affect what we see and how we see.

Psychologists have shown that we see a subject's generalities before we take note of its specifics. We can easily prove this for ourselves by glancing in some direction for one second, turning away, and drawing what we remember of the scene. Our glance may have taken in a corner of a room or a view through a window, but beyond a vague notion of the subject's outstanding features, few if any of its details will have registered. Our drawings may show something of the general shape, scale, and location of a number of dominant forms, but little else. Each object will have been reduced to the simplest expression of its dominant condition. A chair may be shown by a few straight or curved lines, and a tree as a stem supporting an irregular shape that represents the branches or leaves.

If we turn to examine the scene again for, say, five seconds more, returning to add new observations to the drawing, not very much more information will have been gained. The chair may now be shown to have an inclined back and cross-braces below, and the tree may gain a more definite shape and general form, but clearly, far more observation is required to establish the chair's or the tree's large and small masses and textures in any precise way. There is, then, an order of importance, a kind of hierarchy of impressions in our observations that provides us with a subject's essential character and situation before we discover its countless details.

Seasoned painters, aware of the importance of their first reactions, begin a painting (as they do a drawing) in more or less the same way as they (and we) first experience a subject. Knowing that these first impressions contain vital insights and responses that go to the heart of the matter before them, they begin by trying to manifest, often in as short a time as possible, their first, excited feelings and judgments — the gist — of their understanding of the subject's actual and potential attractions.

115

Figure 5.1
REMBRANDT VAN RIJN, *Hendrickje Bathing in a Stream*
The National Gallery, London.

Whether hoped for or not, sometimes the artist concludes that his or her first impressions cannot be improved upon; that the goal which first impelled the act to paint has been realized almost at once, as in the chemise and arms in Figure 5.1. Berger's *The Park at Tepozlan* (Figure 5.2) demonstrates the visual and expressive power that such an immediate grasp of essentials can command. Note how simply Berger states the foliage in the foreground, the large trees, and the small church beyond them. Not only does the artist establish the essential form and space of the scene with remarkable economy, he also manages to suggest the sunlight and the lushness of the foliage. More than that, the scene is set in motion by shapes, values, and textures expressed by animated brushstrokes that leap and charge in a joyous, telling way. Such vigorous brushwork is not the result of abandon or caprice; each is a sensitive reduction of a thing seen, and a necessary building-block in the painting's organization and mood.

Too often, beginners, uncertain of a purpose or a theme, or seeing only little of the relational life that their subject—any subject—offers, begin to paint in a manner that is the reverse of the way they see. Instead of beginning *deductively*, from the general to the specific, they work *inductively*, by setting down, in a rather precise way, a single, small fact, and proceeding to add other little facts around it, completing the painting in this sequential manner. But such a piecemeal operation does not permit the beginner to respond to the relational nature of the subject, to its visual and expressive dynamics. If no means exists for discerning the tensions, movements, patterns, and other dynamic energies in the subject, none will appear in the painting.

It is important to recognize that we all respond to more than the dimensions and surface effects of a subject's parts, each seen in an isolated, independent way. We also see at least some of the relationships and patterns among the parts, groupings, and energies that organize and animate the things around us. For, as we saw in Chapter One, objects form visual relationships based on their various physical characteristics. All the blue, red, dark, light, round, small, or soft objects in an arrangement join in several bonds, according to their color, value, shape, scale, texture, and so on. Mature painters have learned to see their world in such relational terms, and the best painters see the most relational play, sense the most discreet connections. For them no color or value, no form or space exists in a wholly independent or static way. Artists perceive in their subjects a network of dynamic energies. They sense tensions, pulsations, rhythms, and directional thrusts acting within and between the parts of their subject. Everything they observe or envision is imbued with such expressive energies—with dynamic activity.

In looking at, say, an archway and an eyebrow, beginning painters must not only learn to see their similar curved orientation, but must feel the moving energy in these arcs. They must come to recognize that a storm at sea, a swirled cake-frosting, and a head of curly hair all possess something of the same abstract visual turbulence, and that both the mountain and the molehill are alike in their rise and fall.

That we all sense such underlying forces acting through the things around us is evidenced in the kinds of terms we use to describe them. In referring to a car as small or low, or a cat as large and gray, we are describing their *measurable* physical qualities. In speaking of a sleek car or cat, a wan or radiant smile, incisive or flowing folds, rolling or roiling waves, we are describing sensations evoked by the intrinsic condition of these things; all these adjectives allude to integral character—*dynamic* expression—and not to the measurable matters.

But the painter's felt response to a subject's expressive qualities is not limited to storms and smiles. As noted above, artists see expressions of energy in all things. A slight change in color or value, the limpness of a fold, the force of a long diagonal edge, such perceptions are felt as visual activities. Indeed, expression in painting is often more a matter of how we look at a subject than it is how a subject may look. That is what can make a turban by Rembrandt or an apple by Cézanne more passionate and monumental than many a *Last Supper*.

To uncover such dynamic meanings in nature we must turn again to the "vocabulary" of vision: the visual elements. Beyond the vocabulary is the individual. Vocabularies can be mastered, but without the creative syntax that

Figure 5.2
JASON BERGER, *The Park at Tepozlan* (1972)
Oil on canvas, 32 × 39½ in.
Courtesy of the artist.

our inner feelings shape, there can be no dynamic poetry in the work. The visual elements are the means through which we establish our meanings, but those meanings are to be found as much in us as in the subject. And meanings cannot be taught. They must emerge from our turning inward to uncover *our* responses to a subject's actualities and potential for expression. The best artists of whatever period or style seem always to find meanings that transcend the subject; the image becomes a metaphor for human values of universal interest. Such works do not *exemplify* a style, they extend it; they do not merely record a subject, they express through it. The most telling extensions and expressions come from artists most sensitive to the dynamic behavior of the visual elements.

USES OF LINE

Because most paintings rely on color and value to sort out shapes, masses, space, and texture, line *as line* is not frequently a dominant device in painting. But that it can evoke powerful energies in the context of a painterly image is demonstrated in Schiele's *Embrace* (Figure 5.3). The drawn lines do not stifle the restless excitement of the brushwork; they add to it by their own vigorous twists and tremors. The artist uses lines to create a system of trembling, contorted shapes and forms that *abstractly enact* the same energy and mood we find in the figurative situation. The depiction and the dynamics reinforce each other's passion.

Rouault's *Woman at a Table* (Figure 5.4) also shows a use of line as outline, but the broad, dark lines suggest a brooding light. Here we come upon line in the process of becoming shape. Sometimes, as in the upraised arm and in the neck, the thick lines serve as planes or abutments of dark shapes to light ones, but elsewhere line creates a harsh pattern that augments the painting's bitter mood. The stormy nature of the composition itself, comprised of slashing lines, splashes of color, and cutting shapes, further amplifies Rouault's biting interpretation of a jaded courtesan.

Another example of the direct use of line in painting is Elaine de Kooning's *Scrimmage*

(Figure 5.5). Here we see how in the same painting, line can shift from delineation, as in the contours of most of the players' parts, to feeling out space, as in the background areas where linear brushwork seems to measure distances between groups and figures. A linear use of paint also suggests the direction of planes and forms. Here, the strokes scrubbed upon legs and backs strengthen their moving force. The artist avoids a too similar use of line throughout the painting by allowing lines to dominate in the painting's lower half but subduing their presence in the upper half, where she overpaints much of the original drawing. And, as in the previous examples, line character and handling are in accord with the nature of the figurative action.

The direct use of line in painting is hardly a recent innovation. Indeed much of Western and Oriental painting relies on quite pronounced uses of line. Nor, as we saw in Chapter One, does its presence, when used directly, need to be as evident as in the foregoing examples. At first glance, Giovanni Battista Tiepolo's *Adoration of the Magi* (Figure 5.6) does not appear to be heavily dependent on line, but closer inspection shows it to be the artist's chief means of developing his image. Indeed Tiepolo's sketch is a good example of works which, in their treatment, seem to bridge drawing and painting.

But as we saw in Chapter One, line in painting is more often conveyed by the other elements. Such linear conditions may be carried by edges, by axial directions of long shapes and forms, and in the alignment between two or more shapes, tones, or masses. As such, implications of line pervade all visual imagery and are always a factor in our reading of an image.

Not only do we see such implied lines as enacting various movements, we even see such actions as having certain speeds. For example, in Beyeren's *Still Life with Lobster and Fruit* (Figure 5.7), the lines of the drapery's folds move slowly, the vertical rise of the tall and stately vase is stronger, and the movements of the lemon peel and the lobster's feelers are energetic. Line is a major device in Beyeren's work. The design is based largely on the swirling action of the various rounded forms which are arranged in a manner that permits our eye

Figure 5.3
Egon Schiele, *Embrace*
Oil on canvas, 39⅜ × 67 in.
Österreichische Galerie, Vienna.

Figure 5.4
GEORGES ROUAULT
Woman at a Table (1906)
Watercolor, 12⅛ × 9½ in.
The Museum of Modern Art, New York. Acquired
through the Lillie P. Bliss Bequest.

Figure 5.5
ELAINE DE KOONING
Scrimmage (1953)
Oil on canvas, 25 × 26 in.
Albright-Knox Art Gallery, Buffalo, N. Y.
The Martha Jackson Collection.

Figure 5.6
GIOVANNI BATTISTA TIEPOLO, *Adoration of the Magi*
Oil on canvas, 23¾ × 18¾ in.
The Metropolitan Museum of Art, Rogers Fund.

Figure 5.7

ABRAHAM VAN BEYEREN, *Still Life with Lobster and Fruit*
Oil on wood, 38 × 31 in.
The Metropolitan Museum of Art, Anonymous gift.

movements to travel along various routes, as Figure 5.8 suggests.

Sheeler's *Staircase, Doylestown* (Figure 5.9) demonstrates the power of unseen "lines" created by our sensitivity to movement energies. The painting does not possess a single curved line or edge, and yet its binding organizational device is the grand swirl of the staircase. This ascending spiral movement is our perceptual summary of what the shapes, planes, and values seem to say. Note how the diagonally placed, dark table in the painting's lower right corner further extends the unseen spiraling movement. If we place our hand over the table, the force of the curving sweep is lessened and the design's vertical forces grow too strong.

Sheeler's painting shows another kind of energy at work, one that makes us "see" the

Figure 5.8
The rhythms and directed movements in this analysis of Figure 5.7 show that Beyeren is sensitive to the abstract linear forces that spring up between forms.

invisible spiral as moving upward. Denman Ross, an earlier lecturer and teacher of art, has observed that the eye follows the direction of diminishing intervals. This means that we tend to read any sequence of changes as moving from larger to smaller differences in the sequence. For example, when we look down a road we sense the line of telephone poles, diminishing in scale and in the amount of space separating them, to be moving away and not toward us. In the same way, we understand a tree's branches to be lifting upward and outward, away from the trunk, and not as moving downward into it. In this painting, the graduation in both the scale and value of the steps—which diminish in size and in the contrast with the white walls—urges our eye upward. This is one of the most effective devices by which artists give direction to the energies that spring up between the parts of an image. Whether such directed movements are carried by a sequence of shapes, masses, colors, values, and textures, or by a combination of such elements, they are essentially linear in their visual effect and must be regarded as line phenomena. This suggests how pervasive the element of line is in painting.

USES OF SHAPE

Although, as Figures 5.7 and 5.9 reveal, line and linear movement are more important factors in the organization of a painting than is frequently supposed, and no visual work is free of some kind of line behavior, many works are based on other elements. Wyeth's *First Snow* (Figure 5.10), while it is reducible to line analysis, is formed mainly by a pattern of shapes. The design owes its balance, and the depiction its clarity and mood chiefly to the way the shapes are arranged. Wyeth seems to stress the subject's shape-nature by avoiding outlines. These patches of tone and color are freely brushed into place, their boundaries abutting or overlapping each other.

Nor does the artist "soften" the organizational impact of these shapes by strong or extensive painting inside them. In fact, the white shapes of the snow-covered surfaces and the dark ones of the tree and the walls on the far right side are not modeled at all. Even in the sky and in the lighter-toned walls, inner

Figure 5.9
CHARLES SHEELER, *Staircase, Doylestown* (1925)
Oil on canvas, 24× 20 in.
Hirshhorn Museum and Sculpture Garden, Smithsonian Institution.

Figure 5.10
ANDREW WYETH, *First Snow* (1959)
Watercolor, 13⅝ × 21¼ in.
Delaware Art Museum.

shapes and modeling are kept vague and simple. Thus the painting's dynamics are carried mainly by the location, scale, and character of the shapes, their similarities and contrasts setting off visual bonds and oppositions of an engaging sort. For example, the large log in the foreground is made to relate with the large, centrally located wall by having both white-topped, and undergoing a dark-to-light tonal graduation. Yet two similar forms, the small structures to either side of the large building, while alike in scale, location, and general shape-character, are made to contrast by their differing values.

The artist's choice of a shape-dominated design is not an arbitrary one. In limiting the scene to the general shapes and masses our vision is restricted to when viewing a blustery snowfall, Wyeth strengthens the representation's expressive meaning. This union of the visual means and the expressive meanings of a work, whether the image is figurative, abstract, or nonobjective, is a universal characteristic in all paintings of serious aesthetic worth. For, no matter what our style or purpose in painting is, if we fail to respond to our subject's *given* substructure of relationships and energies, then we restrict ourselves to a passive denoting of parts and surface effects, and remain outside the subject's full meaning and potential for expression. Had Wyeth only recorded, instead of analyzed and identified with the winter scene, we might have more facts but less meaning.

Creative vision is never passive. It consists of judgments, feelings, and intuitions that emerge from active inquiry, from a desire to fully experience our outer or inner world. Nor is it altogether a matter of learning to see what we don't now see; it is to some degree a matter of recognizing the importance of much that we do see. In fact, without making a concentrated effort, we can't see anything as isolated from its surroundings—as having no directional, tonal, chromatic, shape, or scale relationships with its neighboring parts. Seeing the pointing index finger as an offshoot of the fist, or a blossom as centered on its stem are integral aspects of seeing them at all. What is needed is an understanding of the vital dynamic role such alignments, contrasts, and associations play in visual organization and expression.

Less evident but always part of our percepts are the forces generated by such relationships, as in the earlier example of the energy in an archway or an eyebrow. The finger's thrusting action suggests a directed force; and the blossom's shape, the "flowering" action upon its vertically *moving* stem, suggests a burst of energy in many directions. These forces are never "assigned" to such relationships, they are as evident as the finger's or the flower's measurable properties. They are, however, too often overlooked. Yet, becoming aware of the dynamic activity underlying the things we see or invent is crucial to the forming of visually expressive themes and individual style.

Even more than Wyeth's painting, Diebenkorn's *Interior with View of the Ocean* (Figure 5.11) is an image made up of large, simple shapes. But by their angular and hard-edged character, and by the wedge-like or oblong nature of many, these shapes suggest a strong presence of line at work in the design. For example, note the zig-zag lines in the foreground, the result of abutting light and dark shapes.

The large shapes in the painting's upper half, by their horizontal and vertical orientation, their shape-character, and their simple, dark and light "beat" suggest slow movement; there is a stately calm to their arrangement that accords with the grand and tranquil view. The smaller shapes in the lower half of the painting are faster moving, as diagonally placed "shards" of light and dark tones are bound to be. But these wedge-shaped areas, the light shapes answering the thrusts of the dark ones, largely cancel out each other's actions. Additionally, the artist slows their movement by the more or less vertically oriented table and chairs, and by adhering to the laws of perspective in establishing the shapes that represent sunlight and shadow, thereby reaffirming the large plane of the floor, and suggesting the interior's barren, silent state. Only the chairs' few curves, a last, tender flutter of ardor, relieves the harshness of the deserted room. Again, the design and the depiction interwork to create a universal expression that owes its force to abstract as well as representational conditions. Diebenkorn's painting may be farther removed from objective reality than

Wyeth's, but it is no less evocative in its representational mood. We have all experienced the silence, the melancholy, and the grandeur of such scenes. The artist, by translating such felt impressions into an arrangement of elements whose character and behavior summon up these feelings, does more than describe the event; he evokes its expressive chords. We sense them only because the artist did, and we add to the image inflections of meaning provided by our own remembrance of such moments.

That shapes, like colors, lines, values, and masses, are freighted with inner meanings is best demonstrated by nonobjective shapes. Gottlieb's *Blast I* (Figure 5.12) is an arrangement of three shapes: the rounded and relatively stable one above, the vehemently animated one below, and the shape of the rectangular spatial field. Each shape defines it-

Figure 5.11
Richard Diebenkorn, *Interior with View of the Ocean* (1957)
Oil on canvas, 49⅝ × 54¾ in.
The Phillips Collection, Washington, D.C.

self but is intensified by the others. The disk-like shape is inherently slow-moving, as are all simple geometric shapes whose boundaries are roughly equidistant from their center. In being poised between the shape below and the upper edge of the rectangle, as well as centered upon the latter's vertical edges, it gains much stability, but is not neutralized, as we shall see. Its directed motion has been slowed, but not its pulsations—its attention-getting beat—resulting from the effect upon us of the tension between it and the lower shape as they struggle for dominance, a battle that is destined never to be won by either shape. The artist has placed these shapes just close enough to each other to produce an intended ambiguity about their intentions. Are they striving toward or away from each other? Is the animated shape aggressor or victim? Because we can't be sure of these things, and because each shape's character stimulates in us a desire for a respite, quickly provided by the other shape, our attention is evenly divided between them. And this struggle is in part clarified by the third shape, which is less passive than it may seem at first glance. If the rectangle were smaller, it would intrude on the interchanges between the two shapes within it; if it were larger, longer, or wider, the struggle for dominance between the dark shapes would lose much of its meaning. In its present state the rectangle provides an arena that magnifies the drama and also participates in it, by showing the lower shape to be "cornered" and striving for relocation.

Shapes, then, whether or not they go on to refer to objects, planes, spatial areas, or the effects of light, establish patterns and energies of their own. In figurative painting their dynamic behavior can, as we have seen, be in harmony with the depiction's theme, enhancing it, or can, by contrasting with it, regulate or lessen various characteristics in the subject's condition. For example, Matisse, in his *Carmelina* (Figure 5.13), develops a system of sharply defined shapes that diminish the subject's atmospheric and sensual properties but more fully explore its architectural and spatial structure.

It is important for beginning painters to see the "shapeness" in the things around them and to consider the role of shape in interpreting their subject's salient qualities. Testing your sensitivity to shape in paintings that em-

Figure 5.12
Adolph Gottlieb, *Blast I* (1957)
Oil on canvas, 90 × 45⅛ in.
The Museum of Modern Art, New York.
Philip Johnson Fund.

phasize this element should be a notable part of your early efforts. Matisse's painting reveals one such approach to the exploration of shape. And, as in Wyeth's and Diebenkorn's works, these shapes enact abstract activities that heighten representational meaning. For,

Figure 5.13

HENRI MATISSE, *Carmelina* (1903)

Oil, 31½ × 25¼ in.

Museum of Fine Arts, Boston. Tompkins Collection.

through their strong shape-character and boldly stated manner, they express the same rugged strength and frankness as the sculpture-like planes and forms they collectively produce.

In Figure 5.13 shapes do more than explore mass and space. They also play a dominant role in the painting's two-dimensional design. The variously sized square and rectangular shapes of the background are made to offset each other by bold outlines and by contrasts in value, color, scale, and location. These strongly stated contrasts tend to bring the shapes forward, permitting us to read them as either on the same (picture) plane as the shapes of the figure or as located farther back in the spatial field. Seen as an arrangement of shapes on the picture-plane, those of the background engage in a complex pattern of checked horizontal and vertical movements, against which the great pyramid of the shapes of the figure and drapery appear to rise with majestic grandeur. This two-dimensional design reinforces the artist's representational theme: the figure's substantiality, simplicity, and grace seen against a cluttered studio interior.

Matisse is so successful in conveying the figure's masses that we may not at first see the important role that shapes play in forming them, or how essential the abstract play of the shapes is in conveying the figure's elegance and restrained vigor. If we turn the picture upside-down, the graceful and energetic actions of these shapes are more readily apparent.

Some of the shapes in the painting, especially those small ones that define a plane, such as the shapes of the figure's head and neck or those which comprise the mirrored reflection of the artist and his model, are made by a single brushstroke. But even at this small scale the shapes are alive with dynamic movement. They interlock, bridge over, and chase each other in a variety of ways, imparting a sense of animation to the forms they produce.

The forming of images by brushstroke shapes is a convention that reappears often in the history of painting. Evidence of such painting dates back to the second century, A.D. Egypto-Roman mummy case portraits of El Faiyum (Figure 5.14). In our example the sensitive use of brushstroke shapes is especially evident in the painting of the features of the child's face. Note that the construction of the

nose is achieved with only some nine or ten strokes.

Although this technique is found in passages of many paintings of various styles and periods, it represents a dominant theme for

Figure 5.14
Egypto-Roman (2nd Century A.D.), from El Faiyum
Portrait of a Boy
Encaustic on wood panel
The Metropolitan Museum of Art.
Gift of Edward S. Harkness.

Figure 5.15
CLAUDE MONET, *The Seine at Bougival* (ca. 1870)
Oil on canvas, 25¾ × 36⅜ in.
The Currier Gallery of Art, Manchester, N. H.

some artists and styles. Oddly enough, the Impressionist painters, whose works epitomize the technique of painting by small strokes, do not often show a strong sense of shape activity between such daubs and touches. Instead, the effect is one of an overall texture of marks. This is due partly to the small scale of the shapes and partly to their intended function, which is to produce through their color differences much larger shapes of color resulting from their collective color effect in the eye of the viewer. We are all familiar with the phenomenon of "seeing" green in an area comprised of closely placed and alternating daubs of yellow and blue.

We must look to the broader handling in the early Impressionist works to see how engaging and eloquent brushstroke shapes can be. Monet's *The Seine at Bougival* (Figure 5.15) is an excellent example of direct painting with brushstroke shapes as the basic building unit of image and action. The convincing sense that the clouds and waves are moving forms owes much to the patterns of strokes in these areas. Note that the paint is undiluted and thickly applied with the point or side of moderate and large-sized brushes, a handling that imparts a stronger force to small shapes than does thin paint applied by small brushes. Monet's brushwork produces shapes small enough to suggest something of the shimmering light so important to the Impressionist painters, but large enough to maintain the sprightly system of movements that enlivens the scene.

Brushstroke shapes often play a leading role in direct painting techniques. Another Impressionist painter, Pissaro, in a letter of advice to a young artist, provides us with an insight to the way some Impressionist painters approach direct painting—an approach which, with varying degrees of emphasis, is found in some works that precede Impressionism and in many works that follow it: "The motif should be observed more for shape and color than for drawing.... Precise drawing is dry and hampers the impression of the whole.... Do not define too closely the outline of things; it is the brushstroke of the right value and color which should produce the drawing.... Paint the essential character of things.... When painting, make a choice of subject, see what is lying at the right and at the left, then work on everything simultaneously. Don't

work bit by bit, but paint everything at once by placing tones everywhere, with brushstrokes of the right color and value, while noticing what is alongside.... Paint generously and unhesitatingly, for it is best not to lose the first impression."

That such a direct attack on a broad front, using brushstroke shapes as a means for capturing "the impression of the whole," attracted some artists long before Impressionism, can be seen in Hals' *Willem Croes* (Figure 5.16). Hals' analytical style, the translation of all forms into economically conceived planar solutions, often depends on shapes formed by the brush. But, as this vibrant portrait clearly demonstrates, these strokes are not placid in character or execution. Their nervous energy and their authority reflect a joy and gusto for the processes of perception and painting, as well as a brilliant analytical mind. The artist's sheer pleasure in handling paint, his penetrating visual acuity, and his sensitivity to the dynamic energy of aggressive shape formations all converge to define *and* animate the subject.

Forming images out of brushstroke shapes continues to be a popular mode of approach to painting, one capable of serving a great range of styles, themes, and media. It is a visually economical and aesthetically pleasing way of stating the planes, values, and colors that make up the form and space conditions of many of the things we see or envision. In *Duck Trap* (Figure 5.17), Welliver uses this means to sort out and organize a highly complex subject. Single strokes define branches, leaves, sky, sunlight, shadow, and surface textures. A "by-product" of such an insistent use of small and sharply focused shapes is the richly faceted and sparkling texture they produce across the canvas. But the artist's involvement with this process never diverts him from designing the larger shapes that organize the painting. There are the large shapes formed by the foliage and by the maze of branches, by the light and the leaves on the ground, and by the trunks, which part to create a shape of both two- and three-dimensional space between them.

No discussion of the use of the brushstroke as the basic dynamic unit of form and space building would be complete without mentioning Cézanne's great impact on this mode of painting. For Cézanne, "the little sensations," as he called them, of form and space

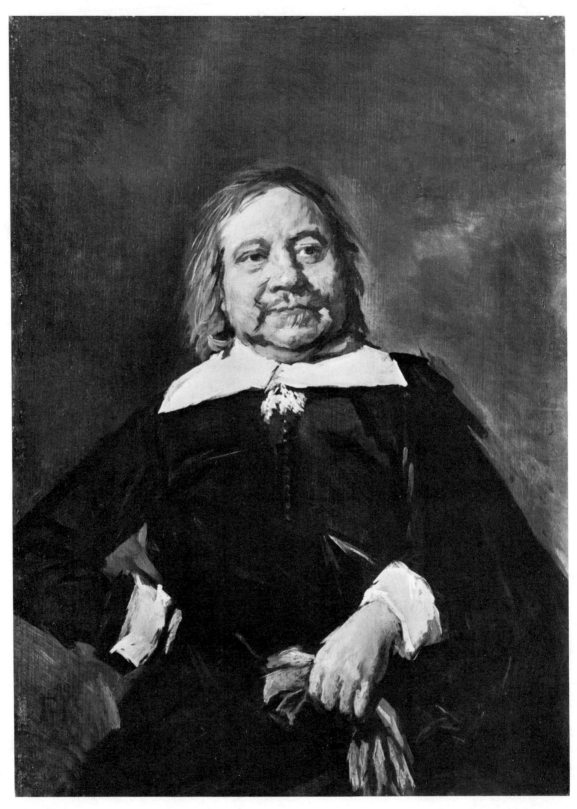

Figure 5.16
FRANS HALS, *Willem Croes* (1660)
Oil on wood, 47 × 34.4 cm.
Alte Pinakothek, Munich.

Figure 5.17
NEIL WELLIVER, *Duck Trap*
Oil, 60⅜× 59¹¹/₁₆ in.
Colby College Art Museum, Waterville, Maine.

by which his monumental images emerge, are translated into brushstrokes whose shape, size, and direction are as important as their color and value (see Plates 4 and 11).

USES OF VALUE

Insofar as shapes have value, we have of course been discussing value or tone. And, as earlier observed, unless all of the colors in a work are the same in value, shapes and patterns of tone will emerge. But value should not be regarded as only an attribute of shape, for sometimes fluctuations of tone are too subtle and gradual to be understood as forming shapes. Do we really see the slight nuances of tone in the upper part of Tanguy's *Naked Water* (Figure 5.18) as dividing into shapes, and is there easy agreement on just where the ground plane ends and the sky-like area begins? Then, too, in some works the shapes of value are interlinked and fused in such tempestuous ways that we regard them as unbound by definable outlines. As an example, in Constable's *Weymouth Bay* (Figure 5.19), the convulsive fury of the clouds is expressed by values that elude definition as shapes. Or, we may see large "shapes" of tone formed by separated smaller tones, as in Fragonard's *The Italian Family* (Figure 5.20), where the light tones form an active pattern. Establishing patterns of value in com-

plex images such as Fragonard's contributes to the order and moving energies that guide us through what might otherwise be a confusing maze of impressions.

The potent organizational and expressive powers of value to either reinforce or diminish the powers of shape can be seen in re-examining some of the works discussed earlier. The large light gray shapes of the building in Wyeth's painting (Figure 5.10), in being similar in their light tones, are almost outweighed by the small dark shapes of the tree and the small house on the far right. So visually heavy are these dark tones, that Wyeth's emphasis of the large building's blocky mass is essential to achieving balance in the design.

The shapes and values work together in Figure 5.11, where the moving energy of the blazing sunlight cutting through the stilled and unoccupied room is activated by more than the shape and diagonal orientation of the sunlit areas; the near-white harshness of their value, in the context of the painting's more somber tonal key, amplifies the force of these shapes.

In Figure 5.13, Matisse adjusts and unifies the painting's design by finely tuned values, as well as by color and shape. The small, dark shape in the framed picture on the painting's right side, by repeating the tone of the similar small shapes above it, keeps the row of dark shapes from appearing isolated. The framed picture itself serves a similar role by relating with the light-toned shapes of the wall and table on the left side. Note that Matisse alternates light and dark tones throughout the painting, almost as if he were designing a checkerboard made of differently sized

Figure 5.18
YVES TANGUY, *Naked Water* (1942)
Oil, 36¼ × 28 in.
Hirshhorn Museum and Sculpture Garden, Smithsonian Institution.

Figure 5.19
JOHN CONSTABLE, *Weymouth Bay*
Oil on millboard, 8 × 9¾ in.
Crown copyright. Victoria and Albert Museum.

squares. Note, too, that Matisse gives the lightest value to the most animated shape in the painting: the drape extended from the figure's thigh. This serves to unify the painting's values; each is unlike the drape in value or in windblown character. But the drape, by belonging to the circular pattern which envelops the figure's legs, avoids being isolated by its shape and value differences. As Matisse's solution here shows, any part of a design may depart in several ways from the main theme of the design's components, but only if it is joined with them in other ways.

In Figure 5.16, the sense of the white collar and cuffs as bursting upon the scene is only partly due to the driving energy of their shape. The sudden and extreme value change in these areas, like the subtler flashes of tone in the sitter's coat and the strong shadows in the head, reveals the same lively spirit in the artist's use of tone as enlivens his use of shape.

Value, like line and shape, can suggest movement, give emphasis, and relate dissimilar things. In Shinn's *London Hippodrome* (Figure 5.21), the sensed movement to the right, of the figure on the trapeze, and the

Figure 5.20
Jean Honoré Fragonard, *The Italian Family*

Figure 5.21
Everett Shinn, *London Hippodrome* (1902)
Oil on canvas, 25½ × 34¼ in.
The Art Institute of Chicago.

139

Figure 5.22
Jan Vermeer, *Young Girl with a Flute*
Oil on panel, 22.2 × 18 cm.
National Gallery of Art, Washington, D. C. Widener Collection.

carved balcony wall's movement to the left, are due to more than their wedge-like shape. The light tone of the figure, in "reaching out" and making contact with the light-toned area of the audience, is visually pulled to the right side. Shinn even darkens the upper part of the figure to further detach it from the painting's upper left corner. Likewise, he weakens the balcony wall's contact with the painting's lower right corner by fused tones, overhanging coats that run counter to the axis of the wall, and by less form definition. But on the painting's left side no form intrudes on the wall's movement, and only here does the artist show us the entire wall, its repeated curves adding more force to the leftward movement. But the changing value of the wall plays an important role in urging it to the left. All gradual changes of tone suggest movement. Given the other clues to the wall's directed movement, not the least of which is its perspective, the fading light on the wall serves to emphasize its leftward turn into the darkened interior.

That value can relate dissimilar things is easily seen in the relationship of the figure's form and tone to the light-toned wedge near the top of the painting, which, in moving to the right side, adds more force to the figure's swing in that direction. But value can also place similar things in opposition. We see the light-toned triangle of people not only as emphasized through value, but as a light shape that contrasts with the large, dark triangles on either side of it.

In addition to its organizational functions, value is a major means of conveying the convincing impression of variously colored masses in space. It does so in three ways: (a) by showing a form's inherent lightness or darkness, its *local tone*, a given property of all things that is separate from but influenced by the effects of light falling upon them; (b) by modeling masses through gradual and abrupt changes that correspond to the gradual and abrupt changes in a form's surface; and (c) by suggesting the presence of light playing across a form's surface.

Vermeer's *Young Girl with a Flute* (Figure 5.22) reveals all three of these functions interworking to build the form, the space, *and* the design. Had Vermeer chosen to illuminate the background, the figure might have appeared cut out, isolated. Had he selected a lighter (or darker) local tone for the girl's coat, the overall value pattern or the design's balance would have been destroyed. There is a sense of *necessity* to the present arrangement of values as both a balanced pattern and as a lucid definition of volumes in space. Note how simply the planes of the head express the form and how skillfully Vermeer suggests the indiscernible edge of the figure's right coat sleeve. Note, too, how the girl's pensive mood is echoed by the painting's somber tone, and by the gently fading light that, in striking only some of the surfaces, establishes a melancholy note: darkness is the prevailing state, only sometimes relieved by light.

Value, then, is also a potent expressive force. But light-bathed imagery can express many moods and need not result in forms welling up out of the shadows. Light can search out the deepest crevice or the brightest spirit. Nor does painting in a manner that counts heavily on value-order and light—what is commonly called *tonal painting*—always require a great many values or subtly graduated changes between them. Many painters favor the more explicit visual and expressive consequences of a tonal order based on a few values and on less smoothly changing tones. Kuhn's *The Blue Clown* (Figure 5.23) is established mainly in four tones: the near-whites of the head and hands, the near-blacks of the background, the more or less middle-gray tone of the blouse, and the somewhat lighter overall tone of the decorated vest. Graduations of tone, especially in the head and blouse, are rather abrupt and ruggedly stated. Such a bold and simple tonal design, stated in such a direct and forceful manner, reinforces (as do the boldly fashioned and strongly interlocked shapes) the forthright stance and the monumental strength the depiction suggests.

Only three values form the tonal design of Modigliani's *Anna Zborowska* (Figure 5.24), and again the handling of the paint, especially in the background and the sofa, is direct and vigorous. Yet the result is an image of sensual elegance, eloquent testimony to the expressive power of value, line, and shape to abstractly *be* what the depiction only refers to. Note how in Figure 5.23 the spiral shape in the clown's vest states a visual theme enacted by many of the painting's lines and shapes, and underlies the stance of the figure itself. Similarly, in Figure

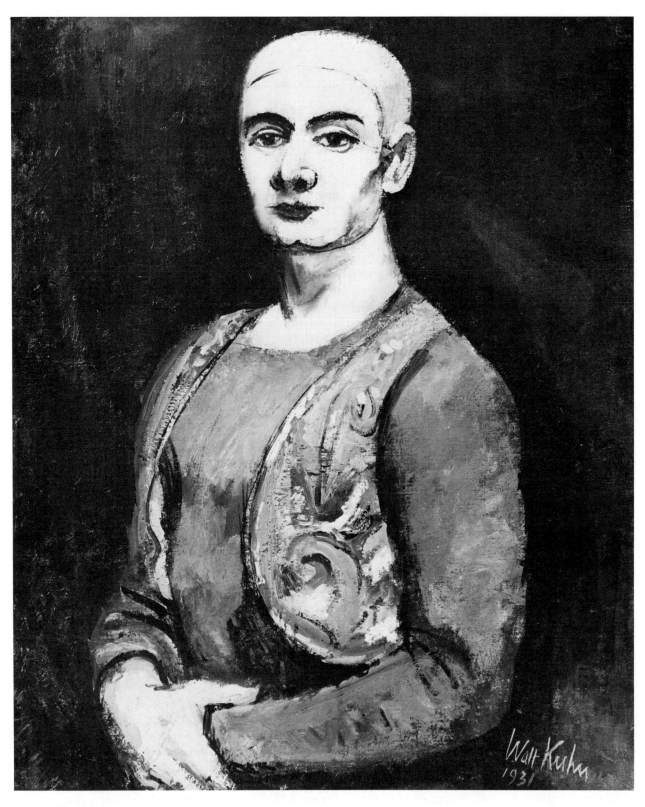

Figure 5.23
WALT KUHN, *The Blue Clown* (1931)
Oil, 30 × 25 in.
Whitney Museum of American Art.

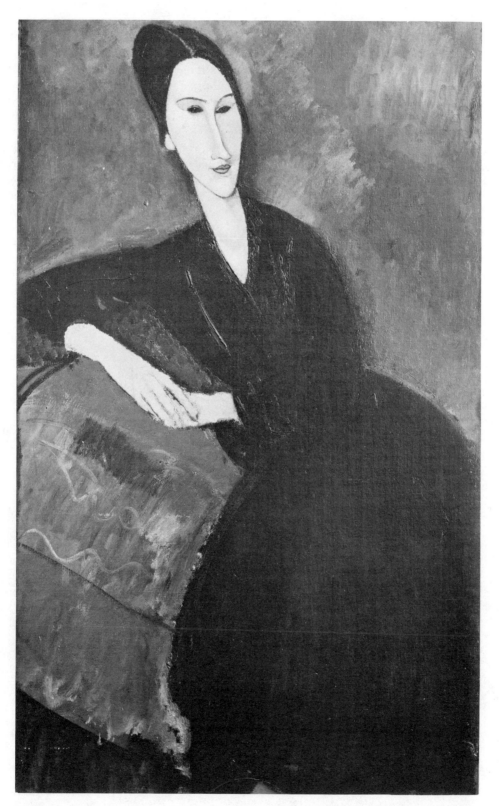

Figure 5.24
Amedeo Modigliani, *Anna Zborowska* (1917)
Oil on canvas, 51½ × 32 in.
The Museum of Modern Art, New York. Little P. Bliss Collection.

5.24, the sharply stated, slender ellipse of the head is implied in the darker shapes of the torso and skirt, and in the pattern of the two arms. Even the neck, eyes, and lips are resolved into this shape. In elongating the figure's forms, Modigliani further amplifies the subject's fluid rhythms. Yet if these two paintings show a roughly similar number, kind, and handling of values supporting very different expressions, this use of these tones in both works is expressively necessary. For, despite their emotive differences, both images are alike in their feeling of grandeur and of sensitive introspection, qualities which emerge from these large and sonorous tones.

Hartley's *Mt. Katahdin* (Figure 5.25), a dynamically as well as literally monumental image, illustrates that large, dark, and simple shapes of tone can lend an air of stately solemnity to any subject. Here, as in the two previous works, light tones are carried by rather strong, active shapes. By contrasting with the larger, darker, less vigorous tonal areas of a painting, such light tones serve as foils that underscore the main thrust of a work's emotive nature. In painting, some contrast with a work's main visual and expressive theme is necessary to give the theme clearer meaning. Whether the contrast is of tone, scale, direction, color intensity, clarity of focus, or handling, it serves to magnify meanings, not blur them. For example, if we place our hand over the trees in Figure 5.25, the grand scale of the mountain is lessened; and by covering over the horizontal line of the shore, the mountain's majestic rise is weakened. In Chapter One we

Figure 5.25
Marsden Hartley, *Mt. Katahdin* (1941)
Oil, 22 × 28 in.
Hirshhorn Museum and Sculpture Garden, Smithsonian Institution.

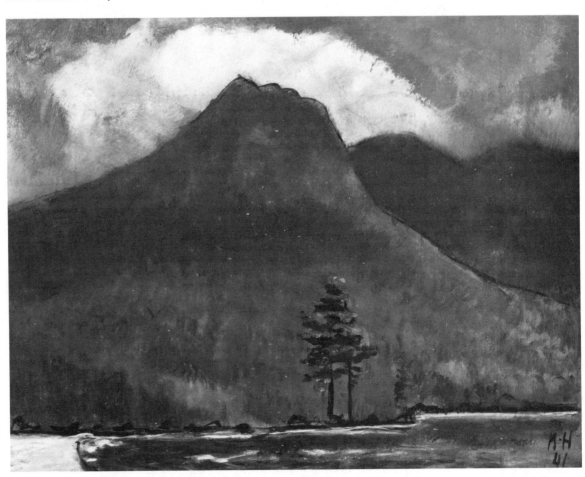

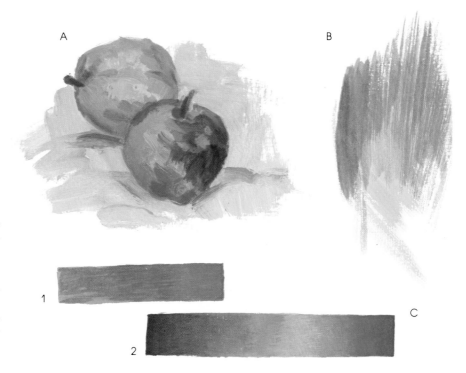

A

B

Plate 1

A. *Modeling with color.* The subject's three-dimensional form is expressed here as much through color differences as by changes in value.

B. *Optical color mixture.* The dry-brushed blue and yellow strokes create an optical impression of green.

C. *Color transitions.* Color changes need not always be value changes (1), and colors can gradually shift in "temperature" as well as in value (2).

1

2

C

Plate 2
J. M. W. TURNER, *Lyons*
Watercolor, 9⅜ × 11⅞ in.

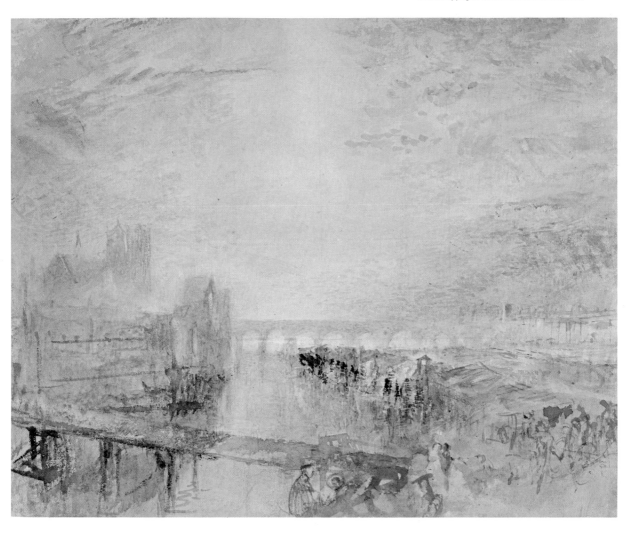

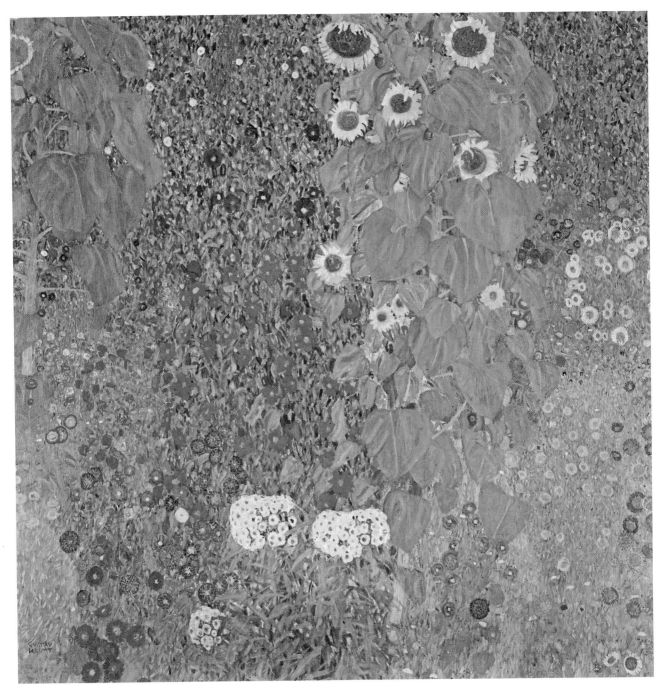

Plate 3
GUSTAVE KLIMPT, *Farm Garden with Sunflowers*
Oil on canvas, 110 × 110 cm.
Österreichische Galerie, Vienna.

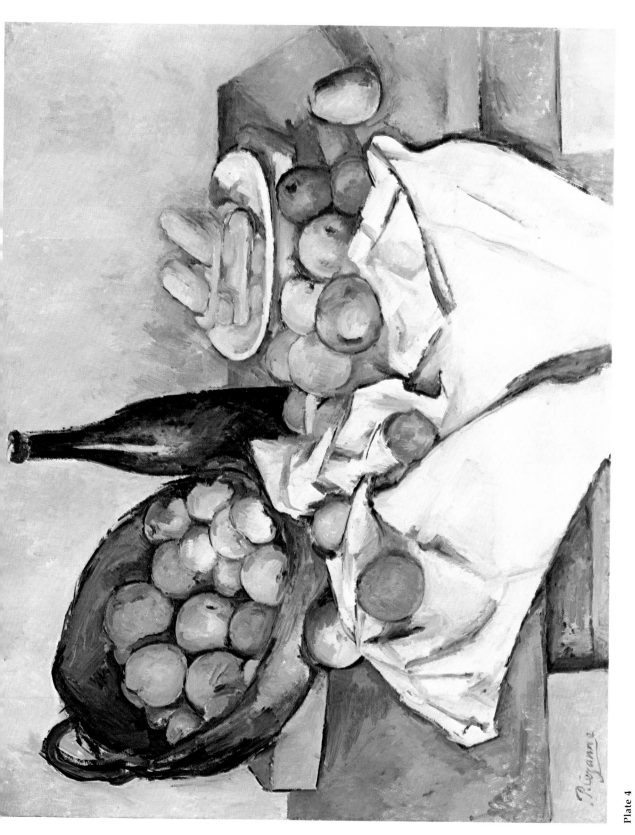

Plate 4
PAUL CEZANNE, *The Basket of Apples*
Oil on canvas. 24⅜ × 31 in.
Courtesy of The Art Institute of Chicago.

Plate 6
ANDRE DERAIN, *Portrait of Matisse*
Oil on canvas.
The Tate Gallery, London.
© A.D.A.G.P. Paris 1979.

Plate 5
ODILON REDON, *Roger and Angelica*
Pastel, 36½ × 28¾ in.
The Museum of Modern Art, New York.
Lillie P. Bliss Collection.

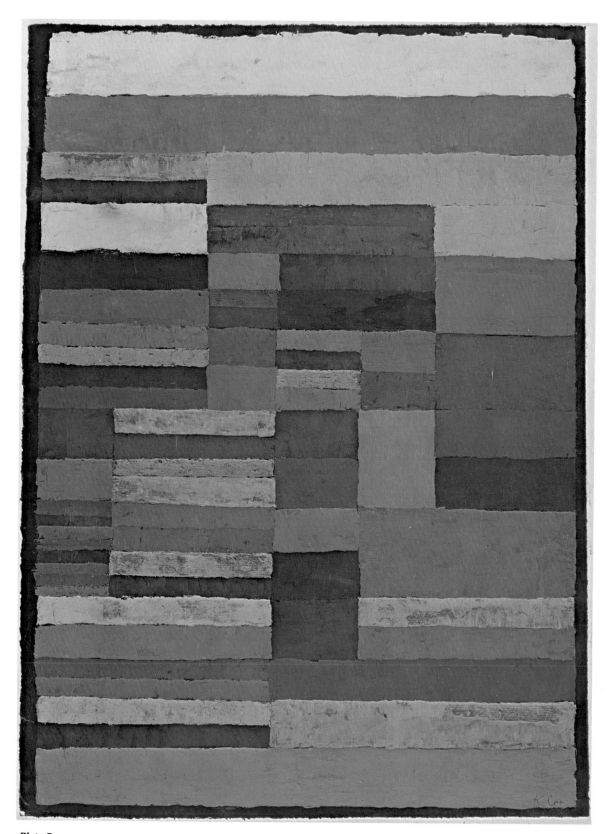

Plate 7
PAUL KLEE, *Individualized Measurement of Strata*
Pastel.

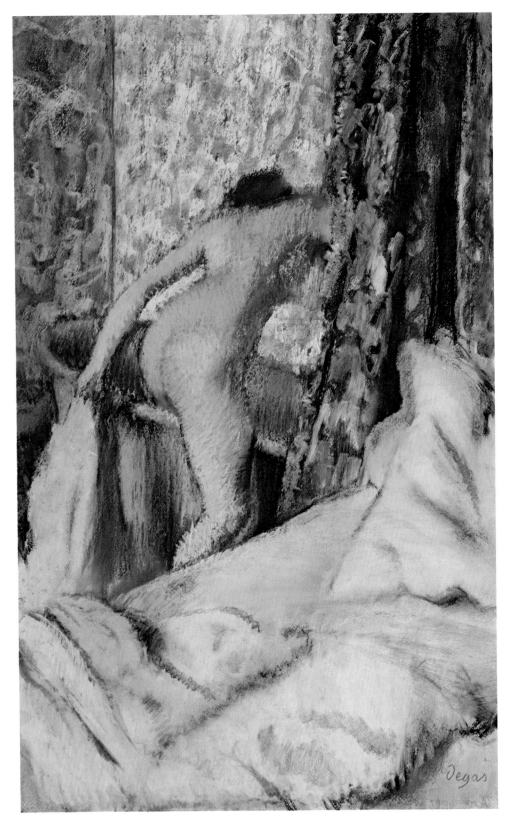

Plate 8
EDGAR DEGAS, *The Morning Bath*
Pastel, 27¾ × 17 in.
Courtesy of The Art Institute of Chicago.

Plate 9
PABLO PICASSO, *Two Acrobats with a Dog*
Gouache, 45 × 24 in.
The Museum of Modern Art, New York.

Plate 10
BEN SHAHN, *Liberation*
Tempera, 29¾ × 39¾ in.
Collection James Thrall Soby, New Canaan, Conn.

Plate 11
PAUL CEZANNE, *The Bridge of Trois-Sautets*
Watercolor and pencil, 16 × 21⅜ in.
Cincinnati Art Museum. Gift of John J. Emery

Plate 12
REMBRANDT VAN RIJN, *Lady with a Pink*
Oil on canvas, 36¼ × 29⅜ in.
The Metropolitan Museum of Art.
Bequest of Mrs. H. O. Havemeyer.

Plate 13
EDGAR DEGAS, *The Collector of Prints*
Oil on canvas, 20 ⅞ × 15 ¾ in.
The Metropolitan Museum of Art.
Bequest of Mrs. H. O. Havemeyer.

Plate 14
WILLIAM HARNETT, *Old Models*
Oil on canvas, 54 × 28 in.
Museum of Fine Arts, Boston.

Plate 15
JASPER JOHNS, *Numbers in Color*
Encaustic and collage on canvas, 66½ × 49½ in.
Albright-Knox Art Gallery, Buffalo. Gift of Seymour H. Knox.

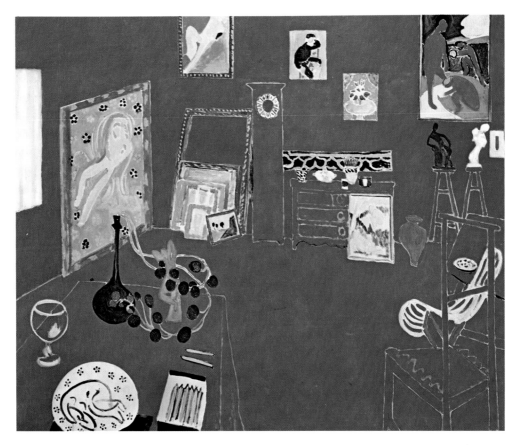

Plate 18
PIERRE BONNARD, *Breakfast*
Oil on canvas.
Musée du Petit Palais, Paris.

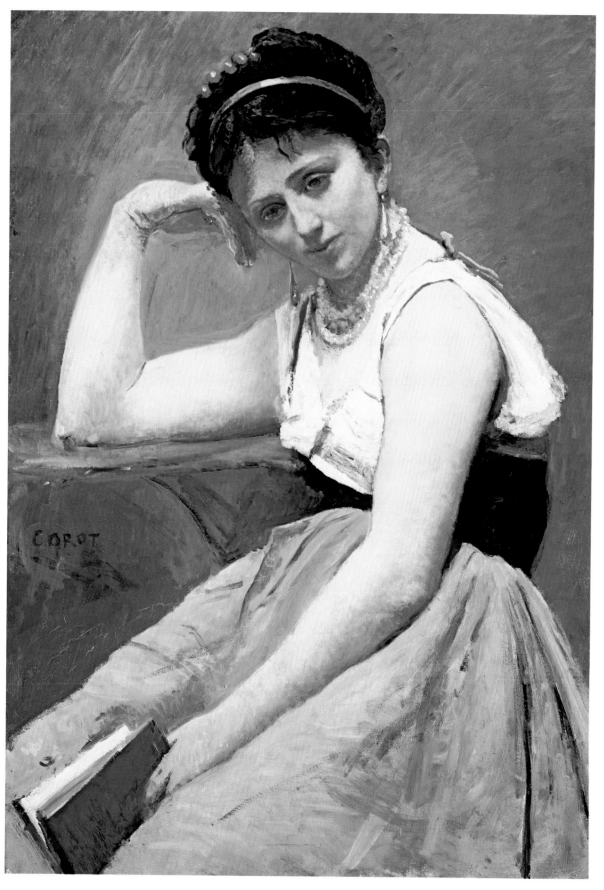

Plate 19
CAMILLE COROT, *Interrupted Reading*
Oil on canvas, 36½ × 25¾ in.
Courtesy of The Art Institute of Chicago.

Plate 20
MORRIS LOUIS, *Number 99*
Acrylic on canvas, 99 × 142 in.
Contemporary Collection of The Cleveland Museum of Art.

Plate 21
J. M. W. TURNER, *The Slave Ship*
Oil on canvas.
Museum of Fine Arts, Boston.

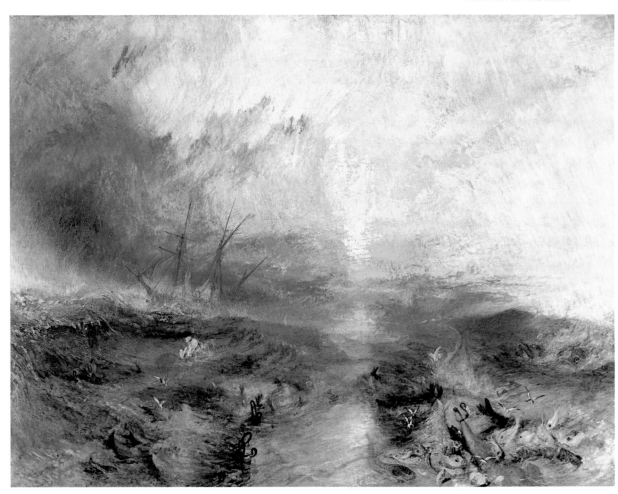

Figure 5.26
DAVID LEVINE, *Coney Island Bathing* (1965)
Watercolor, 18½ × 24 in.
Hirshhorn Museum and Sculpture Garden, Smithsonian Institution.

saw that any color is intensified if its complementary is nearby. As Figure 5.22 shows, our sense of the solidity of the young woman's volumes is heightened by the loss of form clarity and light on the painting's left side.

Several such important contrasts are at work in David Levine's *Coney Island Bathing* (Figure 5.26). Not only do the pronounced shadows explain the sunlight but, in being repeated throughout the design, they add their busy pattern to that of the figures and umbrellas, intensifying the sense of density and crowding among the bathers. This is further reinforced by the large expanse of open sky,

and by the contrast of the cloud's vaporous swellings with the crowd's weighty ones.

In using values to create illuminated forms in space, it is necessary to recognize the distinction between the great range of values occurring in nature that result from natural or artificial light, and the far smaller tonal range available to the artist. The deepest black we can apply to a canvas will appear as a dark gray when compared to the deep crevices of a black velvet drape or the far recesses of a darkened room. Our most brilliant white cannot begin to approach the intense whiteness of a neon bulb or a sunlit cloud. Recognizing this,

Figure 5.27

artists have used several methods of spreading their relatively few tones to embrace the many tones in nature.

In Figure 5.27 the extremes of nature's value range are marked *I* for intensity and lightness of tone far beyond the reach of our lightest colors, and *D* for depth of tone well below the range of our darkest ones. The remaining values in nature's scale can be matched by those our paints can produce; and in painting subjects that possess few values beyond those which our paints can match, nature's tones can be fairly accurately recorded. However, nature seldom provides such tonal conditions, and artists must then resort to one of the three main options illustrated in Figure 5.27.* As option *A* shows, we can make use of most of our values to explain the form and light conditions of the subject's more highly illuminated passages even though we cannot duplicate their intensities of light. But, in having alloted so many of our available tones in approximating the lighter ones we see or desire (1), we have fewer to "spend" on stating the form and light conditions of our subject's darker passages (2). This means that we can quite fully explain the

volume, space, and quality of the light in our subject's more illuminated parts, but must forsake all but the most general observations about these matters in its darker passages.

This is a solution favored by many of the Renaissance and Baroque masters and by many painters since, who intend images in which forms emerge from the darkness to be bathed in brilliant light. Such works often show an overall dark tonal key, as in Figures 4.2, 5.7, and 5.22. This is also evident in Rembrandt's *Portrait of the Artist* (Figure 5.28), where light tones define many subtle changes in the surface form of the head, but none at all in the surface form of the hat. Rembrandt uses another important means for suggesting tonal intensities in addition to those described above: contrast. By emphasizing the darkness of the hat and lowering the tones throughout the painting, he creates an effective illusion of brilliance. How effective it is can be tested by holding a piece of white paper up to the illuminated part of the head; it is not very bright at all. Only some parts of the forehead and the nose reach toward a white tone.

Referring again to Figure 5.27, observe that a second option, *B*, permits us to match those values in the subject that fall well inside the upper and lower limits of nature's tonal

*For an extensive examination of this use of tone, see Arthur Pope, *The Language of Drawing and Painting* (Cambridge, Mass.: Harvard University Press, 1968), pp. 101–3.

Figure 5.28
REMBRANDT VAN RIJN, *Self-Portrait* (1660)
Oil on canvas, 31⅝ × 26½ in.
The Metropolitan Museum of Art. Bequest of Benjamin Altman.

range, but prevents us from applying more than a few tones to explain the considerable number of values that lie beyond at either extreme. In this mode, the form and space of somewhat darker passages can be explained (1), at the loss of tonal subtleties in more light-toned areas (2A), but with some gain in explaining the tonal subtleties of the subject's darkest passages (2B). Such works often appear to have a lighter overall tonal key, as in Manet's *Reading an Illustrated Paper* (Figure 5.29), where the artist permits us to see into the depths of the dark hat and coat, but tells us little about the structure of the woman's face. Similarly, in Figures 1.8 and 5.13, we find somewhat less form expressed by values in the very light passages. Note that in all three works the very darkest parts are also simplified.

A third mode (option C in Figure 5.27) aims at explaining more fully the form and space of the subject's darkest passages (1), but, with so much of our value scale given over to this, we remain with few tones to apply to the subject's lighter parts, which must then be treated in a more summarized way (2). Such a distribution of value is often employed in watercolor painting, in drawing (especially in pen and ink works of a tonal nature), in etching, and in works in which the impression of an intense light source is desired. Figures 3.11, 5.23, and 5.26 show something of the effects of such a use of tones. So does Koninck's *Wide River Landscape* (Figure 5.30), where we can see into the shadows to make out the form and space among the trees and buildings, but find relatively little form clarity in the lighter passages. But as this example shows, the best tonal painters can so adapt contrasts and tones to their needs that we are seldom aware of the fact that a few values have been made to stand for many. Here, the artist, recognizing that most of his tones are "invested" in tracking nature's darker values, uses his few light tones to establish quite simple things: a sail, some brilliantly lit clouds, and the surface of the water.

Another less often used variant of those illustrated in Figure 5.27 deserves mention. Some painters apply their values to both extremes of nature's tonal range, leaving themselves few tones with which to respond to observed or desired middle values. The results of such a mode are often boldly polarized tonal statements, as in Figure 3.21, and in Ryder's *Jonah* (Figure 5.31), where a raging storm of undulating and strongly contrasted shapes of tone evoke the fury of the biblical storm.

In whatever manner the tones are distributed to achieve an impression of light, and in addition to their various organizational functions in the design, the effect tones create *as light* is itself a great unifier of the things represented. For, in such works, all the forms, no matter how unrelated they may be in other respects, share in the effects of the common light source; each is bathed in light on one side and surrenders to the dark on the other.

Such a use of tones doesn't exempt us from arranging them to serve in the several abstract and clarifying ways already discussed. Even the unifying effects of light cannot overcome the visual chaos of an obvious disorder among a painting's values. Rather, the presence of light in a work should serve to reinforce its design, to give emphasis to segments, and to give form to masses and heighten their visual and expressive meanings.

COLOR VALUES

In concentrating on the important element of value in painting, we have made little mention of color. However, the differing values of hues are crucial, not only to the success or failure of a painting's color qualities, but to the descriptive and expressive meanings of the painting's tonal character. Not only can several closely placed colors of nearly the same value create larger tonal shapes in the design, they can clarify the structure of a form. By their intensities and hue character, colors can strengthen the expressive force of such an area in the design. This is demonstrated by the V-shaped segment of the head, neck, and bodice in Plate 12, where the shape's luminous glow is as much a matter of color as of value.

The great masters of tonal painting may have placed much emphasis on value as a chief means of organizing an image, and on light effects, but they never reduced the role of color to one of decorative embellishment. Unfortunately, this is too often a fault of many lesser tonal painters, for whom painting is essentially

Figure 5.29
EDOUARD MANET, *Reading an Illustrated Paper*
Oil on canvas, 24¼ × 19⅞ in.
The Art Institute of Chicago.

Figure 5.30
Philips de Koninck, *Wide River Landscape*
Oil on canvas, 16¾ × 23½ in.
The Metropolitan Museum of Art.
Anonymous gift.

Figure 5.31
ALBERT PINKHAM RYDER, *Jonah* (ca. 1885)
Oil on canvas, 27¼ × 34⅜ in.
National Collection of Fine Arts,
Smithsonian Institution. Gift of John Gellatly.

a drawing process, and color a gratuitous frill.

Although, in the works of the greatest tonal painters color is used less for form building, and while many of these works appear less colorful than nontonal paintings, nevertheless, color is a vital and necessary aspect of their dynamic and representational meanings. Neither the mere presence of many colors, nor even the variety of visual functions the artist assigns them to, guarantees color sensitivity. Some of the most succulent, touching, or glorious color events in the long history of painting occur in works painted with few colors. When such a work is placed alongside more richly hued paintings, it may at first glance seem dull by comparison. But soon enough its color relationships and expression, because they are necessary to the whole of the painting's meaning, erupt into rich chromatic life.

SOME MODES OF INDIRECT PAINTING

Although many tonal painters work in a direct manner, earlier painters, especially those of the Renaissance and Baroque periods, those of the "Little Dutch School," and indeed most European artists from the fifteenth to the nineteenth centuries worked in various indirect methods and almost exclusively in a tonal manner. We saw in Chapter Four that indirect paintings are begun by first establishing a (usually) monochromatic underpainting, the colors being introduced after the forms and composition of the underpainting have reached a fairly advanced stage of realization. Early users of oil paint would develop the underpainting in tempera, applying the oil paint over it in mainly thin applications. But, because the brittle nature of tempera paint restricted such works to panels and thus to small-scale works, most practitioners of this mixed technique, upon the advent of canvas as a support for oil paint, abandoned the tempera underpainting and developed indirect painting techniques that could be executed entirely in oils.

Several different methods emerged in response to the creative requirements of the artists and the practical ones of their patrons and clients. In Italy, where commissioned projects were often large in scale, indirect painting techniques evolved that permitted large paintings to be developed quickly. Usually, the prepared canvas received a reddish-brown imprimatura and the underpainting was developed by varying degrees of tone produced by differing thicknesses of the white paint with which they were executed. Tones darker in value than the imprimatura were produced by washes of brown or black. In this way, areas intended to be light-toned in the painting's final state were painted somewhat more thickly in the underpainting than were passages meant to be dark, the latter usually being brushed on in a semi-transparent layer that permitted the light from the prepared ground to have its effect through both the imprimatura and these thinly-painted dark tones.

Many Italian Renaissance painters, especially of the Venetian school, modeled the forms of the underpainting to an advanced stage of completion. The underpainting was intentionally executed in a somewhat higher tonal register than that desired in the final work. This was done because much of the overpainting would consist of half-covering and glazed colors, which, to the extent that they were transparent, would have a darkening effect on the tones below.

The completed modeling in the underpainting of, say, a head, might then appear to consist of opaque layers of white or near white tones in the most illuminated segments, and various light and dark pinkish or tan tones in the more shaded segments—these tones resulting from either optical mixtures of thinly applied white paint over the imprimatura, or by directly mixing such darker tones on the palette. In places, the cooler brown or gray tones used for the darkest segments of the underpainting might also be washed thinly over some of the half-tone areas of the head.

A number of later Italian painters, forsaking the building up of forms with opaque and semi-opaque layers of light tone, established instead a more linear drawing upon usually darker and even less transparent imprimaturas, using some opaque light tones only to underlie what would be the lightest parts of the completed work. Tintoretto's unfinished painting (Figure 4.8) shows something of this looser handling. Unfortunately, oil paint's tendency to grow somewhat more transparent over the years led to the eventual darkening of most of their work.

In the North, the Flemish painter Rubens evolved a technique of underpainting on a white surface, sometimes washed lightly with a yellow ochre tone to increase the luminous glow of the dark tones, which were always thinly painted and never contained white paint. For, as Rubens warned, "If white is ever allowed to dull the perfect transparency and golden warmth of your shadows, your coloring will no longer be glowing, but heavy and gray." He would sometimes thinly paint the light areas of a work in their final colors directly upon the white priming, achieving a watercolor-like sparkle, but more often the forms of such areas were developed in the underpainting by thin washes of gray and thicker applications of white, or by mixtures of various cool, light-gray tones of varying degrees of opacity, which were applied more heavily in the lighter passages, where they reached a near white tone.

Rembrandt's paintings, usually begun by underpainting on quite dark imprimaturas of a brown, gray-brown, or reddish-brown tone, were spared the fate of those Italian works noted above, by being executed, in the overpainting, in heavy impastos of light tones, leaving the imprimatura to stand only for the darkest values of the completed work. In his later years, Rembrandt treated the forms of the underpainting in a most aggressive and broad manner, establishing no more than their general masses and tones, and relying more on a direct painting style for his final results. Often, such direct painting was integrated with glazes and scumbles, but it was mainly by the direct application of colors, often very heavily applied with fully charged brushes and painting knives, that he achieved the brilliant luminosities, textures, and almost sculptural relief which characterize much of his work (Figure 5.1).

Overpainting methods, whether in the Venetian manner of alternating layers of glazed and scumbled color with layers of opaque color (Titian is said to have built up many such layers to attain the glowing richness of his imagery), or in the heavy impastos of Rembrandt and to a lesser extent Rubens, are all designed to utilize—as they obscure—the underpainting, which works its effects from below, modifying the color in the upper layers. And, just as a single painting may show areas where the underpainting is visible or only lightly veiled alongside areas where it is buried under thick brushwork and no longer affects the surface paint, so individual artists in some works will rely heavily on the underpainting while in others the underpainting may be so reduced in function that the handling approaches a direct manner. Hals, Rembrandt, and Velazquez are a few of the many artists whose paintings can often more accurately be described as direct in manner. Other artists, such as Titian and Degas, whose early works are models of indirect painting, moved toward a more direct handling as they grew older. It may be that as these masters developed in perceptual and technical skill—in fluency—and as their goals shifted from an emphasis on denotation to evocation, they required less assistance from this tonal "prelude," or came to regard it as a restriction. For, in the indirect manner, the more one is obliged to make changes in the upper layers, or allows the forming image to form itself, the more inappropriate and even intrusive the underpainting becomes.

Clearly, neither direct nor indirect painting should be thought of as fixed systems. All artists, whatever manner predominated their formal art education, soon evolve their own style of forming images. Most freely adapt techniques from both modes according to their creative interests in general and to the demands of a given work in particular.

Nor is it always the case that highly representational artists of a tonal orientation are the only ones likely to be attracted to indirect techniques. Strongly subjective responses to form and color can also benefit from layered painting. Although indirect painting is especially well suited to establishing the tonal, chromatic, and textural qualities of an observed subject (Figure 5.32), it can serve a vast range of visual interests, as Soutine's and Frankenthaler's paintings (Figures 5.33 and 5.34) indicate. Note how Soutine uses the dried surface of the darkened area of the sky to modify segments of the lighter color over it, and how important the dark undertone is to the "framing" function of the light tones of the sky. In Frankenthaler's painting, the preliminary stains of muted gray-greens, tan-pinks, and blue-grays strongly affect the bolder reds and yellows painted over them.

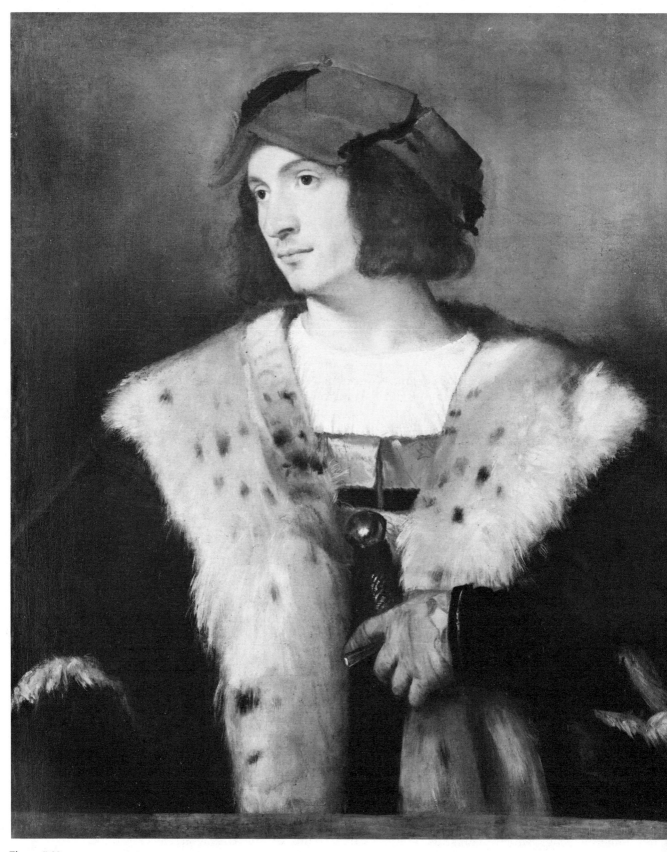

Figure 5.32
TITIAN, *Portrait of a Man in a Red Cap*
Oil on canvas, 32⅜ × 28 in.
Copyright The Frick Collection, New York.

154

Figure 5.33
CHAIM SOUTINE
Chartres Cathedral (1933)
Oil on wood, 36 × 19¾ in.
The Museum of Modern Art, New York.
Gift of Mrs. Lloyd Bruce Westcott.

Figure 5.34
Helen Frankenthaler
Jacob's Ladder (1957)
Oil on canvas, 9 ft 5⅜ in. × 69⅞
Collection, The Museum of Modern Art,
New York. Gift of Hyman N. Glickstein.

Some media, such as watercolor, strongly urge indirect techniques, while acrylics, free of the technical limitations of oil paint, allow for rich color in the underpainting. Many contemporary painters, whatever their aesthetic persuasion, often utilize aspects of indirect handling for effects that can be had in no other way. For example, an area of opaquely painted orange delivers its special, strong chromatic punch; a similar area, painted by glazing red over a dried yellow, while it can match the hue and value of the first area, will be mysteriously luminous, have depth, and relate differently with its neighboring colors. Most of the color qualities in Plates 12 and 21 are simply not possible in opaque painting (which has its own exhilirating virtues, as Plates 6, 13, and 18 show). Whatever the indirect method, and for whatever creative purpose, this mode, born out of the needs of the tonal painter, provides an impressive arsenal of visual responses that deserve study.

MASS, BALANCE, VISUAL WEIGHT

The notion of mass as an element is, surprisingly, sometimes overlooked. Mass, it is argued, is after all, a result, an effect of other elements. In fact, elements often create other elements. A group of shapes arranged in a ring produce the circular shape at their center, and a *horizontal* row of many short, *vertical* lines is the product of those short lines. Similarly, values can be arranged to suggest other values and colors can give rise to other colors, as when a red shape on a light gray field turns the field toward green.

But if we understand the visual elements to be the visible matter that constitutes our images, then mass—the sense of solid volume occupying space—is a powerful factor in giving our images order and meaning. Like other elements, it engages in bonds and contrasts with its own kind *and* with the other elements, and is simultaneously perceived by the sensitive viewer as an abstract phenomenon in the design *and* as a readable structure in the depiction. Mass enjoys a full dynamic life.

Often, beginners in painting, engrossed with the challenge of producing the sense of convincing masses in a convincing spatial container, fail to consider the profound effects on a painting's organization of such visually and physically weighty forms. Yet we do read a volume as having both kinds of weight, and both must be balanced in the design.

Here let us turn briefly to a more explicit description of what is meant by visual and physical weight and by balance. We have, of course, been discussing these matters all along, but on a "case history" basis, in the many paintings discussed so far. In noting the visual impact and directed action of a line, shape, or tone, we were responding to its visual or pictorial weight, its *attracting power* in the design. When we sensed the substantiality of a figure or an apple as exerting weight upon other objects, we were responding to its physical weight in the depiction. And in both cases we were responding to important factors in the painting's balance. All three of these considerations are greatly affected by mass and space.

We have seen that the dynamic energies generated by the lines, shapes, and tones in a work, whatever the descriptive or expressive function of these elements may be, must be countered, checked by opposing actions. When such energies are left unchecked in a work, we sense a lack of stability and of unity. In painting, as in living, uncontrolled forces are unsettling and we try to counter or control them. But an ordered balance in our daily lives occurs as a result of an appropriate and successful governing of our activities and interests as they are acted upon by our outer and inner experiences, and by the people and events around us. Balance in living is a necessity, not a goal. We accept the certainty of ongoing change and achieve balance on a daily basis when we are able to counter, or turn to our account, the many unexpected challenges that each day brings.

Similarly, in painting, we need to understand that balance, harmony, and unity, and the relational activities that bring them about are not the goals of painting, but conditions necessary to creative expression. The best painters, of whatever period or style, accept the certainty of energies flowing among the elements that make up their images, and know that the successful governing of these energies is a vital part of a painting's meanings, not as an end in itself but for the visual coherence that a balanced ordering of parts supplies.

Without balance (and, consequently, unity), a painting's dominant themes are always those of isolation and disorder.

But the painting's balanced arrangement must suit and express the painter's theme. The best painters would no more think of imposing an arbitrary balance in a painting than we would think of disregarding what happens to us on a given day, and consider merely *how* it happens. The compositional solutions of the best paintings always reflect the artist's sensitivity to arranging just those visual conditions that clarify his or her intent. Balance is a principal factor in establishing those conditions.

A painting can be said to be in balance when the directed thrusts and rhythms, the tensions, and the groupings between the elements succeed in regulating each other's energies in a way that holds them all in a state of interdependent activity. It is an activity based on compensations of weight and direction, of actions and reactions that may threaten, but not destroy, the equilibrium of the whole. A well-balanced composition is a self-governing, never-ending cycle of visual activity.

The visual weight of an element in a painting, whether it is the eye attraction of a single brushstroke, or the volume of a mountain of which the brushstroke is a part, is determined by that element's visual importance in the design. Its location and direction contribute greatly to its importance, as does the relative strength of its shape, scale, value, and color in the design. But location and direction are potent modifiers of these other factors in determining the element's visual appeal—its visual weight. As Arnheim has observed, other factors being equal, an element located close to the center of a composition or on the central vertical axis, exerts less visual weight than when it is located elsewhere in the design.* For example, if two small and identically colored shapes are shown inside a square, one located near the center and one near the lower right corner, the lower shape will appear heavier, more in need of counterbalancing. Similarly, again with other factors being equal, an element located higher up in the design will

exert more visual weight than one placed lower, and any group of elements will weigh more on the right side of a composition than when they are located on the left side. This last phenomenon can be easily tested by holding up to a mirror most of the reproductions in this book. For example, seen in reverse, Vermeer's and Ryder's paintings (Figures 5.22 and 5.31) are now too heavily weighted by dark tones on the lower right side. Similarly, in Hartley's and Levine's works (Figures 5.25 and 5.26), the mirror images seem weighted too much on the right side. In the Hartley, the mountain is no longer balanced by the other elements; in the Levine, the large mass of crowded bathers seems to press heavily to the right. But, seen directly again, the disequilibrium in each of these works disappears.

Direction also affects balance. Elements located on a vertical or horizontal axis appear less weighty, less boldly in motion, than when diagonally oriented, as Figure 5.35 suggests. We have seen that the directional axis running through a number of parts, whether the result of alignment, color, or value, generates motion, and motion in painting generates visual weight. Thus, in the de Staël (Figure 1.11), the large, complex oval shape encircled by the small dark shapes, while its visual weight is lessened because of its central location, exerts some weight on the left because of its direction downward on that side.

Similarly, Modigliani, in Figure 5.24, compensates for the figure's threatening diagonal thrust toward the lower right corner by counterweights which include the large shape of the couch, the chevron-like shape of the two hands, and the leftward tilting, box-like shape of the two arms and the shoulders.

A second kind of weight is at work here. Our *prior knowledge* of the physical weight of the subject tells us that a solid and weighty volume—the figure—is leaning toward the lower left corner. So much is this a factor in the reading of the painting's balance that, if the canvas were wide enough for the entire dress to be shown on the right side, and thus, not attached to that side of the picture-plane, we would sense the design to be imbalanced, as too heavy on the left side. Modigliani, by treating the lower part of the dress as a shape, while emphasizing the volume of the head and neck, further utilizes physical weight as a

*Rudolf Arnheim, *Art and Visual Perception* (Berkeley and Los Angeles: University of California Press, 1969), pp. 1–32.

Figure 5.35

counterthrust to the overall direction of the figure.

Degas, always an inventive designer, in *Sulking* (Figure 5.36), achieves equilibrium by pitting both the physical weight of the leaning figure and the visual weight of the strong curve of her body against the visual and physical weight on the painting's right side. Even so, balance is only tenuously established; the composition seems to rock in a see-saw fashion from the "fulcrum" of the framed painting on the wall. But the horses in that painting, furiously racing to the left (as do the converging lines of the framed painting, and the near-white wedge of papers on the desk) urge our attention to the left, adding to the composition's stability.

That visual weight in figurative imagery can sometimes have more compositional force than physical weight is demonstrated in Turner's *Venice: The Mouth of the Grand Canal* (Figure 5.37). The freely brushed and essentially flat shape of dark tone representing a dock, boats, and their reflections, by its strong value and animated treatment, exerts a more attracting pictorial function than does the delicate painting of the buildings on the far left. Were it not for these dark strokes, the visual weight of the buildings on the far left could not counteract the visual weight of the buildings on the right side.

The composition of an early, figurative work by the nonobjective painter Kandinsky (Figure 5.38) reveals the same general scheme for achieving balance as Turner's. Here, too, a dark, essentially flat area serves as a visually heavy counterweight to the substantial physical weight exerted by the buildings on the right. As these two very different works show, the need for a balanced resolution of visual forces (and here, even to the extent of arriving at a similar solution) is a universal factor in paintings of serious creative worth, of whatever aesthetic persuasion.

Usually the known physical weight of recognizable forms is a strong factor in representational painting, as Figure 5.36 suggests. Nor is the role of physical weight in design restricted to figurative paintings of a more or less objective nature. Physical weight is a factor in any kind of painting that suggests mass, even in nonobjective works such as Figure 5.18 or Figure 5.39, a later work by Kandinsky, where those forms which imply volume "earn their keep" by participating in establishing the painting's equilibrium.

Although many of the painting's forms fluctuate between being seen as shapes and as masses, Kandinsky's sensitivity to their visual and physical weight, a large part of the painting's dynamic situation, gives us a sense of this turbulent work's ultimate balance. Of course, even figurative paintings can show such fluctuations—such intended ambiguities—in the reading of a part as having or not having mass. In Willem de Kooning's *Queen of Hearts* (Figure 5.40), some segments, such as the figure's left arm and the central part of the dress, seem to come and go as masses. But note that the artist emphasizes the volume of the figure's right arm, breast, and left leg, utilizing physical weight on the painting's left side where it is needed to balance the design.

On the other hand, in some paintings where weighty masses are carved with almost sculptural insistence, balance is at least as much a matter of visual as it is of physical weight. In Van Gogh's *Three Pairs of Shoes* (Figure 5.41), physical weight is mainly on the right side. Equilibrium is achieved by balancing the physical weight of the shoes against the visual weight of their direction and that of the light-toned drape on which they rest. The entire configuration leans to the left to check the weight on the right.

The composing of masses in paintings

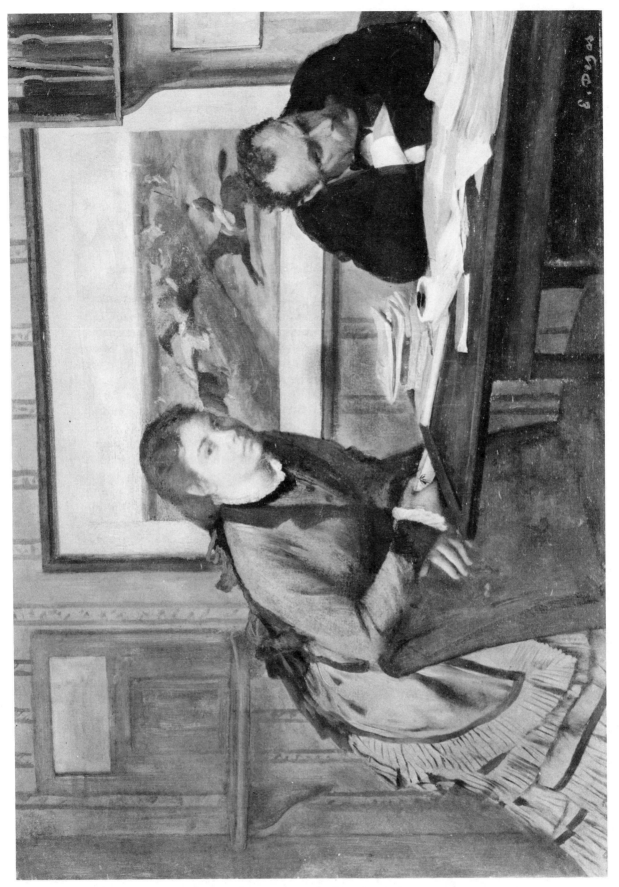

Figure 5.36
EDGAR DEGAS, *Sulking*
Oil on canvas, 12¾ × 18¼ in.
The Metropolitan Museum of Art.
Bequest of Mrs. H. O. Havemeyer.

Figure 5.37
JOSEPH M. W. TURNER
Venice: The Mouth of the Grand Canal (ca. 1840)
Watercolor, 8⅝ × 12½ in.
Yale Center for British Art. Paul Mellon Collection.

Figure 5.38
WASSILY KANDINSKY, *Grüngasse in Murnau* (1909)
Oil on canvas.
Städtische Galerie, Munich.

Figure 5.39
WASSILY KANDINSKY
Panel 3 (1914)
Oil on canvas, 64 × 31½ in.
Collection, The Museum of Modern Art,
New York. Mrs. Simon Guggenheim Fund.

Figure 5.40
Willem de Kooning
Queen of Hearts (1943-46)
Oil on board, 46 × 27½ in.
Hirshhorn Museum and Sculpture Garden,
Smithsonian Institution.

164

Figure 5.41
VINCENT VAN GOGH, *Three Pairs of Shoes* (1887)
Oil on canvas, 19½ × 28 in.
Fogg Art Museum, Harvard University. Bequest—Collection of Maurice Wertheim.

that emphasize volumetric and spatial clarity must not only take into account their balance on the picture-plane, but needs to show a balanced arrangement in the spatial field. For example, in de Hooch's *The Mother* (Figure 5.42) the volumes come forward from the dark recess on the left, approach the viewer, move back to the light wall in the rear room, and return toward the viewer along the shadowed wall on the far right. Because the impression of volume and three-dimensional space are inseparable, we sense the pattern of the "vol-

ume" of space itself, a horizontally oriented U-shape of space, to be part of the pattern of the painting's design. But note that the overall design scheme, in relying on a pattern of rectangular and square shapes surrounding a concentration of forms in a forward and central position, is not unlike the compositional solution in Matisse's painting (Figure 5.13).

Similarly, in Jack Levine's *Welcome Home* (Figure 5.43), the pattern of masses functions in both a two- and three-dimensional way, as Figure 5.44 illustrates. As de Hooch's and

Figure 5.42
PIETER DE HOOCH, *The Mother*
Oil, 92 × 100 cm.
Staatliche Museum Preussischer Kulturbesitz, Berlin.

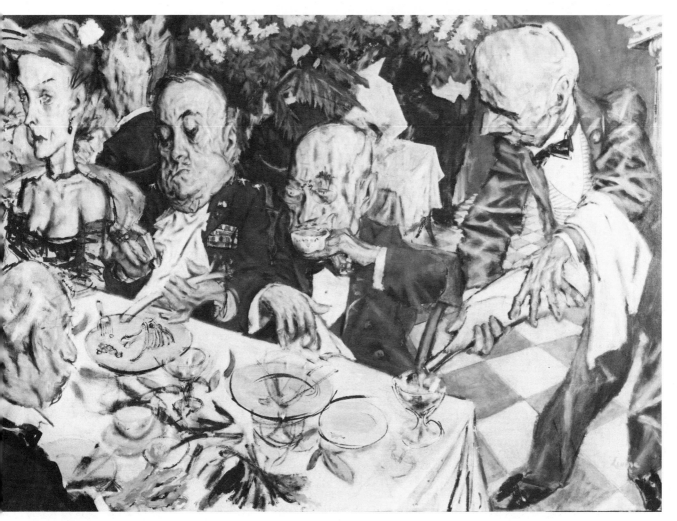

Figure 5.43
JACK LEVINE, *Welcome Home* (1946)
Oil on canvas, 40 × 60 in.
The Brooklyn Museum.
Woodward Memorial Funds.

Figure 5.44
These analyses of Figure 5.43 reveal some of the underlying two-
and three-dimensional patterns that course through Levine's
work, organizing it and amplifying its expressive character.

167

Levine's paintings point out, works that suggest form and space are just as responsible for the integrity of their two-dimensional organization as are more two-dimensionally conceived images.

MASS AS AN EXPRESSIVE AGENT

Sometimes the expressive impact of strongly structured mass is itself a dominant theme. In painting, as in life, we tend to admire, or at least respect, attitudes and qualities that are strong in their way, even when they disagree with our own aesthetic or philosophical views. Paintings that are keenly linear or tonal, rugged or delicate, or that utilize color in an emphatically unique manner, works that show an extreme emphasis on illusionistic, painterly, or geometric imagery, all arrest our attention by the intensity of their purpose. When the substantiality and structural essence of mass is the theme, the resulting works may possess a monumentality capable of powerful expressive force. Such bold mass and space conceptions can act as metaphors for majestic strength and timelessness; they touch off associations of ceaseless potency, of exceptional permanence and stability.

The forms emphasized in Cézanne's *Louis Guillaume* (Figure 5.45), by their simple massiveness and domination, allude to such lasting and powerful qualities. Cézanne's humility before nature and his penetrating sensitivity to the meanings hidden in its structures and spaces enable him, as someone has observed, to see "a bowler hat as if it were a mountain, and a mountain as if it were a bowler hat." Here the extracting of the volumes' essential structural nature, whether of the draped torso or an eyelid, imparts a universally understood dignity to the depiction that is in telling harmony with the sensitive introspection of the sitter.

The power of monumental form is even more evident in Picasso's *Two Nudes* (Figure 5.46). By giving a massive heft to the forms of these figures Picasso reveals that sheer mass, the presentation of bold volumes, boldly carved, carries strong emotive energy. We sense the experiencing of such volumes to be the artist's main theme.

Again, in Rembrandt's *Hendrickje Bathing in a Stream* (Figures 5.1 and 5.47), the eloquence of mass and space as agents of expression is evident. As in Cézanne's and Picasso's works, the simplifications of forms, in hinting at their geometric "core," suggest universal, lasting stability. And, by bathing these forms in a blazing light, Rembrandt dramatically underscores the emotive power that flows from their structural character (as well as his relish in experiencing them).

In passing, it should be pointed out that this painting, begun in an indirect manner (most of the dark passages show the reddish-brown tones of the underpainting) is completed in a mainly direct mode. Indeed, the bold painting of the chemise and figure, their planar construction revealed with an impressive economy and vigor, stands as one of the most astounding performances of direct painting in the history of Western art.

But Rembrandt's authoritative resolution of these forms as volumes in space is not only the result of a wish for solidity. Such creative inventions, especially evident in the daring fluency with which the chemise is stated, emerge from two important sources: the artist's sensitivity to the moving energies in all things, *including the planar components of a volume*, and his penetrating search for a volume's essential structural properties. For, when perceptual interests embrace both the analysis of an object's dominant architectural character *and* its dynamic situation, unique insights for inventive visual solutions are revealed.

Responsive painters regard *seeing* (or envisioning) and *feeling* as inextricably woven parts of the percept. Mere intellectual analysis of masses leads quickly to lifeless constructions, just as mere empathy leads only to indulgent emotional reactions that fail to communicate a volume's structure.

But when a strong desire for inquiry *and* experiencing is the motive, subjects will yield different and unique solutions to each of us. The structural analysis of mass, undertaken in the spirit of discovering dynamic as well as measurable conditions, is an important key to creative invention, a key that provides visual themes and motives for the ways you will use shape, value, color, and mass itself. Every painting reproduced in this book, however figural or abstract, is to some degree a statement about the artist's grasp of, and feelings for, a

Figure 5.45
PAUL CÉZANNE, *Louis Guillaume*
Oil, 22 × 18⅜ in.
National Gallery of Art, Washington, D. C.
Chester Dale Collection.

Figure 5.46
PABLO PICASSO
Two Nudes (1906)
Oil on canvas, 59⅝ × 36⅝ in.
The Museum of Modern Art, New York.
Gift of G. David Thompson in
honor of Alfred H. Barr, Jr.

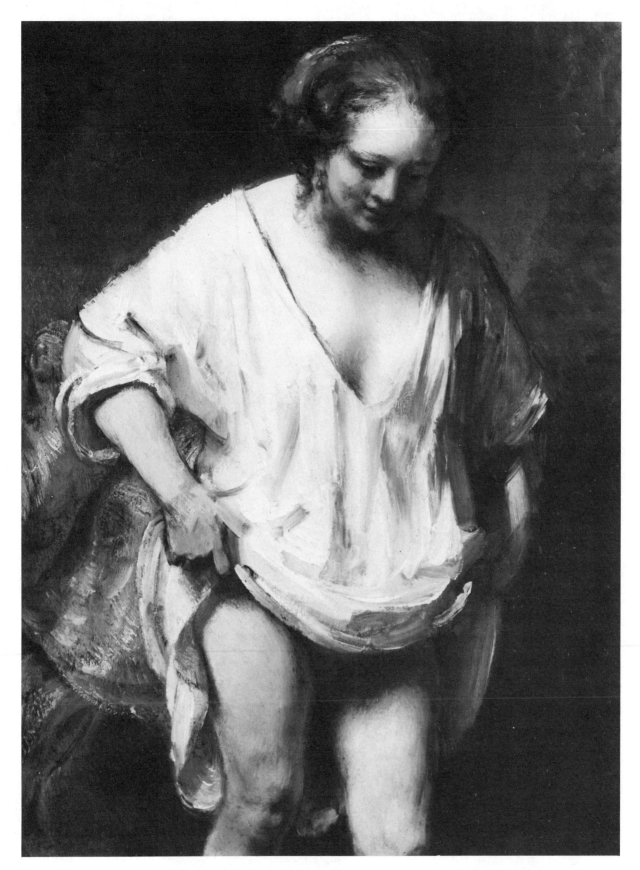

Figure 5.47
Rembrandt van Rijn, *Hendrickje Bathing in a Stream* (detail)
Oil, 24⁵/₁₆ × 18½ in.
The National Gallery, London.

Figure 5.48
GEORGES BRAQUE
Woman with a Basket of Fruit
Oil on canvas, 57⅝ × 30½ in.
Worcester Art Museum, Worcester,
Massachusetts.

form-order that has its obvious or distant origins in his successful ability *to fully experience* the things that make up his *outer* as well as *inner* world.

Emphasis on the clarity of mass need not restrict the artist to an objective treatment of such forms, or even to the more naturalistic effects of illumination. It is evident from the main depictive theme in Braque's *Standing Figure* (Figure 5.48) that the artist is attracted to the experiencing of massive forms. Yet the painting is handled in a manner that embraces many of the engaging devices of more two-dimensionally conceived images. Again, a penetrating grasp of the structural and dynamic nature of a subject's forms leads to original solutions. The figure paintings by Titian and de Kooning (Figures 5.32 and 5.40), or those by de Staël and van der Weyden (Figures 1.11 and 3.10) while differing greatly, are hardly extremes of response to human forms and dress, but they suggest something of the limitless range of imagery that felt analysis can encompass.

TEXTURE IN PAINTING

The element of texture in painting has two identities: it is manifested in the representation of the surface character of physical objects such as cloth, grass, skin, metal, etc., and in the surface character of the painting materials themselves—the density of the paint or chalk, the manner of their application, and even the smooth or rough grain of the support. In its first sense, texture includes patterns such as stripes, plaids, and so on, and the "textures" that result from the repetition of things in an area. For example, a flight of birds or a cluster of leaves, if seen as a busy pattern of small forms in contrast with their surrounding, simple background, functions as texture. In its second sense, texture includes the textures of the elements themselves—the patterns of lines, values, colors, or masses, when they form a discernibly differing surface quality from surrounding elements. For example, the red spots of color in Plate 3, or the curved edges and shapes throughout Figure 5.26 act as textures.

We can even regard the rectangular shapes in Plate 7 or in Figure 5.13 to be functioning as textures. In Figure 5.37, the texture of the delicate lines of the buildings on the left differs from the bolder texture of the darker lines nearby. But in its second sense, texture is more often evident in the application of the paint itself. For example, the texture of the paint in Figure 5.33 differs greatly from the paint texture in Figure 5.43, and in Figure 5.16, the texture of the brushstrokes of the head is unlike that of the background.

Like the other elements, texture, in either of its manifestations, is an agent of design and of expression. Although an overbearing concentration on the textural nature of the things depicted has been the ruination of many paintings, texture in its second form is a given condition of painting and thus cannot be disregarded.

Textures that reproduce the surface quality of known things can be a source of dynamic activity, can amplify expression, and can be subtle unifiers of an image. All three functions are evident in Cassatt's *The Bath* (Figure 5.49). The flower patterns of the wall and bureau, in activating the upper part of the background, serve as foils that reinforce the more stilled "frozen moment" of the depiction, just as the pronounced patterns of the woman's robe and the oriental rug, in contrasting with the child's more "unadorned" texture, emphasize the velvety smoothness of her skin. Further, by encircling the child, the variously textured areas, more like each other in their complexities than any is like the simple surface of the child, unify into a large, enveloping field, broken only by the jug in the lower right corner, an inanimate echo of the texture of the child's skin, as well as a form that prevents the child from being too isolated in the design. Notice that Cassatt avoids overstating any texture. To do so would call too much attention to itself. Whether it is the varnished bureau, the hair's sheen, or the coarse textures of the towel and rug, textures are always discreetly suggested, not exhaustively detailed.

Yet, even when the texture of things *is* emphasized, the sensitive painter never treats them as ends in themselves, but as necessary qualities in the painting's expressive order. In Flinck's *Bearded Man with a Velvet Cap* (Figure 5.50), the strong undulations that animate the

Figure 5.49
MARY CASSATT, *The Bath* (1891)
Oil on canvas, 39 × 26 in.
The Art Institute of Chicago.

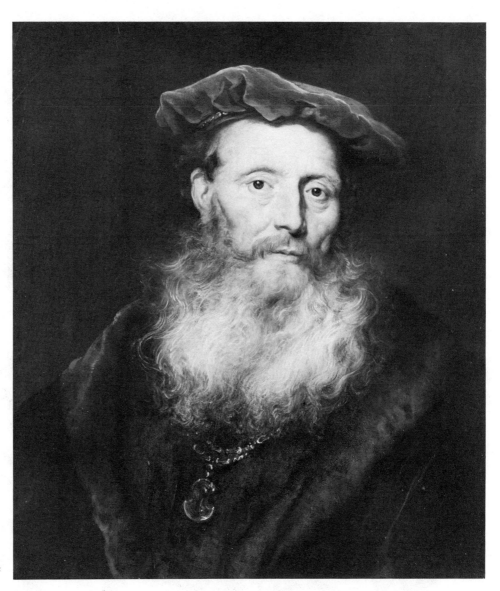

Figure 5.50
GOVAERT FLINCK
Bearded Man with a Velvet Cap
Oil on wood, 23¾ × 20⅝ in.
The Metropolitan Museum of Art, Bequest
of Collis P. Huntington.

cap, head, beard, fur collar, and pendant are all of a piece in their spirited movement. They impart an appealing liveliness to the sitter and a vitality to the design.

The severe textural character of Beckmann's *Still Life with Skulls* (Figure 5.51) is eloquent in its expressive consequences. The texture of the shapes, like cruel shards of glass, the coarse texture of the paint, the ruthless patterns of brushstrokes, and even the harsh texture of the dark and light values all abstractly evoke what the depiction describes.

By way of contrast, the textures in Murch's *Transformer* (Figure 5.52) effect a poetic metamorphosis of the subject that does indeed "transform" it into a moving visual simile of solitude. This sensitive artist, in finding a compelling human theme in a piece of

discarded machinery, reminds us that in painting, expression is more a matter of *how* we see than *what* we see.

Texture is so important for some artists that they find the textural range of a single medium to be restricting. They may then combine media or even add various materials to the work—a form of painting called *collage*. The Cubist painters were attracted to the visual possibilities of such real and imitated textures, often adhering paper, cardboard, fabric, and even chair-caning to the support, sometimes matching the textures of these materials in paint. Other artists merely regard such additions as extensions of their painting materials. And usually the colors and surface effects of such works do provide a visual dimension that paint alone cannot duplicate. Note, for ex-

Figure 5.51
Max Beckmann, *Still Life with Skulls* (1945)
Oil on canvas, 21¾ × 35⅛ in.
Museum of Fine Arts, Boston.
Gift of Mrs. Culver Orswell.

Figure 5.52
WALTER MURCH, *Transformer* (1965)
Oil on canvas, 38 × 28¼ in.
Museum of Art, Rhode Island School of Design.
Gift of Gail Caroll Silver.

Figure 5.53
ROBERT MOTHERWELL
Pancho Villa, Dead or Alive (1943)
Gouache and oil with collage, 38 × 35⅞ in.
Collection, The Museum of Modern Art, New York.

ample, Motherwell's *Pancho Villa, Dead or Alive* (Figure 5.53), where the cardboard, paper, and cloth additions supply a droll visual pun that reinforces the painting's title.

Most painters, however, regard the element of texture as one more manifestation of the paints they use and do not single it out for special consideration. They find their creative themes in no way limited by being restricted to paint. Indeed, the interest of many artists in texture is mainly concentrated on the paint texture of their works—the kind of surface "fabric" the paint yields—for the physical character of the paint itself bears part of the painting's meaning.

This can be seen by comparing the paint textures of three portraits, each concerned with volume and light, and more or less objectively interpreted. But because each intends a theme that differs from the other two, each shows a different paint texture in keeping with the artist's goal. In the Pisanello (Figure 5.54), the delicate graduations of the tempera paint gently model the forms, the paint texture revealing the same refined precision that characterizes the work in general. The image evokes a stately tranquility and the paint texture, like the finely crafted forms it caresses into being, reflects this.

But in Figure 5.55, Van Gogh's zealous determination to fully explore the terrain of the subject's forms produces impastos made of "schools" of strokes, crowded along various routes like fish moving in a stream. The dense texture of the paint and the bold texture of the brushwork express both the strong forms of the sitter and the artist's fervor in seizing them.

178

Figure 5.54
PISANELLO
Portrait of a Princess of the House of Este
Tempera on panel, 17 × 11¾ in.
Cliché des Musées Nationaux, Paris.

Figure 5.55
VINCENT VAN GOGH
Working Girl
Oil on canvas, 35 × 24 cm.
Vincent Van Gogh National Museum, Amsterdam.

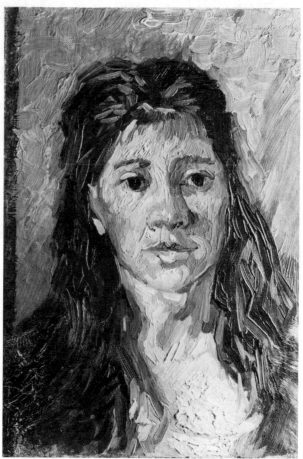

Figure 5.56
EARL KERKAM, *Self-Portrait* (1953)
Oil, 24½ × 19 in.
Hirshhorn Museum and Sculpture Garden, Smithsonian Institute.

The search for large forms emerging as from an atmospheric veil leads Kerkam, in Figure 5.56, to still another kind of paint texture. Thin washes of colors stain a still visible and broadly stated underpainting, settling in crevices and even running down the canvas. The overall fluidity of the paint, and the loose texture of the scribbled brushwork, in reducing forms to generalities, support the artist's theme.

Although these three examples hardly exhaust the vast textural possibilities of painting, they do suggest that texture is an element to be considered. More than that, like the lines and tones of drawing, texture, at least in its second sense, reveals our emotional and perceptual involvement—or lack of it. But a conscientious effort to employ paint textures that will support our intentions often fails to convince. The best textures and handling result from the most ardent involvement. Our handwriting will reveal our excitement when we write to tell a friend about the fortune we've just inherited; it will not show such undertones when we write out a laundry list. Likewise will our brushwork reveal earnest excitement, delicacy, or certainty when those emotional states are genuinely felt.

FUNCTIONS OF COLOR

Finally, the element of color, more thoroughly discussed in Chapter One, is here only briefly examined as a factor in the dynamic life of paintings. As we have seen, color can be an *exponent*, and not only a property of form. It can, along with line, shape, value, and texture, actively participate in creating volume and space, instead of merely assigning to them differences of hue.

But colors, by their various bright or dark values, their differing intensities, and by their relative "temperature," that is, their warm or cool qualities, in forming visual relationships based on these properties, are powerful modifiers of the other elements. For example, in any black and white reproduction in this book our eye follows tonal roads, but the same painting, if seen in color, may have the eye take other roads based on hue or intensity relationships.

This happens in Cézanne's *The Basket of Apples* (Figure 5.57 and Plate 4). In the black

and white state the fruit in the basket divides into a dark-toned group above and a light-toned group below. In the lower left corner, the two dark-toned parts of the table move together under the light-toned drape (which here, relates with the other light values in the fruits, dish, and bottle). But in Plate 4 a diagonal road of green colors moves diagonally down through the basket of fruit and, crossing horizontally to the right side, reappears in a muted state upon the table top and even in the background. No clue of such a movement is provided in Figure 5.57. In the color plate, the two dark-toned parts of the table in the lower right are no longer so fully allied; each is a member of opposing color patterns. And the light-toned drape, a light blue color, now relates with the dish and the bottle's highlight, but strongly opposes a visual bond with the light-toned yellows in the fruit.

Similarly, in Plate 6, the green, shaded part of the head and the reddish-browns of the beard show their contrasting shapes clearly, as do, on the left side, the green-ochres of the background and the violet passage of the shirt. But a black and white reproduction would show both of these areas fused by values; in the head the dark tone would too strongly move across the face; on the left side the figure's form would dissolve into the background. Also in black and white there would be no way of recognizing the artist's intended bond among the green tones that occupy much of the upper half of the painting, the delightful and necessary opposition by the light blue of the shirt to the overall green-gold state of the upper half, or of recognizing the role color plays in the modeling of the head.

Like the other elements, which suggest motion through any discernible sequence of change in size, location, shape, or value, any changes in a color's hue, value, or intensity suggests movement—energy. Just as we sense motion when a group of lines or shapes shows gradually decreasing intervals, or undergoes a change in size or configuration, or when a sequence of tones moves from light to dark, so do we sense a moving energy in a gradual shift from say, yellow ochre to cadmium yellow. Thus, in Plate 4, the increasing brightness of tone and the shift from green in the apples on the far left, to greenish-yellow in the apples on the right, implies movement, as do the color

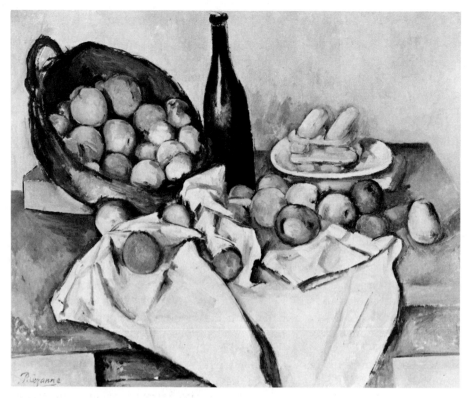

Figure 5.57
PAUL CÉZANNE, *The Basket of Apples* (ca. 1895)
Oil on canvas, 24⅜ × 31 in.
The Art Institute of Chicago.

changes in the wooden table top. In Plate 9, the subtly changing colors of the entire background, and of the building and parts of the figures' costumes invest the painting with quiet tremors that activate the design.

Nor do such graduations in hue, value, or intensity need to be contiguous. We sense movement even when such changes are interrupted by large intervals. It is difficult to see the flower in Plate 12 as anything but a culmination of intensity and movement of the leftward-moving "storm" of red in the woman's cloak. And in Harnett's *Old Models* (Plate 14), the outer ring of warm tones, comprised of the hinge, key plate, books, and violin, form a pattern of motion that contrasts with the inner zig-zag of the yellow-toned objects.

Sometimes, as in Plate 3, the energy is as much a matter of pulsations as of directed motion. Here color intensities and brightness seem to burst in sequences of yellow, white, red, and blue from the intentionally dulled green tones of the foliage. These jewel-like flashes of color would be meaningless had Klimt used intensely strong greens for the leaves and grass that surround the flowers.

In Plate 10, Shahn uses color as one of the several means for explaining in which direction the children rotate. Two of the strongest clues are, of course, the gesture and back view position of the child on the far left; it would be difficult to see this child as turning about the pole in a counter-clockwise direction. The gesture and tilt of the child in the center again suggest a clockwise movement (note how the legs are drawn as if running to the right). But if the movement is to be clockwise, then the child on the right side must be made to move in the opposite direction, and here Shahn uses the bright reds of her blouse, the wallpaper in the bombed out building, and in the pole to reinforce her required leftward movement. The association of these three red shapes is inescapable and, urged on by the left-leaning building, we tend to see the child as moving toward, and not away from the center of the painting. But in Figure 5.58, the absence of the red color bond between the three areas described above has the effect of making the child on the right seem more fixed in her position and unaccountably related with the dark tones in the building's shattered roof. Note,

Figure 5.58
BEN SHAHN, *Liberation* (1945)
Egg tempera, 29¾ × 39¾ in.
Collection James Thrall Soby, New Canaan, Connecticut.

too, that the central figure, without the cool, receding green of the dress to separate her from the warm, advancing red of the pole, appears to have run into it.

Beginners sometimes gravitate to strident color combinations, often pitting the three primaries against each other, although the colors red, yellow, and blue have the least to do with each other. Even complementary colors, in mutually supplying the other's color opposite (see, Complementary Contrasts, Chapter One), provide a kind of completeness missing among the primaries. Arrangements among secondary colors and among all other colors show varying degrees of color relationships: orange and green both share yellow, purple and burnt sienna have an underlying bond of red, and so on.

Paintings based on an arrangement of primary colors *are* quite manageable, but only when one of the primary colors dominates, or when the three colors are related by at least some gradual color or value transitions between them, or are so interlaced in small shapes and daubs as to lessen their mutually isolating tendencies. We can see this in Johns' *Numbers in Color* (Plate 15), where the primaries are so finely interworked as to create a mellow overall color. Frequently, as in Plate 6, painters desiring strong color intensities tend to employ the secondary colors more liberally, and the primary ones, more sparingly.

Other beginners go to the opposite extreme, avoiding any approaching purity or intensity of hue by graying their colors, or by dulling them through complex mixtures of many colors. Often their paintings are dark in key and appear to have an overall brown or muddy effect. Such muddy works suggest a wish to avoid color altogether and return to tonal drawing, or to emulate the darker, warmer color key of many of the old masters. But, as an examination of the best of such masterworks quickly shows, the color (when not obscured by layers of darkened and yellowed varnish), while sometimes of a lower tonal register, is invariably resonant and fresh.

Many fine colorists of widely differing visual interests tend to use few colors. But they use them less brilliantly or liberally than the strident type of beginner might, and in richer confrontations and fusions than the color-shy

type of beginner would. In Plate 6, except for a few small daubs, there are no pure reds, yellows, or blues, nor any pure secondaries. Each color is a mixture, with one of the above colors strongly dominant, but rarely seen alone. Even in Plate 15, the primaries are only occasionally used in a pure state; most of Johns' colors are mixtures and often tinted with white.

The best colorists generally integrate brilliant and muted colors, with one or the other of these groups dominating. That they do so is not a matter of style or aesthetic good manners. They do so in order to give their works color variety and meaning in the design. Even the clamorous intensities of Fauve paintings, of which Plate 6 is an example, are usually relieved by subdued passages of color, if only sometimes through the device of leaving some of the white canvas as part of the completed work.

Unrelieved extremes of color intensity, like unrelieved muted color, often defeats itself. For, just as the brooding mood of a dark-toned painting is magnified by a counterpoint of light tone (Figure 5.25), so is the strong, gentle, or sonorous thrust of a painting's color function clarified by some opposing color notes. We have already seen how Klimpt (Plate 3), to give visual meaning to the rich color of the flowers, muffles the intensity of the green foliage. Likewise, the mellow serenity of Klee's color (Plate 7) is amplified by the several light, intense colors, and how the quiet of Degas' color (Plate 13) is further subdued by the few sparkling colors such as those of the flower reproductions, the book on the table, and among the patterned papers within the frame in the upper right corner. As this Degas shows, compelling color events need not involve emphatic confrontations, but can often concern extremely delicate sensations.

In this work Degas creates a gradually changing pattern of colors that grow subtly cooler and darker as they descend in the composition. Beginning with the yellow-white tone within the frame at the upper right, and continuing in both the golden and mauve segments behind the figure, Degas completes this transition of color and value with the warm gray of the trousers. That each of these areas is roughly alike in shape and in scale relative to other areas in the painting further underscores

their relational color and value role. Interestingly, the two lighter segments, because of their similar color, value, shape activity (texture), and flower illustrations, are not part of this changing pattern but, by their diagonal orientation, join to counter the diagonal position of the figure's torso, thus stablizing the design.

Bonnard's unique use of color for organizational and expressive purposes is well demonstrated in *Breakfast* (Plate 18). It is immediately apparent that Bonnard is less concerned with illumination than with the kind of inner light that emanates from the play of the colors themselves, and that perspective and structural modeling and the tonalities that such considerations require are largely subdued, enabling the abstract color dynamics to play a dominant role.

The small blue cup acts as a vital link between the left and right sides of the composition, which isolate each other when we cover the cup with a bit of paper. It serves as a blue "sun" holding the smaller or duller blue "satellites" throughout the work in "orbit," as the white tablecloth does for the small areas of white in the painting. Because of their somewhat isolated position the blue cup and brown pot increase in visual weight, just as the figure's visual and physical weight is lessened by being "hidden" among colors and values similar to it. The brown pot, along with the other dark-toned or richly colored objects on the table form an arc that reverberates in the design in two ways: by the discreet repetition of the arc in the alignment of the figure's shoulder and head with the curving mass of the flowers on the left, and as strong color notes that are echoed throughout the design in numerous tints, shades, and variations. Further, the brown pot, by departing from the dominant value and color-character of the painting, enhances these qualities.

Like most of the best exponents of color, Bonnard provides a painting with a major color theme, and a minor opposing one. Here, the overall golden tone of the intense and dulled yellow, orange, and red hues, along with the various tints and shades of these colors dominate the scene, while flashes of blue serve as contrasting accents that heighten the warmth and charm of the painting's major color theme. Note how the several purple and violet-pink tones, colors that have hue "loyalties" to both the major and minor color patterns, act as bridges to link up warm and cold colors. It is important for the beginner to recognize the near universality of such color themes. That this occurs in works of widely divergent styles and purposes is evident in paintings as different as those of Turner and Klimpt (Plates 2 and 3). In the Klimpt cool colors predominate and are relieved by warm ones, while the reverse occurs in the Turner.

Implicit in the foregoing is, of course, color's strong emotive powers. Unlike the other elements, which often require a degree of effort on our part to comprehend, color meanings strike instantaneously. For example, except for the most simple shapes such as the circle, the triangle, and the square, whose configurations are immediately evident, our eyes need to examine the boundaries of shapes to figure out their visual state and purpose, or to actively unravel the descriptive role of a calligraphic line or a texture. But a color's impact is immediate—as is the psychological mood of a painting's total color-character. Paintings that speak *through*, and not *with* color instantly express an attitude that helps to convey the emotive meanings of the image, and this is in turn intensified by the behavior of the other elements that constitute the image. For example, even when, to lessen the clarity of their figurative condition, Plates 5 and 9 are viewed upside down, their expressive moods are essentially unchanged. The mystery of the Redon and the melancholy of the Picasso continue to communicate through the color; we are unlikely to feel either should be re-titled *Happy Birthday*.

Because the expressive force of color is somewhat autonomous, highly abstract and nonobjective works can evince all manner of provocative or pleasant moods through its use. The purposely ambiguous mood of Willem de Kooning's *Excavation* (Plate 17)—a kind of quiet frenzy—is immediately intimated by the dual nature of the color. The vast expanse of the muted, warm gray tone strives toward becoming a pure yellow, occasionally falling just short of it. This color tension is consistent with the recurring breakthrough of fresher colors, which only rarely assert themselves; we are

teased by glimpses of a kaleidoscopic play of color that struggles for existence in the storm of the torn, grayed shapes. And these shapes themselves struggle to become masses or simply to be seen; for almost none possess a complete boundary, but are fused or intermingled with other shapes in equivocal unions. The ambiguity and tension among the colors and shapes defeat our attempts to locate form and space or to orient ourselves to the color's "stance." The artist, in devising such an elusive set of visual circumstances—the shapes even elude being described as elastic or rigid, just as the entire design seems both graceful and grating, symmetrical and scrambled—creates the visual equivalent of the turbulent and rootless state felt by many in the face of political, social, or personal crises, and the color's shifting mood helps to say this.

Color's unique functions, whether as a shaper of form and space, as a participant in the design, or as an emotive voice, lead many painters to regard it as the queen of the visual elements. And though they hold it to be the most strongly expressive and visually imposing of the elements, they also recognize it to be the most elusive and intangible one. Most painters will agree that felt perceptions and intuition are the best guides in leading us to the colors *necessary* to our intent. Matisse put it this way: "The chief aim of color should be to serve expression as well as possible. . . . My choice of colors does not rest on any scientific theory. . . . I merely try to find a color that will fit my sensation. There is an impelling proportion of tones that can induce me to change the shape of a figure or to transform my composition. Until I have achieved this proportion in all the parts of the composition I strive towards it and keep working. Then a moment comes when every part has found its definite relationship, and from then on it would be impossible for me to add a stroke to my picture without having to paint it all over again."

The composition of a painting's color, then, is as integral a part of the final work as the linear or tonal composition which it shapes and is shaped by. Color is capable of powerful organizational and expressive force. But if it is to deepen, and not diminish meanings—and it *always* does one or the other—it must not be restricted to mere description or decoration. Its strengths lie not in sensory amusement but in visual and spiritual enlightenment.

SUGGESTED EXERCISES

Most of the following exercises are too demanding of time and skill to attempt in a concentrated period of painting. They need not be begun until you have completed reading the book, or have gained enough technical and visual control over the material dealt with in the preceding chapters. They are intended to serve as a long-term list of painting projects that will test various aspects of your organizational and expressive strengths. They can be done in any order, can be used as a guide in independent study, and can serve in a formal course of study as a rough outline of painting projects, or as points of departure for still other projects.

Because it is vital, as young painters develop their skills, to develop faith in those responses that voice their deepest visual and expressive interests, the exercise descriptions depart somewhat from the format of the earlier chapters, in the direction of brevity and generality. Unless otherwise noted, now the choice of media, subject matter, size, and manner of handling are up to you. For, in the end, it is not so much a matter of how well you can graduate values, construct solids, or create textures as ends in themselves (or for assigned goals that do not excite your imagination), but how well and how far these skills need to be pursued to enable you to convey your creative interests with persuasive fluency. Testing such skills in creating the kinds of images you desire is both more logical and more likely to succeed.

While some of these exercises can only be realized by working from observed subjects in an analytical manner that aims at establishing certain truths about the subject's actualities, it is best to think in terms of expressing the subject's essential visual and emotive character by utilizing the abstract energies of the elements, and not merely by recording surface conditions. But there is no reason why other exercises cannot be executed wholly from your imagination, with the expanded freedom of choice and change that such envisioned themes promote. Given the varying nature of these exercises, you may wish to treat some more subjectively than others. As long as the final results of each work reflect a system of expressive order stemming from a strong desire to fully experience something observed or envisioned, and do not suggest willful and arbitrary indulgence of whims,

the form your images take has a legitimate claim to serious evaluation as art.

Most of the paintings reproduced in this book are executed in oils. Either oil or acrylic paints will serve well for these exercises, especially those you choose to approach in an indirect manner, or where extensive changes or pronounced paint textures occur. Other media can of course also be used. Ideally, a few projects should be done first in one medium and then in another different one, so that you may note the strong influences of materials on conception and interpretation.

Paintings used as examples in the text are often referred to in the exercises. These references should serve as reminders and rough guides. It is not intended that your painting need necessarily reflect their style, subject, or technique. Approach these exercises in whatever way you feel best suits your present skills and interests.

1. *Personal color chart.* Few beginners realize that they tend to favor a particular range and type of color. This exercise is designed to help you explore your present, personal color preferences and sense of color harmony. On a suitable support, rule a horizontal rectangle 1 inch high by 12 inches wide, and divide it into twelve 1-inch squares. In the square on the far left, paint in any color you *like,* a favorite color, or one that suits your present mood. In the square next to it again paint in a color that you like, which you feel is a harmonious partner for the first one. Continue to add colors to each square, basing each choice on its congeniality and rapport with the colors already on the chart. The only criterion is your judgment as to each color's compatibility with the rest, and not on making a balanced or necessarily multicolored row of colors. They may be tints, shades, mixtures, and colors used as they come from the tube or chalk. When you have filled in the entire row, continue to make changes, adjusting or even replacing any colors you wish, to more nearly establish twelve colors that you enjoy seeing together.

No doubt you will select somewhat different colors if you redo this exercise in a month or so. You may find that your mood dictates the kind of chart that results, and that doing another chart in a few days or even a few hours later, when you are feeling differently, will affect the results. But if you collect some eight or ten of these charts painted over a period of months, they will usually show a basic similarity. Some students will produce mainly muted and dark charts; others will veer to light-toned charts of mainly warm tones; still others will tend to favor intense hues offset by a few dark, earth colors; and so on. Each of us, at all times, has some particular color tendencies, and knowing which colors attract you can have important expressive significance.

2. *Line as line.* Do a painting in which painted lines play a principal role, but are fully integrated in the design. Refer to Figures 1.1, 1.2, 1.13, 3.2, 5.3, 5.40, 5.51, and 5.53.

3. *Implied line.* Do a painting based chiefly on strong directed movements implicit in the alignment of its parts. Refer to Figures 1.4, 1.9, 3.13, 5.2, 5.7, 5.9, 5.24, 5.31, 5.36, and 5.54, and Plates 4, 8, 14, and 19.

4. *Shape predominant, volume and space.* Do a painting of masses in a spatial field wherein shape is a leading theme in the design. Refer to Figures 1.8, 3.5, 3.11, 3.22, 4.9, 4.10, 5.10, 5.11, 5.13, 5.25, and 5.31, and Plates 8, 9, and 13.

5. *Shape predominant, primarily two-dimensional.* Do a painting chiefly conceived in two-dimensional terms, or in which the dynamic activities of the picture-plane are emphasized, mainly by shape. Refer to Figures 1.11, 3.8, 5.12, 5.39, 5.48, and 5.57, and Plates 7, 15, 17, and 20.

6. *Brushstroke shapes.* Do a painting whose imagery emerges from the shapes made by a pronounced use of the brush and/or painting knife. See Figures 1.11, 1.15, 5.16, 5.17, 5.19, 5.38, and 5.55, and Plates 6, 11, and 18.

7. *Tonal painting according to Figure 5.27A.* In this painting use values to state the tonal range and the tonal subtleties that explain the structure and space of an observed subject's *more illuminated parts,* simplifying the form and space of its darker passages with the few dark values remaining in the tonal range of your paints. Refer to Figures 1.4, 1.7, 3.12, 4.2, 5.7, 5.16, 5.28, 5.42, 5.47, and 5.50, and Plates 12, 13, and 14.

8. *Tonal painting according to Figure 5.27B.* Do a painting in which most of the values are used to state the tonal range and the tonal subtleties

that explain the structure and space of an observed subject's *less illuminated parts*, simplifying the form and space of its lightest and darkest passages with the few darkest and lightest values remaining in the tonal range of your paints. Refer to Figures 1.8, 1.9, 3.13, 5.8, 5.9, 5.13, 5.20, 5.29, 5.45, and 5.55, and Plates 4, 10, and 19.

9. *Tonal painting according to Figure 5.27C.* Do a painting in which most of the values are used to state the tonal range and the tonal subtleties that explain the structure and space of an observed subject's darkest parts, simplifying the form and space of its lighter passages with the few light values remaining in the tonal range of your paints. Refer to Figures 3.11, 3.15, 3.20, 3.23, 5.17, 5.26, and 5.30, and Plates 2 and 11.

10. *Restricted tonal painting.* Do a painting whose tonal design is principally based on no more than three or four values. Refer to Figures 1.2, 3.4, 3.10, 5.10, 5.12, 5.23, 5.24, 5.25, and 5.56, and Plates 6 and 18.

11. *Balance of visual and physical weight, #1.* Do a painting that achieves balance by countering a visual weight on the left side of the design with a physical weight on the right. Refer to Figures 1.2, 2.2, 3.13, 3.15, 3.21, 5.7, 5.22, 5.30, 5.38 and 5.58, and Plates 8, 10, and 18.

12. *Balance of visual and physical weight, #2.* Do a painting that achieves balance by countering a visual weight on the right side of the design with a physical weight on the left. Refer to Figures 1.10, 1.14, 1.15, 3.11, 5.10, 5.24, 5.26, 5.40, and 5.42, and Plates 2, 4, and 12.

13. *Balance of masses in space.* Do a painting that achieves a balanced arrangement of the masses in the field of depth, as well as a balanced design of the elements on the picture-plane. Refer to Figures 1.4, 1.8, 1.9, 1.10, 3.16, 5.6, 5.7, 5.9, 5.11, 5.17, 5.18, 5.19, 5.20, 5.21, 5.26, 5.42, 5.43, 5.47, and 5.49, and Plates 4, 9, 10, 13, and 14.

14. *Structural legibility.* Do a painting in which the forms are constructed through clearly defined planes. Refer to Figures 1.4, 1.7, 1.8, 1.15, 4.10, 5.3, 5.13, 5.16, 5.22, 5.23, 5.28, 5.32, 5.41, 5.45, 5.46, 5.47, and 5.55, and Plates 4, 6, 12, 13, and 19.

15. *Textures.* Do a painting which shows a use of both aspects of texture discussed in the text, and in which one of these aspects is dominant in the design. Refer to Figures 1.7, 1.8, 1.9, 3.3, 3.11, 3.20, 3.21, 4.10, 5.3, 5.7, 5.10, 5.18, 5.21, 5.22, 5.32, 5.43, 5.49, 5.50, and 5.52, and Plates 3, 10, 12, and 14.

16. *Motion through color.* Do a painting in which graduations of color and intensity are the foremost dynamic factor in its organization. Refer to Plates 5, 6, 7, 8, 11, 15, 16, 17, 18, 20, and 21.

17. *Intense color.* Do a painting whose colors are predominantly strong in hue purity, but which may show some passages of muted colors, or colors low in hue brilliance. Refer to Plates 6, 8, 16, 18, and 20.

18. *Muted color.* Do a painting whose colors are predominantly grayed and muted in hue brilliance, but which may show some small passages of more intense color. Refer to Plates 7, 9, 12, 13, 14, and 19.

19. *Structure through color.* Do a painting in which color strongly participates in the construction of masses in space. Refer to Plates 4, 6, 8, 9, and 11.

20. *Expression through color.* Do a painting whose expressive theme is predominantly conveyed by color. Refer to Plates 5, 7, 15, 16, 18, 20, and 21.

SIX
motives
and themes

In this chapter we will look at the interplay of media and motives, and expand our focus to include various other painting issues not touched on earlier. Finally, we will examine some visual themes and tactics that the young painter may wish to consider both as tests of skill and as a means of broadening his or her conception of what the purposes of painting might embrace.

MATERIALS AND MEANINGS

Our discussion of painting fundamentals has concentrated on two seemingly independent considerations: conception and craft. But these two factors—what shall I paint? and how shall I do it?—are related in two important ways. Each influences the visual and expressive character of the other, and both influence the kinds of perceptions and judgments we make when painting. We choose a particular medium for its suitability to express a certain visual conception, only to find that, as the painting de-

velops, the medium provides unexpected opportunities for (and obstacles to) expression that influence our choices and hence, our conception. But because we strongly intend a certain result, we insist that the medium serve us in certain other ways that show some new inflections of its use, thus redefining its potential for both artists and viewers.

Further, in using a particular medium for a certain result, we consult both factors in making our perceptions and judgments. That is, we search for different things when using, say, oils, than when we use pastels or watercolors. For example, in Figure 3.13, Wyeth's treatment of shape, value, and color, his handling of the paint, and the resulting clarity of the forms are all affected by (*and* affect his use of) egg tempera's special qualities and restrictions. The same subject, painted in transparent watercolor, would result in a somewhat altered theme. Watercolor's own qualities and restrictions, along with the artist's particular manner of using the medium, would shunt the kinds of perceptions—of choices—he would make onto other tracks of inquiry and usage.

189

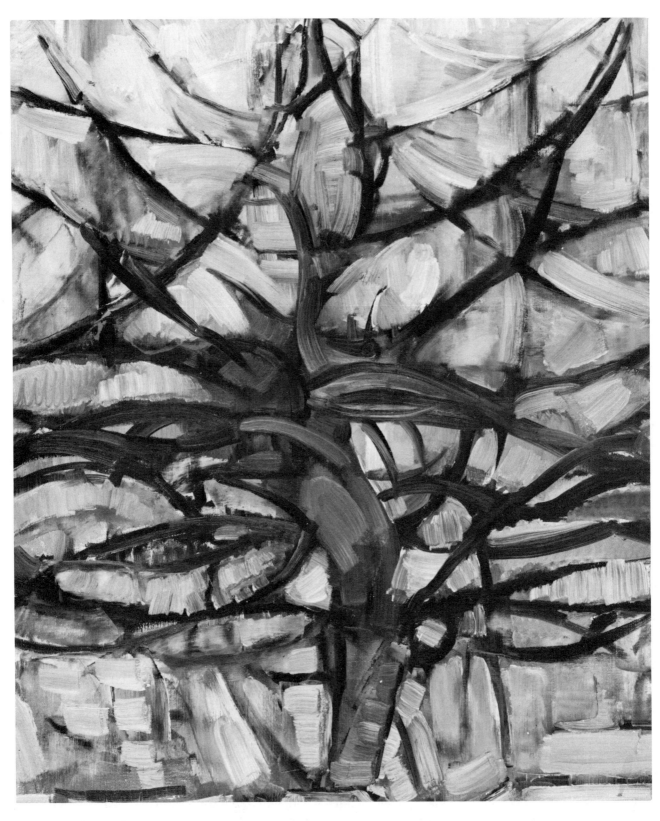

Figure 6.1
PIET MONDRIAN, *The Gray Tree* (detail)
Collection Haags Gemeentemuseum, The Hague.

Wyeth's choice of medium is a good one to achieve the precise and tranquil nature of the imagery in Figure 3.13, just as his choice of medium is right for the psychological tone and livelier spirit of Figure 3.21 or 5.10. But it is safe to assume that in each case the medium suggested nuances of treatment that changed, if only moderately, the original conception. For the act of painting is not entirely a matter of fixed, conscious will. Ideas, options, intuitions, and obstacles occur at every moment as the work develops, and highly responsive artists rule out no technical or perceptual insight without first sensing its rightness or wrongness for their intentions in a work.

Again, in Figure 5.46 and Plate 9, or in Figure 4.7 and Plate 11, craft, conception, and perception interwork in subtle ways. Picasso and Cézanne alter their handling and purpose in each case partly because their media is changed, and they change their media partly because their themes have altered. Oils can certainly produce the delicate color quality of Picasso's gouache or the airy sparkle of Cézanne's watercolor, but these water-based media are more easily suited to such effects than are oils, just as oils are more naturally adaptable to the modeling of structurally emphatic masses or powerful brushwork (Figure 6.1) than are watercolor or gouache. Whether the medium affected the character of the image, or the desired image affected the choice of the medium, comparing the two examples by Cézanne and by Picasso suggests something of the influence that the medium has on meanings, and vice-versa.

The range of effects of most media is considerable, and it would seem that the above remarks can be neutralized by pointing to Sandby's use of watercolor, which is precise, and to Shahn's use of egg tempera, which is rather free in handling (Figures 3.15 and 5.58 or Plate 10). Then, too, there are the many kinds of surface effects possible with oil or acrylic paint. But there remain differences among media, and among artists using the same media, which force differences, obvious or subtle, in the results. Had Sandby used tempera, and Shahn watercolor, their resulting works, for better or worse, would not show the same conception in another medium; they would be works different in form and meaning. And some of these differences cannot be predicted in advance. For example, in Schiele's *The Artist's Room in Neulengbach* (Figure 6.2), thinned oil paint is applied to a rather non-absorbent surface and tends to slide about in unpredictable ways. Noting the tones and textures of the thinly painted passages, Schiele's response elsewhere in the work takes those effects into account. Indeed, there is a pattern of thinly painted areas that confronts a pattern of heavier paint areas. Even the kinds of edges that thin paint produces becomes a factor in the organization of the whole, and their crispness here is as much a technical, as a conceptual matter. Such edges in pastel or egg tempera are unlikely, just as pastel's charming grain or tempera's luminous opalescence cannot easily be duplicated here. To have painted this scene in either of these media would have resulted in other percepts, other relationships, and hence, in a different set of meanings.

There is, then, an interplay between materials and purpose that the beginner should take into account. It is no exaggeration to note that the medium an artist chooses, and the size, shape, and physical composition of the support are four of the most critical early judgments to be made in the realization of a work's intended goals. In fact, the first stroke made in a painting is the fifth, and not the first step in its progress toward completion.

That the choice of size is no casual matter can be seen by comparing Plate 17, a work almost 7 by 9 feet, with Monet's *Fish* (Figure 6.3), which is only 14 by 19¾ inches. One of the frustrations of viewing reproductions in a book is that we get the false impression that the originals are fairly alike in size. But if we can imagine ourselves centered before the de Kooning, and standing some four or five feet away from it, we may sense something of the overwhelming impact of its ambigious actions moving over our entire field of vision. Had the artist attempted to paint this image in the small scale of the book's reproduction, both technical and conceptual differences would have had their inevitable influence, and a different image would have resulted. An important way in which this reproduction (or any of the others) begins to *mean* what the original does, comes from our imagining its real size.

Monet's painting needs to be seen closer up, where we can enjoy the calligraphic action and luscious texture of the brushwork. He

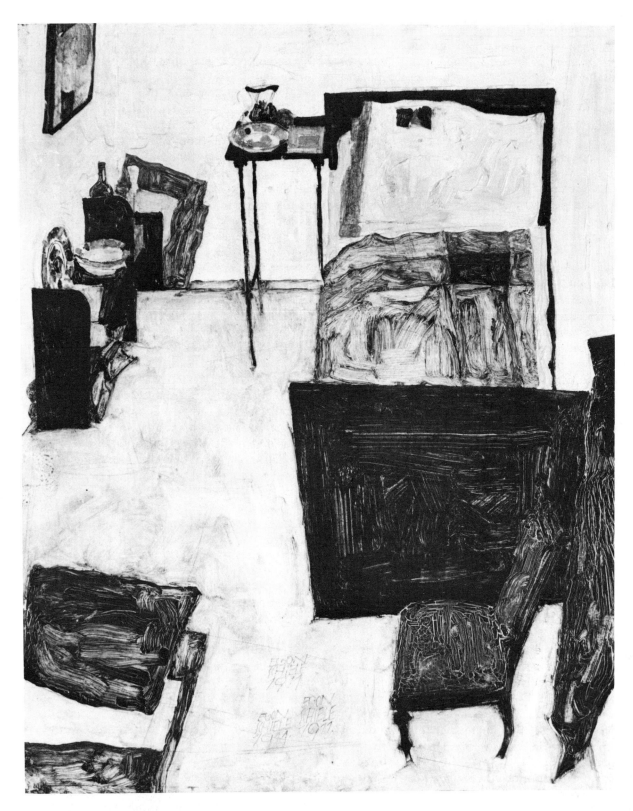

Figure 6.2
Egon Schiele
The Artist's Room in Neulengbach (1911)
Oil on wood, 15¾ × 12½ in.
Historical Museum of the City of Vienna.

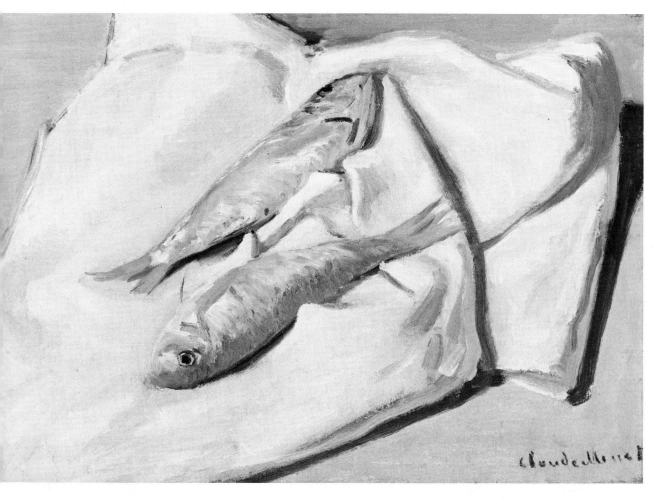

Figure 6.3
CLAUDE MONET, *Fish* (ca. 1870)
Oil on canvas, 14 × 19¾ in.
Fogg Art Museum, Harvard University.
Gift, Friends of the Fogg Art Museum.

might have considered such intimate form clarity and dynamic actions among small forms unnecessary had the work been much larger, where the viewer's necessary distance and the differing organizational needs of a larger scale work make such an emphasis less visually important.

In addition to a necessary scale, a particular theme requires a particular shape. The all over ferment of the de Kooning, caught up in flame-like and rotating movements that envelop the entire surface, benefit from the squat proportions of the picture-plane. But Monet's theme is better served by the longer-shaped canvas. For de Kooning to have called attention away from the all over turbulence of his image by using a long-shaped support would have weakened its effect. The design would then be competing with the inherent directed force of the support's long axis. Had he selected a long shape, the energies he would then have selected to "answer" the shape's inner forces would, of course, have led him to create an entirely different design.

Each rectangular shape offers its own pattern of diagonal lines running from corner to

Figure 6.4
Each number indicates the origin of a fan-like pattern in the design of Figure 6.3.

corner, and its own horizontal-vertical lines in some proportional relationship. Such sensed energies are already at work on the blank surface of the support and must be taken into account at the outset of a painting's evolution. We must fit our conception into the field of forces created by the support's shape.

In the Monet, the two sleek fish moving in opposite directions are alike in their obliquity and find reinforcement in the similarly directed lower part of the drape. Against this vigorous diagonal thrust the rectangular shape of the drape's upper part tilts downward toward the lower right corner, its visual weight providing the design's necessary equilibrium. This criss-cross design *uses* the support's longer shape, sending energies to all of its four corners.

A second, submerged, but important design strategy involves three fan-like patterns made up of edges and folds that likewise show a kinship with the support's shape, as Figure 6.4 illustrates. As with any good design, it is hard to imagine how Monet's could be improved upon by relocating any of its components or by changing the shape of the support.

Although the manner in which paint is applied is always a part of the painting's expression, some works, as de Kooning's and Monet's paintings suggest, show that paint can be a notably active dynamic feature. When this is the case, the paint film is not restricted primarily to the role of an impersonal or passive transmitter of the image, but is, by its varied textures, thicknesses, and shapes, a potent visual and emotive force, adding its own calligraphy and character to the design. De Kooning's alternating of smooth and scraped paint reinforces his equivocal theme, just as Monet's use of stiff but flowing paint underscores the rhythmic *and* the representational character of his subject with economical authority.

The handling of paint, then, like our use of the visual elements themselves, must be appropriate to our intentions. The best painters never enshrine their techniques, limiting themselves to a certain policy for applying paint; rather in searching for new meanings, they find new ways of extending their technique. They do not merely feed various kinds of subject matter through the attitudinal filter of a fixed technique, but suit both their concepts and their handling to their visual and tempermental impressions.

Sometimes, as in the works of Titian, Rubens, Rembrandt, Degas, and Cézanne, such changes in purpose and handling occur gradually over a period of many years. Other painters, such as Redon, Schiele, Picasso, and Diebenkorn show more frequent or marked changes, sometimes from work to work. Golub, in Figures 4.12 and 6.5, shows how much meanings may affect means and ends. In these two works the treatment of paint, of mass and space, and even the level of objectivity with

Figure 6.5
LEON GOLUB, *Franco* (1976)
Acrylic, 18 × 23 in.
Collection of the artist.

which the human head is stated are all affected by the differing themes. In the former, the raw warring of shapes, values, forms, and of harshly textured strokes, and the resulting emphasis of the work's two-dimensional state all force forward upon the viewer the rage and violence of combat. The furious visual noise of the elements, of the paint, and of the design is in sharp contrast to the delicacy and quiet of these factors in Figure 6.5. Now the paint is applied in gentle stains and scumbles, and in discreet linear strokes. Instead of a storm among the visual elements there is an almost becalmed state in which the ominous downward thrust of the dark collar and the casket take on eloquent meaning.

So much can paint lead the way in our reading of a work, that sometimes it seems as if the paint handling has shifted from being a means toward an expressive end which the technique amplifies, to being a principal part of a painting's purpose—as if the paint's behavior is now a leading part of the work's message. There can be danger here. The results of elevating paint to such a commanding role can be tantalizing or terrible, depending on whether the artist's motive is an experiencing of his materials' abstract dynamic powers or a performance of facile agility.

In the former instance, the paint acts as one more element in the family of visual elements, one called on to more forcefully be itself in the forming of the image. And, though the paint may then represent forms as if *they* are a vehicle for *its* expressive activity, it doesn't abuse its role in the design. Such a use of paint always works *with* the other elements to create an image in which there are visual and expressive meanings that go beyond those carried by the condition of the paint.

The logical necessity for the paint's forward role is then supported by the other visual elements as well as by the things depicted. This is well demonstrated by Thiebaud's *Cut Meringues* (Figure 6.6.), where the vigorously applied impastos of buttery paint not only hint at the tasty delight of such velvety desserts, but are in keeping with the strong character of these elastic wedge forms and rigid ovals, and with their rhythmic flow and beat. Here, the strength of the shapes, masses, values, and the impression of light, like the power of the paint handling *and* the actual nature of the subject matter all work together. Whether or not the role of paint is a leading device in a work, the union between a subject's essential nature and the artist's means of grasping it is a large part of what most paintings are all about. Van Gogh put it this way: "When the thing represented is, in point of character, absolutely in agreement and one with the manner of representing it, isn't it just that which gives a work of art its quality?"*

But when an artist's handling of paint is meant chiefly as a display of versatility, the concentration on such deftness all too often re-sults in an overbearing cleverness. More seriously, in the willful pursuit of facility as an end in itself, attention is diverted from a sensitive encounter with the nature of the things being depicted and from the needs of the design. Instead of the give and take of painting, a blend of desire and inquiry that wrestles with certain unique truths in the subject, and has useful creative expression and growth as a goal, the real goal of a fascination with deftness is the applause expected for a clever performance. An exaggerated concern with facility replaces the more demanding, and even painful, struggle to grasp the subject's elusive spirit, with the interesting game of processing all subjects through a pre-set formula for economical solutions.

Yet facility, understood as an effective fluency in the articulation of our discoveries and interests, is a necessity. Whistler was right to point out that, "To say of a picture, as is often said in its praise, that it shows great and earnest labor, is to say that it is incomplete. . . ."† It is only when this necessary skill is expanded into a major purpose that painting turns from the realm of creativity to that of sport.

Although the gifted painter Sargent reveals important creative strengths, especially in his early works, he frequently resorts to skillful mannerisms that purport to establish mass and space, but only hint at some aspects of these qualities, and not always the most vital or telling ones. Something of this breezy agility as an end in itself can be seen in *The Breakfast Table* (Figure 6.7). The artist's chief devices here are a heavy reliance on a graceful, almost windblown brushstroke to represent anything from a rose petal to a reflected light and, with few exceptions, on a forcing of the light-effects on forms, not so much as a means of suggesting mass, but rather to convey various surface effects. The flashy reflections of metal and glass too frequently overrule a reading of form and space. For example, if we turn the reproduction upside-down to view it, far too much of the clarity of the objects on the table and on the shelf beyond it is lost. The room's sense of airy space disappears, and objects seem isolated and randomly situated.

*From a letter to his brother Theo, June 9, 1889. See Herschel B. Chipp, *Theories of Modern Art* (Berkeley and Los Angeles: University of California Press, 1971), p. 43.

†James McNeill Whistler, *The Gentle Art of Making Enemies,* 1890. Reprinted by G. P. Putnam's Sons, New York, 1953, p. 115.

Figure 6.6
WAYNE THIEBAUD, *Cut Meringues* (1961)
Oil on canvas, 16 × 20 in.
The Museum of Modern Art, New York. Larry Aldrich Foundation Fund.

Figure 6.7
John Singer Sargent, *The Breakfast Table*
Oil on canvas, 21¾ × 18¼ in.
Fogg Art Museum, Harvard University.
Bequest, Grenville L. Winthrop.

In the context of the painting's objective realism there is no compelling visual logic to the near disappearance of the figure's torso or the oriental scroll's hovering location. There is only a weak order in the painting's form arrangement; the concentration on a facile rendition of each thing shown is achieved at the loss of a design theme for the depictive essay. Everything is about as important as everything else, and it is unclear what (beyond the accomplished agility of the brushwork) the artist is getting at. Similarly, at the dynamic level, there is an uncertain wandering of forces. What necessary functions as weight, value, or shape does the large table or the fast-moving line of the foreshortened door serve? Does the isolated, jagged dark shape at the lower right corner have an abstract, as well as a figurative function? There are many other visually unanswered questions here, for the artist's chief incentive is deftness and not the painting's internal consistency of expressive order.

Yet the painting has its virtues. When Sargent's adroit handling does get at a part's essential form character, as in the painting of the head, the foreshortened door, and some of the objects on the table, we can sense their grace and strength, and there is a tonal order throughout the work that shows sensitive control. Lest it appear that the gift (or the development) of facility with paint is to be guarded against, it should be pointed out that masters such as El Greco, Rubens, Hals, and the young Rembrandt all show an astounding versatility, as indeed does Sargent in some of his best works. But such facility is best regarded as a double-edged sword. Whether it cuts toward or away from a unified clarity of expression depends on whether it serves or masters the artist. Nor is this an issue only for the figurative painter. A willful fixation on handling, whatever the mode or style of painting, always reveals itself. In art, as in living, "handsome is as handsome does," and the most impressive style of behavior in both realms issues from sincerity and necessity, and not from cultivated mannerisms.

MODES OF APPROACH

The art historian Heinrich Wölfflin, in his *Principles of Art History,* classifies a number of opposing characteristics of style that can pro-vide the young painter with useful insights to qualities in image-making that might otherwise go unregarded. Because a thorough examination of these considerations would lead us far beyond the scope of this book, we will only briefly touch on some aspects of his main theme in a general way, for it concerns matters that are best considered at the outset of the study of painting.

Wölfflin presents a series of contrasting qualities such as "linear and painterly," "closed and open forms," and "clearness and unclearness," as a means of sorting out differences of emphasis among several schools of European art of the fifteenth and sixteenth centuries. These contrastive pairs can also be applied in sorting out our own preferences for the characteristics we find appealing in painting. Taken together, the main thrust of these pairs of opposing qualities is to show that paintings (and other visual art forms) are mainly given either to fact or to impression, to letter or spirit, to the concrete or the fluid, to the fixed and explicit or to the moving and metaphorical.

The forms and the design of some paintings are best understood by their edges and alignments. The linear approach is, to quote Wölfflin, "the path of vision and guide of the eye" while the painterly eye "aims at that movement which passes over the sum of things." For linear painters shapes, colors, and values are more likely to be everywhere enclosed and focused, for painterly ones they are often open-ended and unfocused. The images of the linear painter more often tend toward symmetry, or at least toward a vertical and horizontal alignment of movements, toward a frontal placement of the things depicted, and toward a use of light to clarify forms and to spread attention to all corners of the painting. For the painterly artist, asymmetry is usual, energies move in any direction, frontality is avoided, and light unifies as it bathes forms, as often obscuring as explaining them.

Compare, for example, Pisanello's *Portrait* (Figure 5.54) with Memling's *Maria Portinari* (Figure 6.8). Both show strong tendencies toward the linear and closed attitude to image-making. Especially in Pisanello's work do we sense the striving for frontality—for the subject to face us with a true front or side view. Both use a light that is wholly subordinate to

form clarity. Both works rely on a sharp focus of every object, however small, and show a desire for strong stability, delineation, and a shape-by-shape reading of the image.

Now let's compare with these examples Hals' *Willem Croes* (Figure 5.16) and Rembrandt's *Portrait of Jan Six* (Figure 6.9), which also portray half-length single figures and show mergings of shapes, values, and forms. Here, however, forms are less readable by edge, but must be seen as masses emerging from the shadows. Shapes no longer enjoy a self-contained completeness, but depend on each other for meaning. In Wölfflin's words, "as soon as the depreciation of line as boundary takes place, painterly possibilities set in. Then it is as if at all points everything was enlivened by a mysterious movement." For if, in Pisanello's and Memling's paintings, a dominant theme is tranquility and a sense of "en-

Figure 6.8
HANS MEMLING, *Maria Portinari*
Tempera and oil on wood, 17⅜ × 13⅜ in.
The Metropolitan Museum of Art. Bequest of Benjamin Altman.

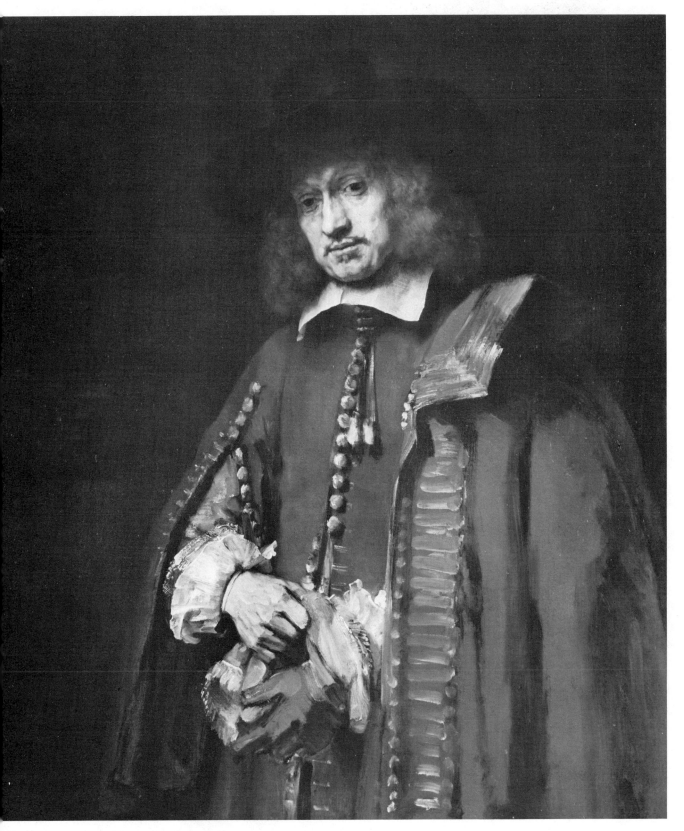

Figure 6.9
REMBRANDT VAN RIJN, *Portrait of Jan Six* (1654)
Oil on canvas, 44 × 40¼ in.
The Six Collection, Amsterdam.

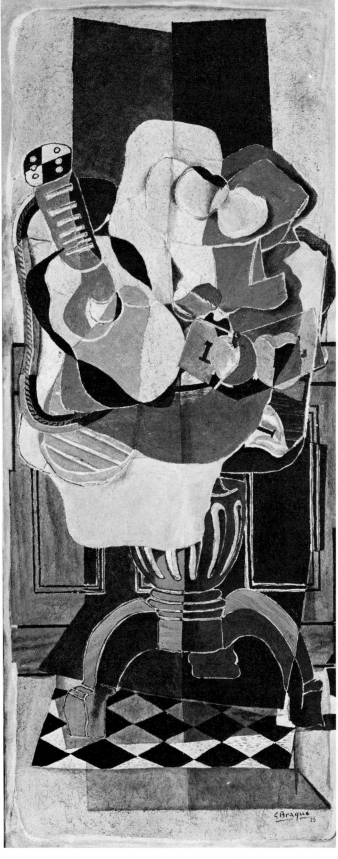

Figure 6.10
GEORGES BRAQUE, *The Table* (1928)
Oil on canvas, 70¾ × 28¾ in.
Collection, The Museum of Modern Art, New York. Acquired
through the Lillie P. Bliss Bequest.

during form, measurable, finite,'' it is apparent that a central theme in Hals' and Rembrandt's paintings is restrained energies, ''the movement, the form in function . . . the thing in its relations.'' Note, for example, in Figure 6.9, how the shapes that constitute the sleeve, cuffs, hands, and gloves seem to chase each other, turning and flowing along several routes, creating a passage of intense activity. Even the cape falls with a sense of speed, and there is an evident rushing in the vertical band of strokes representing the cape's decorative trim. Note, too, that not a single shape in the painting provides us with complete boundaries. Shadows and fluid edges prevent them from having fixed and uninterrupted limits. And, as we saw in Chapter Five, such graduations of value and color also induce the sense of movement.

The tendency toward either linearity and closed forms or toward the painterly and open forms is of course a relative matter. Pisanello is a purer example of the former than is Memling, just as Rembrandt is a purer example of the latter than is Hals. Nor are these distinctions limited to the old masters. All painters, except as their adherence to certain proscribed styles of painting such as the several hard-edge or color-staining conventions forbid, show a tendency toward one or the other of these attitudes. *The Table,* by Braque (Figure 6.10), seems a visual ode to linearity and closed form, while Cretara's *Animal Skull* (Figure 6.11) strongly demonstrates the energetic fluidity and metaphorical play of the painterly artist. The Braque is rich in movement and the Cretara provides an equilibrium, but the former aims at stability while the latter strains against it.

Many painters combine characteristics of both modes, and some painters seem to evolve from one mode (usually linear) to the other over the course of their lifetime, or even from one painting to the next. Comparing Plates 8 and 13 shows how Degas, a relatively linear painter as a young man, began to work in a decidedly painterly manner in his later pastel paintings. Often, as in the examples shown thus far, linear works tend to subdue the sensuous role of paint, and painterly works tend to utilize paint's textural range. But this is not always the case.

Vermeer's *Young Woman with a Water Jug* (Figure 6.12) is an example of the painterly

202

Figure 6.11
DOMENIC CRETARA, *Animal Skull* (1975)
Oil on canvas panel, 5 × 7 in.
Collection of Marianne Smith.

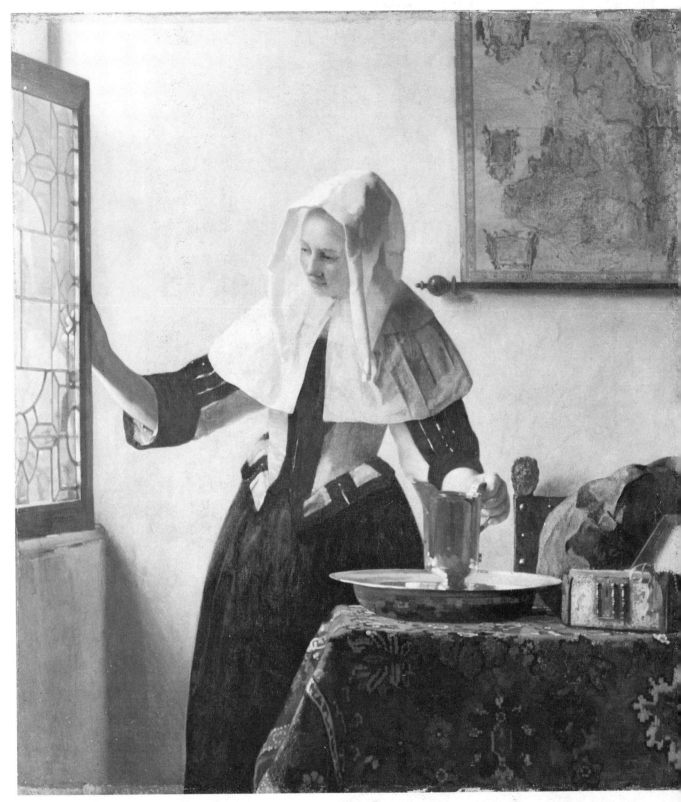

Figure 6.12
JAN VERMEER, *Young Woman with a Water Jug*
Oil on canvas, 18 × 16 in.
The Metropolitan Museum of Art.
Gift of Henry G. Marquand

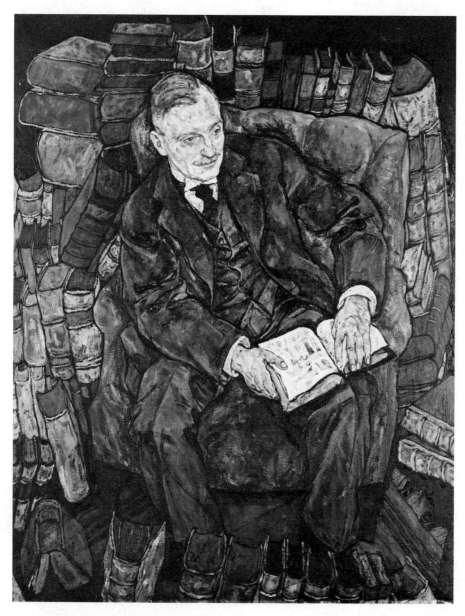

Figure 6.13
EGON SCHIELE, *Portrait of Dr. Hugo Koller* (1918)
Oil on canvas, 55¼ × 43¼ in.
Österreichische Galerie, Vienna.

mode in which, while the handling is most en-
gaging, paint's first duty is to describe and
not itself enact dynamic events. Indeed, the
artist's frequent insistence on shape clarity and
on movements that follow edges shows other
linear characteristics at work. But the play of
light, the tonal graduations, the occasional lost
edge, and the movement along masses as well
as edges make this a predominantly painterly
work. By contrast, Shiele's *Portrait of Dr. Hugo*

Koller (Figure 6.13), while primarily linear,
uses rich paint textures to enliven the shapes.
Again, nuances of the opposing mode appear
in the design's emphasis on masses rather
than edges, and, despite their delineation, in
the dependence shapes have for each other as
components in the design.

Sometimes the mixture of aspects from
these two basically different modes is intricate
and subtle. We can more easily accept the Ver-

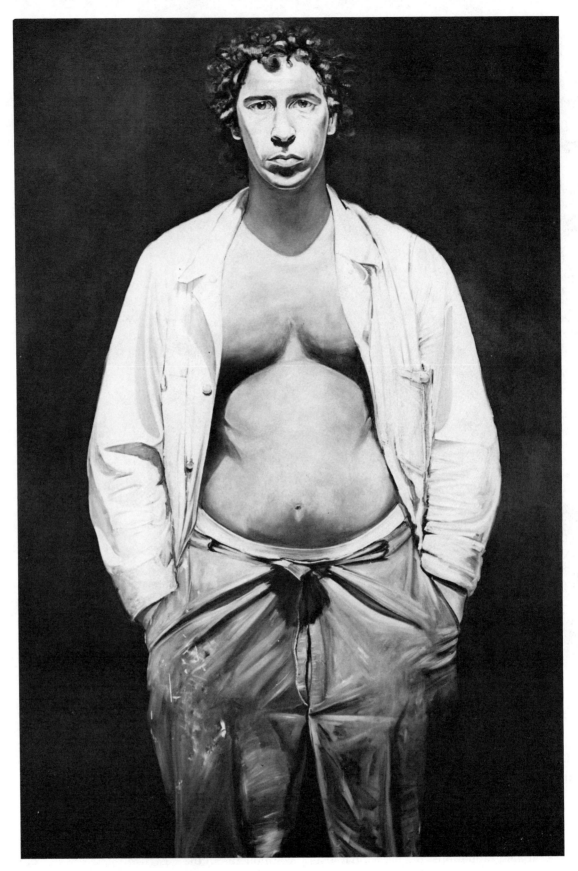

Figure 6.14
Alfred Leslie, *Alfred Leslie* (1966-67)
Oil on canvas, 108 × 72 in.
Collection of the Whitney Museum of American Art.

meer as a painterly statement than we can Leslie's *Alfred Leslie* (Figure 6.14), where the frontality, symmetry, and linearity all point to the closed, linear, and focused mode, but where the strong light and modeling, the loss of edges in shadow, and the moving energy of masses are all painterly devices having important roles in the painting's meanings. Again, in Figure 6.15, the generally sensuous and animated handling, the forms emerging into light, and the emphasis on mass rather than on delineation are painterly choices, but the striving for frontality, the reluctance (except in the dark coat) to surrender edges, and the resulting emphasis on shape are all linear ones. And, while we understand it as a mainly painterly image, the insistence on lingering echoes of the closed and linear mode give the work its particular visual traits. Such necessary mixtures give birth to style.

For the beginner it may seem that such matters as linear and painterly modes needn't be considered until at least most of the basic skills of painting have been mastered. But any meaningful progress in painting must be progress suited to *our* particular needs and intentions, and these cannot be altogether understood unless we ask ourselves just what these general painting interests are. For, the inclination toward one or the other of these modes appears very early in our work, and much time and effort is saved in recognizing our given but malleable approach to image-making.

As the foregoing examples suggest, we must discover and develop our instinctive and special formula for painting if our works are to possess unique visual meanings for others. Such personal "recipes" have always transcended stylistic conventions. Certain periods and styles of art emphasize one or the other of these modes. Classical styles tend to favor linearity, romantic styles more painterly devices. Yet most artists working in those periods or styles show differing degrees of departure from the dominant mode. Soutine and Beckmann (Figures 5.33 and 5.51) are both Expressionist painters, but the former is clearly an open-form and painterly artist, the latter a more linear one. Rembrandt and Vermeer are both sixteenth century Dutch artists working in a painterly tradition, but show the differences noted earlier. The process of discovering

our own necessary formula for image-making, and the development of those skills that will make it manifest in our works cannot begin too early, and ought really to be ongoing.

The process of self-discovery begins by examining the reasons for our attraction to certain painters and periods of art, to certain media and uses, and even to certain kinds of subject matter. This is not to suggest that we should in any way resist the changing attitudes, the challenges, and the sometimes unsettling ideas that are part of a good program of art study. It is important to consider whether such changes go toward or away from our instincts and aspirations, and how they might be adjusted and incorporated in our works.

Occasionally beginners have all too fixed aspirations and notions about painting that are naive or commonplace, and will unselectively resist just those concepts and skills that would provide them with inventive visual abilities. Among the talents necessary for progress in art is the capability of keeping an open mind, objectively considering an instructor's guidance, and absorbing the good advice that masterworks offer the perceptive viewer. But in doing so we must distinguish between our early notions, some of which may need to be abandoned, and our basic temperamental stamp, which should never be abandoned. And this right to our *selves* should extend to include various idosyncratic features in our paintings, as long as these personal features do not represent mannerisms standing in the way of our development.

Of course, one of the best means of finding one's way in painting is by painting—and painting. But, lest these efforts only reinforce old and superficial notions, our paintings must be made against a background of questions of every sort that test our perceptual acuity and our attitudes and help shape intentions. Here are some questions that may stimulate you to compile your own list.

1. How near to (or far from) objective realism is this image to be?
2. Along what routes will the main directed actions run?
3. What is the general color theme to be?
4. Is the paint handling to play a dominant or subordinate role?

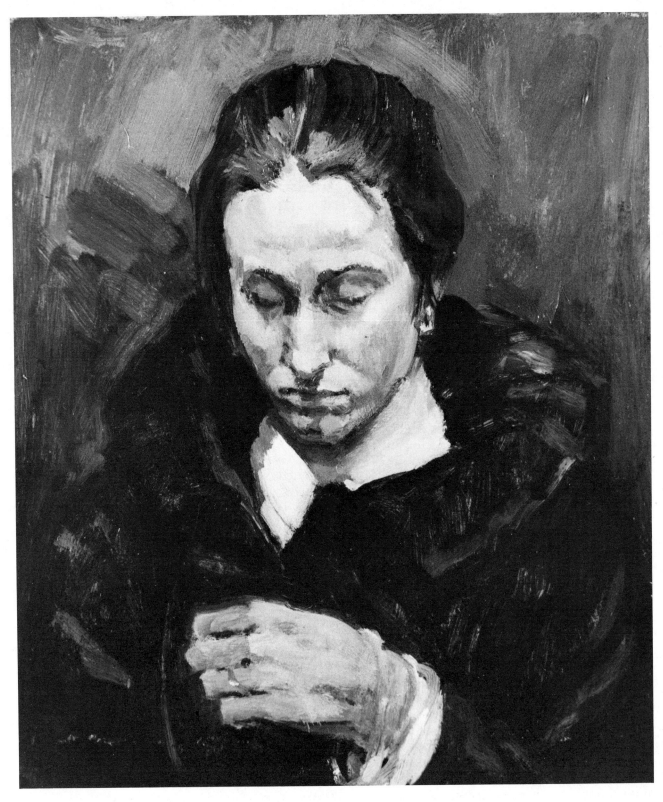

Figure 6.15
NATHAN GOLDSTEIN, *Fiona* (1975)
Oil on panel, 8¼ × 9¾ in.
Collection of the author.

5. Is form clarity to be emphasized or subdued?

6. Is the tonal register to be high or low?

7. Shall this be treated directly or indirectly?

8. How much illusionist texture shall I use?

9. Are shapes to be closed or open?

10. What role is the sense of illumination to play?

11. Are the dynamics of the picture-plane to be as strong as the three-dimensional ones or stronger?

12. Are transitions of color and tone to be gradual or abrupt?

There are of course many more questions one might ask before the painting is begun. Once under way, many of these considerations continue to be relevant, but new ones are added:

1. Shall I work this passage further, or wait and return to it?

2. Is this large red (or whatever color) working with or against the rest?

3. Should I keep this part or paint it out?

4. Do the shapes work together?

5. Is this passage isolated?

6. Does the painting seem balanced?

7. Does the painting, at this point, express my intentions?

8. Are the edges too much alike (or too varied)?

9. Would glazing help here?

10. Have I carried things far enough, too far?

This list, too, can go on and on. And, along with these questions are the questions we ask of our subject, and even of our materials. Painting is as much a process of inquiry as of declaration and involves the painter wholly. For, our concepts and percepts, our intuitions and intent are not islands of special interest; they are facets of our inventive prism, working together in receiving and transforming impressions as only we can. The more nearly this prism reflects our essential nature as well as that of the subject, the more creatively original the results will be.

SUBJECT MATTER

If the ultimate challenge for artists is what form to give to their intentions, the next most important challenge is finding subjects that enable those intentions to be fully expressed. Artists and students alike ponder the question, "What shall I paint?" For students contending with visual and technical fundamentals, the best subjects are (as they are for most artists) those things, places, events, and people with which they are most familiar. And the best treatment of these subjects is one that takes into account responses to their actual and potential dynamic possibilities, a treatment which tests the student's ability to judge many kinds of relationships and to utilize many technical skills. This means that you are more likely to achieve visual and expressive eloquence by painting a few simple, familiar objects as in Figure 4.14, than by turning to picturesque or unusual themes that are quite outside your realm of experience.

For these reasons, the *steady* practice of *overly* simplified themes is generally not helpful, although the benefits of concentrating on, say, shape or color considerations by omitting tonal or volumetric ones has obvious merit as a learning device. But the too frequent choice of themes that exclude color, mass, texture, or tone activities, in skirting these challenges (often in the name of freedom of expression), only slows an understanding of these factors. While such restricted themes are altogether valid and necessary for some artists, and among them some of the best, those limited themes emerge for them through the distillation of experiences and insights gained from long periods of confrontation with the many challenges of painting and of nature. Such restricted themes are the fruit of their acute perceptual sensitivites. They set aside the challenge of volume or color or texture, not out of impulse or a willful insistence on novelty or artistic license, but to explore important visual and expressive meanings that will not surface in the presence of these elements. A painting such as Gottlieb's (Figure 5.12), Louis' (Plate 20), or Kline's (Figure 6.16) is not an indulgent escapade but the inevitable result of a chain of visually expressive necessities. Kline's reduction of an impression of New York to monster-sized bridgelike forms in vast space is a felt and compelling statement.

But such specialized creative necessities cannot logically precede the generally lengthy and difficult distillation process which gives rise to them. Therefore, beginners who choose (or are advised to choose) such severely nar-

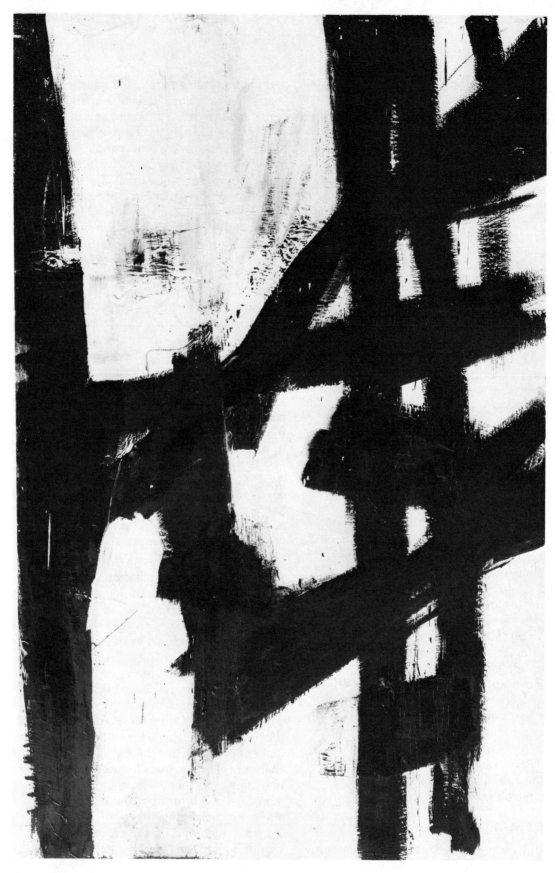

Figure 6.16
Franz Kline, *New York* (1953)
Oil on canvas, 79 × 50½ in.
Albright-Knox Art Gallery, Buffalo. Gift of Seymour H. Knox.

rowed themes will gain comparably narrowed experience. Students must explore a wide variety of concepts and modes, but the main thrust of their efforts, especially at the outset, should be towards themes simple enough to manage yet freighted with visual challenge. Also they should in general strive to develop skills in the analysis of their outer world before turning those skills inward. Without wishing to opt for or against any particular style 'of painting, I may cite the example of Mondrian's move from representational toward abstract imagery as demonstrating the process of starting with an appraisal of what *is*, in order to apprehend what might be.

In Mondrian's case, we can trace his development of "what might be" in three works concerned with extracting the principal line and space behavior of trees. Figure 6.17 already reveals the first strivings for a stronger abstract accommodation between the branches and their interspaces. In Figure 6.18 the painting's "what" and its "how" strongly contend for dominance in an exchange of highly animated and appealing visual thrusts and counterthrusts. It is the most lively and stormy of the three works shown (as battles are likely to be). In Figure 6.19 the depictive aspects subside into the calm of a stately system of rhythms that owe their particular dynamic character to the original subject.

Had the artist bypassed his patient study of trees (he made numerous studies of them) he would have bypassed the insights and urgings that such inquiries invariably stimulate. Such insights help us to discover who we are as artists, and what we ought to be doing about it. For, in discovering more about what in nature is important to us, we discover ourselves. Again, it is the search for what forms to

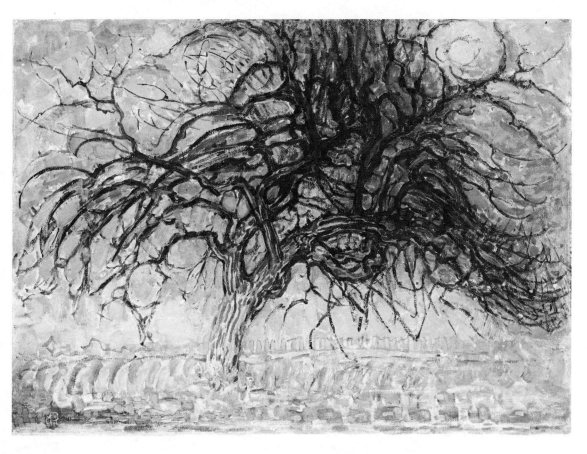

Figure 6.17
PIET MONDRIAN, *The Red Tree* (1908)
Oil on canvas, 27⅝ × 39 in.
Collection Haags Gemeentemuseum, The Hague.

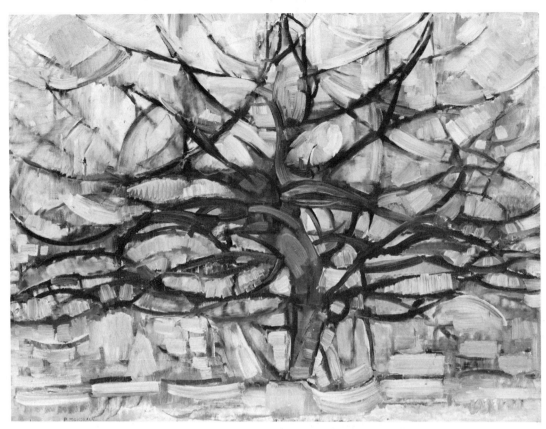

Figure 6.18
PIET MONDRIAN, *The Gray Tree* (1912)
Oil on canvas, 78.5 × 107.5 cm.
Collection Haags Gemeentemuseum, The Hague.

Figure 6.19
PIET MONDRIAN, *Apple Tree in Blossom* (1912)
Oil on canvas, 78 × 106 cm.
Collection Haags Gemeentemuseum, The Hague.

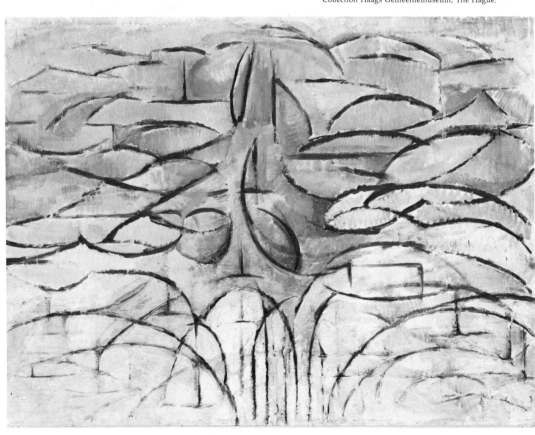

give our intentions, and the quality of those intentions, that together bring us to the only road leading to inventions of important creative worth. The forms and qualities of expression are best evolved through the development of our perceptual sensitivity to the things around us, through the practice of the processes of painting, and through the study of the art of the past and present.

STILL LIFE

The simplest subjects are often the best ones. They make it obvious to artist and viewer alike that whatever occurs in transforming the properties of the raw material into art is due more to *how* the subject matter is seen, than to *what* it is.

Two egg plants, two pears, and the faint suggestion of a table top and a wall are all that Demuth requires (Figure 6.20) to evoke the feel of a magnetic visual field in which pulsations alternately attract and project energy. Similar alternating currents take place between the egg plants and the pears. On the one hand, they attract each other through their vertical-horizontal alignment and their physical proximity; on the other, they oppose each other through differences in color (the reddish-purple of the egg plants and the yellow-green of the pears are complementary), size, and classification. Such potent abstract actions give this initially simple looking still life an intriguing dynamic life. They also tell us something about the nature of the artist's fertile conceptual mind.

Cézanne's slow and meditative approach to nature only partly explains his devotion to still-life painting. Such subjects not only enabled him to make the patient inquiries he needed, but permitted him to put together structural and spatial situations of almost any kind, which allowed him to pursue many engrossing issues. One such issue in his *Still Life with a Commode* (Figure 6.21) is the dramatic contest between the drape's animated movement, its striving for flight, and the imposing substantiality of the forms that hold it down.

Another issue concerns the contest between an overt and covert pattern of circularity, and a pattern of vertical and horizontal rectangles. These two systems, interplaying throughout the work, come together in the forms of the drape, which is composed equally of angular and curved units. On the table, ovals dominate, suggesting mass and space, while the circular apples and drawer pulls, by their shape and location, reinforce the presence of the picture-plane. Similarly, the "grid" of the painting's rectangles, now hidden, now visible, also strengthens our awareness of the two-dimensional design.

A third issue is the balance of values. If we squint at the painting it is immediately apparent that Cézanne has organized three main bands of tone, each of which has some small outposts located elsewhere in the design. For example, the light tone of the objects on the table is seen again in the far wall on the left, and the middle tone of the table and floor reappears in the drawer pulls and on the far left wall. A fourth, smaller and darkest value, that of the upper part of the vase at the far left corner of the table, by contrasting with the other tones, unifies them. A weighty form, the vase also exerts a downward motion that restrains the rise of the drape on the right side.

Against the design's rather classical horizontal-vertical orientation, a fourth idea—the large diagonal movements that criss-cross through the objects on the table—serves to animate the image. Note that the drape constitutes one diagonal force; the other moves through the lower part of the aforementioned vase, the small bowl alongside it, the alignment of the lowest row of apples, and continues through the downward tilted segments of the white drape.

Another issue, one of the artist's life-long themes, is color's figurative and dynamic functions. Here, as in Plate 4, color accounts for numerous relationships that form additional harmonies and contrasts to enrich and clarify the artist's purpose. Cézanne's tireless exploration of color's structural, organizational, and expressive qualities makes possible the poetry and awesome power of his later works (Plate 11).

We might also note in passing, that Figure 6.21 is a good example of a work balanced in interest between painterly and linear devices. The emphasis on weighty mass rather than edge and the building-block nature of the brushstrokes are painterly concepts. The closing of shapes, the dominance of form clarity rather than the effects of illumination, and a striving for frontality, are all linear devices.

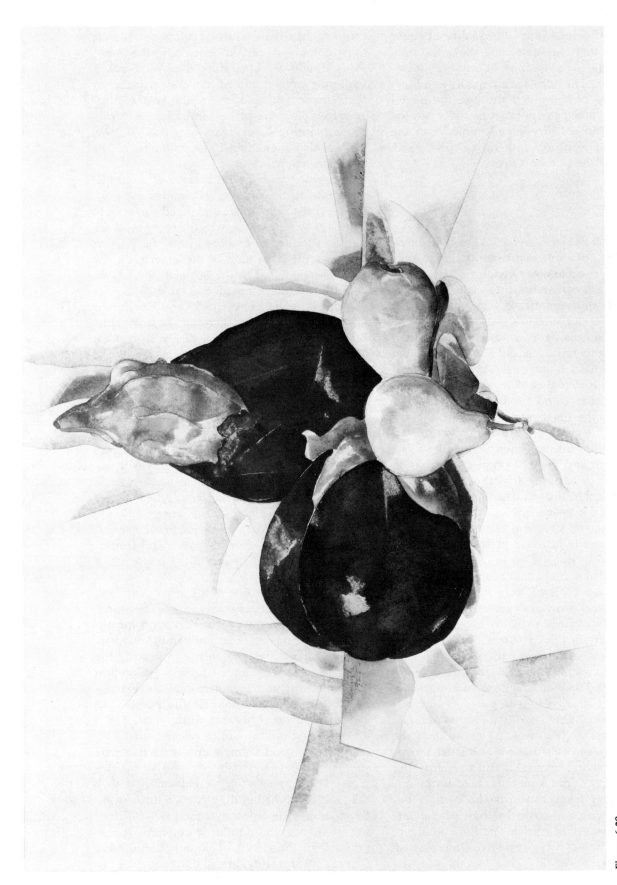

Figure 6.20
CHARLES HENRY DEMUTH, *Eggplant and Pears* (1925)
Watercolor and pencil, 13⅝ × 19⁹/₁₆ in.
Courtesy Museum of Fine Arts, Boston.
Spaulding Collection.

214

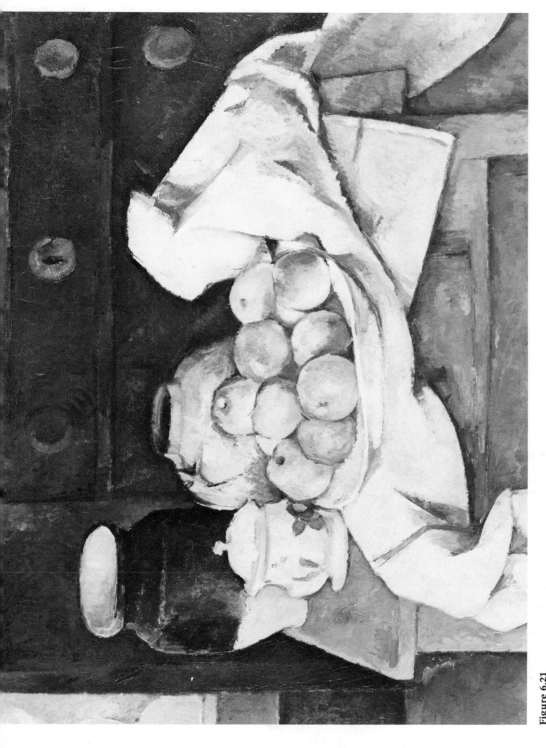

Figure 6.21
PAUL CEZANNE, *Still Life with a Commode* (ca. 1885)
Oil on canvas, 25¾ × 31⅞ in.
Fogg Art Museum, Harvard University.
Bequest, Collection of Maurice Wertheim.

Some beginners are perplexed by the still-life painting genre and by the emphasis given to it in studio art courses. The visual and expressive possibilities of still-life painting are vast and especially useful for the student. Almost any form, shape, color, and texture situation can be arranged at any level of complexity and in limitless compositional formations. In fact, few other subjects allow such a total freedom of selection and arrangement. Some kinds of observed subjects, which may fascinate us by their social, psychological, or literary meanings, can more easily blind us to their visual conditions. In diverting our attention from expressing *through* the subject's visual

character to recounting its story-telling message, we drift from visual evocation to a kind of illustrative prose.

The best painters always aim at expressions of visual significance that emerge from the subject's fundamental nature. Such painters find vital meanings in whatever they paint. Kandinsky, commenting on just this quality in Cézanne's work, observed that, "Cézanne made a living thing out of a teacup, or rather, in a teacup he realized the existence of something alive."* Young painters sensitive to

*Wassily Kandinsky, *Concerning the Spiritual in Art,* 1912. Reprinted by Wittenborn, Schultz, Inc., New York, 1944, p. 36.

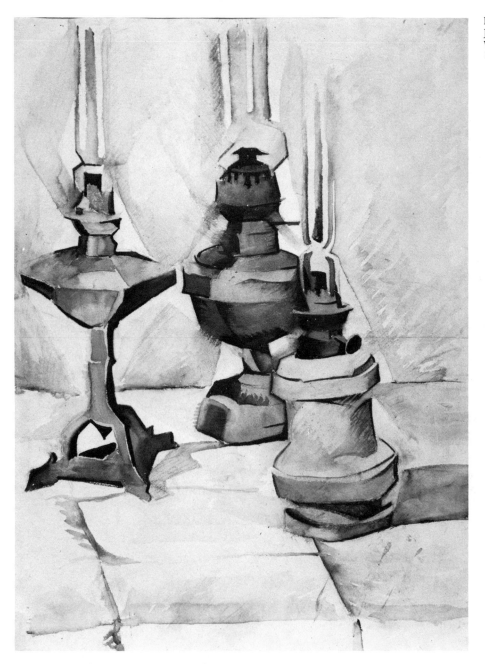

Figure 6.22
JUAN GRIS, *Three Lamps* (1910-11)
Watercolor, 61.8 × 47.8 cm.
Kunstmuseum, Bern. © 1979 by ADAGP, Paris.

the energies that animate all forms will find in their still-life arrangements the visual metaphors for the actions, tensions, and harmonies of life among the interworking elements that constitute their subject. We may find the expressive, abstract patterns that attracted painters such as Beckmann and Braque (Figures 5.51 and 6.10). We may discover the dynamics hidden in things as they are, as in Klimpt's, Harnett's, and Monet's works (Plates 3 and 14, and Figure 6.3). Or we may, as Gris does in his *Three Lamps* (Figure 6.22), further expand on a subject's potential to be seen as constructed in a planar (or some other) way. Whichever issues make up the themes you may wish to pursue, you will soon become aware that still life is a versatile and rewarding genre.

INTERIORS

The logical extension of still-life painting is the painting of many objects in their environment, as in Figures 5.11 and 6.2. Interior views often contain the figure, but, as these two examples and Wyeth's *McVey's Barn* (Figure 6.23) demonstrate, such long views are primarily large still lifes.

In *McVey's Barn* Wyeth employs three of his favorite themes: light, texture, and bold compositional strategy. Although the work is highly realistic, everything functions at both the abstract and figurative levels. The upright beam in the center of the painting's dark upper segment acts as a fulcrum for the see-saw balance achieved by the differing halves of the design. The shapes of sunlight on the hay and on the wooden bin act to fuse these two dissimilar parts, relating them with the other squares of light tone. Additionally, these sunlit areas, by their location, size, and angle, work to animate and balance the design.

The artist's use of egg tempera, a medium admirably suited to denoting the finest textural nuance, is never given over only to textural effects. Wyeth gives first consideration to the scene's volumetric and spatial conditions. And, in the unfaltering commitment to his theme, makes us aware of the creative potential of this untypical subject matter. Our own surroundings also offer numerous painting opportunities. No doubt we have objects or interior settings close at hand that, like Van Gogh's work shoes, Murch's transformer, or Diebenkorn's view of an interior (Figures 5.41, 5.52, and 5.11) can serve us well if we ponder their visual and expressive possibilities.

One advantage of beginning to paint the figure in some environmental setting is that it helps the beginner to see that, like the inanimate objects around it, the figure is after all comprised of shapes, colors, masses, and so on. In other words, the figure can be seen with something of the necessary objectivity we bring to the painting of still life and interior arrangements. To do so is not to diminish its special qualities. On the contrary, not only is responding to the formal, visual properties of whatever we see, including the figure, prerequisite to painting in *any* mode, but in judging the figure's visual properties with the same objectivity we apply to objects, and in relating these properties with those of the figure's surroundings, we integrate it in the work. The figure's vital human qualities are more eloquently expressed when integrated with the inanimate objects of its environment than when it is isolated by a different treatment. When the figure is the center of attention in a scene, some students, in awe of its special status or weighted down with preconceptions of what the figure should look like, *dare* not see its actual visual conditions as they do an apple or a chair. Instead, they "see" and paint it in a more solicitous way, supplanting perceptions with cliché solutions and lavishing attention to details and surface effects, missing just those perceptions that could give life to the figure in the painting.

This is less likely to occur when the figure represents only a small part of a scene, and is clearly subordinate to the total view. There is a split-second of surprise in seeing the figure in Vuillard's *Model in the Studio* (Figure 6.24), even though the artist has placed her in the center of the design. The painting's strongest impact is on the left, where the great mass of dark tone and its contrast with the light shapes within it seem to call our attention. Only by resisting the weight of the dark tones toward the right do we locate the figure, somewhat camouflaged among similar tones or lost among the stronger textures and tones that surround her.

Vuillard's manner of painting emphasizes large patterns of shape, color, value, and tex-

Figure 6.23
ANDREW WYETH, *McVey's Barn*
Tempera, 32½ × 48 in.
Collection of the New Britain Museum of American Art,
Harriet Russell Stanley Fund.

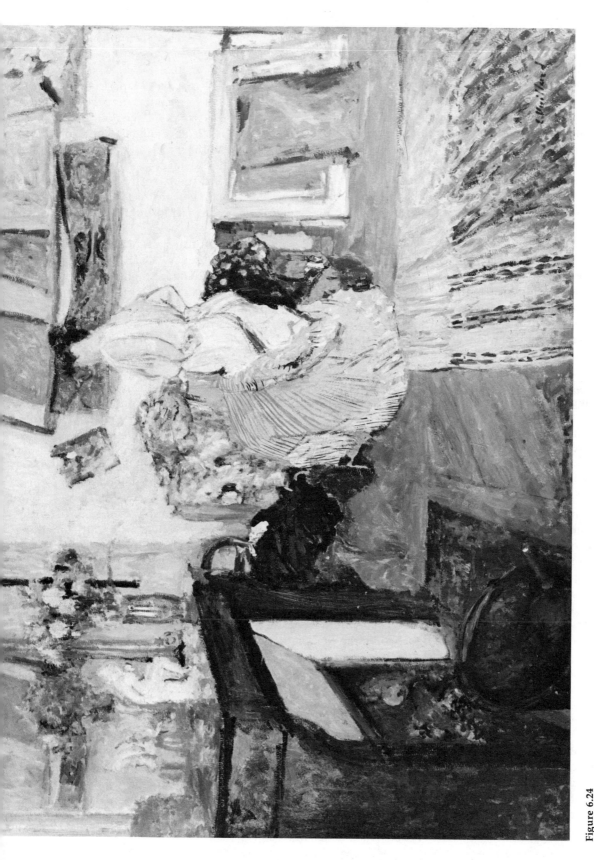

Figure 6.24
EDOUARD VUILLARD, *Model in the Studio* (1904-6)
Oil on cardboard, 24⅜ × 33⅜ in.
Collection Kimbell Art Museum, Fort Worth.

ture. His only concession to the figure's distinctive status is to somewhat more define her arms and bodice. In the main, she is treated to the same generality as the other forms in the composition. In fact, we know more about the form of the vase of flowers on the fireplace mantle than we do about the features of the woman's head. The more we examine this work, the more we realize that the artist provides us with only a minimum of form clarity, a few clues by which, with the addition of our knowledge about figures, frames, and furnishings *we* complete the construction of the forms and space. The artist's interests are elsewhere.

Unlike Wyeth's painting, which invites us into the darkened atmosphere where we can experience the *feel* of the space and even of the old wood and the hay, Vuillard, in withholding the atmospheric and tactile illusion, holds us back from entering the studio, reminding us instead that we are looking at elements and brushstrokes interworking. Vuillard's purpose here is to establish an engaging play of abstract relationships that act as forcibly on our sensibilities as does the painting's figural aspects, for his interest equally concerns both spheres. In Vuillard's painting it is difficult to tell whether the observed scene or a desire to manipulate the visual elements (and the paint) first stimulated him to begin.

No such doubts exist when viewing Matisse's *Studio, Quai St. Michel* (Figure 6.25). For Matisse, the dynamic life of the elements account for much of the painting's visual "treat." The interior arrangement includes a posing model, a still life on a tall table, a floor-to-ceiling view of the room, and even a landscape. This varied complex of subjects is reduced to economical terms that show an engaging abstract interaction, and an ordered hierarchy among them. We know the figure to be the focal point of the design by her relatively central location, but more important, by the system of encircling light-toned rectangles, one of which takes us to the still life, of which it is a part. In moving around the circle of rectangular shapes, we are stopped by the still life's rectangle because of the bold circular shape that sets it apart somewhat from the other angular shapes. This circle of the tray, in repeating the arch in the distance, and the table's legs, in alignment with the distant tower, take us to the landscape. But the relative delicacy of tone in the buildings and sky lose out to the powerful vertical movement of the dark window frame and the drape on the far right, and we return to the room, our eye moving along the drape's curving sweep, to begin the cycle of action again.

A gifted colorist, Matisse utilizes color confrontations to establish important relationships here that we don't see. Yet, note that the values of these colors suggest light, tell the local value of things, play at least a rudimentary role in defining mass—as in the figure, the landscape, and the large drape on the right—provide the lively abstract pattern discussed above, and are factors in the painting's balanced order.

Wyeth, Vuillard, and Matisse make much of shape and texture, all are sophisticated exponents of drawing, and all are inventive designers. Yet each of these three paintings of interiors aims at a very different formulation of abstract and figurative factors. Wyeth uses abstract devices in the service of realism, Vuillard insists on an even-handed presence of both considerations, while Matisse uses realistic devices in the service of abstraction. This is not to suggest that Wyeth or Matisse are less concerned with the subordinate factor in their works. Both men are extremely sensitive to dynamic and depictive matters, but because they intend very different (and equally valid) meanings, they assign very different roles to these two factors.

Whether a painting's abstract activities support a realistic statement about something seen, or conversely, something seen serves as a vehicle for extracting a play of abstract activities, even to the point of having the results appear nonobjective, both factors must interwork in some visually logical way if our goal is to be realized. It is not how *evident* either factor is in the work that gives it worth, but how *well utilized* and allied they are in conveying our meanings. Only works that are wholly slavish imitations of nature, or works that are wholly willful and arbitrary acts fall outside the boundaries of aesthetic experience. Mere accuracy of observation and mere sensory entertainment are not yet art.

Works of universal aesthetic quality always convey the experienced impact of an encounter with something seen or envisioned. They reveal what facts and forces impress the artist, affect his thinking and feeling, and in

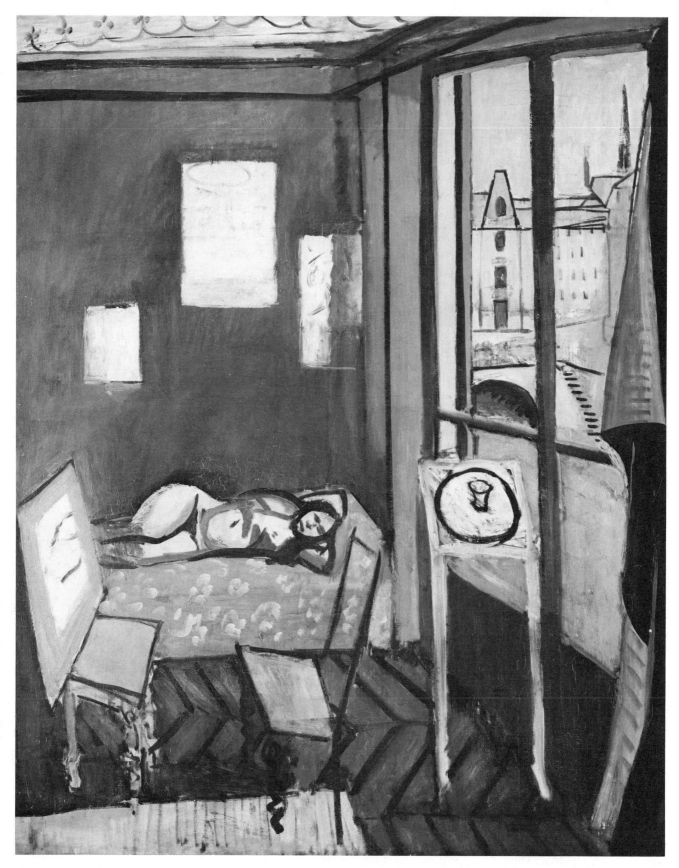

Figure 6.25
Henri Matisse, *Studio, Quai St. Michel* (1916)
Oil on canvas, 57¼ × 45¾ in.
The Phillips Collection, Washington, D. C.

doing so, enrich his (and our) experience of living. Such works are motivated by a need to search out visual solutions that not only convey the artist's response to his subject's essential character, but which, transcending the subject, act as visual metaphors for human qualities and conditions important to the artist. That is why there can be no "right" or "best" interpretations of our subjects, but only more and less penetrating ones.

Our particular approach to painting, the quality of our inquiries, our temperamental attitude, and our general purposes should not change drastically (if at all) when we change the *category* of our subject matter. That is, figure paintings needn't be treated to one kind of formulation and still-life painting to another. Such changes in formulation, when they occur, should be determined by our responses to a subject's particular visual condition, and not because of its general status as a landscape, an interior, or a portrait. So much does the resulting image depend on how artists react to their subject, rather than to its category, that Schiele paints an interior and a city in a similar style (Figures 6.2 and 6.32), while the imagery of two Golub portraits, as we have seen, differs greatly (Figures 4.12 and 6.5). This being the case, the worth of a work should be determined by the quality of its total content—by how visually and expressively compelling it is—and not by whether its dynamic or depictive properties dominate.

Although our images should be shaped by our experiences and not by a policy toward a particular subject category, each category does set different conditions for extracting its essential characteristics, as we shall see. Still-life painting, as noted earlier, permits us to arrange any kind of visual situation we desire. We can work on a single arrangement for many days or even months, and can, if necessary, rearrange the still life after the painting is under way. But a landscape must be taken *as found*. Of course, we make whatever changes are necessary in the painting's color, in the location of parts, in value, and so on, but often we begin landscape works contending with conditions we accept but would not have put together. Then, too, painting out-doors cannot be a long-term affair, for the changing light (and the changing conditions of some subjects) do not permit this. Envisioned subjects, unlike observed ones, in continuing to change as we "see" them while we paint, pose conditions that require a more direct line of attack. Here it is often best to quickly grasp the essentials of an imagined situation, before it shifts or fades. And figure paintings, because we do invest human forms with dimensions of meaning that don't apply to other subjects, demand a discipline that will prevent us from drifting toward nonvisual issues.

LANDSCAPE

Landscape painting requires the greatest changes in scale between what we see and what we paint. A nearby garden or house is huge in comparison to the size of even a large canvas. When distant objects such as houses, trees, or hills are painted, the opposite situation exists. Now, each brushstroke, however small, stands for a quite large segment of the object's mass. For example, a single brushstroke only one-half inch square might represent the entire side of a house, the sunlit half of a tree, or an acre-sized plane on a hill. A figure, a tower, or a cloud might be stated in some seven or eight strokes. Such reductions of mass to a relatively few brushmarks demand a sound grasp of structural essentials and of the fundamentals of perspective.

These skills enable Troyon, in his *Landscape near Paris* (Figure 6.26), to suggest buildings, trees, clouds, and figures in a few telling shapes of color. Note how the artist uses the paint's viscous texture to suggest the textures of the field, the clothing, and the clouds. Indeed, the economy of means and the lively paint handling account for much of the painting's spontaneity and charm.

Similarly, an early Monet, *Village Street* (Figure 6.27), shows the artist's economical and structure-clarifying solutions to the complexities of form in the scene. Doors, gables, and figures are established with a few strokes, each one simultaneously stating the color, shape, value, and plane of a segment of a form. Here, too, Monet's knowledge of perspective guides his judgments about the structure, location, scale, and value of each form.

A knowledge of perspective is necessary to fully understand a volume's situation in space; the inability to arrange forms according

Figure 6.26
CONSTANT TROYON, *Landscape near Paris*
Oil on panel, 10½ × 18 in.
Courtesy Museum of Fine Arts, Boston.
Gift of Martha B. Angell.

Figure 6.27
CLAUDE MONET, *Village Street*
Oil on canvas, 22 × 24 in.
Courtesy Museum of Fine Arts, Boston.
Spaulding Collection.

to the principles of linear and aerial perspective is a grave drawing restriction. "Correct" perspective, however, is often purposely modified. Many artists do so to better compose their works, or for expressive reasons. Those who understand these principles best can best turn them to their own account. Subtle suspensions of perspective are often at work in highly objective paintings. For example, Canaletto's *The Stonemason's Yard* (Figure 6.28) appears to be a model of linear perspective. But in fact, few of the converging lines on any of the structures on the painting's right side go to the same vanishing point, as you can confirm by placing a ruler along such lines and following their paths back in space. Instead, the artist uses several vanishing points along the horizon line to avoid the mechanical look that often results when all of a work's converging lines aim at the same spot.

Canaletto organizes this complex scene with admirable subtlety. The seeming randomness of the foreground is arranged along two opposing diagonal lines: the one created by the building's shadow on the left, and that of the long shed on the right. The roof of the shed, in being aligned with the far bank of the canal, leads us well back into space. The artist further organizes the work through the unifying effects of light, and by a sophisticated system of vertical and horizontal patterns of shape and value. Note, for example, how the small white passages, be they stones, curtains, or parts of houses, are arranged to form relationships that link together parts of the design.

The rules of perspective are more diligently obeyed in Ruisdael's *The Shore at Egmond-Aan-Zee* (Figure 6.29), but are less in evidence because of the subject's more organic character. Here, perspective assists expression. The force of the wind's gusting to the right is amplified by the strong converging of the axial lines of the undulating waves and clouds. They seem to aim for a point located behind the dark rise along the beach. Ruisdael reinforces the movement of the sea and the clouds by emphasizing curvilinear motions. Even the beach is seen as a pattern of serpentine lines. The painting's psychological tone is one of impending change, the result of many kinds of contrast. There is contrast between the activity of the wind and the passivity of the people, between the sunny, "benign" passages and the more clouded, ominous ones, and between the restful areas in the sky and the agitated ones along the shore. All these opposing qualities suggest the onset of a sudden spring storm.

Another kind of movement is at work here. Constable is supposed to have remarked that the most important advice he ever received as a student was the observation that, out-of-doors, light is constantly moving. Ruisdael's earlier appreciation of that fact is shown by the suggestion of light moving across the scene, illuminating places by the chance location of the windswept clouds. And, in establishing the panoramic view necessary to give light's motion emotive force, the contrast between the small boats, figures, and buildings, and the vast expanse of sea and sky adds another expressive opposition. Note how, in this indirectly painted work, the thin paint layers of the sky and the denser layers of the things below help to suggest the ethereal nature of the one and the substantial nature of the other.

Like Ruisdael's painting, Kokoschka's *The Coast at Dover* (Figure 6.30) also shows a panoramic view of sea, land, and sky, and a moving light that here darkens the hill on the left. But the force moving through Kokoschka's painting is due less to the wind than to a gust of abstract energy. The dynamic force of a curving movement begun in the lower right corner reaches the far hill and continues in the arc of the dark clouds to return again to the right side of the canvas. Other pathways of motion permit other routes to our eye; all the actions are energetic, as is the artist's spontaneous treatment of the forms. If the mood of Canaletto's painting is tranquil, and that of Ruisdael's shows an awakening of natural forces, Kokoschka's work is a tempest of dynamic forces that parallel rather than describe natural ones.

Complex panoramic views can be as severely reduced to a few necessary essentials as can still life and interior scenes. This is demonstrated by de Staël's *La Seine* (Figure 6.31). The Eiffel tower, spires, buildings, the river, the bridge, and all the rest are simplified to a pattern of mainly block-like shapes and simple curves oriented frontally. Three important perspective devices—scale, value, and overlapping—continue to clarify the location of forms in this vast space, although the design's

Figure 6.28
CANALETTO, *The Stonemason's Yard*
Oil, 48¾ × 64⅛ in.
The National Gallery, London.

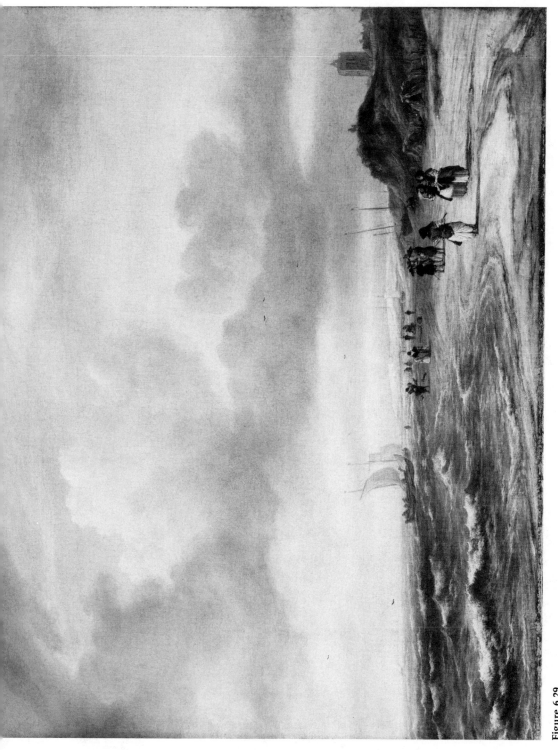

Figure 6.29
JACOB VAN RUISDAEL, *The Shore at Egmond-aan-zee*
Oil on canvas.
The National Gallery, London.

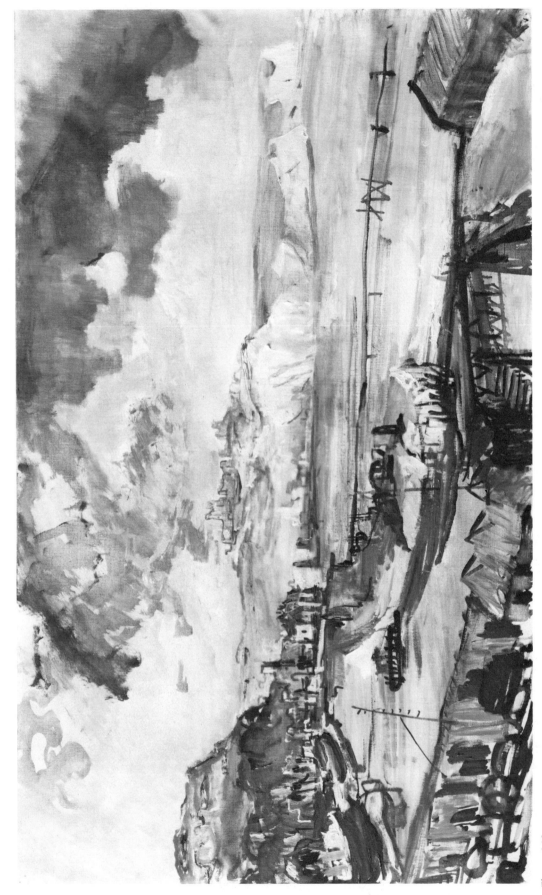

Figure 6.30
OSKAR KOKOSCHKA, *The Coast at Dover* (1926)
Oil on canvas, 76.5 × 127.4 cm.
Collection of the Kunstmuseum, Basel.
© 1979 COSMOPRESS/SPADEM.

Figure 6.31
NICOLAS DE STAEL, *La Seine* (1954)
Oil on canvas, 35 × 51⅜ in.
Hirshhorn Museum and Sculpture Garden,
Smithsonian Institution.

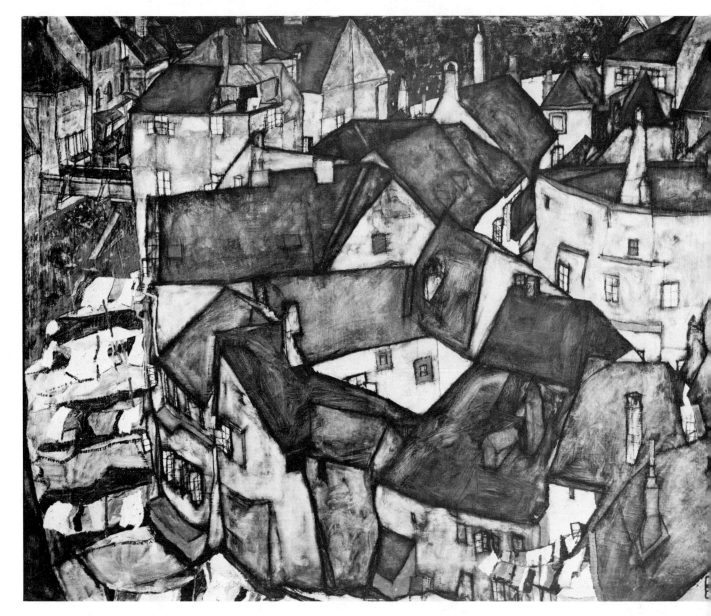

Figure 6.32
EGON SCHIELE, *City* (1915)
Oil on canvas, 43¾ × 55⅛ in.
The Israel Museum, Jerusalem.

main thrust is in the two-dimensional pattern these simplified forms provide.

The landscape paintings that we have been discussing all show a sensitivity to both depictive and design considerations. The more representational works by Canaletto and Ruisdael reveal a refined sense of abstract order, while Kokoschka's and de Staël's more abstractly motivated works show a sensitivity for structural and spatial analysis and for the subject's psychological mood.

In Schiele's *City* (Figure 6.32), the overall emphasis is on a two-dimensional design. This is to some degree the result of the high vantage point from where the pattern of rooftops,

walls, windows, and clotheslines lends itself to such a reading. But clearly, Schiele is absorbed in the busy play of light and dark angular shapes, and in their collective curving action. Here, as in Figure 5.9, there is not a single curving edge, yet the design's major directed movement turns in a gentle spiral. As this painting suggests, untypical form arrangements and viewpoints offer many fresh cityscape situations. Notice that the "wrong" perspective, in being consistently and only moderately awry, does not disturb. It serves instead as a device that makes the houses seem less mechanical, more malleable and alive.

Schiele's design concept of 1915 supports

the quiet, inviting scene. Shapes and masses are nudged into oblongs, rectangles, and wedges that are not severely geometric. Just the opposite happens in *The City* by Vieira da Silva, painted in 1951 (Figure 6.33). Here the artist fragments forms into fast-moving shards that abstractly restate the frantic pace and tension of a modern city. But this active field of racing lines and flashing values is not hit upon arbitrarily. It is an ordered and harmonious pattern of movements that offer a hierarchy of impressions. In the lower portion of the canvas large vertical shapes lift upward to intermingle with the smaller shapes that form a horizontal band extending from side to side. Several smaller units and directions emerge and subside within these two large systems. At the top, a relatively restful passage of sky acts as a foil for the dynamic ferment below.

This portrait captures the feel of a modern city by intention, not by impulse. Intentions may be conscious or intuitive. Some are always with us as part of our way of seeing and responding. Others may arise spontaneously, born of events and options in the emerging work, and are essentially felt convictions about what the image requires to meet our goals. Impulse, however, is nearer to caprice or compulsion. A strong wish to express is not the same as sensing ways to do so.

Some students are attracted to the seemingly easy and free-wheeling air of works such as da Silva's (or Kline's, Figure 6.16, or Matisse's, Figure 6.25), and they attempt to paint in a similarly daring and summarized manner. Often, the "outer casing" of an artist's style is easy to adopt, but not so the particular types of inner tensions and energies that give his

Figure 6.33
Maria Helena Viera da Silva, *The City* (1951)
Oil on canvas, 37¼ × 32½ in.
The Toledo Museum of Art, Toledo, Ohio. Gift of Edward Drummond Libbey.

works important creative value. These dynamic forces, acting in a way *necessary* to the innovator, are what shape his images and give them their unique stamp. His imagery is the fruit of his perceptual skills, his experiences as a painter and as a person, and his conceptual wit. Without these skills and experiences, that is, without the innovator's creative sensibilities, all the follower can do is imitate surface idiosyncracies and "handwriting." Matisse had this in mind when he wrote (in a letter to Henry Clifford dated February 14, 1948) that he feared that "the young painters are avoiding the slow and painful preparation which is necessary for the education of any contemporary painter...." The only kind of influence an admired artist's work should have on the student is one that encourages explorations of similar dynamic activities, and not surface effects. When a sensitive student examines a master's work closely he soon realizes that, like the artist under study, he must nurture his skills by a penetrating study of nature. As Matisse further observes, "An artist must possess Nature. He must identify himself with her rhythm, by efforts that will prepare the mastery which will later enable him to express himself in his own language."

FIGURE PAINTING AND PORTRAITURE

Perhaps the most attracting but taxing subject for the beginner is the human figure. Its subtle forms and special importance demand unflagging visual sensitivity and discipline. The need to see the figure's actualities of direction, shape, mass, and color must overrule temptations to set down preconceived notions, if our figure paintings are to avoid being mere collections of clichés about human form. This is not to suggest that paintings of the figure must be more objectively oriented. The point is that we must be more objective in seeing the figure because we have more formula solutions at our disposal. As owners of human forms that we know well, it is all too easy to unknowingly shift from noting the measurable facts before us to substituting preconceived familiar solutions, especially when confronted by unusual or foreshortened views of the figure. Unless we have studied figure drawing and at least the rudiments of anatomy, these preconceived

notions about the forms and character of the figure are often rather trite, too generalized to be useful, or simply wrong. Ironically, the beginning figure painter possesses too much rather than too little information about human form, but much of it is detrimental to creativity. Whether our goal is an objective or abstract image, analyzing and experiencing the figure's form actualities is crucial to making those telling choices and changes that bring figure paintings to life.

A dominant concern in figure painting is to keep psychological or anecdotal considerations from overtaking visually expressive ones. Much of the figure's spirit and behavior is revealed through sensitive responses to its measurable and dynamic properties. Again, the best paintings speak *through*, and not merely *about* the subject.

A case in point is Degas' *The Tub* (Figure 6.34). Although the tender (yet troubling) psychological tone conveyed by the artist's depiction of a woman who presumably assumes herself to be in the secluded confines of her boudoir is a significant quality in our response to this work, much of Degas' interest is in the figure's structure and its function in the design. He concentrates on a pattern of circular forms and curved lines that, beginning with the head, extend to include the white drape, the woman's back, and the forward rim of the tub. Note that the figure, while modeled in some greater detail than the surrounding objects, is still treated to the same analytical scrutiny and painterly handling that Degas gives the draperies and the tub. As this work (and the many other figure paintings in this book) demonstrates, the figure, for all its unique importance, must first be seen as raw material capable of numerous interpretations. Had, say, Vermeer, Schiele, or Matisse painted this arrangement, other themes would lead them to other relationships and thus to other meanings.

Although the subject and pose are similar in Prendergast's *Seated Girl* and Powers' *Seated Child with Doll* (Figures 6.35 and 6.36), and though both artists stress something of the same curvilinear character in the forms, these two works differ greatly in conception. For Prendergast, the solidity of volumes and the dynamic play of swarms of block-like strokes that form them are equally important and in-

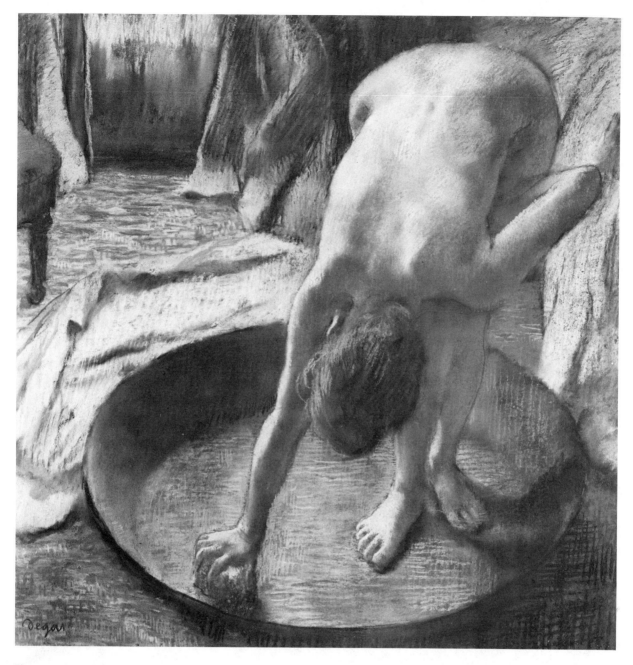

Figure 6.34
EDGAR DEGAS, *The Tub*
Pastel, 27½ × 27½
The Hill-Stead Museum, Farmington, Connecticut

terworking themes. Here and there the impression of weighty mass overtakes the abstract play of the brushwork; in other places strokes and forms compete for dominance. The tensions created by masses striving to form out of clouds of brushstrokes, and their victory in doing so in the head and shoulders, are visual activities charged with energies that enliven the depiction, suggesting something of an impressionistic shimmer of forms in light and of the child's restrained energies. The artist's emphasis is on mass, not edge, and on a painterly bathing of forms by light.

But in Powers' painting, movements are directed mainly by edges, and light is everywhere. Whereas Prendergast avoids shape clar-

Figure 6.35
MAURICE PRENDERGAST, *Seated Girl* (ca. 1912)
Oil on canvas, 24 × 18⅛ in.
Hirshhorn Museum and Sculpture Garden,
Smithsonian Institution.

Figure 6.36
Marilyn Powers
Seated Child, with Doll
Oil on canvas, 18 × 22 in.
Courtesy of Jason Berger.

ity, Powers creates a surging pattern of shapes whose swelling edges generate a storm of undulating movements that activate the entire canvas. Prendergast, in hinting at a vertical orientation to the strokes in the background, concentrates the curvilinear actions in the child. Powers, in enlarging upon the curvilinear actions of the child's forms by the billowing shapes that surround her, achieves an opposite effect. In the former, it is the figure that is brimming with dynamic activity; in the latter, it is the figure's surroundings. Both works are affectionate and visually engaging interpretations of a child, using abstract meanings to convey human ones.

The advent of photography exerted an important influence on painting. Although the camera's single eye does not see around forms as well as our two eyes can, it provided artists with a fairly accurate substitute for most of the subject's qualities, and it influenced compositional treatments. The accidental effects of photos, in showing unusual views and parts obscured or cut off, expanded artists' thinking about the arrangement of forms in their works. Degas took numerous photographs and occasionally used them as models (as did other artists before him). His works often show something of the influence of the camera's candid manner of composition, as in *At the Milliner's* (Figure 6.37). While this pastel was probably developed from sketches or from a live model, it shows the compositional influence of the impersonal camera. The saleswoman, obscured

Figure 6.37
EDGAR DEGAS, *At the Milliner's* (1882)
Pastel, 30 × 34 in.
The Metropolitan Museum of Art.
Bequest of Mrs. H. O. Havemeyer.

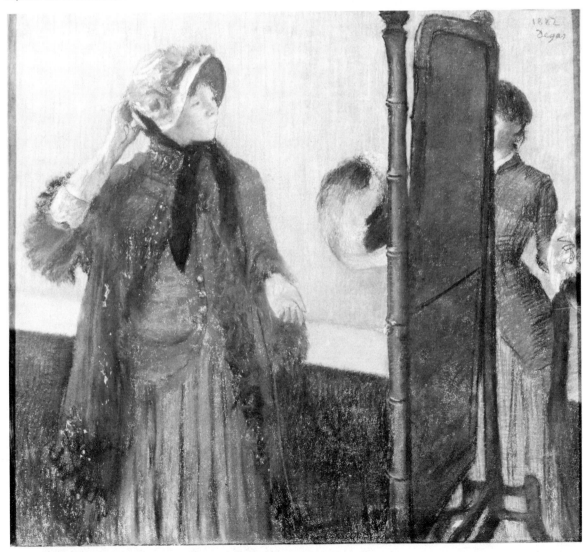

Figure 6.38
PETER BLAKE, *Coco Chanel* (1967)
Acrylic on masonite, 14 × 11 in.
Hirshhorn Museum and Sculpture Garden,
Smithsonian Institution.

and partially cut off by the right side of the paper, and the mirror, cutting off the far right side of the paper, are just the kinds of effects the camera frequently produced, and became favorite compositional devices for Degas.

Degas keeps the vertical strip at the painting's right side from seeming isolated by establishing many similarities in the two figures, and thus bridging the obstacle of the mirror. The figures are similarly dressed and more or less alike in value, they are located at about the same height, and their left arms are similarly placed. Additionally, the hat the saleswoman holds, in appearing to the left of the mirror, helps her to rejoin the rest of the design.

Blake's Coco Chanel (Figure 6.38) shows a further involvement with candid camera ef-

fects. Although such effects precede the invention of the camera by several centuries (some of Hals' early portraits show similar gestural attitudes), there is in Blake's work just the harsh focus, the narrow field of depth that generalizes the advancing hands and the background, and the sense of a frozen moment which we associate with photography.

In touching on the camera's uses, it should be pointed out that there are considerable risks for the beginner in working from photographs. Usually, the results show a mechanical harshness and distortion, and there is a tendency to follow the accidental and random patterns of tone the camera records instead of establishing those tones required by our analysis of the subject's forms and their or-

ganization in the design. Then, too, it is harder to see a form's important structural characteristics in a photograph than when confronting the form itself. But, if integrated with paintings done from life, the occasional use of photographs as models can be a useful aid in expanding our experiences in painting the figure (or anything else). In general, though, the kinds of visual essays that are painted in the presence of the living model (Plates 6, 12, and 19) have an authority and sensitivity harder to come by when using photographs.

For the young painter, the occasional examination of the figure's surface facets—the planar nature of the forms—is an important study. In Pearlstein's exhaustive planar exploration (Figure 6.39), the figures are illuminated

Figure 6.39
PHILIP PEARLSTEIN, *Male and Female Nudes with Red and Purple Drape* (1968)
Oil on canvas, 75¼ × 75⅝ in.
Hirshhorn Museum and Sculpture Garden, Smithsonian Institution.

by several artificial light sources to further reveal the constructional interlocking of planes and form-units.

Portrait painting has stimulated some of the most aesthetically pleasing and psychologically penetrating works ever created. Too often, however, portrait painting is wholly given over to the accumulation of surface facts. Works limited to an objective illustration of surface conditions (sometimes prettified just to please), may achieve a likeness of the sitter's clothing and surroundings, but they often lack a sense of convincing volume and space, of spirit, and are generally commonplace in both conception and spirit.

The best portrait paintings seem always to transcend their subject—to suggest universal human qualities through universally understood visual ones. The portraits by Modigliani (Figure 5.24), Titian (Figure 5.32), Cézanne (5.45), and Schiele (Figure 6.13) all differ widely in the way the artist integrates and uses abstract and figurative considerations. But in each of these portraits much of what we learn about the sitter's character and spirit is conveyed by the character and spirit of the painting's visual dynamics. In the Titian, there is an elegance and flair in the young man *and* in the design, just as there is an abstract and figurative sensuality in the Modigliani, an introspection in the Cézanne, and a restless vigor in the Schiele. The more sensitive the artist's analytical and empathic attitudes are, the more clearly does the painting reveal the sitter's (and the artist's) temperament.

That portrait painting of a highly realistic nature can be more than an impersonal or mannered recording of a sitter's surface features is demonstrated by Van Dyke's *Cornelius van de Geest* (Figure 6.40). A rich pattern of rhythmic shape and line harmonies relates all parts of the design. The large arrowhead shape of the ruffled collar is repeated in the shape of the head, beard, and cheeks. In the area of the eyes, the eyebrows are the rounded tops of two more arrowhead shapes whose points are the skin folds beneath the eyes. More arrowhead shapes can be seen in the ear, jowls, and mouth. A countering pattern of upward-pointing arrowheads appears in the folds of the collar and in the shape of the nose. At either side of the head rich curving lines call to the inner

curves of the head, such as those of the moustache, nostrils, eyes, and ear, further uniting the design. These subtle harmonies and the strong but refined modeling of the forms (so clear-cut, the head could serve as a model for a sculpture in marble) convey the subject as a suave and strong-willed person. In finding dynamic activities that reflect his feelings about the sitter, Van Dyke not only amplifies his interpretation but endows the image with lifelike energies that intensify our experience of being in communication with this genteel but powerful person.

Figure 6.40 is a little masterpiece of indirect painting. Note the thick impastos of the white underpainting in the forehead, nose, and ruffled collar. Darker passages of the underpainting are executed in warm brown tones. The overpainting is thinly applied, mainly in glazes and scumbles, but note the direct painting in the hair and beard, and in small touches about the face.

When the sitter is also the artist, there can be a strong concentration of insights and intentions that result in works of moving intensity. In his early self-portraits, Rembrandt sometimes saw himself as a vigorous and even dashing figure. And, for all their awesome skill, many of these idealized interpretations lack the probing introspection and conviction of his later self-portraits. In his *Self-Portrait* of 1658 (Figure 6.41), and in another painted two years later (see Figure 5.28), both works following a series of personal tragedies and financial setbacks, the artist abandons the lush costumes and the themes of elegance and power they were meant to suggest. Instead, there is a frank self-confrontation—a penetrating soliloquy carried out in visual terms. It is as if he deliberates about his strengths and experiences as a person and a painter. Such affecting qualities do not emerge from the mere scrutiny of surface features but from inquiries touched off by philosophical as well as visual motives.

In Figure 6.41 the artist faces us squarely. The forms are arranged in a monumental pyramid suggesting stability and strength. The gaze is turned inward and the expression, devoid of romantic illusions, suggests a confidence and spirit that have weathered serious challenges. The forms—simple and massive— like the bold and forthright handling all imply

Figure 6.40
ANTHONY VAN DYKE, *Cornelius van de Geest*
Oil on canvas.
The National Gallery, London.

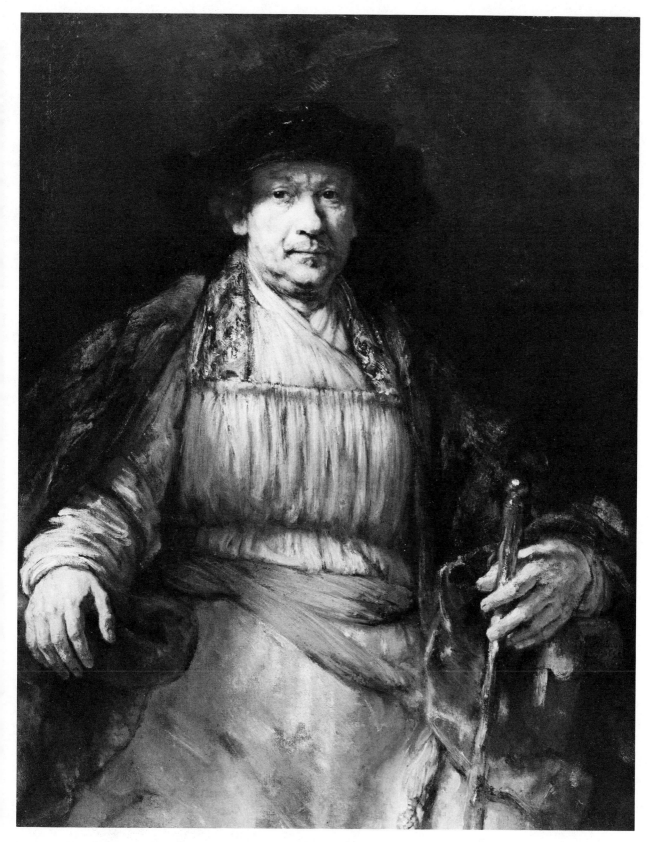

Figure 6.41
REMBRANDT VAN RIJN, *Self-Portrait*
Oil on canvas, 52⅝ × 40⅞ in.

enduring strength. In the painting of the head (Figure 6.42), the same concentration on the essential shape and mass of forms, and on their economical manifestation by a resolute brushwork that seems to fuse color and light, further adds to our appreciation of the artist's strength and sensitivity of spirit.

Here, too, an indirect technique more rugged than Van Dyke's shows the heavy impastos of the underpainting in the light-toned areas, and the quite thin painting of darker passages in both the underpainting and the upper layers. This detail shows the vigor with which Rembrandt applies the paint at the collar and at various places throughout the head, the brushstrokes turning with the form. Note that here, as in the Van Dyke (and in all volume-oriented paintings of heads), the emphasis is not on the so-called features: the eyes, nose, mouth, and ears, but on *all* of the head's

Figure 6.42
REMBRANDT VAN RIJN
Self-Portrait (detail)
Copyright The Frick Collection, New York.

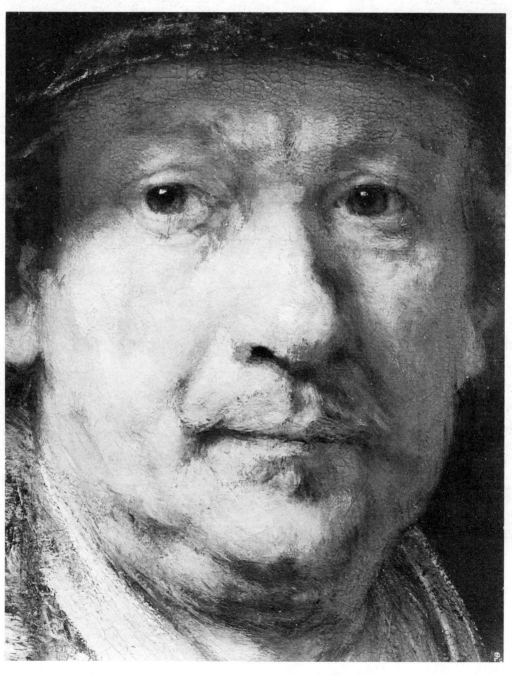

form-features. For great portrait artists, any of the interlocking form-units that comprise the cheeks, jowls, temples, forehead, and so on are as important as those features most beginners tend to concentrate on.

That such structurally oriented painting is an important theme for some artists in every age, and can provide an avenue to psychological and dynamic expressions of an inventive nature, can be seen in the self-portraits by Corinth and Bell (Figures 6.43 and 6.44). A structural approach to painting is, of course, not limited to portrait painting. But, in showing some few of its limitless manifestations in the rather restricted area of portraiture, it is perhaps more strongly evident that sensitive inquiries and responses to a subject's constructional and spatial nature can unlock vital creative forces, even when the subject category is as specific as the forms of the human head.

Figure 6.43
Lovis Corinth, *Self-Portrait* (1917)
Oil on canvas, 18⅛ × 14⅝ in.
Courtesy of The Art Institute of Chicago.

Figure 6.44
LELAND BELL, *Self-Portrait*
Oil on panel, 12½ × 17½ in.
Collection of the artist.

ENVISIONED THEMES

For some artists the stimulus to paint begins with seeing an actual subject, whether it be a person, a bowl of fruit, an outdoor scene, etc. For others the stimulus begins as a desire to depict some inner, imagined subject or idea, whether wholly invented or based on a recollection. The first group has to use imagination to recreate the subject before them; the second group must call upon perceptual judgments to bring their subject into being. To some extent all artists, regardless of their subject, are always involved with both imagining *and* visual judging. No matter which mode stimulates the urge to paint, all works of serious creative worth are nurtured by both *percepts*—visions of the senses, and *concepts*—visions of the mind.

In time, most artists gravitate to one or the other of these two modes of visualization. Before the young painter can make a choice, he needs to explore his innermost attraction to forms, colors, textures, etc., and to the use of paint itself. What and how we choose to paint

when we have examined our feelings and our materials in some depth is of much significance; we gain insights about our deeper visual interests and intuitions. These may be unique or commonplace, inventive or banal, but knowing what they are is essential to their development or re-direction.

The number of possible envisioned themes is without bound. There are as many inner subject matter possibilities as there are imaginative artists. This book cannot provide a blueprint, but it can suggest helpful guidelines. In forming the images of our imagination we must call on the knowledge and experience we have gained through the direct study of the forms around us. Being mindful of the challenges involved in painting even simple objects placed before us should guide our choice of imagined themes and keep us from attempting a too difficult subject. Painting from imagination also reminds us of how important the study of nature is in developing our skills and insights.

When working from our imagination we must rely, even more than the artist whose subject is arranged before him, on an immediate grasp of our envisioned theme's essential visual characteristics. The often unfocused and fleeting nature of an envisioned subject does not allow for a leisurely approach.

Dream-like images often make for provocative expression and a great freedom of visualization. Surrealism, a form of painting that seeks to express processes of thought and feeling through a kind of visual free-association, results in images in which there may be a suspension of the laws of nature and even of reason. Such images generally show unusual or impossible combinations or changes in things and activities. In permitting artists to juxtapose or transform any objects, events, or effects they wish, surrealism further extends the freedom available to the still life painter to select his shapes, colors, textures, etc., and to suggest psychological, religious, or social meanings through these expanded means.

Unfortunately, many students (and some artists), by relying on such a painting's narrative message to convey the painting's meaning, are soon diverted to a concern with nonvisual issues, at a deadly cost to the work's inherent visual quality. For, in the surreal mode, as in any other, the quality of a painting's visually expressive nature is paramount. The most novel or profound nonvisual meanings cannot elevate undeveloped visual skills to the level of art. In the surreal mode, too, expression comes through our way of seeing and relating the things represented. Here too, the dynamic behavior of the elements must be in accord with our impressions, must speak as loudly as the depictive aspects. The examples discussed below are intended only as stimuli to encourage the examination of your own inner imagery.

In concentrating on the "how" of these surrealistic paintings, we should not overlook the psychological meanings that their symbolism and manner hold for us. For these artists mean to provoke our feelings and our imagination.

De Chirico's *The Great Metaphysician* (Figure 6.45) expresses an ominous tranquility through the character and arrangement of the elements. The painting's mood owes much to its harsh shapes, forms, and tonal contrasts, and to the tensions they create. There is tension in the struggle between the vertical-horizontal movements and the diagonal ones; between the crowded, small shapes and the simple, large ones; between the strongly illuminated forms and evening-like quality of the sky; and between the bold vertical structure in the foreground and the strong converging lines of the background. The unease that exists in the equivocal abstract clues augments the unease suggested by the mysterious figurative situation. Such fine-tuned ambiguities at both the dynamic and figurative levels give the painting its haunting mood.

Similarly, the psychological shock of Magritte's *The False Mirror* (Figure 6.46) is amplified by abstract and figurative means. Abstractly, the calming effect of the design's symmetry discreetly reinforces the representationally innocent sky. Both effects, along with the patient and gentle rendering of the forms, lull us into a restful state of mind; this is then shattered by the astounding realization that we are either looking into an eye that functions as a window through which we view the sky, or are looking through (presumably) our own eye and seeing the sky. In either case, the centrally located black disk (an unidentified shape or our eye's pupil), encircled

Figure 6.45
GIORGIO DE CHIRICO, *The Great Metaphysician* (1917)
Oil on canvas, 41⅛ × 27½ in.
Collection, The Museum of Modern Art, New York.
The Philip L. Goodwin Collection.

246

Figure 6.46
RENÉ MAGRITTE, *The False Mirror* (1928)
Oil on canvas, 21¼ × 31⅞ in.
Collection, The Museum of Modern Art, New York. Purchase.

by the "iris" and eyelids, exerts a hypnotic effect that further disorients and intensifies our reactions.

Again, in Bacon's *Painting* (Figure 6.47), the elements, the kinds of moving energies and tensions they enact, and the depiction all interwork to heighten the painting's expressive force. The calming effects of the near-symmetry and the unsettling effects of explosive strokes and shapes, the slashing diagonals and racing curves contrasting with carefully drawn shapes and vertical-horizontal alignments, and the alternating gentleness and fury of the handling are all compatible with the depiction's mood: an impalpable presence of horror rather than an explicit presentation of a horrible event.

Of course, dream-like images needn't be expressions of mystery or horror. Artists such as Henri Rousseau, Miro, Klee, and Chagall painted surreal works of great charm and humor. In Chagall's *Birthday* (Figure 6.48), the tender scene finds immediate support in the dynamic character of the elements. Here, curves turn in gentle, playful ways. The shapes of the objects in the room are those placid geometric curves arranged to offset the improbable leap and angle of the two figures. The window and table on the far left turn away from the vertical-horizontal alignment of the rest of the room's objects to counter the figures' angle with their own. The plush red of the rug also serves to cushion the action of the figures, and to heighten the scene's sensual and dream-like nature.

The inner visions of some painters are less concerned with surreal states than with a forceful reshaping and reordering of familiar subject matter in highly subjective ways. De Staël, Motherwell, and Kline (see Figures 1.11, 5.53, and 6.16) are among the many artists who "process" their images, whether observed or envisioned, through a markedly subjective viewpoint. Of course all artists, to one degree or another, manipulate their subjects to meet their inner intentions. But some apply a quite pronounced set of conditions, a certain fixed visual policy that give their works an especially novel stamp. The various "isms" of nineteenth and twentieth century painting: Impressionism, Cubism, Futurism, and so on, represent various conspicuous visual persuasions brought to bear on seen or imagined subjects to explore new avenues of visual experience and expression.

Leger's *Three Women* (Figure 6.49) is conceived in simplified volumes and shapes that strongly show the influence of Cubism. For Leger, all forms are processed into a kind of machine-tooled state, where cylinders, cones, and spheres predominate. Such polished yet sensual form treatment, such shape, value, and directional activity, and the unique elegance they produce are possible only through a more aggressive reshaping of nature's forms and space.

Other artists reshape according to other conventions and needs. Bloom, Ryder, and Redon create their visionary images out of more organic forms and a more turbulent handling (see Figures 4.9 and 5.31, and Plate 5). Such eruptive and spontaneously conceived works are in the expressionist tradition, a convention that some artists applied to works painted in the presence of the subject, as in Soutine's and Beckmann's paintings (Figures 5.33 and 5.51). Cubism, itself shaped mainly by the influence of Cézanne's paintings on artists such as Picasso and Braque, has exerted an influence on many twentieth century artists, touching off points of view as divergent as Figures 5.11 and 6.33.

Conventions such as these "isms," and even those of individual artists such as Monet and Cézanne, have guided many painters to fertile creative ground where their own ideas and instincts could take root and produce further original points of view. But when conventions are seen as panaceas, as creative cure-alls, they can also lead to overbearingly mannered or derivative results. Besides, established styles, however attractive, sometimes prevent a young painter from developing his or her own visual strengths. Unlike innovative artists who conceive a style that is expressively natural and necessary for their creative purposes, and in whose work the signs of change and extension of the style are always evident, painters *dominated* by an established convention only exemplify its characteristics, and usually in an uninspired manner.

The best painters never merely extoll a style's virtues; they exploit, extend, and exhaust them and then move on. Whether given

Figure 6.47
FRANCIS BACON, *Painting* (1946)
Oil and tempera, 77⅞ × 52 in.
Collection, The Museum of Modern Art, New York. Purchase.

Figure 6.48
MARC CHAGALL, *Birthday*
Oil on canvas, 31⅞ × 29½ in.
The Solomon R. Guggenheim Museum.

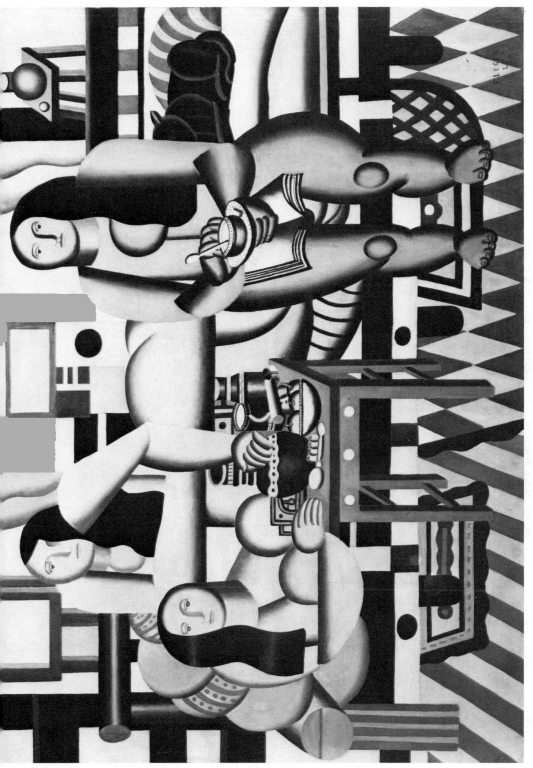

Figure 6.49

FERNAND LEGER, *Three Women* ("*Le Grand Dejeuner*") 1921

Oil on canvas, 6¼ ft. × 8 ft. 3 in.

Collection, The Museum of Modern Art, New York.

Mrs. Simon Guggenheim Fund.

to abstract or figurative imagery, they always pursue experiences and images that, once realized, create new challenges. No matter how quickly or well their skills develop, their concepts stay ahead of their achievements. For such artists there is neither the time nor the temperament to stop the chase in order to eulogize a style. We think of Monet as central to Impressionism, yet his late works are more nearly expressionistic in temperament and purpose. Similar changes in style can be found by comparing the early and late works of, for example, Titian, Rembrandt, Cézanne, Degas, Matisse, Picasso, and many contemporary painters. They all work *through* and not *for a*

style, changing or even abandoning it as their goals change.

Some envisioned images do not depend on recognizable subject matter. Klee's arrangement of rectangular shapes (Plate 7), de Kooning's turbulent forms (Plate 17), and Louis' interpenetrating fields of color (Plate 20) are self-sufficient systems of expressive order. Each is governed by visual sensitivities that establish a hierarchy of events, a balanced order, and an emotive force.

These qualities are present in Riley's *Drift 2* (Figure 6.50), where tones darken toward the edges to emphasize the billowing undulations of the stripes. Note how, despite the vertical

Figure 6.50
BRIDGET RILEY, *Drift Number 2* (1966)
Acrylic on canvas, 91½ × 89½ in.
Albright-Knox Art Gallery, Buffalo, New York.
Gift of Seymour H. Knox.

Figure 6.51
AUDREY FLACK, *Leonardo's Lady* (1974)
Acrylic on canvas, 74 × 80 in.
Collection, The Museum of Modern Art, New York, Purchase.

orientation of the light and dark stripes, diagonal movements insinuate themselves in the design. Far from a casual treatment, these shapes are subtly arranged to evince the optical activities we respond to.

Whether the young painter investigates envisioned images of a figurative, abstract, or nonobjective kind, in occasionally turning inward we uncover creative and temperamental aspects of our selves that can be carried over into other kinds of painting themes. Sometimes such a carry-over can be rather direct. For example, Flack's *Leonardo's Lady* (Figure 6.51) seems at first glance to be a quite believable and highly realistic still life. But on closer inspection we find that forms hover, tilt, and possess impossible scale or perspective properties. The painting is simultaneously a fool-

the-eye piece of naturalism and an unsettling fantasy.

To one degree or another, the experiences of painting from our imagination have the effect of making us treat observed subjects in a more personal way. Our selecting, ordering, and handling seem to grow in authority and state our viewpoint more clearly. Having enjoyed the freedom, insights, and effects that envisioned imagery permits us to experience, we tend to utilize these experiences more insistently in our encounter with the subjects before us.

Many painters find startling similarities between their envisioned works and those painted from nature. Even when the former are nonobjective and the latter are highly figurative in nature, there is often a strong resemblance between compositional solutions, color characteristics, paint uses, and emotional tone. Such comparisons reveal a deeper content in our works—a set of dynamic and psychological characteristics that represent deeply held convictions and feelings. And, as noted earlier, learning what these qualities are is vital to the development or redirection of our creative purposes. If we disregard such introspective examination, we fail to find our fundamental creative personality, and hence we fail to find the best means for shaping a genuinely original means of visual expression.

COLOR FUNCTIONS

The black and white reproductions we have been examining in this review of subject categories have not allowed us to discuss adequately the role of color as a stimulus in the selection and treatment of a subject.

If we turn our attention now to the color plates, we can observe some of the ways in which color functions. Sometimes, as in Degas, Harnett, or Corot (Plates 13, 14, and 19), the colors of the finished work, with only a few subtle adjustments of hue or value, are the colors of the subject. Whether these artists are faithful to a subject's color because their aesthetic persuasion urges them to contend objectively with the things they see or because they find the color of a particular subject attracting, the subject's color actualities are an important part of the stimulus to paint. In such works,

adjustments in color for various form and space, organizational, and expressive purposes do not vary drastically from the colors seen. This is presumably also the case in some imaginary works, for the envisioned image is usually "seen" in the mind's eye in its desired colors. It may well be that when Redon paints a purple rider on an orange horse (Plate 5), he is being as faithful to what he "sees" in his mind's eye as Corot is faithful to his perception of the subtly cooler skin tones in his model's shoulders and arms (Plate 19). In either case, the artist responds to an agreeable color situation, making only discreet changes.

Often, however, a subject's colors serve more as points of departure for the artist. Such departures may be made to more forcefully engage color in structural and dynamic activities, or because the artist requires color to serve a more subjective role. But whether observed colors are stated more or less objectively, or undergo drastic changes is mainly a matter of creative intent, and is not an indicator of the work's color *quality*. The view that, "Anyone who sees and paints a sky green and pastures blue ought to be sterilized ''* is, of course, an insane one. But the fact that a painting's color is subjectively arrived at does not necessarily mean that the color has artistic worth, any more than faithfully denoted color is bound to be good color.

A good use of color is, as noted in earlier chapters, one that directly participates in the painting's organization and expression. Good color is not a matter of quantity or dominance in the design. Color is good when, through its activities in the design and its relevance to the expression, it gratifies and extends our aesthetic and human sensibility. Good color is never incidental to the painting's forms, space, balance, and mood, but plays a key role in shaping and synthesizing these conditions. And this can occur even when color is used in a highly descriptive manner.

The color in Harnett's painting (Plate 14) helps us better understand the location of forms in space. The warm color, as well as the light value of the music sheet on the shelf, strengthens the illusion of its nearness and the sense of the space between it and the cool-

*Adolf Hitler, quoted in the New York Post, January 3, 1944.

toned wall. In the same way, the light-toned music booklet beneath the horn is prevented, by its cool color, from advancing toward us. Had the booklet been orange, it would have required other color changes in the design to hold it in place. Note that the main colors always show one or two concentrations of a relatively strong hue, surrounded by muted variations. The objects painted in the yellow family have their relatively pure voice in the highlights of the horn and in the music sheet, the brown-toned objects in the violin, and the cool-colored ones in the music booklet. All three of these stronger colors occur in the main circle of moving action in the design. In choosing a cool, grayed green for the largest areas, and in painting most of the objects in mellow warm tones, Harnett uses colors that directly express the painting's mood. His sensitivity to the abstract and emotive rightness of these subtle color harmonies and confrontations played an important role in arranging this still life.

No doubt, color considerations also influenced Cézanne's still life arrangement (Plate 4). But here, color is more strongly activated. Each object's color is stated by chords of tones. For example, the blue wall is painted by several kinds of blue and green colors, just as apples and oranges show their main color *and* their warm and cool variations. Such color "themes and variations" enable Cézanne to more directly rely on color to model form, create space, and activate as well as unify the design.

Like Harnett, Degas treats the colors of his painting of a figure in an interior more or less objectively (Plate 13). While he uses color more interpretively in the man's head and trousers, and no doubt made other color adjustments as well, he is more attracted to meeting nature on its own terms, bringing color to an engaging dynamic state through a few discreet inflections. Bonnard, on the other hand, like Cézanne, expands upon the subject's colors, but goes even further, introducing any color that will heighten the abstract and emotive state of the emerging work (Plate 18).

Matisse's *The Red Studio* (Plate 16) elevates color to a commanding role. The impact of such an overwhelming field of color imparts a delightful decorative quality to the objects that encircle the large room. On and against the walls are a number of the artist's earlier, Fauve paintings which, while greatly simplified, are fairly accurate in their general color. Seen as rest areas from the great expanse of earth red color, they become rather jewel-like. In contrast to the paintings and the vase of flowers in the foreground, all the furniture and the modeling stands are left simply as delicate line drawings in yellow. Yellow, mainly appearing as line, acts here as a kind of thread that weaves together the seemingly random arrangement of the objects. Note the intensity of the green leaves. In fact, they are not of a pure hue, but gain strength by being seen against the red tone.

Closer study of Plate 16 reveals interesting mixtures of visual and physical weight. For example, the attracting power of the ceramic dish in the lower left visually outweighs the chairs on the right, but the delicate yellow lines that represent the table add physical weight to the left side, where it is needed to balance the numerous objects of the center and the right side. In selectively omitting the color from some objects, and in suspending the laws of perspective for others, Matisse emphasizes the painting's two-dimensional design, at little loss of the clarity with which we read the painting as a collection of masses in a large interior space. Such a formulation cannot achieve the effects of the Degas or the Bonnard, but neither can either of their formulations approach the kinds of dynamic effects of Matisse's mode of approach. Every artist, in arriving at his or her visual "recipe" for image-making, surrenders certain creative possibilities in order to more clearly express others.

The light-toned blue, russet, pink, and yellow colors in both Turner's and Cézanne's watercolor landscapes (Plates 2 and 11), although similar, function in the two differing modes we have been examining here. In the Turner, color functions in a mainly objective way. While the artist has no doubt intensified the color of some parts and modified the color of others, it is safe to assume that the colors of the painting are basically those of the scene.

In the Cézanne, however, there is a reasoned ordering, a polarizing of the scene's colors into warm and cool facets and lines that establish the major planes and edges of masses, and locate the masses in the spatial field. Unlike the vast stretch of deep space in the

Turner, Cézanne purposely establishes a more shallow spatial field, increasing our awareness of the picture-plane's abstract life.

In the Turner, color creates a sense of light and atmosphere, and suggests something of the local color and value of the things depicted. And, while color directly shapes the great dome of the sky, the buildings and bridges are constructed mainly by brown lines, color appearing only as flat washes. But Cézanne subordinates atmospheric light to the "light" that issues from contrasts of colors and values, and sacrifices information about the local color and value of parts to further this end, and to concentrate more fully on color's structural role. Cézanne's color is more analytical, Turner's more sensual; yet Cézanne's reveals a tender empathy for his subject, while Turner's shows a disciplined reason.

As Derain's *Portrait of Matisse* (Plate 6) demonstrates, color need not be restricted to a merely descriptive function in figure or portrait painting, but can play a principal dynamic role. Even when appearing subdued and retiring, as in Corot's *The Interrupted Reading* (Plate 19), color can perform vital organizational and expressive duties.

Derain's painting is a good example of a subject's color serving as point of departure. It may be that the sitter's shirt was blue and the pipe bowl yellow, but obviously almost every observed color has been intensified or replaced by another one. These color changes are not the result of a capricious whimsy. They come of an astute understanding of the organizational and mass-building characteristics of brilliant hues. In the context of such intense colors, the orange eyelids do seem to suggest the mellower tone we often see in the region of the eye, and the pink tones of the forehead, temple, and cheek do function as depressions in the yellow surface. For the same reason, the pink stroke representing the side plane of the nose does recede from the bridge of the nose to the plane of the cheek, just as dark green shadows model the darkened side of the head, and violet ones the shirt. Organizationally, the nature of these intense colors, in resisting the illusion of atmospheric space even as they model the forms, creates an aggressive play of surface tensions and energies, and of jarring color confrontations.

In contrast, Corot's more tonally oriented work demonstrates how a knowing colorist can achieve, with a quite restricted palette, handsome color harmonies that subtly assist design and expression.

In addition to black and white, Corot uses only some three or four colors: rose madder (the equivalent of our contemporary alizarin crimson), yellow ochre, a more cadmium-like red, and, although they can be made by mixing with the foregoing colors, perhaps an umber or a raw sienna tone, or both. He may for convenience, have added Naples yellow, but this too can be made by mixing his other colors. Interestingly, just these colors, with the probable addition of a pure yellow and an earth red, make up the colors used by Rembrandt in Plate 12.

In the Corot, earth yellows and wine reds from a large, subtle pattern of wedges that aim at the torso, reinforcing the large wedge implied by the position of the arms. Note that, starting with the yellow tone of the background, the colors alternate five times. Except for the skin tones, each of the painting's main colors appears twice: the earth yellow of the wall is repeated as a tint in the skirt, the dark red of the tablecloth is seen in the book's still darker red, the white of the blouse reappears in the pages of the open book, and the black bodice is matched by the tone of the hair. The few, stronger reds are used only in small touches that encircle the head, enlivening that important focal point of the design, which is the terminal of each of the design's directed movements. The skin tones are a synthesis of all the other colors. In the head and shoulders, and in the hands, we can see the subtle violet implications of mixing black with the other colors.

Expressively, the psychological effect of such a warm, mellow setting instantly imparts a lively freshness to the skin tones. The peach-like character of the skin's color gratifies our need to balance the effect of the darker, sonorous colors; its refreshing bite is a satisfying visual answer to the more somber mood of the painting's other colors. In doing so, the skin color unites the painting's color both visually and psychologically.

No doubt the actual colors of Corot's subject were almost those of the painting. *Almost*, but not quite. The color's dynamic functions

and handsome resonance are here due to the artist's awareness of the visual and expressive powers of discreet adjustments in the random colors of the things around us.

If Corot's painting demonstrates a more objective, and Derain's a more subjective approach to color, both show that moving results of important aesthetic worth are available to either mode. No matter what our creative intentions are, color (and any other element) yields the best results when reason *and* feeling guide our judgments for its use. Derain's colors show the effects of shrewd reasoning as well as passion, and Corot's colors are as expressive of the subject's mood as they are representationally logical.

The color of Rembrandt's *Lady with a Pink* (Plate 12), while it appears to be objectively oriented, is nevertheless the result of regarding the colors of the subject as points of departure. The mysterious incandescence of the forms that culminates in the chest and head suggests a light emanating from the figure. The artist infuses all the colors with a golden undertone and, in those places where the light is most intense, lightens the value of the colors beyond what is possible for the tonal order of the overall scene. Some painters, attracted to the "Rembrandtesque glow," have tried to emulate the master by merely adding yellow to every color, or by glazing over their completed works with warm tones. But the strange light and orchestral resonance of Rembrandt's color is not the result of such technical tricks, and certainly not the result of the yellowing varnish that sooner or later darkens and warms the colors of any oil painting. Recently cleaned Rembrandt works increase in their other-worldly light effects, though they often do show rather more cooler color than before their cleaning.

For Rembrandt, color and light are inseparable phenomena. Each color judgment, whether of a passage as large as the wall or the dress, or as small as the touches of warm color along the nose and cheek, must answer his demand that both color and light define *and* transcend the forms. Together they must describe a particular scene and suggest a universal state of grace. Rembrandt's profound humanism and conceptual powers find expression in color *as* light. Perhaps Sir Kenneth Clark had this in mind when he observed that "a painter's greatest gift [is] an emotional response to light."*

In paintings inspired by envisioned images, color, as noted earlier, is often a basic aspect of the initial idea. Whether or not it is, the freedom to introduce or change colors at will permits artists to more easily accommodate their wish to experiment with the color and form of their emerging work. Without a fixed subject before them, which for some artists acts as a main road that limits the degree of departure from the structural, tonal, or chromatic state of the subject, artists working from their imagination are free to change the forming image in any way they feel will better state their intentions. This can be a mixed blessing for beginners, who may soon lose their way in the vast and tantalizing forest of visual options, and wander down enchanting experimental trails, their original intentions forgotten or abandoned. While such free-wheeling exploration is certainly useful, the best results occur when we do not lose sight of our original purposes, but search for solutions that will help us realize them. In the best imaginary works of any period or style, the artist's visual strategy and expressive purpose is clear. Good artists do not wander aimlessly among visual options; they keep the main road of their envisioned image in sight.

Klee and Johns (Plates 7 and 15) both work with a grid system that depends heavily on color, but for opposite reasons. In the Klee, color patterns emerge through the location and value of various colors. As we study the painting, colors seem to switch allegiance before our eyes. For example, at first glance, all the blue tones seem related, but soon sort themselves into lighter and darker groups. No sooner do we recognize their different patterns based on value, than we find light blue tones in association with other light colors, and the dark blue tones linking up with other dark colors. Different visual bonds occur based on color intensity, and even on the location, size, or direction of a color. In fact, there is no end to the visual bonds that occur; the colors change incessantly, advancing or receding depending on what relationship we find them in.

Although in the Johns painting colors do form into small, tenuous patterns, the in-

*Clark, *Landscape into Art* (New York, Harper & Row, 1976).

tention is clearly to keep such unions from oc-curing on a large scale. Here, red acts as a base upon which various yellow and blue tones do more to neutralize each other's effects than to fight for dominance. The resulting impression is of a tapestry-like surface where the "weave" of the brushwork and the grid lines have as much visual impact as does the interplay among the colors. In the Klee, changing actions are cunningly brought into play; here, the power of the three primary colors and of a strong grid pattern are just as cunningly be-calmed.

In Chapter Five, we saw that the color in de Kooning's *Excavation* (Plate 17) was central to his visual and expressive theme of turbu-lence. In Redon's *Roger and Angelica* (Plate 5), a more romantic storm issues from different colors but similarly agitated shapes and forms, which are almost as hard to disentangle as are those in the de Kooning. Another similarity between these two very differing works is the strategy of permitting light, pure colors to ap-pear only as small flashes in an activated sea of duller or darker color.

As this comparison suggests, what we paint deeply affects how we paint it, and, whatever our particular style may be, similar feelings will turn to certain solutions that are universally understood. The more we are moti-vated by a strong desire to experience and share the meanings we find in the things we see or imagine, the more clearly does the lan-guage of painting communicate universally. Paintings that often fail to communicate are those which require a knowledge of the cir-cumstances under which they were painted, or depend on their title, or merely claim attention because of the story-telling or novelty appeal of their imagery. This is bound to be the case when the meanings are not inherent in the vi-sual nature of the work, but rely on its nonvi-sual or bizarre state.

For Louis, in *Number 99* (Plate 20), color also suggests light. The enormous stain that all but covers the variously colored shapes, in fall-ing short of doing so, serves as a large glaze that permits the light of the canvas to shine through. From the unglazed sections of the col-ored shapes we infer the brilliance of their col-ors that the large stain softens. Because the stain imparts its color to so many of the other

colors, there is an almost overbearing harmony among them. But the encircling band of un-glazed colors, in addition to providing a much needed visual relief, provides clues to the real color of many of the glazed shapes, further re-lieving the situation, and allows us to study the differing effects of the stain's color on many of the rest. A secondary theme involves the overlapping of the variously colored shapes, in which the colors recede or advance, sometimes in agreement with their overlapped or overlapping state, and sometimes in con-trast to it. This results in the suggestion of space as well as light. Collectively, the colors strike a splendid visual chord of chromatic ef-fects that underscore the muted liveliness and grandeur of the image.

Color can sometimes be the initial stimu-lus even for envisioned images in a figurative vein. Unlike the usually delicate color of his works in watercolor, Turner's oil paintings, es-pecially his later ones, possess great color bril-liance. Sometimes, as in his paintings of storms at sea, the color is of a pale brilliance, what Constable referred to as "tinted steam." In other works, as in Turner's *The Slave Ship* (Plate 21), rich colors glow with an extraordi-nary incandescence.

Like Rembrandt, Turner fuses color and light, and even more daringly intensifies both phenomena. Indeed, in some of Turner's paintings, where vast stretches of sky and sea merge in radiant whorls of color, one suspects that colored light is the real subject, and the representational event a convenient and sel-dom intrusive adjunct. This is somewhat the case in Plate 21, where the presence of the floundering ship and the figures in the water do not encroach on the flame-like eruption of luminescent colors. And, while the drama of the scene is strongly magnified by the ex-pressive force of the color's actions and energies, it is apparent that removing the ship and figures would scarcely affect the meaning and beauty of the flaming vapors that are Turner's foremost interest.

FINDING YOUR WAY

Throughout this book I have tried to avoid dic-tating what or how to paint. Those observa-

tions which may have bordered on the how-to-do-it variety point to universal processes that can serve a wide range of painting interests, and not to fixed techniques and conventions. Those observations on perception and on the abstract and figurative dynamics of painting which may have seemed weighted to reflect my own bias were intended to point to universal qualities that all works of art possess in various formulations. While total objectivity is ever elusive, my purpose was not to lobby for personal creative values, and certainly not to limit creativity, but to alert the reader to those perceptual and dynamic factors which, if they are left unregarded, do seriously limit creativity.

This book's purpose is to help you find *your* way of responding to visual events important to *you*. The ability to inquire and inform, to exchange insights and feelings, and by this give and take to reassure ourselves that we are not altogether alone, is a profound human need. The uniquely human conditions for such exchanges, our need for balanced discourse, for harmony, and for expressive clarity is rooted as much in our instincts for survival as in our creative sensibilities. Indeed, the history of art, as of civilization, is as much the story of the struggle against chaos, dictate, and rigidity, as it is the unfolding of concepts and ideals for achieving greater human fulfillment.

Our human desire to explore, to create, and to share those of our ideas and artifacts that satisfy our need for order and expression—in both our creative and our daily life—is founded on fixed universal instincts woven into the very fabric of our being. These instincts shape the basic patterns and boundaries by which we live and create. This book has tried to point to some of these universal instincts, and to their implications for creativity in painting.

bibliography

BAZZI, MARIA. *The Artist's Methods and Materials.* trans. Francesca Priuli. New York: Pitman Publishing Corp., 1960.

BIRREN, FABER. *History of Color in Painting.* New York: Van Nostrand Reinhold Co., 1965.

CENNINI, CENNINO. *The Craftsman's Handbook; "Il Libro dell Arte,"* trans. Daniel V. Thompson, Jr., New Haven, Conn.: Yale University Press, 1953.

CHAET, BERNARD. *Artists at Work.* Cambridge, Mass.: Webb Books, 1960. Distrib. Hill & Wang.

CHIEFFO, CLIFFORD T. *The Contemporary Oil Painter's Handbook.* Englewood Cliffs, N. J.: Prentice-Hall, Inc., 1976.

CHIPP, HERSHELL B. *Theories of Modern Art.* Berkeley and Los Angeles: University of California Press, 1971.

CHOMICKY, YAR G. *Watercolor Painting.* Englewood Cliffs, N.J.: Prentice-Hall, Inc., 1968.

CONSTABLE, WILLIAM G. *The Painter's Workshop.* New York and London: Oxford University Press, 1954.

COOKE, HEREWARD LESTER. *Painting Techniques of the Masters.* New York: Watson-Guptill Publications; London: Pitman Publishing Corp., 1972.

DEHN, ADOLF ARTHUR. *Watercolor, Gouache, and Casein Painting.* New York: The Studio Publica-

tions, Inc.; in association with Thomas Y. Crowell Company, London, 1955.

DE REYNA, RUDY. *Painting in Opaque Watercolor.* New York: Watson-Guptill Publications, 1969.

DOERNER, MAX. *The Materials of the Artist and Their Use in Painting,* trans. Eugen Neuhaus. rev. ed. London: Hart-Davis Ltd. 1969.

DUNSTAN, BERNARD. *Painting Methods of the Impressionists.* New York: Watson-Guptill Publications; London: Pitman Publishing Co., 1976.

EASTLAKE, SIR CHARLES. *Methods and Materials of Painting of the Great Schools and Masters.* New York: Dover Publications, 1960.

FABRI, RALPH. *Color, A Complete Guide for Artists.* New York: Watson-Guptill Publications, 1967.

GETTENS, R.M. AND G. STOUT. *Painting Materials: A Short Encyclopedia.* New York: Dover Publications, 1966.

HILER, HILAIRE. *Notes on the Techniques of Painting.* New York: Watson-Guptill Publications, 1969.

HUNT, W. M. *On Painting and Drawing.* New York: Dover Publications, 1976.

ITTEN, JOHANNES. *The Art of Color,* trans. Ernst von Haagen. New York: Van Nostrand Reinhold Co., 1961.

KAY, REED. *The Painter's Guide to Studio Methods and Materials.* New York: Doubleday & Co., Inc., 1972.

KOSCHATZKY, WALTER. *Watercolor: History and Technique,* trans. Mary Whittall. New York: McGraw-Hill Book Company, 1970.

LAURIE, ARTHUR P. *The Painter's Methods and Materials.* New York: Dover Publications, 1967.

MERRIFIELD, M. P. *Original Treatises on the Arts of Painting,* vols 1 and 2. New York: Dover Publications, 1967.

MEYER, RALPH. *The Artist's Handbook of Materials and Techniques;* rev. ed. New York: The Viking Press, 1970.

NICHOLLS, BERTRAM. *Painting In Oils.* New York: The Studio Publications, Inc., 1959.

OCVIRK, BONE, STINSON, AND WIGG. *Art Fundamentals.* Dubuque, Iowa: Wm. C. Brown Company, Publishers, 1975.

SEARS, ELINOR L. *Pastel Painting Step by Step.* New York: Watson-Guptill Publications, 1968.

SPERRY, VICCI. *The Art Experience.* Boston: Boston Book and Art Shop, 1974.

TAUBES, FREDERIC. *Acrylic Painting for the Beginner.* New York: Watson-Guptil Publications, 1971.

TAUBES, FREDERIC, *Painting Methods and Techniques.* New York: Watson-Guptill Publications, 1964.

THOMPSON, DANIEL V. *The Practice of Tempera Painting.* New York: Dover Publications, 1962.

TORCHE, JUDITH. *Acrylic and Other Water-Base Paints.* New York: Sterling Publishing Co., Inc., 1967.

VICKERY, ROBERT. *New Techniques in Egg Tempera.* New York: Watson-Guptill Publications, 1973.

WATROUS, JAMES. *The Craft of Old Master Drawings.* Madison: University of Wisconsin Press, 1957.

WATSON, DORI. *The Techniques of Painting.* New York: Van Nostrand Reinhold Co., 1970.

WEHLTE, KURT. *The Materials and Techniques of Painting,* trans. Ursus Dix. New York: Van Nostrand Reinhold Co., 1975.

WÖLFFLIN, HEINRICH. *Principles of Art History,* trans. M. D. Hottinger. New York: Dover Publications (no date).

WOODY, RUSSELL. *Painting with Synthetic Media.* New York: Van Nostrand Reinhold Co., 1965.

index